KAREL TEIGE / 1900–1951

THE MIT PRESS
CAMBRIDGE,
MASSACHUSETTS
LONDON, ENGLAND

KAREL TEIGE / 1900–1951

L'ENFANT TERRIBLE

OF THE CZECH

MODERNIST

AVANT-GARDE

EDITED BY

ERIC DLUHOSCH

ROSTISLAV ŠVÁCHA

Source information is given on p. 390.

Published with the assistance of the Getty Grant Program.

The Publisher wishes to thank an anonymous donor for helping to make the publication of this book possible.

This book was set in Bembo and Helvetica by Graphic Composition, Inc. and was printed and bound in the United States of America.

Library of Congress Cataloging-in-Publication Data

Karel Teige : l'enfant terrible of the Czech modernist avant-garde / edited by
 Eric Dluhosch and Rostislav Švácha.
 p. cm.
 Includes bibliographical references and index.
 ISBN 0-262-04170-7 (alk. paper)
 1. Teige, Karel, 1900–1951—Criticism and interpretation. I. Dluhosch,
Eric, 1927– . II. Švácha, Rostislav.
 N6834.5.T45K37 1999
 700'.92—dc21 99-14923
 CIP

Karel Teige. Photo by Olga Hilmerová, ca. 1948.

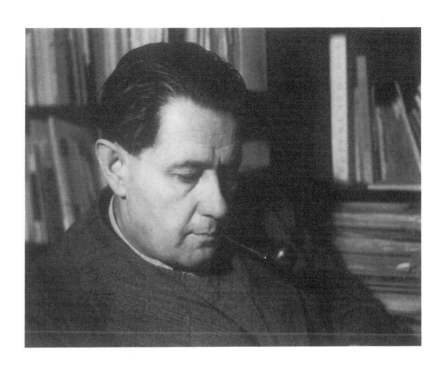

C O N T E N T S

3/ Lenka Bydžovská, "The Avant-Garde Ideal of Poiēsis: Poetism and Artificialism during the Late 1920s"

1. Karel Teige, cover for the review *ReD* 1, no. 1 (October 1927)
2. Josef Šíma, *Neskutečna těla* or *Bílé tělo* (*Unreal Bodies* or *White Body*), 1927
3. Josef Šíma, *Ml,* 1927
4. Toyen, *Fata morgana* (*Mirage*), 1926, and Jindřich Štyrský, *Krajina v oblacích* (*Landscape in Clouds*), 1925
5. Jindřich Štyrský, *Jinovatka* (*Hoarfrost*), 1927
6. Toyen, *Tonouci koráb* (*Shipwreck*), 1927
7. Toyen, *Cigaretový dým* or *Umbre* (*Cigarette Smoke* or *Mist*), 1927
8. Jindřich Štyrský, *Noční rychlík* (*Night Express*), 1927
9. Toyen, *Čajovna* (*Teahouse*), 1927
10. Jaromír Funke, *Two Photograms,* 1929
11. *Argo Argonautus,* from the UfA-film "Wunder des Blauen Golfes" ("Miracle of the Blue Lagoon")
12. *Landscape under the Sea,* with the caption "Štyrský? Toyen? Photo!" 1928
13. Jindřich Štyrský, *Povodeň* (*Flood*), 1927

5/ Polana Bregantová, "Typography"

1. Karel Teige, cover for the Czech translation of Guillaume Apollinaire's book *Prsy Tiresiovy* (*The Breasts of Tiresias*) 1926
2. František Muzika, cover for Vítězslav Nezval's book *Básně noci* (*Poems of the Night*) 1930
3. Karel Teige, a proposal for the reform of Herbert Bayer's typeface, showing the changes he made to the letters *a, g, k, x,* 1929
4. Vít Obrtel, title page and frontispiece for Vítězslav Nezval's book *Akrobat,* 1927
5. Karel Teige and Otakar Mrkvička, cover for the Czech translation of Guillaume Apollinaire's book *Sedící žena* (*La Femme Assise*), 1925
6. Karel Teige, illustration for Vítězslav Nezval's book *Abeceda* (*Alphabet*), showing the letter G, 1926
7. Karel Teige, illustration for Nezval's *Abeceda,* showing the letter S
8. Karel Teige, cover for Konstantin Biebl's book *Zlom* (*The Break*), 1928
9. (a)–(d) Karel Teige, four typographical illustrations for Biebl's *Zlom*

12/ Vojtěch Lahoda, "Karel Teige's Collages, 1935–1951: The Erotic Object, the Social Object, and Surrealist Landscape Art"

Man proceeds in the fog. But when he looks back to judge people of the past, he sees no fog on their path. From his present, which was their faraway future, their path looks perfectly clear to him, good visibility all the way. Looking back, he sees the path, he sees the people proceeding, he sees their mistakes, but not the fog. And yet all of them—Heidegger, Mayakovsky, Aragon, Ezra Pound, Gorky, . . . all were walking in fog, and one might wonder: who is more blind? Mayakovsky who as he wrote his poem on Lenin did not know where Leninism would lead? Or we, who judge him decades later and do not see the fog that enveloped him?

— MILAN KUNDERA *Testaments Betrayed* (1995)

And Teige? And the modernist avant-garde of the 1920s and 1930s? Did they not all walk in the fog? The fog of modernism, the fog of world revolution, the fog of two world conflagrations, the fog of fascism and communism, the fog of the illusion of unstoppable Marxist progress? And, finally, ourselves, who pretend to see so clearly from the precarious perch of our postmodern disillusionments, are we really out of the fog? And what about the past? Should we bury it, or judge it? Or simply tell its tale?

It is the latter course that the editors have decided to pursue in telling the story of Karel Teige, a true child of the twentieth century, born in 1900, at its very dawn, and destined to grow up in a country that too was a child of this century: Czechoslovakia, born in 1918, the same year that Teige reached maturity. He burst on its small but lively cultural stage as a veritable jack-of-all-trades: painter, graphic artist, poet, critic, theorist of art and architecture, actor, political agitator, lover, anarchist, Marxist ideologue (though never a member of the Communist Party)—in short, a dreamer of impossible dreams right to his tragic end, when the twentieth century rewarded him with the magic of its ability to transform every utopia, even a personal one, into a nightmare.

In that sense, Teige is in good company, for he knew and consorted with other dreamers of his generation, from André Breton to Le Corbusier in France to Hannes Meyer and Walter Gropius in Germany, and he was godfather to his own Czech brotherhood of avant-garde artists and intellectuals in Devětsil. He did not know Walter Benjamin (1892–1940), nor Ernst Bloch (1885–1977), but in many ways he belongs in their company as well, for his writings ponder many

of the same questions asked by these other two great proponents and interpreters of the modern. The affinities with as well as the differences between the writings of Teige and those of Benjamin and Bloch are as yet unexplored and certainly warrant serious study. This volume is a modest beginning in providing the raw material for such an undertaking.

It is for the above reasons that we have decided to eschew the current propensity to dissect, deconstruct, or generally reinterpret in presenting the legacy of Karel Teige. Moreover, we realize that his work is virtually unknown in the English-speaking cultural realm, primarily because of the failure to translate his writings from a difficult, minor Central European language—Czech.

This brings up a second point: small nations and the question of translation. Here again Kundera, the Czech novelist who started his writing career in Czech but now writes in French to reach a worldwide audience, may be quoted: "Small nations. The concept is not quantitative; it describes a situation; a destiny: small nations do not have the comfortable sense of being there always, past and future; they have all, at some point or another in their history, passed through the antechamber of death; always faced with the arrogant ignorance of the large nations, they see their existence perpetually threatened or called into question; for their very existence *is* the question."[1]

One can only speculate what Teige's exposure would have been if he had been born in France, Germany, Russia, or the United States. Apart from writing in a major language, he would have certainly reached a home readership many times that of his small audience of Czechs. Only after his quarrel with Le Corbusier and his stormy relationship with the Bauhaus and the CIAM did his name became known on the international scene.

However, it is the purpose of this volume not to present Teige as a protagonist or antagonist with respect to this or that international movement or personality, but to allow him to speak with his own voice and convince with his works. It is also for this reason that some of his more important essays have been included, translated from the original Czech without editorial comment, thus providing the reader with a flavor of his original thinking, in his own words.

Most of the volume consists of essays on various aspects of Teige's accomplishments by a range of authors who have tried to present the reader with a

well-rounded cross-section of Teige's oeuvre. In preparing this book, we have attempted to provide the authors with maximum freedom, while at the same time trying to avoid excursions into overly narrow and compartmentalized "academic" criticism. Surely Teige himself would have resisted such a treatment of his writings, as he firmly believed in an *ars una,* free of the artificial separation of one branch of the arts from the other.

The concept of *ars una* is also reflected in the organization of the book. The aim was not to produce an anthology, or a taxonomy of Teige's oeuvre, but to present the reader with a kind of multitheme tapestry, in which all aspects of Teige's accomplishments are composed into a rich and tightly interwoven intellectual (as well as pictorial) pattern. Hence, the book can be read from front to back, back to front, or randomly; the reader is encouraged to select an area of his or her individual interest first and pick up the overall thread in the other chapters later. This approach may have resulted in some textual overlaps, which we have tried to keep to a minimum; but such overlapping is inevitable if each contribution is both to be comprehensible on its own merit and at the same time is to mesh with the rest of the volume.

Finally, a few words on Teige's personal fate. It is the blight of our modern age to judge everything and everybody on the assumption that we already possess the certitude of perfect historical hindsight and the license to praise or condemn, as if there were no nuances, even when dealing with "good" personalities sometimes paying obeisance to "bad" masters. Teige experienced this wicked habit of our age to turn everything into its opposite in his own life. From passionate supporter of the "proletarian" revolution to persona non grata of the very regime that he had so ardently wished to assume power, Teige suffered the typical fate of the avant-garde idealist confronted by the stark realities of human lust for power and political venality, who is ultimately forced to face the vexing question of whether human nature can be genuinely and permanently changed to abandon war, oppression, and greed and whether he can embrace his surrealistic dreams of a technically perfect but humanly fallible utopia.

He too walked in the fog, and when he emerged from it he met a monster that not only crushed his spirit but broke his heart as well. Thus the editors dedicate this book to Teige the poet-anarchist, rather than Teige the ideologue-Marxist.

ERIC DLUHOSCH Cambridge, Massachusetts, 15 May 1998

Note
1. Milan Kundera, *Testaments Betrayed* (New York: HarperCollins, 1995), 192.

Eric Dluhosch's foreword moves me, in the name of all the Czech contributors to this volume, to explain to the English-speaking reader our own reasons why we consider it to be important to publish, at the close of the twentieth century, the legacy of a leftist utopian and why we have decided to introduce the work of Karel Teige to a Western audience. Our explanation may sound redundant, since all the substantive arguments for this publication may be found in Eric's foreword. Nevertheless, a few additional points warrant emphasis.

The study of Teige's work in particular, as well as the accomplishments of the Czech avant-garde in general, was initiated by Czech scholars already before the "Velvet Revolution" of 1989, even though the publication of our research was hampered by various political prohibitions, which prevented us from bringing into the open many aspects of Teige's oeuvre that then were considered politically inadmissible by the Communist regime. It was only after 1989 that an open discussion of all aspects of Teige's legacy was possible, prompting the authors to use this newly won freedom to tell the full story of Teige's contribution as part of the larger story of the Central European avant-garde. We believe that a discussion of Teige (as well as of other groups and personalities of the Central European avant-garde) will yield satisfactory results only if it becomes part of a truly international discourse.

A genuine exchange of views on the history of the cultural contributions of the avant-gardes of Central Europe can, however, never occur if it remains handicapped by linguistic barriers, barriers that eventually exclude as effectively as political or ideological ones did in the past. Hence, no serious investigation of all the avant-gardes of the early twentieth century can proceed without the direct study of avant-garde texts in their original form, even if in translations. Most members of the avant-gardes of Central Europe naturally published primarily in their own native language, be it Czech, Polish, Hungarian, or Romanian, and it is an unfortunate fact of life that these languages do not fall into the common pool of linguistic resources of the dominant schools of Western cultural scholarship.

A good example is Teige's well-publicized critique of Le Corbusier's Mundaneum project in Geneva. It is useful to remember that Le Corbusier was able to provide an answer to Teige's attack only after someone translated it to him from the Czech to French (and who knows how accurate that translation might

XX

have been?). It is an equally unfortunate fact that the most important writings on the subject of the Central European avant-garde have so far been available almost exclusively in their original "exotic" languages, remaining unavailable to the Western public and thus largely unknown. Our book is an attempt to break through this language barrier and thereby also add to the understanding of our own contribution not only to avant-garde modernism in Europe but to world culture.

As mentioned in the foreword, translations of four original essays authored by Teige himself have been added to the text; these are considered by the Czech authors as typical of his style and theoretical thinking, and they provide at the same time a condensed example of Teige's own artistic credo. In the same vein, our own essays are intended as guides through the intellectual and artistic territory of Teige's prolific oeuvre, which also happens to be the territory of our own native tongue.

Having said this, we wish to express our deep gratitude to Roger Conover, acquisitions editor at The MIT Press, for his farsighted understanding of the cultural importance of publishing contributions from the hitherto neglected Central European cultural sphere, now happily part of the larger Western cultural community again.

ROSTISLAV ŠVÁCHA Prague, 15 May 1998

ACKNOWLEDGMENTS

The book was written in cooperation with the Institute of Art History of the Academy of Sciences of the Czech Republic (Ústav dějin umění Akademie věd České republiky, abbreviated ÚDU AVČR); special thanks are due to its director and contributor to this volume, Vojtěch Lahoda. The editors wish to extend their sincere gratitude to members of the ÚDU AVČR for their steadfast help and collegial cooperation in the preparation of this volume.

The contribution of scholars associated with the ÚDU AVČR speaks for itself and attests to the willingness of all the authors to sacrifice their time and exert much energy not only to provide original essays, procure the English translations, patiently accept the inevitable delays and complexities of transatlantic communications, but—above all—to submit to the selfless discipline of integrating their individual essays with one another's with minimum overlap.

Dušana Barčová, head of the photo archive of the Institute, and František Krejčí, staff photographer, must be commended for the thoroughness of their efforts in providing The MIT Press with the many excellent reproductions of Teige's work included in this volume from the ÚDU AVČR archives in Prague.

Special thanks are due to Karel Srp, curator of the Prague Municipal Gallery, for his advice on the intellectual and conceptual organization of the contents of the main text, not to mention for his contribution of two key essays.

In addition, the individuals and staffs of the following cultural institutions in the Czech Republic have generously provided material for this volume: the Prague Municipal Gallery and its director, Jaroslav Fatka; the National Gallery of Prague and its director, Martin Zlatohlávek; the National Technical Museum in Prague and its director, Ivo Janoušek; the District Building Archives in Prague; Galerie Benedikta Rejta in Louny and its director, Alica Štefančíková; and the State Gallery in Zlín.

On the other side of the Atlantic, gratitude must be extended to the Wolfsonian–Florida International University, a museum and research center devoted to art and design from 1885 to 1945, which not only provided the U.S. editor with resources to conduct much of the necessary preliminary research on Teige but also generously supplied a substantial number of the book's illustrations. Peggy Loar, former director, and Cathy Leff, acting director, were unsparing in their effort to facilitate unrestricted access to the rich resources of the Wolfsonian

and to provide a true home for me during my annual winter sojourns. Joel Hoffman, associate director of academic programs and administration, both contributed intellectual support and become a true friend in helping me to adjust to the new environment of a research museum. The same is true of all members of the Wolfsonian's friendly and dedicated staff.

The Wolfsonian librarians, Pedro Figueredo and Francis Luca, assiduously gathered together all the relevant books, journals, pamphlets, posters, and postcards in the vast library collections and spent countless hours copying texts and illustrations intended for reproduction in this volume. Their help was essential for the success of this effort.

Kudos to Wendy Kaplan, the Wolfsonian's associate director for exhibitions, whose curatorial support resulted in the organization of the first exhibition of Teige's oeuvre in America and inspired the editors to extend the initial modest aim of the book to become a companion for an exhibition of Teige's ouevre in 2000.

Alice Falk deserves full credit for her careful editing of the final text.

Finally, I want to thank Mitchell Wolfson Jr., the founder of the Wolfsonian-FIU, whose idea it was to combine the book with an exhibition; he was thus not only the father of the idea but a patron of its realization as well.

XXIII

Polana Bregantová
Born 1954 in Prague. Researcher at the Institute of Art History of the Czech Academy of Sciences, Prague. Her professional work is centered on bibliography and the history of book design. She has published essays in exhibition catalogues, such as "Vít Obrtel, 1901–1988" (Prague, 1992); "Stories of the Publishing House Topič, 1883–1949" (Prague, 1993); "Karel Teige, 1900–1951" (Prague, 1994); and "Vladimír Fuka: Journey into the Labyrinth" (Cheb, 1996).

Lenka Bydžovská
Born 1956 in Děčín. Researcher at the Institute of Art History of the Czech Academy of Sciences, Prague. From 1996 until the present, editor-in-chief of the Czech art journal *Umění* (*Art*). Co-organizer of a number of exhibitions on art, such as the retrospective exhibition *Czech Surrealism, 1929–1953* (Prague, 1996) and the permanent exhibition *Czech Modern Art, 1900–1960,* in the National Gallery in Prague. She publishes regularly on Czech avant-garde art and is coauthor of the book *Volné směry* (*Free Directions*) (Prague, 1993).

Rumjana Dačeva
Born in 1941 in Lom, Bulgaria. Curator of the art collections of the Památník národního písemnictví (PNP; Museum of Czech Literature) in Prague. She has collaborated on a number of exhibitions devoted to important periods and personalities of Czech modern art, such as Adolf Hoffmeister (1992), Josef Váchal (1994), *Moderní revue* (1995), and *Sursum* (1996). She has prepared the sets for Teige's collages for *Fotofest '90* in Houston, Texas (1992), and exhibitions of Teige's work in Prague (1994), Trieste (1996), and Rome (1996).

Eric Dluhosch
Born in 1927 in Jindřichův Hradec. Emigrated to Canada in 1949 and the United States in 1963. Studied architecture in Canada and the United States. Practiced in Canada and the United States from 1960 to 1971; taught architecture at Ohio University, California Polytechnic University (San Luis Obispo), Cornell, and the Massachusetts Institute of Technology (from 1975 until the present). He has done extensive research and consulting on industrialized housing

and building technology in the United States, Middle East, Latin America, and Asia, with publications on housing, building systems, Russian constructivism and urbanism, and the history and theory of the Modern Movement in Architecture. He is currently MIT professor emeritus. Guest curator for exhibition *The Poetry of Life: Karel Teige and the Czech Avant-Garde,* The Wolfsonian-FIU (Miami Beach, fall 2000).

Vojtěch Lahoda
Born 1955 in Prague. Art historian and director of the Institute of Art History of the Academy of Sciences of the Czech Republic. He is engaged in the study of the history and theory of modernism and its avant-gardes in Czech art. He has curated a number of major exhibitions on Czech modernism in Europe and has earned senior fellowships from the National Gallery of Art in Washington, the Netherlands Institute of Advanced Studies in Wassenar, and the Soros Foundation in Prague. Among his books, the following are directly related to the subject of this volume: *Karel Teige: Surrealist Collages, 1935–1951* (Prague, 1991); *Český kubismus* (*Czech Cubism*) (Prague, 1996).

Miroslav Petříček Jr.
Born 1951 in Prague. Teacher at Charles University and the Central European University in Prague. Researcher in the Institute of Philosophy in the Academy of Sciences of the Czech Republic. He has translated into Czech important philosophical works by Derrida, Fink, Barthes, and Lévinas. He has published the books *Úvod do (současné) filosofie* (*Introduction to [Contemporary] Philosophy*) (Prague, 1990), and *Znaky každodennosti* (*Signs of Everyday*) (Prague, 1993).

Klaus Spechtenhauser
Born 1969 in Baden (Switzerland). Studies in the History of Art and Slavic Philology at the Universities of Zurich and Prague. In 1994–1995: active in the Exhibition Department of the Institut für Geschichte und Theorie der Architektur (GTA; Institute of History and Theory of Architecture) at the ETH (Eidgenössische Technische Hochschule) in Zurich. He was co-organizer of the exhibition *Jaromír Krejcar, 1895–1949* (Prague, Vienna, and Zlín, 1995–1996) and supplied the concept for the exhibition *Jiří Kroha—Kubist, Expressionist, Funktionalist, Re-*

alist at the Architektur Zentrum Wien (Architectural Center in Vienna) (1998). Since 1995, he has published regularly on the architectural history of the twentieth century.

Karel Srp
Born 1958 in Prague. Curator of the Prague Municipal Gallery. He has contributed to a number of major exhibitions on Czech and European Art of the twentieth century, including *Tvrdošíjní (The Stubborn Ones)* (Prague, 1986–1987); *Devětsil* (Oxford and London, 1990); *Kubismus in Prag, 1909–1925* (Düsseldorf, 1991); *Wolfgang Denk* (Prague, 1992), *Karel Teige, 1900–1951* (Prague, 1994); *Alfons Mucha, Das Slawische Epos* (Krems, 1994); *Český surrealismus, 1929–1953 (Czech Surrealism, 1929–1953)* (Prague, 1996); and *Close Echoes* (Prague, 1998). He is also coauthor of the permanent exhibition of Czech modern art in the National Gallery in Prague.

Rostislav Švácha
Born 1952 in Prague. Researcher at the Institute of Art History of the Czech Academy of Sciences, Prague. Teaches history of architecture at Palackého University in Olomouc and the Academy of Fine Arts in Prague. He has been instrumental in the preparation of the architectural sections of major exhibitions on modern Czech art, such as *Devětsil, Czech Avant-Garde Art of the 20s and 30s* (Oxford and London, 1990); *Kubismus in Prag, 1909–1925* (Düsseldorf, 1991); and *Karel Teige, 1900–1951* (Prague, 1994). His published books include *Od moderny k funkcionalismu (From Modernism to Functionalism)* (Prague, 1985), *Le Corbusier* (Prague, 1989), *Jaromír Krejcar, 1895–1949* (Prague, 1995), and *The Architecture of New Prague* (Cambridge, Mass., 1995).

Daniel Weiss
Born 1967 in Zurich. Studies in History of Art and General History at the University of Zurich. Since 1993, responsible for the Archive of the Institut für Geschichte und Theorie der Architektur (GTA) at the ETH in Zurich. He has collaborated on several exhibition and publication projects on the architectural history of the twentieth Century. He is actively participating in research on the theory of current city development.

KAREL TEIGE / 1900–1951

INTRODUCTION

POETRY MUST BE
MADE BY ALL!
TRANSFORM
THE WORLD: THE
HEDONISTIC VISION
OF KAREL TEIGE

Kenneth Frampton

Among the accepted histories of the modern movement, scant attention has been paid to the figure of Karel Teige (1900–1951).[1] Along with the rich contribution made by Czech modernism in general between the wars, Teige fell into oblivion after his death — in part because of the invidious imposition of socialist realism and in part because of the cultural amnesia that set in after the Second World War. He was forgotten not only because of the habitual exclusion of Central Europe from the received accounts of European culture but also because he became a persona non grata on both fronts at once, marginalized by apparatchiks and by transatlantic historians alike.[2]

As part of the long process of rehabilitating the European left-wing avant-garde, Teige resurfaced in 1974 with an English translation of his polemical attack on Le Corbusier's 1929 proposal for Paul Otlet's Mundaneum.[3] The measured acerbity of Teige's critique and the avuncular wit with which Le Corbusier responded in his essay "Defense de L'architecture" (1931) only served to underline the ideological gulf that had arisen between the two men, following their friendly collaboration throughout the best part of the twenties.

As this collection amply indicates, Teige was "one of the great ideas men of the modern movement," to borrow Reyner Banham's felicitous phrase, manifesting virtually the same protean energy and restless intelligence as El Lissitzky, Theo van Doesburg, and László Moholy-Nagy — and, at some remove, perhaps the ubiquitous Filippo Tommaso Marinetti, by whom he was more overtly influenced than we care to admit.[4] Teige's precocity as a young Bohemian intellectual anticipates the intensity with which he was to exercise his multiple talents throughout his life. By the age of sixteen he was already engaged in writing poems and stories and in translating from the French; a year later he had a sample of his graphic art published in Franz Pfermfert's anarchic Berlin journal *Die Aktion.* In 1920, the year that he graduated from the gymnasium, he formed the nucleus of the future Devětsil group. With the founding of the magazine *Orfeo* in the same year he began his lifelong practice of establishing or editing one artistic journal after another.

Inaugurated with considerable furor and dissension in the midst of the turbulent beginnings of the young Czech state, Devětsil proclaimed a new "poetist" culture of everyday life, the quintessence of which may be found in the "picture-poems" produced by the group during the early twenties. The notion that "poetism" was a ludic, erotic, egalitarian celebration of the beauty of the modern world may at once be felt in all its inno-

cence in such works as Teige's photo-collage *Greetings from the Journey* of 1923. Relinquishing his ambitions to become a painter, Teige, like many other avant-gardists of the period, felt that photography, cinematography, and kinetic art were the new democratic cultural media par excellence and it is in this vein, with one eye on the productionist agitprop manifestations in the Soviet Union, that Teige would coin the aphorism "Constructivism is the basis of the world. Poetism is the crown of life."

As Jaroslav Anděl has pointed out, this was a doubly articulated aesthetic that sought to unify not only poetry and art but also poetry and architecture.[5] Reflecting a fascination with advertising, tourism, sports, and film, Devětsil was a paean of praise to a new synthetic popular culture, and it is only in the second half of the twenties that Teige would feel obliged to discriminate between the spiritual poetics of everyday life, as represented in art, and the physical constraints of constructivist architecture. This schism highlights the way in which the early Devětsil was less influenced by the early constructivism of Vladimir Tatlin and others than by Parisian purism, particularly after Teige's 1922 visit to Paris where, at Jaromír Krejcar's behest, he met Le Corbusier and Pierre Jeanneret. The multicultural scope and ideology of their magazine *L'Esprit Nouveau,* (then being edited in collaboration with the dadaist poet Paul Dermeé), would surely have resonated with Teige's preoccupations; this affinity was openly declared in the anthology *Život* (*Life*) 2, edited with the architect Krejcar and published in spring 1923.

In many ways 1923 was a critical year for Teige. In that year he met Walter Gropius and became familiar with the Weimar Bauhaus at the very moment when it was in the process of abandoning Johannes Itten's anarchistic, anti-industrial position in favor of a consciously machinist approach to the modern world, to be developed under the aegis of László Moholy-Nagy, Josef Albers, and Herbert Bayer. At the same time Teige began to react negatively to the vestigial classicism that was becoming increasingly evident in the work of Le Corbusier, particularly after the publication of *Vers une architecture,* which referred to the monumental European tradition and advocated a system of proportion based on the golden section. Teige became increasingly embroiled in the international architectural debate at this point, particularly after he assumed the editorship of the magazine *Stavba* (*Building*) in February 1923, whereupon it became a vehicle for the mutual propagation of purist and constructivist architecture.

In 1924 Teige stepped up his involvement with the outside world, traveling to Vienna, Milan, Lyon, Paris, Strasbourg, and Stuttgart. His more momentous visit to Moscow and Leningrad in the following year afforded him firsthand knowledge of the latest achievement of the Soviet avant-garde artists and architects. The pioneering work of the Russian constructivist architects catalyzed his work, affecting not only his writing but also his typographical production. Although one may discriminate between Teige's photomontaged "book cover posters" for distinguished Czech authors and the more abstract constructivist graphics of such graphists as the Hungarian Lajos Kassak or the Dutch designer Piet Zwart, the fact remains that many of his own typographic pieces began to assume a markedly constructivist character. These include the typo-photo alphabet that he designed for Vítězslav Nezval's book *Abeceda* (*Alphabet,* 1926) and his abstract illustrations created for Konstantin Biebl's book *Zlom* (*The Break,* 1928), one of which was included as an exemplary piece of modern design in Jan Tschichold's canonical *Typographische Gestaltung* (*Typographical Design*) of 1935.[6] By virtue of his unceasing activity as an editor–cum–graphic designer, in one magazine after another, he became an accepted exponent of the "new typography"; he lectured on this very subject in the Bauhaus in 1930 and went so far as to redesign Herbert Bayer's typeface, Universal Grotesque.

In the heated international debate surrounding the result of the League of Nations competition in 1927, Teige publicly defended the project submitted by Le Corbusier and Pierre Jeanneret, although he would have been just as favorably disposed toward the scheme of the left-wing, Swiss German architects Hannes Meyer and Hans Wittwer. This split allegiance may perhaps go some way toward explaining the Czech absence from the foundation of CIAM, the Congrès Internationale de l'Architecture Moderne, that took place at La Sarraz in Switzerland in the following year. While Meyer and Wittwer, with whom Teige was in close contact, were surely responsible for the extremely radical character of the initial CIAM declaration of 1928, CIAM moved slowly to the right over the next five years, the result of a left/right split probably evident behind the scenes already in the late twenties. Be this as it may, Teige participated in the Third CIAM Congress, held in Brussels in 1930, where he addressed himself to its themes: the housing question and the minimal dwelling. With Krejcar's radical redesign of his own apartment and his foundation of the left-wing architectural magazine *ReD* in 1927, Teige decisively embraced the materialist wing of international constructivism — a shift

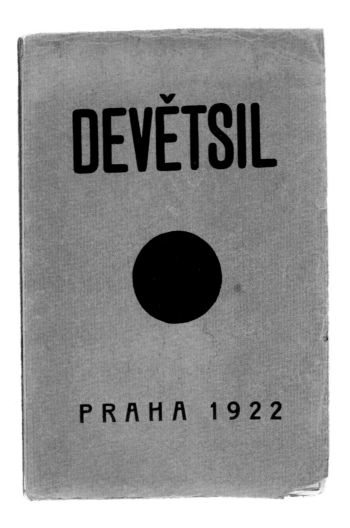

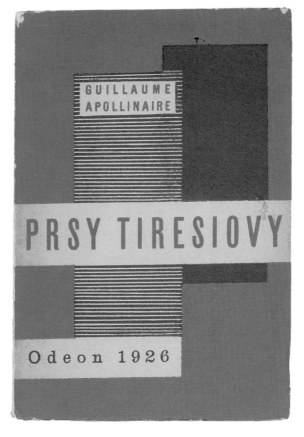

Plate 1 Karel Teige, cover of the anthology *Devětsil* (Prague, 1922).

Plate 2 Karel Teige, cover for the Czech translation of Guillaume Apollinaire's book *Prsy Tiresiovy* (*The Breasts of Tiresias*) (Prague, 1926).

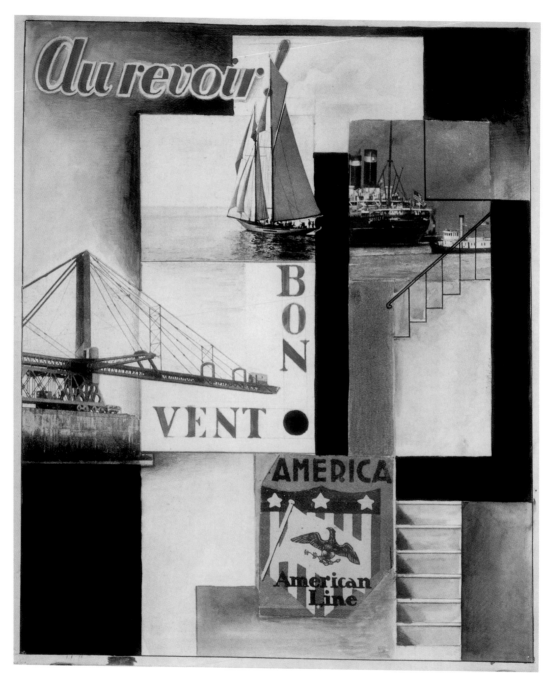

Plate 3 Karel Teige, *Departure for Kythera*.
Picture poem, 1923–1924.

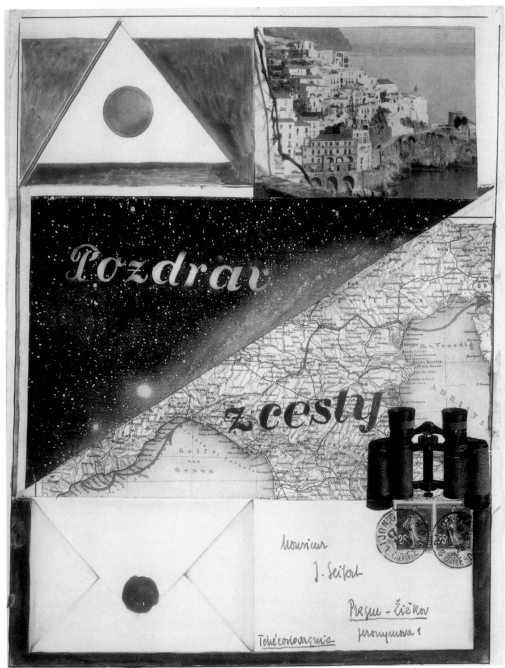

Plate 4 Karel Teige, *Greetings from the Journey.* Picture poem, 1924.

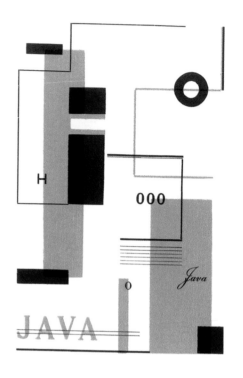

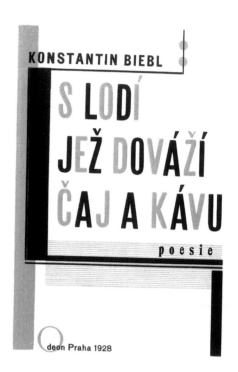

Plate 5 Karel Teige, frontispiece and title
page of Konstantin Biebl's book *S lodí jež
dováží čaj a kávu* (*With a Ship Importing
Tea and Coffee*) (Prague, 1928).

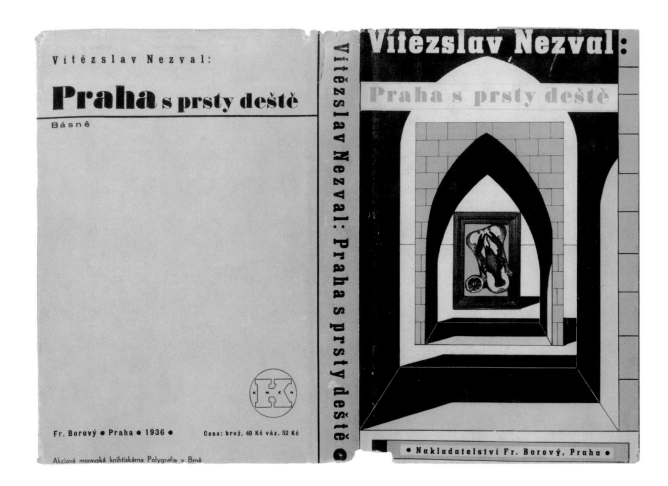

Plate 6 Karel Teige, front and back covers
for Vítězslav Nezval's book *Praha s prsty
deště* (*Prague with Fingers of Rain*)
(Prague, 1936).

Plate 7 Karel Teige, cover for Vítězslav
Nezval's book *Básně noci* (*Poems of the
Night*), 4th ed. (Prague, 1938). ÚDU
AVČR, Prague.

Plate 8 Cover of *ReD* 1, no. 7 (April 1928),
"Osvobozené divadlo" (The Liberated
Theater).

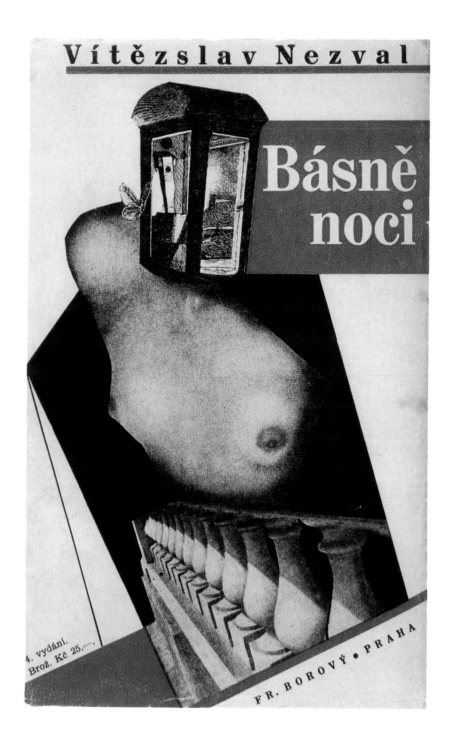

RED

7

měsíčník pro moderní kulturu

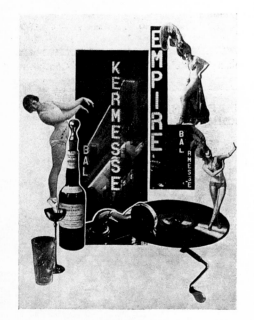

Fotomontáž • Photoplastique • Lichtbild
(pro Osvobozené divadlo k »Methusalemu« Ivana Golla)

JAROSLAV RÖSSLER

→ 44 vyobrazení ←

osvobozené divadlo
v praze
Théâtre libre à Prague
Befreites Theater in Prag

☛ Honzl
Nezval
Vančura
Voskovec & Werich
Obrtel
Holzbachová
Mayerová
Hoffmeister etc.

duben 1928

ODEON 6 Kč

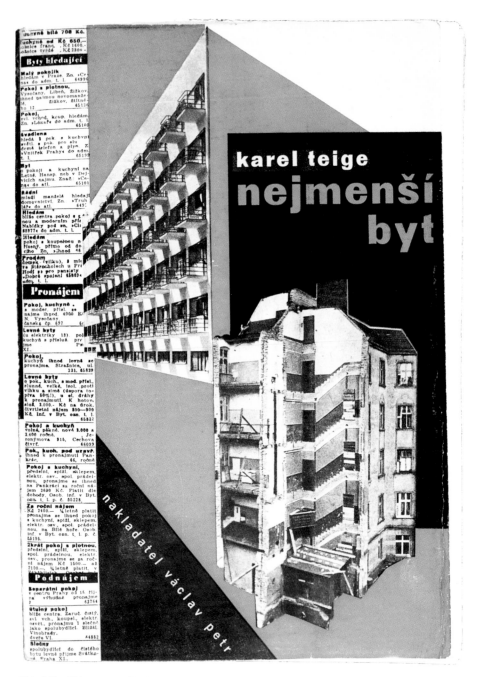

Plate 9 Karel Teige, cover of his book *Nejmenší byt* (*The Minimum Dwelling*)
(Prague, 1932).

that came to be theoretically elaborated in his book *The Minimum Dwelling* (1931), two years after Nikolai Miliutin's equally seminal *Sotsgorod* (*Socialist Towns*).

Like Miliutin and other radical Soviet thinkers, Teige was categorically opposed to the bourgeois institution of marriage and to what he called the catafalque of the marital bed. As with the free love advocates of the nineteenth century (one thinks particularly of Charles Fourier), Teige was convinced that every adult should be guaranteed a room of his own that he was free to retire to or to share with another, according to his life situation and frame of mind. In this regard the imminent arrival of the New Man, along with the New World, entailed the emancipation of women, the collective nurturing of children, and the provision of physical and spiritual nourishment in the refectory or the auditorium of the collective dwelling (or *dom kommuna,* as it was referred to by the Soviet avant-garde). Czech avant-gardist architects tried to emulate this vision in the form of the so-called *Koldom.* We find a surprising echo here of Le Corbusier's lifelong monastic ideal, namely, "silence and solitude but also daily contact with men" that he would first experience in the Charter house of Ema in Tuscany and that emerges as the main impulse of his work by his Unité d'habitation, realized in Marseille in 1952.

There was not a trace of either monasticism or puritanism in Teige's makeup, however: for him the image of the female body was a constant exhilaration, as one may judge from the countless erotic collages, of varying surrealist tone, that he produced from the end of the twenties onward. For Teige as for his enlightened colleagues, particularly the psychoanalyst Bohuslav Brouk and the architect Oldřich Tyl, the erotic embodied a world transformed by desire. We are reminded here of the erotic "wish image" of the surrealists or the "not yet" of Ernst Bloch — that is to say, of the overall debt of the liberative left to Baudelaire's image of redemption; *La tout n'est que ordre et beauté, Luxe, calme et volupté.*[7] But the balance of world power and geopolitical conflict changed irrevocably at the end of the twenties, particularly between the Great Crash of 1929 and the rise of the Third Reich in 1933. The cultural and political repercussions following from these events were many and varied, as much in the communist East as in the capitalist West and as much at the level of governmental policy as at the level of local reaction. Thus one passes in rapid succession from the exile of Trotsky (1925) to the rise of Stalin (1928), or from the suicide of Vladimir Mayakovsky to the enforced resignation of the communist Hannes Meyer from the directorship of the Bauhaus (both 1930), or from the ukase of 1932 decreeing the cultural hegemony of

socialist realism and the eclipse of the Soviet avant-garde to the withdrawal of the left-wing German faction from the organization of the CIAM and thus to its "depoliticiza-tion" by the fourth CIAM Congress that took place on the SS *Patras* in 1934. Teige responded to this shift to the right by founding in 1933 a would-be rival, the Czech Association of Socialist Architects (SSA).

Teige received firsthand confirmation of the disheartening situation in the Soviet Union from Krejcar when he returned to Prague in 1935 after a year in Russia. The Moscow trials and the Spanish Civil War followed in close succession, foreclosing the possibility of realizing a humane socialism in the foreseeable future. Teige reacted to these events by channeling his creative and critical energy into the second wave of Czech surrealism, thereby proffering the liberating potential of the oneiric in the face of petrified, authoritarian culture, whether of the left or the right. This stance brought him into open conflict with his lifelong colleague Nezval, who elected at this juncture to repudiate surrealism and to adopt the Stalinist cultural line. This endgame was followed in March 1939 by the German annexation of Bohemia and Moravia, leaving Teige little choice but to withdraw from public life and devote himself to writing his *Phenomenology of Art.*

This ten-volume project, while destined to remain unfinished, continued throughout the occupation and the Czech communist hard-line rule of the late forties and early fifties. It is fitting that in the face of the regime's exclusion of Teige from all political discourse, he would devote a portion of his final years to the proto-ecological theme of biotechnics. Stimulated by the ecological work of Ladislav Žák he would write in 1947, just four years before his death, "Today the aim is for the Earth and Nature to become Man's Dwelling without palaces, without temples, without architecture"; this position brought him paradoxically close to the dematerialized pacific vision of Mies van der Rohe.[8] Despite his unquestionable talent and creativity both as a critic and as a graphic artist, Teige was at one and the same time both an agent provocateur and seismograph, at once provoking action and debate and yet simultaneously reacting with the utmost sensitivity to the shifting political spectrum of his time.

Notes

1. The slogan quoted is taken from the title of an exhibition curated by Ronald Hunt in 1969, *Poesin moste gores av alla! Forondra varlden!* (Poetry must be made by all! Transform the world!), Modern Museet, Stockholm.

2. One should note that Sigfried Giedion was an exception; in 1946 he invited Teige to contribute to the CIAM Congress to be held in May 1947.

3. See "Karel Teige's 'Mundaneum' (1929) and Le Corbusier's 'In Defense of Architecture' (1929)," introduction by George Baird, in *Oppositions,* no. 4 (October 1974); 79–108. The dating is in fact incorrect; "Defense de l'architecture" was published in Czech in the magazine *Musaion* in 1931 and in French in *L'architecture d'aujourd'hui* in 1933.

4. It is interesting to note that despite his right-wing views, Marinetti became actively involved with the Devětsil movement in 1921. Quotation from Reyner Banham, *Theory and Design in the First Machine Age* (London: Architectural Press, 1960), 193.

5. See Jaroslav Anděl, "The 1920's: The Improbable Wedding of Constructivism and Poetism," in *The Art of the Avant-Garde in Czechoslovakia, 1918–1938,* ed. Anděl and C. Alborch (Valencia: IVAM, 1993), 21–60.

6. See Jan Tschichold, *Asymmetric Typography,* trans. Ruari McLean (New York: Reinhold, 1967), 46.

7. Significantly enough this phrase from Baudelaire's *Mon Coeur Mis a Nu* is cited by Herbert Marcuse in his book *Eros and Civilization* (New York: Beacon, 1955), 149.

8. Karel Teige, "Předmluva o architektuře a přírodě" (Prolegomena on architecture and nature), in *Obytná krajina* (The inhabited landscape), by Ladislav Žák (Prague, 1947), reprinted in Teige's *Osvobozování života a poesie: Studie ze čtyřicátých let* (The liberation of life and poetry: Studies of the forties), vol. 3 of *Výbor z díla* (Selected works) (Prague, 1994), 257–290; quotation, 286.

 See Fritz Neumeyer's *The Artless Word: Mies van der Rohe on Building Art,* trans. Mark Jarzombek (Cambridge, Mass.: MIT Press, 1991), 96–109. It is clear that Mies was strongly influenced by the biomorphic theories of Raoul France. Mies's pacified vision of a dematerialized continuum fusing together city and country and culture and nature derives partly from this source.

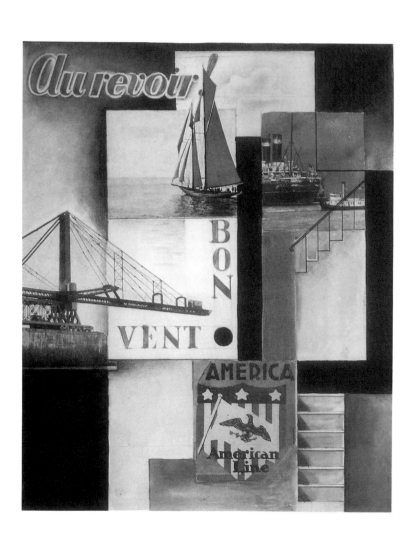

KAREL TEIGE IN THE TWENTIES: THE MOMENT OF SWEET EJACULATION

Karel Srp

(Translated by Karolina Vočadlo)

EARLY DEVĚTSIL

Karel Teige was one of the fourteen signatories of the declaration made by the Devětsil Art Association, which was published in *Pražské pondělí* (*Prague Monday*) on 6 December 1920.[1] The event was a collective effort by contemporaries, and none of the signatories claimed to be the spokesman or leader of this close-knit group, whose membership was to fluctuate considerably during the twenties; their friendships were first formed shortly after the First World War. The association was made up largely of fellow pupils from the distinguished Prague secondary school (*gymnasium* in Czech) on Křemencová Street, who had begun to focus on literature and the fine arts already during their studies.[2] The initiator of Devětsil was Vladislav Vančura, who would become a prominent Czech prose writer.

Karel Teige did not play a particularly important role in the activities of the group at first. Beginning in 1916, he occupied himself with drawing and print graphics, tried his hand at painting, translated, wrote poems and short stories, and organized various meetings. He published the early attempts of his youth in *Listy všeho* (*Journal of All Things*), a college magazine produced in handwritten format and published by the students of the gymnasium on Křemencová Street a few years before the founding of Devětsil. Many of Teige's later views and approaches were already being formulated during the war, when he was unable to establish more progressive contacts abroad. Clear traits of Teige's future dynamic energy are already apparent in a self-caricature drawn on the cover of *Listy všeho* (1919). It captures in cubo-expressionist style the figure of an art activist whose goal is announced in text above and below the drawing: "DER TEIGE MALER," a "Czech cubist of routine, sensitive leanings" (figure 1).

This self-caricature may have unintentionally betrayed both Teige's hitherto unheralded leadership role and his impatience to become part of the important new artistic movements of his time. The speed at which he resolved to absorb their spirit is evident from many of his drawings of this period. The most notable of these, *Landscape with a Sailing Boat* (1916; figure 2), which subsequently appeared as a graphic plate produced both in black and white and in several surviving color versions, clearly shows Teige's attunement with contemporary artistic currents, represented in prewar Bohemia by a combination of cubism and expressionism. During the early war years, which coincided with the period of Teige's first important creative experiments, all cultural life in Prague came to a halt. After 1917, with the partial easing of war censorship, the city

became alive once more with a flurry of activities, including various exhibitions. In this new, more tolerant environment, young unknown artists, no longer subject to compulsory military service, showed their work; they were joined by representatives of the decimated prewar cubist avant-garde, a tiny fragment of which still remained in Prague. Many of these young artists were future members of Devětsil. Under these exceptional circumstances, Teige was able to become acquainted quickly with the founding figures of the Tvrdošíjní (the Stubborn Ones) group in 1917 and 1918.[3] As an artist Teige initially sought inspiration from the Stubborn Ones. However, in his role as a critic, his initial admiration gradually began to wane. By 1921, a year that saw not only the culmination of the group's exhibition programs but also the decline of the artistic quality of their work, he was visibly distancing himself from them.[4]

The Stubborn Ones, a group of artists of the generation preceding Devětsil, espoused their own highly distinctive artistic approaches and views. Artistically, Teige was closest to Josef Čapek, whose allusive paintings inspired him (figure 3), and to Jan Zrzavý, who clearly influenced him during the years 1918 to 1920 and in 1923 became the subject of his first monograph, "Jan Zrzavý" ("Jan Zrzavý") (figure 4).[5] Teige also had close ties with the chief representative of Czech modern painting, Bohumil Kubišta (figure 5); the young generation particularly admired Kubišta's late, primitive graphics. Produced just before his premature death, they were purged of any cubist and symbolist traces.

Expressionism and cubism, characterized by dramatically inclined diagonals, had become established during the years 1916 to 1918, and Teige soon wrested himself free from their influence. He moved on in 1919–1920 to spiritual realism, which, for his

1. Karel Teige, *Teige the Painter.* Pen and ink on paper, 1919. Památník národního písemnictví(PNP; Museum of Czech Literature), Prague. Photo by Ústav dějin umění Akademie věd české republiky (ÚDU AVČR; Institute of Art History of the Academy of Sciences of the Czech Republic), Prague.

2. Karel Teige, *Landscape with a Sailing Boat.* Colored linocut on paper, 1916. PNP, Prague. Photo by ÚDU AVČR, Prague.

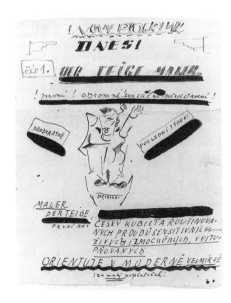

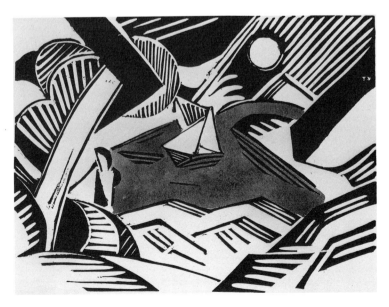

entire generation, represented the first real break away from the influence of prewar artistic movements. Under the influence of Jan Zrzavý, subjects were no longer deformed and simplified as dictated by cubism. His paintings featured instead a variable tonality, with their subject matter dematerialized by means of an internal aqueous light.

The luminescent style of spiritual realism was, however, reappraised after the publication of Devětsil's first manifesto, which reflected more accurately the attitudes of the upcoming generation and its concern with proletarian art. Its artistic representatives decided to devise a somewhat sentimental, naive primitivism that, in their opinion, could serve as a suitable response to bourgeois civility. Although they admired Jan Zrzavý — whom they believed to be the only artist who could hold his ground as the Czech Henri Rousseau — they were quite aware that his paintings' great refinement precluded easy comprehension and thus made them unacceptable as a model for the new proletarian art. It is mainly for this reason that they chose to eliminate spiritual realism from their artistic program. In their criticism of prewar cubism and expressionism, they took their cue from Henri Rousseau and the writer Charles-Louis Philippe. Their unattainable ideal was no longer Picasso, cherished by the cubist generation before 1914, but *le Douanier* Rousseau. In his subsequent theoretical writings, Teige distinguished be-

3. Josef Čapek, *A Girl's Torso*. Woodcut on newspaper, 1915. PNP, Prague. Photo by Jiří Hampl, ÚDU AVČR, Prague.

4. Jan Zrzavý, *Moon and Lilies of the Valley*. Oil on canvas, 1915. Private collection, Prague. Photo by ÚDU AVČR, Prague.

5. Bohumil Kubišta, *Still Life with Skull*, 1912. Oil on Canvas. National Gallery, Prague. Photo by ÚDU AVČR, Prague.

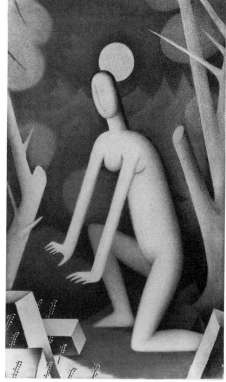

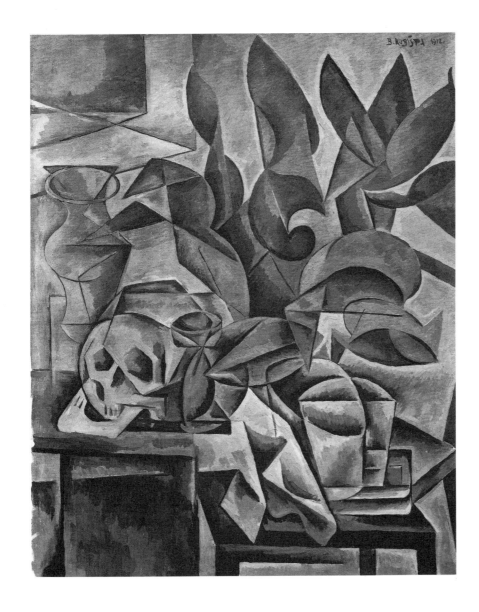

tween the primary, elementary, and primordial primitivism upheld by Rousseau himself and the artificial primitivism adopted by Henri Matisse.[6]

Teige's artistic activities between the ages of seventeen and twenty (i.e., before the founding of Devětsil) were marked by a rapid acceptance of progressive trends. In light of his self-caricature in *Listy všeho* (see figure 1), it appears quite plausible that he was born to become a member of the avant-garde. Even when he was only beginning to develop his own views, given the choice of several possible approaches he was always able to choose a path that was intellectually and artistically unequivocal. If he was mistaken, he would quickly modify or, without embarrassment, disown his own beliefs.

FIGURES AND PREFIGURATIONS

From the very beginning it was clear that Devětsil lacked a theoretical spokesman. Although the group included authors such as the prose writer Vladislav Vančura and the poet Jaroslav Seifert, it was Teige who soon became responsible for articulating its opinions and endeavors. Teige initially focused on a critical reappraisal of all avant-garde movements before 1914. In 1921 he published an essay titled "Obrazy a předobrazy" ("Figures and Prefigurations") in the magazine *Musaion,* the mouthpiece of the Stubborn Ones group; it is generally regarded as Devětsil's earliest declaration.[7] Although the representatives of the older generation were not expressly mentioned, the essay provoked their bitter opposition; they particularly resisted its attempt to dismiss all modernist traditions, beginning with postimpressionism and cubism, and ending with orphism, futurism, dadaism, and even expressionism.

Even though Devětsil, in existence for only two years, had not achieved any convincing results on its own, its members nevertheless felt the need to establish their own views in both their artistic and theoretical endeavors, thereby liberating themselves from the influence of the preceding generation. To this end Teige formulated the "law of antagonism" as the dynamic force driving historical processes. He developed this "law" as one of the constant principles guiding his conception of artistic development, elaborating on the simple idea that "every new, fresh art is necessarily a reaction against the previous one."[8] What was important here was not the successive communication of one generation with another, as espoused and proclaimed by certain Czech art historians, but the necessity of *dis*continuity.

Even before renouncing his own early artistic works, and prior to his efforts to promote an artistic conception that was to prove highly influential throughout the 1920s and 1930s, Teige decided that as a first step he had to clarify his skepticism about the artistic approaches adopted by the Stubborn Ones. However, even a close reading of "Figures and Prefigurations" fails to reveal a precise definition of Teige's newly minted antithetical model of development. The examples Teige presented here were taken to a large extent from the international rather than the domestic scene, an expedient that provoked considerable controversy. The exceedingly general statement that "the building materials for our intellectual exegesis are . . . dream and desire, love, and hatred of evil" could hardly have been expected to aid his struggle against prewar modernism, which Teige—Henri Rousseau aside—condemned as formalistic. Teige honed his model in "Nové umění proletářské" ("New Proletarian Art"), published as an introduction to Devětsil's *Revoluční sborník Devětsil* (*Revolutionary Anthology of Devětsil*), where he called attention to the "dialectical tension of two opposites" and separated art into a "traditional period" and an "antitraditional . . . revolutionary" period. As a Marxist inspired by Hegel, he maintained that "developmental continuity . . . does not constitute mechanical progression; development occurs in conditions of contradiction and builds up an authentic synthesis in the midst of the tensions brought about by (the Hegelian concept of) thesis and antithesis. The ensuing synthesis in turn emerges as the thesis for the following period, antithetically focused in relation to the previous period."[9]

This model, which Teige used after 1918 to counter the influence of the earlier generation, was accompanied by another formulation: in the next phase, he was to elaborate in more specific terms what such a future development was to entail. For Teige, the passing of generations brought with it new means of expression that could not coexist side by side. Instead, the former was to be replaced by the latter—as, for example, the drawing by the photograph, or the novel by reportage.

At the moment when Teige linked his "law of antagonism" to the change of artistic media as it occurred first in post-Renaissance art—performing the highly radical act of introducing generational discontinuity into art theory—he managed to create a foundation for a fresh avant-garde view. This eventually became his main programmatic platform during the twenties and thirties.

ANTHROPOMORPHISM

Teige's antithetical model, however, should not be viewed as resting merely on a simplistic notion of autonomous, immanent development; it encompasses humanity as a whole, capable of tempering some of the more extreme claims of the avant-garde. Apart from formulating the law of antagonism, the treatise "Figures and Prefigurations" also contained the seeds of what was later to become Teige's distinct anthropomorphism. In its first manifesto of November 1920, Devětsil urged the new artist to take note of "the table at which we sit, and the lamp that affords us light": in other words, to pay attention to the most ordinary of situations and the most simple of things. Teige presented a highly general picture of this "proletarianization" of art in "Figures and Prefigurations": "The content of a work of art — not the subject — can be a person, not as an isolated individual but someone possessing all his psychological complexities and ephemeral inner dramas and an ineffable need for harmony and happiness." [10] Man, as the "common denominator of all things" became Teige's "vanishing point," as evidenced by his later study "Konstruktivismus a likvidace 'umění'" ("Constructivism and the Liquidation of 'Art'"), in which he spoke of the "biomorphous strength of human inventiveness" as the stimulus of development itself, so subtle that there is within it "always room for revolution." [11] Teige used anthropomorphism as a defense against certain manifestations of mechanical development and against an overly rigid interpretation of a stereotyped notion of the cycle of thesis, antithesis, and synthesis. As a new field, biomechanics opened the way toward a conception of poetry encompassing all the senses and toward a theory of an *ars una,* one of his major theoretical syntheses of the 1920s.

The abstract reflections in "Figures and Prefigurations" should be viewed in light of Teige's critical move toward the idea that both the artist and the poet are "builders of a new world," who "do not bring up merely suggestions for a new art but instead propose plans for a new world as well as projects for a new organization of life"; these projects were moreover intended to reflect "a prefiguration of a new art." This notion provided Teige with a future vanishing point, uniting utopian visions and desire.[12] It also points to another aspect of Teige's law of antagonism: namely, the conviction that the upcoming generation would be able to renounce the past while at the same time reaching out "dialectically" to the older generation.

In several of his theoretical writings of the early twenties, Teige made special mention of Otakar Březina as the main representative of Czech symbolist poetry of the 1890s; later, he also cites writers affiliated with *Moderní revue* (*Modern Revue*).[13] This is somewhat surprising, since even though Březina appeared in Devětsil's manifestos as a respected theorist, his ideas here are given a very different interpretation.

SIGNS OF NEW ORIENTATION

Establishing the notion of discontinuity between the younger and older generations was not enough to bring about a full acceptance of avant-garde points of view; it merely produced a more practical distinction between older and newer forms of art. The differences between works that were "developmentally regressive" and those of the "avant-garde" did not become explicit merely in the succession of generations, but principally in the work of a single generation that chose to go in a new direction.

Apart from Teige, the name *Devětsil* chiefly brings to mind such figures as Nezval, Šíma, Toyen, Štyrský — on the whole, artists who had not signed the Devětsil manifesto but had joined the group later, between 1922 and 1923, when it had significantly revised its orientation.[14] The positions of the artists within the group began to differ after the *Jarní výstava* (*Spring Exhibition,* 1922), which presented the results of investigations on the subjects of spiritual realism and naive primitivism. Though this was the earliest official "demonstration" of Devětsil, in 1938 Teige explicitly identified the subsequent *Bazar moderního umění* (*Bazaar of Modern Art,* 1923), as the group's first exhibition (even though the catalogue clearly identifies it as the second).[15] Teige may have been attempting to distinguish between the early Devětsil, which identified with proletarian art and collectivism but lacked internationalism — an aspect deemed essential by the strongly politicized avant-garde — and its later, more sophisticated position. In Teige's view, offering token sympathy to the program of Devětsil by means of published treatises was not enough; it was above all necessary to establish an authentic avant-garde program as such. Although historians generally describe the *Spring Exhibition* as an event held by Devětsil, it was actually organized by an alliance of younger artists, sculptors, and those original signatories of Devětsil who by the end of 1922 had left the group to found the so-called Nová skupina (New Group). The members of the New Group developed their own original artistic program, eventually undercut by their own version of naivism and sentimentalism.

The progressive participants in the *Spring Exhibition* (Bedřich Feuerstein, Josef Šíma, and Karel Teige, who contributed only one oil painting and one watercolor), joined in 1922 by the architect Jaromír Krejcar, made it possible to compile the collection *Život 2* (*Life 2*), which differed significantly from the anthology *Revoluční sborník Devětsil,* published earlier. For financial reasons, both of these publications appeared at almost the same time; they thus must be evaluated together as part of a contemporaneous series of period reviews.

Teige changed his position considerably during 1922, as clearly documented in his essays in these commemorative volumes. He began to write so prolifically that he hardly had any time left for his own artistic activities. He had always been harshly self-critical, so perhaps it is not surprising that the focus of his interest shifted from his own artistic endeavors to criticism and theory. Four comprehensive studies that year— "Umění přítomnosti" ("Contemporary Art"), "Nové umění proletářské" ("New Proletarian Art"), "Kubismus, orfismus, purismus a neokubismus v dnešní Paříži" ("Cubism, Orphism, Purism, and NeoCubism in Contemporary Paris"), and "Umění dnes a zítra" ("Art Today and Tomorrow")— clearly manifest how his thinking had changed, displaying a radicalism never surpassed by any of his later writings.[16]

These works provided the foundation of Teige's own theoretical platform. During the years 1922–1923 he also brought together a circle of colleagues with whom he remained in close touch throughout the twenties and thirties. He translated into reality the previously abstract requirements of his own antithetical model by relentlessly criticizing the preceding generation and at the same time addressing the divisions within his own generation. By such means, Teige delivered himself from his youthful immaturities, creating for himself a new base that could be, to a considerable extent, attributed to

6. Karel Teige, cover for Jaroslav Seifert's book *Město v slzách* (*City in Tears*) (Prague, 1921). PNP, Prague. Photo by ÚDU AVČR, Prague.

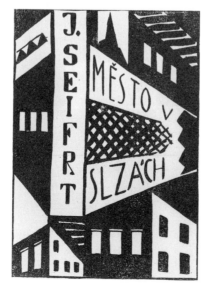

his own failure as an artist. In 1922, when Teige compared his own artistic performance with that of Josef Šíma or František Muzika, who were then considered the two most progressive representatives of the coming generation, he well recognized the limitations of his own talent; instead of painting, he decided to apply his energies to typography and book illustrations. During the early twenties he illustrated and designed two books written by Devětsil poets: Ivan Suk's *Lesy a ulice* (*Forests and Streets,* 1920) and Jaroslav Seifert's *Město v slzách* (*City in Tears,* 1921; figure 6).

PARIS

Teige's visit to Paris (18 June to 12 July 1922) is generally considered to have exerted the greatest influence on his thinking (figure 7). Here he made the acquaintance of numerous leading Paris avant-garde personalities: Ozenfant, Le Corbusier, Man Ray, Léger, Zadkine, Goll, Brancusi, and Birot. It was also during his one-month stay in Paris that he conceived the idea for the *Život* 2 anthology and, more important, revised some of his earlier attitudes. As early as 2 December 1921, he wrote to Artuš Černík, a Brno member of Devětsil: "As far as purism is concerned, I believe it an interesting but unimportant '-ism,' theoretically developed; but the works of both these lads [Le Corbusier and Ozenfant], to the extent that I am familiar with them, are not much to my taste."[17] A few months later however, after his return from Paris, purism was the primary focus of attention in *Život* 2, and Teige's relationship with Le Corbusier developed into one of the most important contacts in his life.[18]

It is evident already from the first declarations of Devětsil that even before Teige's departure to Paris, where he had no trouble absorbing the tenor of his surroundings, he had already become open to the views he was to maintain in the future: condemna-

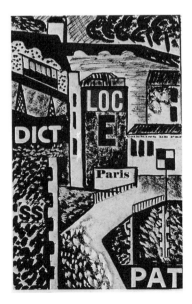

7. Karel Teige, *Paris,* 1922. Reproduced from *Revoluční sborník Devětsil* (*Revolutionary Anthology Devětsil*) (Prague, 1922). PNP, Prague. Photo by ÚDU AVČR, Prague.

tion of all prewar movements as formalistic; insistence on progress as the chief initiator of all artistic and social change; affirmation of the prominence of the historical task of the proletariat, whose goal it was to bring down the bourgeoisie; unequivocal political orientation toward communist Russia, which was considered a model for all other countries of the world; belief in collectivism based on a rationally justified division of work, making possible a true integration of man in society; and an internationalism uniting not only the working class but also the avant-garde artists of all countries, who together should pursue more or less identical goals. While Teige considered himself a Marxist, his left-wing attitudes were not always directly in line with those of the Communists; unlike Vladislav Vančura, the initiator of Devětsil who was a member of the Communist Party, he maintained his independence in this respect. Teige's very nature abhorred subordination, rigid discipline, and bureaucratic organization, and throughout his life he struggled consciously to maintain a free hand. It is this feature of his character that reflects the source of his originality, more anarchic than the Communist Party would countenance.

In Paris, Teige largely reflected on his own artistic and aesthetic orientation, remaining essentially still outside the international context. He reexamined his attitude toward purism and also discovered Man Ray, who eventually became one of the figures most respected by the Czech interwar avant-garde. Teige was one of the first theorists in Europe to assign Man Ray such a prominent position.[19] Of all the artists he met in Paris, Man Ray was the most intriguing; the fascination for his photograms and later his photographs remained with Teige all his life. It is not surprising then that reproductions of Man Ray's works featured frequently in the collages and photomontages that Teige began to create himself during the mid-1930s. Man Ray's influence on the young avant-garde in Bohemia can only be compared with that of Pablo Picasso on the prewar cubist generation.[20]

During his 1922 stay in Paris, Teige was also able to develop his interest in architecture (the following year he became the editor of the periodical *Stavba* [*Building*]), photography, and film. In fact, architecture and photography remained lifelong interests for Teige. In his view these two disciplines provided a certain external framework epitomized by the "tableau" or wall-hung painting, which he had persistently rejected in the past only to accept it — with some reservations — once more. During the early twenties, Teige had clearly defined the limits that painting must never transgress: naturalism on

the one hand and abstraction on the other. In the first case, the painting would become descriptive and could therefore be replaced by a photograph; in the second, it would assume a decorative character that, from the point of view of architecture, was superfluous. In 1922 to 1923 Teige thus devised a theoretical method of reflecting on and comprehending the subject that he sustained in the majority of his subsequent texts.

During the first few years of the emergence of the avant-garde Teige renounced not only formalism, which he condemned all his life, but also — temporarily — Romanticism, which only began to interest him again in the late twenties and early thirties. His initial rejection was partly caused by his reassessment of naive primitivism and by his attitude toward the machine, which the early Devětsil, particularly from a class point of view, had denounced. After the lessons learned in Paris, however, Teige declared the machine to be the leading driving force of contemporary culture and civilization.[21]

Devětsil's anti-Romantic approach to art in 1922–1923 was also reflected in its poetry. Some of the early poems by Jaroslav Seifert, one of the first signatories of Devětsil in 1920, and Vítězslav Nezval, who joined Devětsil in 1922–1923, sound more like manifestos in verse designed to support Teige's theses. For example, in "Všecky krásy světa" ("All the Beauties of the World"), printed in the introduction to *Život* 2, Seifert demanded that the moon, traditional symbol of Romantic poetry, be abolished and be substituted by modern technology: "Island of futile dreams which burns itself out, moon, be extinguished!" Similarly, in Nezval's poem titled "Abeceda" ("Alphabet"), which — in effect — initiated poetism and which was published originally in the first issue of *Disk* (1923), the moon was made to recall the letter *C*, "shining like the moon above the water / Wane, great moon! The gondoliers' romances are extinct forever / So, westward ho to America, captain!"[22] In "All the Beauties of the World," Seifert, apparently influenced by Teige,[23] was seduced by airplanes, automobile horns, ballerinas depicted on posters dancing between black letters, reflectors, the construction of lookout towers, cinemas, trains, bridges, and skyscrapers. Seifert, in fact, incorporated into his poetry both the slogan "art is dead," thus insinuating the inspiration of the Berlin Dadaists on Devětsil, and Teige's credo that "the most beautiful paintings in existence today are the ones which were not painted by anyone."[24]

CONSTRUCTIVISM

Constructivism was the "discovery" of 1922. The exceptional international recognition that it enjoyed in Germany during that year would certainly not have escaped Teige's notice.[25] And, as a rule, he confirmed his conviction by tapping other sources as well. One of the chief features of Teige's concept of the present was, in his words, the existence of the "engineering era" whose product was the machine, assembled with standardized parts. During the early twenties, when engineering constructions became the subject of many studies, the avant-garde "resurrected" the Eiffel Tower (built in 1889) and began to emphasize its significance for the development of modern architecture. It appeared in collages and on book covers, and artists had themselves photographed in front of it. Teige described its "constructivist" significance as follows: "Her iron beauty is a symbol of the modern constructive spirit."[26] In that sense, the tower represented a matchless model, a standard difficult to surpass, which presented the architectural avant-garde with a new challenge. It is not surprising, then, to find Šíma's portrait of the "father" of modern architecture, Auguste Perret (1922), with the Eiffel Tower in the background on a two-page spread of *Život* 2. It was also reproduced independently alongside Tatlin's *Tower for the Third International.* In an anonymous critical note, Teige (or was it Krejcar?) asks, "Why is Tatlin constructing a monument to the Third International with various central halls in the form of a tower? This is nothing but blind imitation in the fever of 'machine delirium'": according to Teige, the main creators of the "new beauty" were to be anonymous workers and engineers and not painters and sculptors who maintained a conventional, Romantic attitude toward art.[27]

The machine, which became a subject of Teige's writings in 1922–1923, was neglected for a time during the period of high poetism and intuitive surrealism. Nevertheless, it suddenly reappeared in his collages during the latter half of the thirties as an accessory and counterpoint to the graceful curves of the female body. Already in 1923, Teige had referred to Zola's anthropomorphic interpretation of the fragile charm of the locomotive engine "with its big wheels joined by metal arms," evidently recalled in a collage depicting the wheels of a locomotive engine embraced by female arms (*Collage No. 49,* 1938). In other instances—*Collage No. 57* (1938), *Collage No. 84* (1939)—the machine is fused directly with female outlines. Surprisingly, in other collages, Teige reverses the relationship between machine and woman: he poeticizes the machine and treats the female body as a mechanical article whose parts are freely arranged without regard to physiology.

Teige regarded engineering constructions as examples of collectivism and internationalism, devoid of all traits of national style to which, paradoxically, the prewar cubist architects had returned during the early twenties. Quite unexpectedly, these architects began to experiment with Rondo-cubism — a special attempt to link earlier avant-garde architecture with folk style, often directly derived from Czech and Moravian traditional styles.[28] But, unlike some of the more doctrinaire proponents of a pure constructivist functionalism, Teige arrived at the view that the "engineer's calculations" should be augmented by "poetic vision" and that the engineer's construction should become the "Aeolian harp" to which Seifert had compared the Eiffel Tower, for the beauty of the Eiffel Tower resides in its graceful shape as well as in its being the embodiment, via the engineer's calculations, of the irrational quality of a poetic vision. The tower thus became the result of an inner transformation of poetry into tangible form.

A photograph of some Paris surrealists, closely watching a medium writing automatically on a typewriter, appeared on the cover of the first issue of *La Révolution surréalisme* (12 January 1924), drawing the following reaction from Vítězslav Nezval in his highly lurid poetic manifesto *Papoušek na motocyklu* (*Parrot on a Motorcycle*): "This must be said without ceremony. I waited in vain for the arrival of the clairvoyant stenographer, when fever, having liberated itself from medical encyclopedias, extends even to fireworks and dancing." To evoke poetic states using one's own poetic experience, freed from all artistic norms, was essential to the early poetists. In *Parrot on a Motorcycle,* however, Nezval defined the poem in two ways. As a linguist writing poetry, he saw it as "a distinctive, real object in a world of ideas and their forms, independent of the world of phenomena"; but as a poetist, exulting in the free current of ideas, the poem was "a miraculous bird, the parrot on a motorcycle. Ridiculous, artful and magical. . . . Things such as soap, a knife with a mother-of-pearl handle, or an airplane."[29] Devětsil could thus be characterized by a state of constant creative tension: on the one hand the group stressed unification, industrial production, elemental machine assembly, a perfect standard, to make possible repetition of the same thing over and over again; on the other hand it valued boundless imagination that no norm should restrict, hovering on the edge of automatic writing.

BAZAAR OF MODERN ART

The "strong four" (apart from Karel Teige, this included the architects Bedřich Feuerstein and Jaromír Krejcar and the painter Josef Šíma), who were collectively be-

hind the conception of *Život* 2 and who designed its cover and double spread, formed the new core of Devětsil after the falling out among its original members. They remained together until the whole group gradually broke up at the beginning of the thirties. These four were also the chief protagonists of the important exhibition *Bazaar of Modern Art* (November–December 1923). Alongside various architects (Josef Chochol, Jaroslav Fragner, Karel Honzík, Evžen Linhart, and Vít Obrtel), representing the purists of the coming generation, new artists who had not had direct contact with the early Devětsil made their appearance: Jindřich Štyrský, Toyen, Remo (Jiří Jelínek), and Otakar Mrkvička.

The *Bazaar of Modern Art* was not a traditionally conceived exhibition like the *Spring Exhibition* before it. Its exceptionally loose installation was highly unusual for Prague. Although no photographs have survived, it can be freely reconstructed from various written documents. According to Teige, the architectural projects, paintings, and drawings were supplemented by "machine parts, film shots, photographs of fireworks, and scenes from a circus," which were enhanced by posters, books, and strange objects (e.g., ball bearings, a tailor's dummy, a life jacket) that pointed to the specific iconographic interests of Devětsil.[30] The ball bearing that, according to Teige, was meant to illustrate vividly Ingres's expression "as beautiful as flat, rounded surfaces," was also a reference to the cult of the machine, a reflection of the themes used in the images and reproductions of *L'Esprit Nouveau.* Teige evidently took the idea to use ball bearings directly from the American magazine *Broom,* which was well known in Bohemia. In fact, one of its issues was actually dedicated to the Stubborn Ones group. Teige also used a photograph of ball bearings (taken by Paul Strand in *Broom*) for the first issue of *Disk* (figure 8); under the title "Modern Sculpture," he there contrasted ball bearings with sculptures by Jacques Lipchitz and Ossip Zadkine. "Modern Sculpture" brought side by side with ball bearings was furthermore likened to the "graceful wax figures in a barber's shop . . . it had hysterical eyes and undoubtedly strawberry-blond hair." In other words, here was a motif directly anticipating surrealism.

The iconographic tension of ball bearings and a tailor's dummy, freely evoking constructivist and poetist ideas, was intensified at the *Bazaar of Modern Art* by two additional objects included in the exhibition: a mirror placed, according to Teige, "at the back of the exhibition hall," bearing the sign "VISITORS, YOUR PORTRAIT," and a life jacket.[31] The latter also appeared as a theme in unrealized film scripts written by members of Devětsil. In its overall concept, the *Bazaar of Modern Art* was probably based

on the Berlin exhibition *Internationale Dada Messe* (*International Dada Fair,* 1920), although the evidence for this conjecture is indirect. One might also note that the themes used by Devětsil members in their work at that time were not chosen to fulfill any specific sociocritical need but were actually oriented more toward what was then happening in Paris.

The fundamental ideology of Devětsil came to be expressed primarily by slogans. Not only were the journals of that period full of short, pithy quotations, freely positioned along the margins and often without any bearing on the adjacent text, but captions and signs became optically an integral part of, for example, exhibition installations. When preparations were being made at the beginning of 1924 for a condensed version of the *Bazaar of Modern Art* exhibition, Teige sent the following instructions to Artuš Černík: "It would be good to include the following slogans, using beautiful script on long, colored strips of paper:

ART IS THE MOST PRECIOUS FLOWER IN EPICURUS'S GARDEN.

CONSTRUCTION — ECONOMY — PURPOSE — STANDARDIZATION — COLLECTIVISM:
THE PREREQUISITES FOR MODERN ARCHITECTURE.

POETISM: THE ART OF TODAY.

THE NEW SPIRIT IS THE SPIRIT OF CONSTRUCTION.

(LE CORBUSIER-SAUGNIER)

NEW ART WILL CEASE BEING ART. (EHRENBURG)[32]

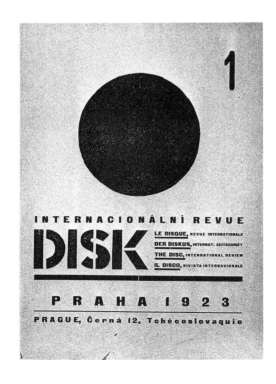

8. Karel Teige, cover for the international review *Disk,* 1923. PNP, Prague. Photo by ÚDU AVČR, Prague.

POETISM VERSUS CONSTRUCTIVISM?

The writings of Vítězslav Nezval from the 1950s indicate that he and Teige "discovered" poetism one spring evening in 1923. It began to be applied as an artistic term in the latter half of 1923. Teige's seminal article titled "Poetismus" ("Poetism") was published in June 1924.[33] In Nezval's retrospective analysis, poetism existed as a "solution to the disharmony of worldviews" — in other words, to the chaos of the early postwar years. Nevertheless, during the time of its existence, its activities were actually much more varied. Back in 1924 Teige did point out that it was the "first -ism to appear in Bohemia."[34] Teige's and Nezval's faith in poetism was limitless from the outset, although the movement was yet to be supported by any important works of art.

At the same time, constructivism was enjoying great international prestige, particularly in Germany, which was at that time the home of many of its Russian representatives. Teige immediately saw an opportunity to promote its singular aesthetics in Bohemia. He perceived constructivism not as a final art form but as a point of departure from which the artist may deviate while still continuing to recognize its essential validity and importance. "Construction is the basis of the world. Poetism is the crown of life," was Teige's famous line. In Marxist terminology, poetism is superstructure. It is "not only the antithesis but also an essential complement to constructivism. It relies on its groundplan."[35] Teige believed that poetism could not survive without constructivism and vice versa: "Constructivism is a working method with rigorous laws, the art of application. Poetism is a living complement, a vital atmosphere . . . the *bon ton* of life . . . the art of living, rejoicing, and laughing."[36] Accordingly, utilitarian function is essentially linked to free imagination.

Teige's interpretation suggests that constructivism and poetism from the start were not seen as equivalent — historically, constructivism preceded poetism — but in dynamic tension, both in theory and program; each could be used in accordance with the needs of the moment. Thus, from the very beginning Teige understood the relationship between constructivism and poetism to be more profound than that portrayed by most subsequent interpreters, who in their characterizations relied largely on overly simplified readings of Teige's words.

His comparison of constructivism and poetism to a week divided into days of work and days of rest hinted at a certain residue of the proletarian conception of poetry as asserted by erstwhile Devětsil poet Jiří Wolker, a notion symptomatic of the early

stages of Devĕtsil. This analogy articulates an uneven tension between the two terms, whose relationship is constantly shifting as their precise or positive definition proves difficult: the utilitarian character of the ordinary working day is completed by the awareness of the impending Sunday that—in turn—enriches it. In Teige's words, poetism "contained the engineer's calculations and provided them with poetic vision."[37] Metaphor, as the main poetic trope of poetism, was chosen for its ability to evoke, retrospectively, the other ordinary constructivist "working days" of the week. It not only expressed liberation from the drudgery of ordinary life but also stood at the very heart of all construction itself, which, if realized according to the principles of purpose and function, is in the end founded on an essentially irrational calculus. Poetism was thus a highly trenchant attempt to transform the world into metaphor. This is why Teige believed that even standard, ordinary products should be permeated with a sense of vision.

The optimism of poetism gave the members of Devĕtsil a new sense of life, expressed by lightness, playfulness, and freedom. It distanced them from metaphysics and tragedy. Teige saw poetism as a force blending the primary data of sensibility with a hedonistic attitude to the world. He chiefly characterized it as a condition of life, expressing itself through "the art of living and enjoying," as individuals embrace all joys that the modern world had to offer. This attitude is expressed in an unrealized film script written by Teige and Seifert, in which a nightclub was given the name "Epicurean Bar," suggesting that a pleasant atmosphere and a disposition devoid of life's worries were enough to create the poetist ambiance.

PICTURE POEMS

In the *Bazaar of Modern Art* exhibition, aside from some charcoal, ink, and watercolor drawings, Teige also exhibited one oil painting, titled *Train Station,* now lost. Teige's letter to Artuš Černík gives an idea of what it may have looked like: "Wouldn't you like to bring together a school of 'railroad station artists,' a picture poem, delightfully composed from various train station features—railway signals, lights, timetables, advertisements, tickets, Morse code, photographs, a few words—all nicely put together. If you provide a sketch, I will endeavor to paint it."[38] It is uncertain whether Černík actually sent Teige a sketch for his *Train Station* painting, but Teige's description makes clear how he imagined the process of creating a picture poem. Indeed, he believed that any-

9. Karel Teige, *Departure for Kythera*. Picture poem, 1923–1924. Prague Municipal Gallery.

10. Karel Teige, cover for Jaroslav Seifert's book *Na vlnách TSF* (*On the Waves of the Telegraph*) (Prague, 1925). Photo by František Krejčí, ÚDU AVČR, Prague.

11. Karel Teige and Jaroslav Seifert, "Cirkus." A typographical picture poem from the book *On the Waves of the Telegraph*. PNP, Prague. Photo by ÚDU AVČR, Prague. *Translation:*
CIRCUS
Today, for the first time, the famous fire
 eater John
embraced the petite dancer Chloe

AND LITTLE CHLOE WAS STILL A
 VIRGIN

That evening, the clown Pom, in front of
 the circus
to welcome the audience, released

A BIG BALLOON

TODAY FOR THE LAST TIME

12. Karel Teige and Jaroslav Seifert, "Objevy" ("Discoveries"). A typographical picture poem from *On the Waves of the Telegraph*. PNP, Prague. Photo by ÚDU AVČR, Prague. *Translation:*
 DISCOVERIES
In the year 1492 the Genoan Christopher
Columbus discovered unknown islands
(Map showing Caribbean with "CUBA"
marked in large letters)
Thank you, Sir!
 I smoke cigarettes!

13. Karel Teige and Jaroslav Seifert, "Počítadlo" ("Abacus [of Love]"). A typographical picture poem from *On the Waves of the Telegraph*. Reproduction of original page. PNP, Prague. Photo by ÚDU AVČR, Prague. *Translation:*
○Your breast
 is like an apple from Australia
●●Your breasts
 are like 2 apples from Australia
 ○○●
 how i love this abacus of love!

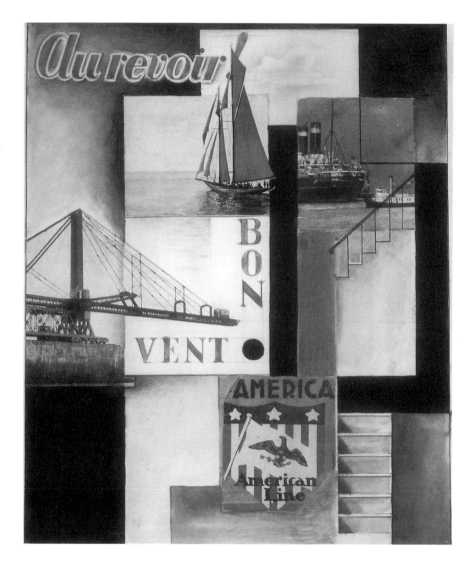

30

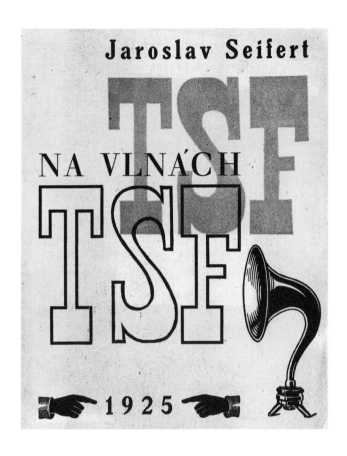

31

body should be able to put together a picture poem by following these instructions. Perhaps that is true, but only a small number of these poems have survived.

Karel Teige worked very closely together with Jaroslav Seifert in 1924. They wrote two unrealized film scripts whose importance for the development of poetism is often overlooked.[39] Along with picture poems and poems such as Seifert's "All the Beauties of the World" (1921), which reflect in their conception Teige's changing views, both film scripts represent an artistic manifestation of Teige's continuing theoretical reflections on poetism. Just as Teige's own film script accompanied the picture poem *Odjezd na Cytheru* (*Departure for Kythera;* figure 9),[40] so "All the Beauties of the World" can be linked with another unrealized film script by Teige and Seifert, "Departure," which includes various themes from Seifert's collection *Na vlnách TSF* (*On the Waves of the Telegraph;* see figures 10–13).

Teige's main poetist themes also appear in the film script *Mr. Odysseus and Various Reports:* the Epicurean Bar, railway signals, train arrivals and departures, train carriages, trams, factories, and machines. Both artists made full use of dissolve techniques through which a given shape would assume different forms: the circle, first represented as a transmission wheel, became a hubcap; the hubcap would then be transformed into a globe that, in turn, assumed the form of an abstract circle; and finally, in the center of the white screen was to appear a spherical life jacket—a favorite subject of Devětsil, also used in the *Bazaar of Modern Art* exhibition with the inscription "Au Revoir." All these were mentioned in Teige's manifesto on poetism as the language of symbols, as a lexical standard.[41]

In his criticism of painting culminating in the articles "Malířství a poesie" ("Painting and Poetry") and "Obrazy" ("Images/Figurations"), Teige asserted the loss of its autonomy. This was caused, on the one hand, by the introduction of printing machines, machine production, and mechanical reproduction, which put the role of painting as such in doubt; on the other hand, to confront the pure space of modern architecture with an easel painting, was—according to Teige—"shocking."

In addition, from the late nineteenth century on, painting was being gradually replaced by the poster and—of course—Devětsil's picture poem. Pure typography and optical poetry, or, as Teige put it, "purely artistic poetry without literature," constituted the main areas of expression for Devětsil during 1923 to 1925, when poetism began to establish itself.

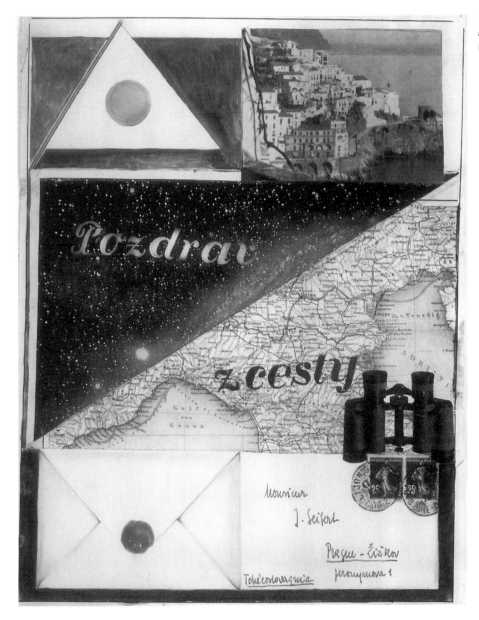

14. Karel Teige, *Greetings from the Journey.* Picture poem, 1924. Prague Municipal Gallery.

Picture poems, as a unique example of Teige's theoretical beliefs and as a particular contribution of the Prague avant-garde movement to the international scene, were premiered in the magazines *Disk, Pásmo* (*Zone*), and *Veraikon*. According to Teige, the picture poem was a new visual form of art. Most of the members of Devětsil—whether they were poets, theorists, directors, actors, artists, or architects—experimented with picture poems during the period 1923 to 1926. The most important, however, were produced by Teige himself. The picture poem *Greetings from the Journey* (1924), which he called a "tourist poem" offering an "image of the lyricism of travel," was compiled, in his own words, from "several typical photogenic elements: ship flags, picture postcards, a photograph of a starry sky, travel maps, binoculars and a letter with the words 'Greetings from Abroad!'[:] . . . allusions that serve to evoke impressions of a vividness inexpressible in words" (figure 14).[42] Not only the range of elements but also the way in which they were arranged was important. The optical composition of *Greetings from the Journey* was arranged into three horizontal zones. Teige commenced to design his picture poem from the top left-hand side, with a specific symbol taken from the maritime code of international flag signals: a red circle in a white triangle.[43]

This motif, which betrays a fascination with the optical alphabet and flag symbolism, actually had its formal precedent in Teige's earlier drawings. The triangle and circle theme had already appeared in the drawings *Road with Telegraph Poles* (1918; figure 15), and *Trees on a Hillside* (1918), which were almost exclusively composed of slanting triangles. One might even notice Teige's penchant for triangles in his early work *Landscape with a Sailing Boat* (see figure 2). In addition, the artist decided to place a verbal caption alongside a black-and-white postcard of a typical Mediterranean town. The sharp diagonal separating the central part of *Greetings from the Journey* into two contrasting halves (one depicting a starry sky and the other a map of northern Italy and southern France), also points to one of Teige's previous artworks; the diagonal of the steep quarries in *Landscape with a Road* (1918/1919; figure 16) provides a similar compositional contrast. On the map, the route from Nice to Trieste is highlighted with a red pencil line.

Greetings from the Journey evidently alludes to the trip Karel Teige made with Jaroslav Seifert to France and Italy in August 1924. While this second visit to France did not make as great an impression on Teige as the first, he perceived the journey in typically poetist terms. He described Nice, where the red line begins, in a letter to his then-

girlfriend Emmy Häuslerová, the future wife of architect Evžen Linhart: "I experienced the most beautiful evening of the whole trip in Nice's dance hall, La Plage Negresco: dancing above the sea, waves throbbing against the embankment, light flashes of two lighthouses communicating in the distance and the sound of jazz rhythms from the wooden pavilion; beautiful girls from all over the world dancing."[44] The experience of the trip is symbolized not only by a pair of binoculars, an essential part of a tourist's paraphernalia, but also by a drawn envelope (not collaged on) with a red seal addressed to Jaroslav Seifert, to which Teige even affixed a cutout stamp with the postmark "Côte d'Or." The closely linked themes chosen for each picture poem, taken together, create a harmonious ensemble of positive associations and at the same time evoke assorted personal references.

Teige's second picture poem, poetically titled *Departure for Kythera* (1924), was more complex (see figure 9). Its theme is also "touristic" in that it actually captures the specific moment of parting itself. It too may be a reference to Teige's original graphic work *Landscape with a Sailing Boat,* depicting a sailing boat gliding across a lake, which Teige described in 1924 as a "modern poem, an instrument of joy." It was not conceived statically but instead represented the "flashing image of a lyrical film." Teige even published it in his book *Film* (1925), where he expanded the theme into a screenplay, beginning with moving abstract geometric planes and including various "traces" of reality that together enunciate the departure of the boat and the farewell, followed by illuminated signs and the pennants "Au revoir! Bon vent!" In *Greetings from the Journey,* the topics are arranged next to one another in horizontal lines. This is not so in *Departure for Kythera,* which is composed of different layers, one merging into to other, so that successive actions are often rendered as simultaneous.

15. Karel Teige, *Road with Telegraph Poles.* Ink on paper, 1918. PNP, Prague. Photo by ÚDU AVČR, Prague.

16. Karel Teige, *Landscape with a Road.* Pencil and watercolor on paper, 1918/1919. Benedikt Rejt Gallery, Louny. Photo by František Krejčí, ÚDU AVČR, Prague.

17. Otakar Mrkvička, cover for Jaroslav Seifert's book *Samá láska* (*Love Alone*) (Prague, 1923). PNP, Prague. Photo by ÚDU AVČR, Prague.

18. Karel Teige and Otakar Mrkvička, cover for the Czech translation of Ilya Ehrenburg's book *Jeanne Neuill's Love Affair* (Prague, 1924). Photo by František Krejčí, ÚDU AVČR, Prague.

19. Karel Teige, *Ocean Bay.* Oil on canvas, 1921. Private collection, Prague. Photo by František Krejčí, ÚDU AVČR, Prague.

20. Karel Teige, *Landscape with Semaphore,* 1922. Reproduced from *Veraikon* (1924). PNP, Prague. Photo by ÚDU AVČR, Prague.

Picture poems that were designed to replace paintings found, for the most part, a practical application as book covers. Teige designed these frequently with Otakar Mrkvička, his new colleague from Devětsil. Mrkvička was the artist behind what is probably the first-ever book cover conceived in this way, designed for the collection of poems by Jaroslav Seifert *Samá láska* (*Love Alone,* 1923; figure 17), for which Teige wrote the afterword. The covers for the books *Svítání* (*Dawn*) by Emil Verhaeren (1925), Ilya Ehrenburg's *Láska Jeanny Neuillové* (*Jeanne Neuille's Love Affair,* 1925; figure 18) and Vladimir Lidin's *Mořský průvan* (*Sea Breeze,* 1925) show abstract, orthogonal planes interwoven with selected reproductions, thereby creating a dynamic visual array of merging abstract planes and specific photographs that reflect the contents of the work.

Although Teige held extremely avant-garde views and consciously abandoned all things connected with the past, his own creative endeavors did take note of artistic developments of the recent past and developed steadily from 1916 onward (figure 19). After absorbing the primary influence of cubism and expressionism as well as the subsequent short-lived movement of purism, he applied intuitive reason to develop his own kind of optical language that would suit both his artistic talents and his theoretical principles. The picture poems, although influenced by both Berlin dadaism and Russian constructivism, were a natural progression from Teige's previous work, unreservedly oriented toward the denial of traditional artistic approaches. For example, at one time Teige introduced an elemental chessboard-like railroad sign into the center of his painting *Landscape with Semaphore* (1922) as a purely impersonal object (figure 20). A similar chessboard also featured as an independent feature in the introductory double spread of *Život* 2 (1923),[45] probably designed by Jaromír Krejcar. It was only a small step to replace a painted or drawn motif with reproductions cut into shapes and glued on to introduce contrast into his abstract geometric designs. Even though Teige's theory encouraged discontinuity, and his avant-garde attitude advocated dismissing everything past, in practice he was more flexible. His choices were based more on the need always to reevaluate continuity rather than simply to negate it: according to Teige, the avant-garde artist improved himself with every new work of art, which thus also contained the possibility of denying his own preceding methods.

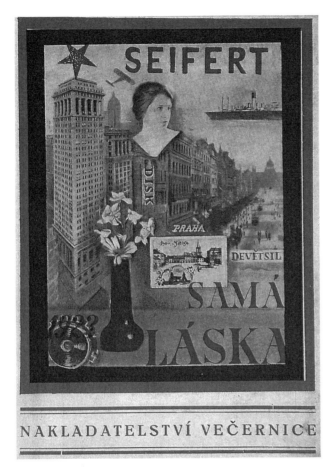

TYPOGRAPHICAL PICTURE POEMS

During this same period, Teige was creating typographical picture poems, which were closer in nature to the second option to replace easel painting; namely, the poster. He published them on the pages of *Disk* and *Pásmo* and in the poetry collections by members of Devětsil.

While the picture poems share common ground with Teige's earlier drawings and graphics, the typographical picture poems evoke instead the first issue of *Listy všeho* (1916), whose title page shows the figure of an artist canvassing for the cause of the modern movement. In a photograph with the title "Mask," published in 1924 in *Pásmo*, Teige actually resembled this cartoon figure: he poses wearing a top hat with a pipe in his mouth, the number *9* pinned to his jacket, and his right arm outstretched in a revolutionary salute (figure 21). The figure in *Listy všeho* is surrounded by various phrases, each line in a different typeface. Tiny hands point to various ideas or phrases, later used for Teige's typographical adaptation of a painting by Štyrský and on the cover of Seifert's collection *On the Waves of the Telegraph.*

Teige was not the only member of Devětsil to create typographical picture poems, but others failed to earn the same kind of acclaim. A telling example is the adaptation of the text *Jízda vlakem* (*Train Journey*) by Devětsil prose writer Karel Schulz, conceived by the Brno-based typographer Zdeněk Rossmann. Teige must be ultimately regarded as the main proponent of this art form (figure 22).

The two typographical poems by Teige published in Nezval's collection *Pantomima* (*Pantomime*) could hardly have rested solely on that prose as their foundation. The first is a reproduction of the picture poem *What Is Most Beautiful in a Café . . .* (probably shown earlier in the *Bazaar of Modern Art* exhibition; figure 24), which incorpo-

21. Karel Teige, *Mask.* Reproduced from *Pásmo* 1, no. 2 (1924). PNP, Prague. Photo by ÚDU AVČR, Prague.

22. Karel Teige and Jaromír Krejcar, cover for Karel Schulz's book *Sever—jih—zá-pad—východ* (*North—South—West—East*), (Prague, 1923). Photo by František Krejčí, ÚDU AVČR, Prague.

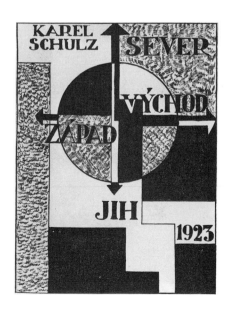

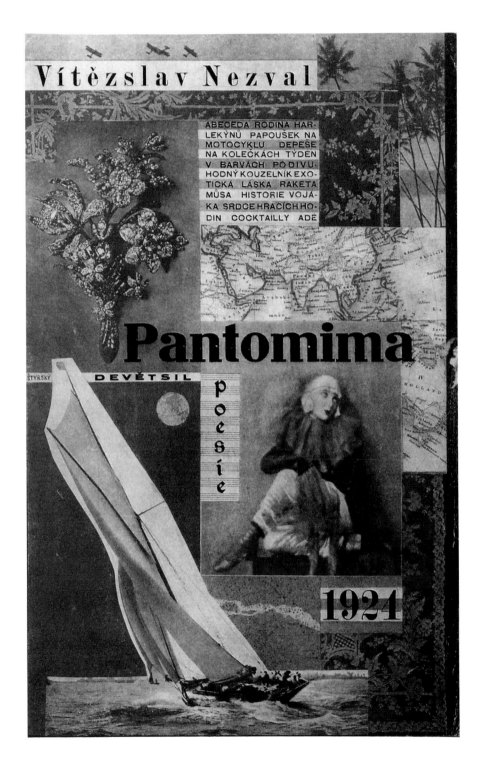

23. Jindřich Štyrský, cover for Vítězslav Nezval's book *Pantomima* (*Pantomime*) (Prague, 1924). PNP, Prague. Photo by ÚDU AVČR, Prague.

rated the type selected by Teige with the design of coffeehouse blinds, a motif with which Teige had experimented earlier in his painting *Landscape with a Semaphore* (see figure 20). The second was a typographical design for Nezval's poem "Adieu . . . adieu . . . adieu . . ." in the style of an obituary (figure 25). The prerequisite was to find a suitable background text to achieve the profound artistic effect he desired.

Even before he knew that he would be working on Nezval's *Pantomima,* Teige asked Jaroslav Seifert to write a special collection of poems for him:

I have this plan for a strange picture book, if one can still call it a book; my plans are quite clearly defined, my thoughts are keen, but I require the cooperation of a writer; thus I am turning to you. They need to be [conceived] in fairly new literary form. . . . You probably know this from our recent conversations. A pure experiment. An attempt at new lyrical forms of art and non-art, a new form of book that, since it is to be printed, will require the services of a typographer; I have conceived the work in black printer's ink and not the ink used to fill a goose's quill pen.[46]

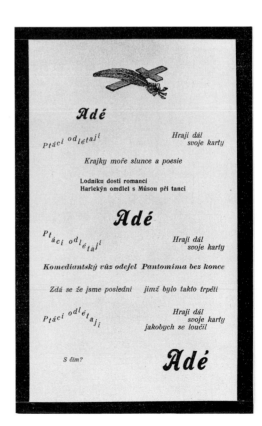

The preparations for publishing the collection *On the Waves of the Telegraph,* which must have delighted Teige as much as the various outings and trips he undertook as part of the most frequent and clearly the best-loved leisure pursuits of Devětsil, were a weekend journey through the new possibilities of typography. It is described by Jaroslav Seifert in his memoirs from the 1970s. During the 1930s, however, Seifert rewrote *On the Waves of the Telegraph* and chose to publish the collection without Teige's typographical modifications. He later explained that "Mr. Obzina's reputable printing house in Vyškov had to use almost all available typefaces in its cases during the typesetting of the book, not to mention that they had to throw to the wind all the classical typographical rules handed down and perfected from the time of Gutenberg to the era of modern book design. . . . Today's youth would characterize Teige's efforts as a 'typographical rodeo.'"[47] Teige's "typographical rodeo" is not only a fine example of a complex, pure typographical design without the use of reproductions but also the only Devětsil work conceived in this way in its entirety. Teige did not approach the design for *On the Waves of the Telegraph* in a formalistic manner (see figure 10). He was quite conscious of the contents of the poems themselves, which indeed reflected Devětsil's intense interest at that time in ports, traveling, France, and all kinds of other anecdotal references designed to subvert the position of poetry as a mannerist genre. Teige's optical rendering of words did not occur spontaneously. He always stressed those concepts that were related to the essential aesthetic premises of Devětsil by using puzzles, maps, abacuses, and above all his favorite black circle, which appeared frequently on his 1922–1923 book covers and which he continued to use in various versions until the early 1930s.

For the individual poems in the collection *On the Waves of the Telegraph,* Seifert incorporated signs found inside trains as well as hotel names, which Teige used to whimsical effect. Thus, each poem was conceived autonomously, and no design in the book was repeated. By detaching and isolating certain words from the context of the poem, Teige afforded them weight as global concepts that, for members of Devětsil, evoked a wealth of other objects of thought, now rendered independent of Seifert's original poem. Moreover, by alternating the typefaces, Teige was able to stress individual lines of verse and highlight or downplay their various levels of meaning. Such devices markedly changed the effect of Seifert's poetry; for example, in the poem "Evening Streetlights" Teige did not shy away from including an advertisement for contraceptives to point to possible meanings of this title.

24. Karel Teige and Vítězslav Nezval, *Co je nejkrásnějšího v kavárně . . .* (*What Is Most Beautiful in a Café . . .*). Picture poem, 1924. PNP, Prague. Photo by František Krejčí, ÚDU AVČR, Prague.

25. Karel Teige and Vítězslav Nezval, *Adé . . .* (*Adieu . . .*). A typographical picture poem from Nezval's book *Pantomima* (Prague, 1924). Reproduction of original page. PNP, Prague. Photo by Zdeněk Matyásko.
Translation:
Adieu
The birds are flying away
 They keep on
 playing their games
Lace of ocean sun and poetry
Captain of many romances
The harlequin and his muse have fainted
in their dances
Adieu
The birds are flying away
 They keep on
 playing their games
The wagon with its comedians has left
Pantomime without end
It seems we are the last who were
made to suffer thus
The birds are flying away
 They keep on
 playing their games
 as if I was saying
to what? **Adieu**

Clearly, the collection *On the Waves of the Telegraph* represents the culmination of his early typographical work, often involving the most radical procedures, as yet unrestrained by the rules Teige later set forth in "Modern Typography," developed during the latter half of the 1920s. It is also epitomizes the notions governing Jaroslav Seifert's poem "A Prayer on the Sidewalk":

This is the world
The world of my life
The world of electricity, inventions and work
And it tosses from side to side like a passionate man
At the moment of sweet ejaculation.[48]

Notes
1. "Umělecký svaz Devětsil" (The Art Association Devětsil), *Pražské pondělí* 2, no. 49 (6 December 1920): 2. This was the first Devětsil manifesto. The founding members of this art group chose a highly original name for themselves—*Devětsil* (Butterbur). In Czech this term has two meanings. The first is literal: a perennial plant or herb with pink or white flowers that grows near water (*Petasites vulgaris*). The second is metaphorical, meaning "nine forces" or "nine strengths" (in fact, there were not nine members affiliated with the group). Devětsil thus acquired one of the most fetching names of any art group of the twentieth century.
2. See Teige's important recollections, which he contributed to the volume dedicated to this unique Prague secondary school: Karel Teige, *Na Křemencárně, či-li příspěvek k embryologii jedné generace* (At the school in Křemencová Street, or a contribution to the embryology of one generation), commemorative volume compiled by the Masaryk State Secondary School in Prague, 2 Křemencová Street, 1871–1946 (Prague, 1948), 96–101.
3. The artistic group *Tvrdošíjní* was founded in 1918 with the innovative exhibition *A přece!* (*And Yet!*), which was held while the First World War was still in progress. The group was chiefly made up of painters (Josef Čapek, Vlastislav Hofman, Rudolf Kremlička, Otakar Marvánek, Václav Špála, and Jan Zrzavý); members worked in close cooperation with the poet Stanislav Kostka Neumann, who published their work and texts in *Červen* (June) magazine, and with theorist Václav Nebeský, who was their unofficial spokesman. See also Karel Srp, ed., *Tvrdošíjní* (The Stubborn Ones), exhibition catalogue, Prague Municipal Gallery (Prague, 1986), and Srp, ed., *Tvrdošíjní a hosté* (The Stubborn Ones and their guests), exhibition catalogue, Prague Municipal Gallery (Prague, 1987). The work of Devětsil was a direct reaction to that of the Stubborn Ones; the two groups coexisted during the first half of the 1920s. See Srp, "Tvrdošíjní a Devětsil" (The Stubborn Ones and the Devětsil), *Umění* 35 (1987): 54–68.
4. Teige's activities in the 1920s are discussed in the special edition of his writings: *Karel Teige, Svět stavby a básně* (Karel Teige: The world of construction/architecture and poetry: Studies from the 1920s) (Prague, 1966). See also Š. Vlašín, ed., *Avantgarda známá a neznámá. Od*

proletářského umění k poetismu (Avant-Garde known and unknown: From proletarian art to poetism) (Prague, 1971); František Šmejkal and Rostislav Švácha, eds., *Devětsil: Czech Avant-Garde Art, Architecture, and Design of the 1920s and 1930s,* exhibition catalogue (Oxford and London, 1990); Jaroslav Anděl and C. Alborch, eds., *The Art of the Avant-Garde in Czechoslovakia, 1918–1938,* exhibition catalogue (Valencia, 1993); Karel Teige, "Architecture and Poetry," *Rassegna* 15, no. 53/1 (1993); Karel Srp, ed., *Karel Teige 1900–1951,* exhibition catalogue, Prague Municipal Gallery (Prague, 1994); special issue on Teige, *Umění* 43 (1995): 1–181; M. Castagnara Codeluppi, ed., *Karel Teige, Architettura, Poesia, Praga 1900–1951* (Milan, 1996).

5. Jan Zrzavý, a member of the Stubborn Ones, was an artist whose work was originally based on the symbolism of the 1890s. However, its unique atmosphere and distinctly fragile links with any kind of artistic program prevailing in Czech art at that time earned him special respect from members of the early Devětsil, who even compared his primitivizing approach with the naivism of Henri Rousseau. The independence of his artistic approach and the melancholy of his paintings made it inevitable that Zrzavý would exemplify one standing apart from accepted period trends. He expressed himself in his own language, conforming neither to cubism nor expressionism, movements that heavily influenced Czech art before 1914. Teige dedicated not only his first monograph to Zrzavý, published as "Jan Zrzavý," *Musaion* 4 (1923), but also a comprehensive study: "Jan Zrzavý—předchůdce" (Jan Zrzavý—Precursor), in *Dílo Jana Zrzavého 1906–1940* (The work of Jan Zrzavý, 1906–1940) (Prague, 1941), 49–66.

6. Like Václav Nebeský in his book *Umění po impresionismu* (Art after impressionism) (Prague, 1923), which presented profiles of major representatives of postimpressionist painting in Paris, Karel Teige also made a distinction between natural and artificial primitivism. See Teige, "Kubismus, orfismus, purismus a neokubismus v dnešní Paříži" (Cubism, orphism, purism, and neocubism in contemporary Paris), *Veraikon* 8, nos. 9–12 (1922): 98–112.

7. Karel Teige, "Obrazy a předobrazy," *Musaion* 2 (1921): 52–58. The magazine was the group publication of the Stubborn Ones, and Teige's text provoked great indignation. Immediately after Teige's article appeared, Karel Čapek himself, as *Musaion*'s editor, published a note distancing himself from it.

8. Ibid.

9. Karel Teige, "Nové umění proletářské," in *Revoluční sborník Devětsil* (Prague, 1922), 5–18.

10. Teige, "Obrazy a předobrazy."

11. Karel Teige, "Konstruktivismus a likvidaci 'uřmení,'" *Disk,* no. 2 (spring 1925): 4–8.

12. Teige, "Obrazy a předobrazy."

13. Teige's attitude toward the so-called 1890s generation and toward decadence—whose representative poet was Otakar Březina, whose theoretical spokesman was František Xaver Šalda, and whose most important journal was *Moderní revue*—was ambivalent to say the least. However, his parallel, or synchronic, developmental model drew on those works as a possible source of inspiration and support. For this reason, Teige appreciated the poetry of Březina, whose visions were admired by the early Devětsil to a certain extent, although later it reinterpreted his works quite differently.

14. The list of Devětsil members was fairly long; see Polana Bregantová, "The Membership of Devětsil," in Šmejkal and Švácha, *Devětsil,* 106–109.

15. See Teige's afterword to his and Vítěslav Nezval's monograph on Jindřich Štyrský and Toyen, "Od artificialismu k surrealismu," in *Štyrský a Toyen* (Štyrský and Toyen) (Prague, 1938), 189–195.

16. Karel Teige, "Umění přítomnosti," in *Život* 2 (Prague, 1922), 119–142, and "Umění dnes a zítra," in *Revoluční sbornik Devětsil,* 187–202. See Karel Srp, "Václav Nebeský," *Umění* 33 (1985): 433–451. Nebeský provided a forceful response to Teige's theories during the early 1920s, defending the principles of prewar modern art and honoring the autonomous artistic eloquence and relevance of certain expressive means. Teige's rejection of easel painting was highly irritating, particularly for the Stubborn Ones' generation.

17. Karel Teige to Artuš Černík, 2 December 1921, Literature Archives of the Památník národního písemnictví (Museum of Czech Literature) in Prague; hereafter cited as PNP.

18. Le Corbusier was the only foreign artist with whom Teige entered into a direct polemic. See Jean-Louis Cohen, "Teige," in *Le Corbusier: Une Encyclopédie,* ed. J. Lucan (Paris, 1987), 401–402.

19. Karel Teige, "Foto Kino Film," in *Život* 2, 153–168. Teige even included a special section, "The Case of Man Ray." In it he discussed an album of twelve photograms, *Champs Délicieux,* which "no longer has anything to do with photography," and pointed to his own avant-garde program where "photo: painting = cinema: theater = orchestration: piano = future photo-sculpture: sculpture." Teige's view is made clear from his summary of cinema and theater: "Cinema is developing at a rocketing pace, theater is sinking further into decline. . . . Theater is a statue on a pedestal, it is not life. Cinema cures us of all epidemics and endemic diseases spread by the theater."

20. Antonín Dufek, "Man Ray et la photografie tchéque," in *Prague, 1900–1938: capitale secrète des avant-gardes,* (Prague, the secret capital of the avant-gardes), ed. E. Starský and J. Andel, exhibition catalogue (Dijon, 1997), 183–186. On Man Ray's photographs in Teige's collages, see Lenka Bydžovská and Karel Srp, "Lingua adamica," in Srp, *Karel Teige 1900–1951,* 96–109.

21. Srp, "Tvrdošíjní a Devětsil," 54–68. In "Umělecký svaz Devětsil," the machine was indiscriminately shunned as an agent of destruction in the First World War and as a tool of the exploitative capitalist system.

22. Jaroslav Seifert, "Všecky krásy světa," in introduction to *Život* 2; Vítězslav Nezval, "Abeceda," *Disk,* no. 1 (November 1923): 3–4.

23. Zdeněk Pešat, *Jaroslav Seifert* (Prague, 1991), 31–53.

24. Seifert was probably referring to a poster bearing the words "Art Is Dead," exhibited at the *Internationale Dada Messe in Berlin* (1920). He may have seen a photograph showing the poster being held up by G. Grosz and J. Heartfield.

25. Surprisingly, the Congress focusing on constructivism did not receive much coverage in Czech avant-garde publications of the time: see *Konstruktivistische Internationale 1922–1927* (Constructivist international, 1922–1927), exhibition catalogue (Düsseldorf, 1992).

26. Karel Teige, "K nové architektuře" (Toward a new architecture), *Stavba* 2 (1923–1924): 179–194.

27. See *Život* 2, 44–45.

28. Pavel Liška, "Symbolický kubismus" (Symbolic cubism), in *Český kubismus 1909–1925* (Czech cubism, 1909–1925), exhibition catalogue, National Gallery in Prague (Prague, 1992), 360–377.

29. Vítězslav Nezval, *Papoušek na motocyklu,* in *Pantomima* (Pantomime) (Prague, 1924).

30. Teige describes the exhibition *Bazaar of Modern Art* in detail in "Od artificialismu k surrealismu," 360–377. Quotations from Teige on the exhibition are from this source.

31. František Šmejkal pointed out that Teige may have gotten the inspiration for the idea of the mirror from Philippe Soupault at the *Dada Salon* in the Montaigne Gallery, which he probably would have seen during his stay in Paris. Soupault wrote the words "Portrait of an Unknown Man" beneath a suspended mirror. See František Šmejkal, "Česká výtvarná avantgarda dvacátých let" (The Czech creative avant-garde of the 1930s), in *Devětsil,* exhibition catalogue, Prague Municipal Gallery (Prague, 1986).

32. See Karel Teige to Artuš Černík, letter, presumably from the end of 1923, Literature Archives, PNP, Prague.

33. Karel Teige, "Poetismus," *Host* 3, nos. 9–10 (1924): 197–208, translated below.

34. Karel Teige, "Obrazy" (Images/Figurations), *Veraikon* 10, nos. 3–5 (1924): 34–40.

35. See "Umělecký svaz Devětsil"; Teige to Černík, end 1923.

36. Teige, "Poetismus."

37. Ibid.

38. Teige to Černík, end 1923 or early 1924.

39. The unrealized film scripts written by Vítězslav Nezval, Karel Teige, and Jaroslav Seifert played as crucial a role as the picture poems in the development of the poetry of the early Devětsil. Seifert and Teige collaborated on the most important ones: "Pan Odysseus a různé zprávy" (Mr. Ulysses and miscellaneus reports), *Pásmo* 1, nos. 5–6 (1924): 7–8; "Přístav" (Harbor), *Disk,* no. 2 (spring 1925): 11–12. See also Viktoria Hradská, *Česká avantgarda a film* (The Czech avant-garde and film) (Prague, 1975).

40. See Karel Teige, *Film* (Prague, 1925).

41. See Karel Teige, "Malířství a poesie" (Painting and poetry), *Disk,* no. 1 (November 1923): 19–20.

42. Teige, "Poetismus."

43. Zdeněk Primus, "Obrazová báseň — entuziastický produkt Devětsilu" (The picture poem — An enthusiastic project of Devětsil), in Srp, *Karel Teige 1900–1951,* 48–61.

44. Quoted in Růžena Hamanová, "Dopisy Karla Teiga Emy Häuslerové" (Letters of Karel Teige to Ema Häuslerová), *Literární archiv* (Literature Archive) 24 (1990): 236.

45. Lenka Bydžovská and Karel Srp, "On the Iconography of the Chessboard in Devětsil," *Umění* 41 (1993): 39–46.

46. Karel Teige to Jaroslav Seifert, summer 1923, PNP.

47. Jaroslav Seifert, *Všecky krásy světa* (All the beauties of the world) (Prague, 1982), 259–260.

48. Jaroslav Seifert, "Modlitba na chodníku," *Kmen,* 24 March 1921.

THE AVANT-GARDE IDEAL OF POIĒSIS: POETISM AND ARTIFICIALISM DURING THE LATE 1920S

/ 3

Lenka Bydžovská

(Translated by Karolina Vočadlo)

DEVĚTSIL AND POETISM

The spring of 1927 saw a rise in the Czech press of a fairly forceful critical wave disclaiming Karel Teige and Vítězslav Nezval's poetism as obsolescent and exhausted.[1] There were soon indications, however, that this "burial" was premature. Devětsil had entered a new stage of its development, in which the original conception and possibilities of poetism were intensified: its proponents were producing original and mature artistic work that was now free of their earlier dependence on foreign avant-garde models. In the autumn of 1927 a new Devětsil forum appeared: the monthly magazine *ReD,* whose name was coined as an abbreviated form of "*Revue Devětsil*" (figure 1). This alone marked the journal as a "red signal of a new cultural epoch."[2] The content and image of the magazine, published from 1927 to 1931, was determined chiefly by Karel Teige, who edited and designed all three volumes. The introductory declaration of *ReD* emphasized both its continuity within the Devětsil program, which was shaped by Teige's conception of the tension between constructivism and poetism, and the prevailing interest in universal modern creativity in all spheres of contemporary life.

POETIST MANIFESTO: DREAMS OF *ARS UNA*

Both external attacks on its program and the evolution of their own views led Teige and Nezval to rethink the idea behind poetism; the result was a new collection of poetist manifestos. In fact, issue 9 of the first volume of *ReD* (June 1928) was entirely devoted to their publication. The requirement characteristic for the developmental models of the 1920s avant-garde was thus fulfilled: namely, the necessity to avoid stagnation, to constantly forge ahead. Teige and Nezval also felt the need to "purge" their own movement of misinterpretation and epigonic devaluation, as well as to undertake the practical task of settling accounts with opponents (generally speaking, André Breton had similar goals a year and a half later in his *Second Surrealist Manifesto*). Nezval's "Kapka inkoustu" ("A Drop of Ink") introduced three manifestos, to be followed by Teige's treatise "Ultrafialové obrazy čili artificielismus" ("Ultraviolet Images or Artificialism"), which examined the art movement proclaimed by Jindřich Štyrský and Toyen in 1926. The most comprehensive and crucial essay was Teige's text bearing the simple title "Manifest poetismu" ("Poetist Manifesto").[3] In this platform he reflected and expanded on ideas contained in his declarations and studies from 1923 onward, now establishing for them an integral, theoretical base. He conceived poetism as the true

culmination of international avant-garde experiments in developing modern culture. He promoted the idea that it had never been intended as an artistic movement or school but was meant as a new philosophy of art and aesthetics — as the conception of a new creativity and a new life. He presented poetism in a universal historical perspective, ranging from its predecessors and its current state to a utopian vision of the future. Drawing on his knowledge of literature,[4] he was able to analyze in detail the genealogy of poetism in a line that ran directly from Baudelaire to Apollinaire, moving toward a pure poetry liberated from all ideological or utilitarian functions. Words were transformed from the bearers of concepts into independent realities, into "direct initiators of emotions" (326). At the same time, the genealogy revealed the correlation between various sensations and also between different fields of art.

In Teige's view, the core of poetist aesthetics consisted in the requirement for an absolute, universal poetry that, through "maximum emotionality," fulfilled a single goal — "to quench humanity's immeasurable thirst for lyricism" (325). He believed that an examination of the analogies between the laws of the individual senses would open up unlimited possibilities, which could be applied aesthetically to a "poetry for the five senses" (326). By acting on the romantic desire for synthesis and fusion of individual ar-

1. Karel Teige, cover for the review *ReD* 1, no. 1 (October 1927). The Mitchell Wolfson Jr. Collection, the Wolfsonian–Florida International University, Miami Beach, Florida. The caption below Rössler's picture reads, "Revised edition after confiscation" (by censors).

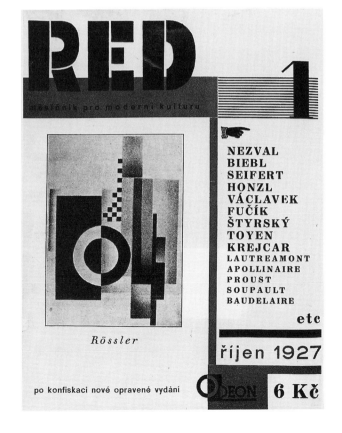

tistic fields, as clearly expressed in Baudelaire's *correspondances,* the idea of a higher unity of art would be recaptured as the conception of one art in many forms: *ars una.* Under such conditions, Teige proposed to abandon the term "art" and instead use the word "poetry" in its primary Greek sense: *poiēsis* (which he understood as supreme creativity). He embraced the idea of a unified human creative instinct whose roots he saw in sexuality as the "vital and creative instinct par excellence" (336). For Teige, poetism brought about the end of the Christian ascetic dictatorship of the soul; tragedy was to be driven out by physical and psychological euphoria, resulting in a harmony of body and soul that was to reside in the coexistence of three basic human powers: sensuality, intelligence, and activity. Contrary to the premises of Kantian aesthetics, poetism, exorcised of metaphysical concerns, was to follow the heritage of a nonscholastic philosophy of Epicureanism and materialism.

Scientific and technical achievements encouraged the avant-garde to invent new aesthetic domains and configurations that could no longer be classified according to current aesthetic categories and that would better correspond to the psychology of modern man: his reflexes and imagination, as reflected in the psychological and psychoanalytical discoveries of the time. In order to create universal poetry for all the senses, Teige believed that it was necessary to support a previously inaccessible utopia with a solid scientific base—to discover and experiment with new means of expression and to explore the spectator's psychological responses. Teige also pointed to the possibility of creating poetry without the use of words, "to compose poetry using more reliable, constructive, and scientifically controllable material: to create poetry through color, shape, light, movement, sound, fragrance, and energy" (332), using all the means and devices provided by today's science and industry. As in constructivism, the terms "purity of shape" (freed from ideology, as well as decorative and literary impediments) and "scientific progress" were deemed relevant to the poetist perspective.

According to Teige, modern civilization greatly influenced human sensibility by exciting an unprecedented heightening of perception and—above all—by transforming optical culture. In his "Poetist Manifesto," Teige pointed to the "optical" nature of the modern era:

Of all the senses, contemporary civilization has cultivated sight the most vigorously (not least, both photography and film can take credit for the sharpening and improved flexibility of our sense

of sight), clearing the way for poetry's gradual shift to pure visualization. At one time the poem was sung; now it is read. Rhythm and rhyme, parallelism and refrain served as technical aids in the pre-Gutenberg era. . . . With the development of book printing, the spoken, living word became stunted; it lost its acoustic timbre and became a system of graphic ciphers: poems assembled typographically are a consequence of these facts. (325)

It is therefore logical that even among his contemporaries, Teige secured the recognition of the supremacy of the print type as a visual phenomenon, formed largely as a result of the influence of photography and film. The activity of the eye was for Teige a life process just as complex as that of thinking, which he described in the conclusion to his extensive study "Slova, slova, slova" ("Words, Words, Words"), published the previous year in *Horizont:* "No word evokes reality from emotion and the subconscious like the image. First and foremost, before it became a verbal concept, thought itself was image."[5] Vision alone can bring other senses into play and vibrate all the strings of the modern soul.

As Teige noted, psychological experiments showed that olfactory, gustatory, tactile, and dermal impressions, as well as impressions of physical well-being and pain, could be transformed into a visual image. Even visual images of dreams (oneiric images) could be summoned by auditory and tactile sensations. Thus, the optical environment revealed its superiority and greater vitality, and for these reasons poetism emphasized its role in contemporary development; moreover, its proponents expected that in the future poetism was destined to touch all the senses and thus affect universal sensibility. For this reason, Teige espoused the future development of varying types of poetry that would improve on the experiments of the international avant-garde to date: poetry for the eyes, which was divided into the dynamic (play of reflections, film, fireworks) and the static (photographic and typographic images, to be produced in editions of thousands); poetry for the ears (radiogenic and radiophonic compositions of sounds and noise whose medium was open space); poetry for the senses of smell, taste, and touch (in connection with Marinetti's tactilism); new optophonetics; poetry of physical and spatial senses (sport, expressive dance, dance poems); and poetry of the "sense for the comic," as presented by film farces.

51

A STEP BACK?

It is somewhat paradoxical that even as the "Poetist Manifesto" was being published, Devětsil's period of interdisciplinary experimentation was nearing its end: no one continued producing picture poems and Teige did not react to the optophonetic experiments carried out by Zdeněk Pešánek. It seemed that having resigned himself to seeing the fulfillment of his utopian visions in a more remote future, he decided instead to focus his attention on three important figures in Devětsil working in the field of visual culture: Josef Šíma, Jindřich Štyrský, and Toyen, who were at that time preoccupied with painting. All three were in direct contact with the Paris avant-garde, but at the same time they were able to preserve their individuality and create their distinctive artistic styles. Teige followed the course of their work and provided them with an opportunity to publish it in the pages of *ReD.* He also wrote introductions to their solo exhibitions in Prague in 1928. In addition, he summarized his views on their role in the development of contemporary world painting in "Abstraktivismus, nadrealismus, artificielismus" ("Abstractivism, Surrealism, Artificialism"),[6] an article in which he clarified his ideas about identifying painting with poetry. Teige publicized cubism as the movement that heralded the liberation of painting from its representational function; he traced the artistic development from cubism to abstraction, which conceived the painting as a subject totally independent of nature, obedient only to the laws of attraction and the equilibrium between shape and color. Teige was also aware that abstract art would be imperiled by decorativeness: that is, the system of forms being understood as an end in itself, instead of functioning as a vehicle for purely emotional stimuli.

Josef Šíma also passed through an abstract period in his paintings during the years 1924–1925. In the mid-1920s Teige discussed his abstract works with great enthusiasm, adapting their interpretation to suit his theory on the demise of traditional forms of art: in his view, Šíma's paintings represented designs that could be industrially produced in series with modern materials, or implemented as dynamic projections in plays and films.[7] For the time being Teige chose to ignore the high artistic quality of these works, such as Šíma's characteristic style and sensitivity to light — qualities that he highlighted three years later as protecting Šíma against the "literary affectations" of surrealism.

Šíma was in close contact with the surrealists and in a sense actually introduced them into Bohemia, although he was never fully involved in the movement. From 1927

onward he developed his own poetics; these were related to the philosophy of Le Grand Jeu, founded by the simplists, a group of French poets of the younger generation that included Roger Gilbert-Lecomte and René Daumal. While Gilbert-Lecomte and Daumal expanded and altered their experiences, disturbing and stimulating the senses by experimenting on their own bodies — often risking permanent harm and even death — Šíma experienced his most important illuminating moments "naturally," during the occurrence of dramatic natural phenomena of which he was a perceptive witness and whose effects he had been contemplating for years. Šíma's work was inspired by visions of world unity, based on a materialistic monism. His paintings were primarily rooted in specific sensual experiences that could emerge in his works at any time, keeping their original intensity as they were enriched by a kind of metaphysical tenor. As Jan Mukařovský noted, Šíma clung to materiality and emphasized this in his paintings; even the most clearly distinguishable motifs in his work were not intended merely to denote a subject matter as such, but were also made to act as symbols of a whole universe of things. In addition, Šíma made a conscious effort to limit the repertoire of the depicted objects only to those that were capable of working on these multiple levels (crystal, egg, female torso, tree, etc.), which reappeared in his paintings in various artistic and morphological variations (figures 2 and 3).[8]

Teige placed Šíma's work at the dividing line between poetism and surrealism. He recognized and admired Šíma's art, which "elevated painting to the boundless sphere of poetry," but he expressed — at that time — a highly critical view of surrealism itself. Together with Vítězslav Nezval and Štyrský, Teige saw surrealism as a step backward from avant-garde development. They argued that it had exchanged the contrivances of

2. Josef Šíma, *Neskutečná těla* or *Bílé tělo* (*Unreal Bodies* or *White Body*), 1927. Reproduced in *ReD* 1, no. 8 (May 1928): 283. Památník národního písemnictví CPNP; Museum of Czech Literature), Prague. Photo by Ústav dějin umění Akademie věd české republiky (ÚDU AVČR; Institute of Art History of the Academy of Sciences of the Czech Republic), Prague.

3. Josef Šíma, *Ml,* 1927. Reproduced in *ReD* 1, no. 8 (May 1928): 282. PNP, Prague. Photo by ÚDU AVČR, Prague.

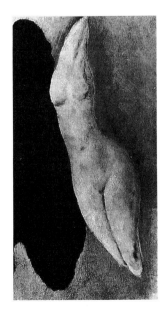

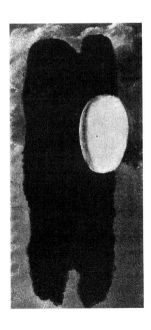

form in abstract art and cubism for the literary, illustrative, and ideoplastic images of the past, making a circuitous return via the symbol. Thus, surrealism was accused of having fallen under the sway of German expressionism and the mystic, metaphysical schools of the past. It could therefore be considered as the most extreme development of Romanticism. Moreover, it was accused of neglecting issues of technique and form, restricting itself to passively representing subconscious events and denying the volitional element of creativity and construction. In Teige's view, surrealism abandoned the white light of intellect (or the pragmatic illuminations of broad daylight) and instead tuned the senses to register an "infrared glow" acting below the threshold of consciousness.

In contrast, artificialism, in agreement with poetism, lived in the ultraviolet world of superconsciousness. Art was seen not as the work of some kind of psychological automatism but as a free, conscious act. Artificialism—in direct opposition to surrealism—developed the postcubist line. Painting, freed of objective representation, literary content, and decorativeness, identified with the poem, which was itself severed from ideology, literature, and the need to communicate along conventional lines of perception. For these reasons Teige included his study "Ultraviolet Paintings or Artificialism" among the poetist manifestos, explaining that artificialism had common roots with poetism and was closely akin to it.[9]

THE ULTRAVIOLET WORLD OF ARTIFICIALISM

Indeed, many connecting links may be found between poetist and artificialist manifestos and paintings, beginning with the identification of painting with poetry, understood by Teige as a supremely free art. Štyrský compared poetry to an electric spark revealing the potential energy of a person's emotional character. Similarly, the painter provides shape and color to his emotional ideas (figure 4). His imagination develops from recollection to recollection, not bound by the logic of memory and practical experience. The goal of the painting was to coax the viewer out of the mechanical humdrum of ordinary imagination, to conjure up a lyrical atmosphere, to awaken poetic emotion and stir sensibility. The artist at work was to remain fully conscious, with his intellect fulfilling merely the secondary function of organizing and modeling emotional faculties.

The artificialists sought and invented new painting techniques affording the most delicate of color transitions and enhancing the color scale to include formerly unknown

("ultraviolet") hues, thus creating an effect comparable to quarter-tone music, which also heightens sensory perception. They employed such methods as spraying paint through a net and using stencils and common objects (feathers, leaves, sugar cubes, thumbtacks, apple-peel spirals, etc.) (figures 5–8). As a result, colored hues and shadows emerged fixed on the canvas, evoking a unique tension between a possible literal reading of the subject and the new lyrical potential of its "liberated" outline, placed in a context devoid of conventional interpretative clichés. By destroying the conventional relationship between the object and its name, and by opening up a new scope for the imagination, these painters were following the principles of Man Ray's photograms ("rayographs"), which were much admired by a whole generation of Devětsil. In elaborating his conception of the death of traditional art, Teige even assigned Man Ray a key role:

Man Ray has arrived, the Columbus of a new continent of optical poetry; he liberates photography. He renders it independent of painting and transforms it into a pure art form, into optical and poetic art. The invention of journalistic photography has brought an end to imitative painting. The discoveries of Man Ray and pure photographic art will lead to the demise of painting, for we do not wish to believe that human perfection would be necessarily more virtuous than the perfection of machines.[10]

4. Left: Toyen, Fata morgana (*Mirage*), 1926. Right: Jindřich Štyrský, Krajina v oblacích (*Landscape in Clouds*), 1925. Reproduced in *ReD* 1, no. 1 (October 1927): 31. The Mitchell Wolfson Jr. Collection, Wolfsonian-FIU, Miami Beach, Florida.

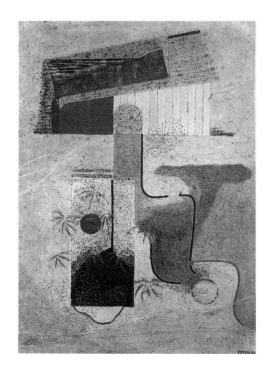

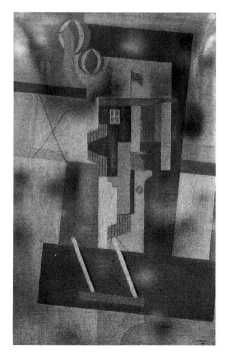

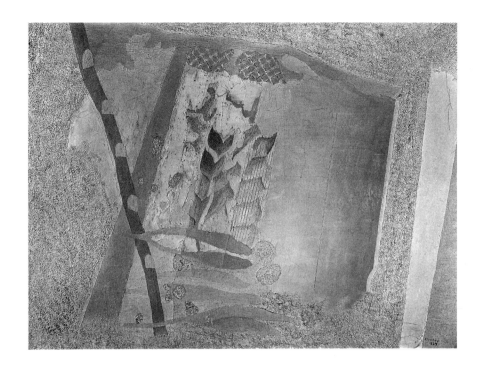

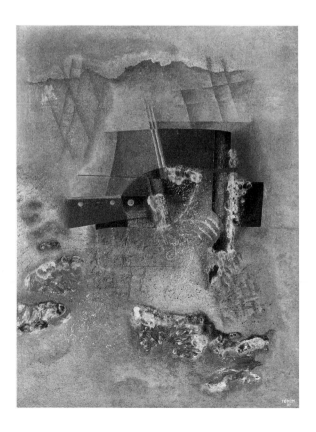

5. Jindřich Štyrský, *Jinovatka* (*Hoarfrost*), 1927. Reproduced in *ReD* 1, no. 1 (1927): 28. PNP, Prague. Photo by ÚDU AVČR, Prague.

6. Toyen, *Tonoucí koráb* (*Shipwreck*), 1927. Reproduced in *ReD* 1, no. 6 (March 1928): 213. The Mitchell Wolfson Jr. Collection, Wolfsonian-FIU, Miami Beach.

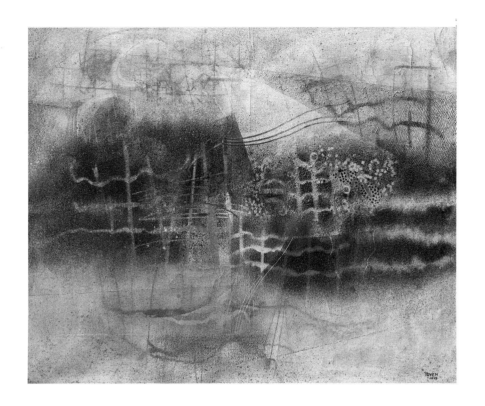

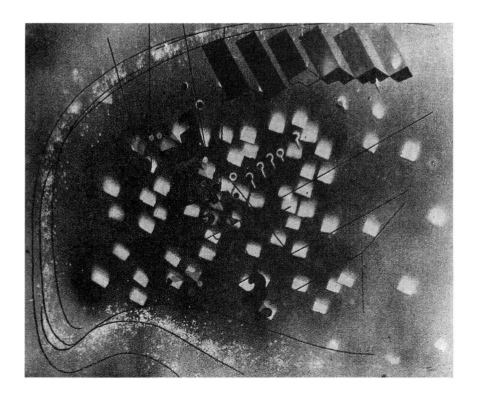

7. Toyen, *Cigaretový dým* or *V mlze* (*Cigarette Smoke* or *Mist*), 1927. Reproduced in *ReD* 2, no. 1 (September 1928): 19. The Mitchell Wolfson Jr. Collection, Wolfsonian-FIU, Miami Beach.

8. Jindřich Štyrský, *Noční rychlík* (*Night Express*), 1927. Reproduced in *ReD* 2, no. 1 (September 1928): 25. The Mitchell Wolfson Jr. Collection, Wolfsonian-FIU, Miami Beach.

In Czechoslovakia, the painters Štyrský and Toyen responded to Man Ray's photograms in their work, as did the photographers Jaroslav Rössler and Jaromír Funke (figures 9 and 10). Funke refused in principle to recognize anything as photography that did not involve the actual use of a camera. He chose to achieve a lyrical effect by using a photographically pure technique that involved what he called shadow play. Thus, in his still lifes shadows gradually acquired a greater significance than the subjects themselves, which eventually were left outside the picture frame entirely. In fact, the orchestration of these works is not too far removed from artificialism.[11]

Artificialist paintings took their cue to a great extent from the new modern optics, influenced both by general and by scientific photography, as indicated by Teige in his "Poetist Manifesto." Shots taken through a microscope, or submarine or aerial photography, suggested a new structure for a new pictorial environment (figure 11). Admiration of documentary photography was an important part of Devětsil aesthetics. For example, in "Vítězná krása fotografie" ("The Victorious Beauty of Photography"), published in *Disk* in 1925, Vilém Santholzer claimed that

9. Toyen, *Čajovna* (*Teahouse*), 1927. Reproduced in *ReD* 1, no. 6 (March 1928): 212. The Mitchell Wolfson Jr. Collection, Wolfsonian-FIU, Miami Beach.

10. Jaromír Funke, *Two Photograms*, 1929. Reproduced in *ReD* 3, no. 4 (January [February] 1930): 111. PNP, Prague. Photo by ÚDU AVČR, Prague.

the beauty of an aerial photograph often has an unprecedented effect on the human imagination and frequently enters the realm of true epicurism. Other subjects were used as well for unveiling new spatial combinations of a photographic nature, such as photographs of craters, marine bays, and high mountain ranges, to name but a few. The beauty of a scientific photograph viewed through the microscope or an astronomical telescope is in itself a sensation of a great mode of expression, since it is entirely authentic. . . . All this competes from the point of view of purely optical impressions with the compositions of Man Ray.[12]

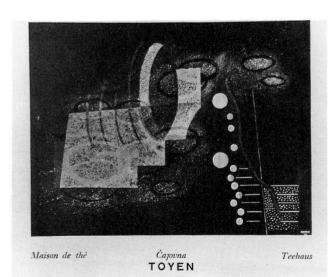

Maison de thé — Čajovna — Teehaus
TOYEN

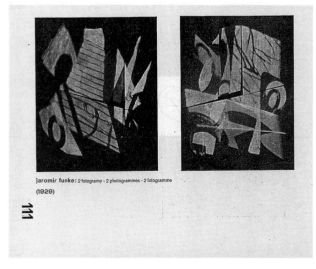

jaromír funke: 2 fotogramy - 2 photogrammes - 2 fotogramme (1929)

111

In the journal *ReD,* artificialist paintings were paired with photographs taken through a microscope and shots of marine life. The caption "Štyrský? Toyen? Photo!" even appeared beneath a photograph titled *Landscape under the Sea,* published in the first volume of *ReD* (figure 12). The artificialists freely admitted drawing from sources such as these. "The poet loves distance. Not distance in space, but in time. He loves the earth in its beginnings and at its end, the diluvial sea that began to invent its own language" — these are Štyrský's words in his introductory address at the *Aventinská mansarda* exhibition, characteristically titled "Básník" ("Poet").[13]

Together with Toyen, Štyrský intended to create an original, "innocent" artistic language. He cleverly combined disparate elements by bringing together in a single painting new organic formations, geometric forms, and arabesques with thread- and phantomlike silhouettes of remote objects, while real objects were dematerialized into mere shadows and fantastic imaginary shapes often acquired a three-dimensional corporeality. During this period he favored extremely fine, almost dim colors. The effects achieved by spraying paint were transferred with precision to his oil paintings. By lightening the colors he created an indefinite space filled with a fluidlike medium in which various new formations came to life, hovering or floating above the canvas.

Toyen represented the other pole of artificialism. In contrast to the intellectualism of Jindřich Štyrský, she painted more elementally. She gradually intensified the materiality of her colored pastes by mixing them with sand, layered in relief or applied by scraping. She was also one of the first to use a technique that involved the pouring and dripping of paint.

11. *Argo Argonautus,* from the Ufa film *Wunder des Blauen Golfes* (*Miracle of the Blue Lagoon*). Reproduced in *ReD.* 1, no. 6 (March 1928): 215. The Mitchell Wolfson Jr. Collection, Wolfsonian-FIU, Miami Beach.

12. *Landscape under the Sea,* with the caption "Štyrský? Toyen? Photo!" Reproduced in *ReD* 1, no. 6 (March 1928): 215. The Mitchell Wolfson Jr. Collection, Wolfsonian-FIU, Miami Beach.

Argo Argonautus

Although the artificialists insisted that the theme of their paintings was the painting itself, they were not satisfied with neutral labels for their works but instead dreamed up poetic titles intended to encourage the viewer to use his or her imagination ("emotional directives"; see, e.g., figure 13). Teige, looking back at artificialism in a 1938 monograph, even compared this phenomenon to a kind of "lingua Adamica": "Štyrský and Toyen, in giving their paintings titles, do not imitate their subjects by their conventional verbal counterparts (which do not exist outside the painting), but they behave like Adam who coined words for realities that were cast up onto the shores of the world from the immeasurable night of creation."[14] The relationship between the artificialist painting and its title should thus be regarded as more analogical than denotative. Even so, the title is a key to the painting itself—it is this independence, freedom, and poetry that ignite the imagination and forestall any attempt at an unambiguous, fixed interpretation.

The late twenties and early thirties were marked by a strange ambivalence in the attitude of the Prague avant-garde toward surrealism. Štyrský, for example, in his "Poznámka k výstavě Štyrského a Toyen" ("Note on the Štyrský and Toyen Exhibition") of 1930, sharply criticized surrealism;[15] at the same time, his work from this period shows a distinct conciliatory inclination toward it. A similar situation occurred in Nezval's work, with its reflection on and greater interest in the inner world of man. The leading article in the first issue of *Zvěrokruh* (*Zodiac*) magazine, founded by Nezval in 1930, expressly assured its readers that this was not a surrealist review. Nevertheless, its subsequent pages were dominated by texts written by André Breton, Paul Eluard, and other surrealists.

It was here that Karel Teige still defended his position regarding poetism in his treatise "Báseň, svět, člověk" ("Poem, World, Man"),[16] sometimes referred to as another poetist manifesto (followed by Nezval's provocative but unpublished "Third Poetist Manifesto," originally written for what was to be the third issue of *Zvěrokruh*). Teige's treatise presented a summary of his views on art formulated during the 1920s, focusing in particular on issues related to Freud's theory of psychoanalysis. Teige put aside his aspirations for poetism to a more distant future, to a "higher stage of communism," in which society would no longer try to paralyze sensual and erotic energy by the forced sublimation of the libido, and art would thus become redundant—a stage in which harmony, beauty, and happiness would permeate all aspects of life's expressions.

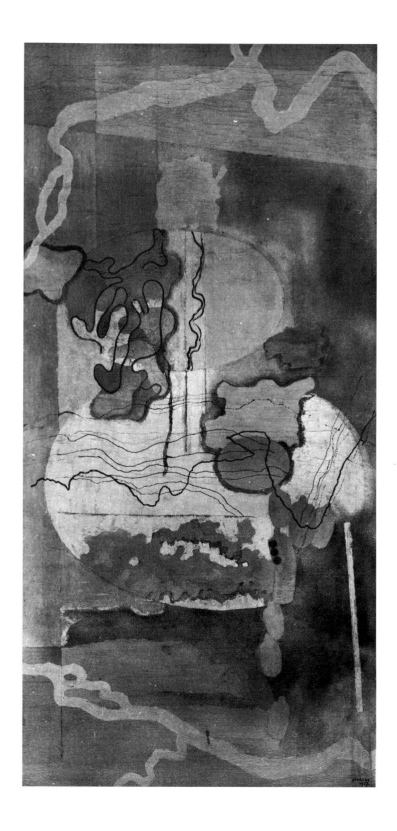

13. Jindřich Štyrský, *Povodeň* (*Flood*), 1927. Reproduced in *ReD* 1, no. 6 (March 1928): 213. The Mitchell Wolfson Jr. Collection, Wolfsonian-FIU, Miami Beach.

The second (and final) issue of *Zvěrokruh*, published in December 1930, contained a translation of the entire text of Breton's *Second Surrealist Manifesto.* Surrealism's new orientation in the direction of dialectic materialism eliminated what was probably the most important reservation held by the Prague avant-garde movement. Within a short time the movement had moved closer to Breton's group, and Teige and Nezval (the creators of poetism), along with Štyrský and Toyen (the creators of artificialism), became the leading figures of the Czechoslovak Surrealist Group, founded in the spring of 1934. This change in their artistic program led to a reinterpretation of their own development. They had to create a new history in order to be able to conceive poetism and artificialism as logical evolutionary links on the road to surrealism.[17]

Notes

1. Poetism was criticized especially by B. Mathesius and J. Hora in the magazine *Tvorba* (Design/Creation) and by J. A. M. Píša in his book *Směry a cíle* (Trends and goals) (Prague, 1927). On poetism and artificialism, see F. Šmejkal, "Artificialismus," *Výtvarné umění* (Creative Arts) 16 (1966): 381–391; Šmejkal, ed., *Devětsil, Česká výtvarná avantgarda dvacátých let* (Devětsil, the Czech avant-garde of the 1920s), exhibition catalogue (Prague, 1986); Šmejkal and R. Švácha, eds., *Devětsil: Czech Avant-Garde Art, Architecture, and Design of the 1920s and 1930s,* exhibition catalogue (Oxford and London, 1990); L. Bydžovská and K. Srp, *Artificialismus,* exhibition catalogue (Karlovy Vary [Karlsbad], Pardubice, Prague, 1992); J. Anděl and C. Alborch, eds., *The Art of the Avant-Garde in Czechoslovakia, 1918–1938,* exhibition catalogue (Valencia, 1993); Srp, ed., *Karel Teige 1900–1951,* exhibition catalogue, Prague Municipal Gallery (Prague, 1994); J. K. Čeliš, "Devětsil," in *Prague, 1900–1938: Capitale secrète des avant-gardes,* ed. E. Starck and J. Anděl, exhibition catalogue (Dijon, 1997), 168–175; J. Toman, "Le poétisme: éclat de rire au milieu des gratte-ciel," in ibid., 176–177.
2. Editorial, "ReD. Revue Svazu Moderní Kultury 'Devětsil' Praha 1927," *ReD* 1 (1927–1928): 2.
3. Karel Teige, "Manifest poetismu," *ReD* 1 (1927–1928): 317–336; this work is hereafter cited parenthetically in the text. Teige had already sketched the main ideas of this manifesto in his article "Poesie pro pět smyslů" (Poetry for the five senses), *Pásmo* 2, no. 2 (1925): 23–24.
4. During the late 1920s, Teige published several essays on his favorite poets, e.g., "Charles Baudelaire," in *Fanfarlo,* by Baudelaire (Prague, 1927), 59–122; "Stéphane Mallarmé," *ReD* 2 (1928–1929): 33–35, 62–64; "Guillaume Apollinaire a jeho doba" (Guillaume Apollinaire and his time), *ReD* 2 (1928–1929): 78–98; "Isidore Ducasse comte de Lautréamont," in *Maldoror,* by Lautréamont, (Prague, 1929), 91–122.
5. Karel Teige, "Slova, slova, slova," *Horizont* 1 (1927): 1–3, 29–32, 44–47, 70–73; quotation, 73.
6. Karel Teige, "Abstraktivismus, nadrealismus, artificielismus," *Kmen* 2 (1928): 120–123. On Teige's relationship to Šíma's work, see also Teige, "Obrazy Josefa Šímy" (The paintings of Josef Šímy), *Rozpravy Aventina* 3, no. 15 (1928): 179–180 (an abbreviated version of this

text was published in the catalogue for the Šíma exhibition in Prague (March–April 1928) and also in *ReD* 1 (1927–1928): 274–276; a parallel version appeared in *Stavba* 6 (1927–1928): 195–196.

7. Karel Teige, "Pozor na malbu" (Pay attention to painting), *Pásmo* 1, no. 9 (1925): 2–3; Karel Teige, "Pražské výstavy" (Exhibitions in Prague), *Stavba* 3 (1924–1925): 167–168.

8. J. Mukařovský, "Josef Šíma," in *Studie z estetiky* (Studies in aesthetics) (Prague, 1971), 426–438. See also F. Šmejkal, *Josef Šíma* (Prague, 1988), also published in French (Paris, 1992); S. Pagé, ed., *Sima: Le Grand Jeu,* exhibition catalogue (Paris, 1992).

9. Karel Teige, "Ultrafialové obrazy čili artificielismus," *ReD* 1 (1927–1928): 315–317 (also published in the catalogue for the Štyrský and Toyen exhibition in Prague, June–July 1928). The most important of the manifestos and other texts on *artificiélisme* written by Jindřich Štyrský had already been published in the first issue of *ReD;* see Štyrský and Toyen, "Artificiélisme," *ReD* 1 (1927–1928): 28–29; see also note 1.

10. Karel Teige, "K estetice filmu" (Toward an aesthetics of film), *Pásmo* 1, nos. 7–8 (1925): 2.

11. Cf. A. Dufek, "Man Ray et la photographie tchéque," in Starck and Anděl, *Prague 1900–1938,* 183–186.

12. V. Santholzer, "Vítězná krása fotografie," *Disk,* no. 2 (spring 1925): 10.

13. J. Štyrský, "Básník," *Rozpravy Aventina* 3 (1927–1928): 241–242.

14. Karel Teige, "Doslov: Od artificialismu k surrealismu") (Afterword: From artificialism to surrealism), in V. Nezval and Teige, *Štyrský a Toyen* (Štyrský and Toyen) (Prague, 1938), 189–195. See also L. Bydžovská and K. Srp, "Lingua adamica," in Srp, *Karel Teige 1900–1951,* 96–109.

15. J. Štyrský, "Poznámka k výstavě Štyrského a Toyen," *Musaion* 1, no. 11 (1928–1930): 241–243.

16. Karel Teige, "Báseň, svět, člověk," *Zvěrokruh,* no. 1 (November 1930): 9–15.

17. See R. Hamanová, "Surrealistický most Praha-Paříž" (The Prague-Paris surrealist bridge], in *Český surrealismus 1929–1953* (Czech surrealism 1929–1953), ed. L. Bydžovská and K. Srp (Prague, 1996), 22–27, 94–105; Bydžovská and Srp, "Fragmenty snu" (Fragments of a dream), in ibid., 28–47.

POETISM

/ 4

Karel Teige

(Translated by Alexandra Büchler)

Note: Widely spaced passages represent emphasis in the original.

Originally published in *Host* 3, nos. 9–10 (July 1924): 197–204.

The nineteenth century, lacking a discrete style, gave birth to -isms, those somewhat more insouciant and noncommittal substitutes for styles. Today, there is no ruling -ism. After cubism, we have witnessed the rivalry of numerous artistic schools and beliefs. With no rules to guide it, art, individualized to the extreme, has broken up into groups called avant-gardes. There is no -ism, only "new art" or the "latest art" that often harbors illusions as old as the world itself and calls them universal truths. The degeneration of -isms is nothing but a symptom of the e v i d e n t d e g e n e r a t i o n o f t h e e x i s t i n g k i n d s o f a r t .

Yet a new style is being born, and together with it a new art that has ceased to be art: free of traditional prejudice, it allows for every promising hypothesis, sympathizes with experimentation; and its ways are as responsive, its sources as rich and abundant, as those of life itself.

And it is likely that it will be those less professional, less literary-minded spirits, yet all the more lively and cheerful for it, who will be, from now on, concerned with this new art. In its blossoming you will discover the intoxicating aroma of life, and that alone will make you forget the problematics of art.

Professionalism in art cannot continue. If the new art, and that which we shall call p o e t i s m , is an art of life, a n a r t o f l i v i n g a n d e n j o y i n g , it must become, eventually, a natural part of everyday life, as delightful and accessible as sport, love, wine, and all manner of other delectations. It cannot be a profession; rather, it will become a universal need. No individual life, that is, a life lived morally, with smiles, happiness, love, and dignity, will be able to do without it. The notion of a professional artist is an error and today, to some extent, an anomaly. The Paris Olympics of 1924 did not admit any professional sports clubs. Why should we not reject just as resolutely the professional guilds of painting, writing, modeling, and chiseling businessmen? An artwork is not a commodity for commercial speculation, and it cannot be the subject of stilted academic debates. It is essentially a gift, a game with no constraints and no consequences.

The fresh, abundant, and exquisite beauty of the world is the daughter of real life. She is not a child of aesthetic speculation, or a product of the romantic mentality of an artist's studio, but a simple result of purposeful, disciplined, positive production and the everyday activity of humankind. She will not find a home in cathedrals or galleries, but outside, in the streets, in the architecture of cities, in the refreshing greenery of parks,

in the bustle of seaports, and in the heat of industry feeding our primary needs. She does not work according to self-prescribed formalist recipes: modern shapes and forms are the outcome of purposeful work; they are being turned out to perfection under the compulsion of purpose and economy. She has embraced the calculations of the engineer and saturated them with poetic vision. In just this way urbanism, the science of designing cities, has provided us with fascinating poetic works, drawn as a blueprint for life and a prospect of days to come, a utopia that shall be achieved in a future that is red. Its products are the engine of plenty and happiness.

The new beauty was born from constructive work, the basis of modern life. The triumph of the constructive method (disappearance of handicrafts, abolition of decorative art, mass production, norms, and standardization), has been rendered operative exclusively by the principles of a cutting-edge intellectualism, manifested in contemporary technical materialism. Marxism. The constructive principle is thus the condition of the very existence of the modern world. Purism is the aesthetic control of constructive work—nothing more, nothing less.

Flaubert wrote a prophetic sentence: "The art of tomorrow will be impersonal and scientific." But will it still be art? Today's architecture, city building, industrial art are all s c i e n c e. This is not artistic creation as a result of gushingly romantic enthusiasm, but simple, intensive, c i v i l i z i n g w o r k. Social technology.

P o e t i s m is the crown of life; constructivism is its basis. As relativists, we are aware of the hidden irrationality overlooked by the scientific system and therefore as yet not sublimated. It is in the interest of life that the calculations of engineers and thinkers be rational. Yet each calculation rationalizes irrationality merely by several decimal points. The calculus of each machine has its pi.

In our time we require a special frame of mind to be able to deal with the psychological contradictions taken to the point of paradoxical extremes. Collective discipline. We are hungry for individual freedom. "After six days of work and building of the world, beauty is the seventh day of the soul." This line by the poet Otokar Březina captures the relationship between poetism and constructivism. A man who has lived as a working citizen wants to live as a human being, as a poet.

Poetism is not only the opposite but also the necessary complement of constructivism. It is based on its layout.

Art as poetism is nonchalant, exuberant, fantastic, playful, nonheroic, and erotic. There is not an iota of romanticism in it. It was born in an atmosphere of cheerful fellowship, i n a w o r l d t h a t l a u g h s, and who cares if it laughs in tears? Humorous disposition prevails, while pessimism has been openly abandoned. The art of today shifts its emphasis toward enjoyment and the beauty of life, away from musty studies and studios; it points the way leading from nowhere to nowhere, revolving in a circle around a magnificent fragrant park, for it is the path of life. Here, the hours arrive as blossoming roses. Is it a scent? Is it a memory?

Nothing. Nothing but lyrical and visual excitement over the spectacle of the modern world. Nothing but love for life and its events, a passion for modernity, "modernolatry," to use the expression coined by Umberto Boccioni. Nothing but happiness, love and poetry, heavenly things that cannot be bought for money and that are not important enough for people to kill each other for. Nothing but joy, magic, and everybody's optimistic faith in the beauty of life. Nothing but the immediate data of sensibility. Nothing but the art of wasting time. Nothing but the melody of the heart. The culture of miraculous enchantment. Poetism wants to turn life into grand entertainment. An eccentric carnival, a harlequinade of emotions and ideas, a series of intoxicating film sequences, a miraculous kaleidoscope. Its muses are kind, tender, and mirthful, their glances as fascinating and impenetrable as a lover's glance.

Poetism has no philosophical orientation. It would probably confess to a dilettante, pragmatic, tasty and tasteful eclecticism. It is not a worldview—for us, this is Marxism—but an ambiance of life: certainly not the stodgy atmosphere of a study, a library, a museum. It probably speaks only to those who belong to the new world; it has no desire to be understood and perverted by those whose views are outdated, who look back into the past. It harmonizes life's contrasts and contradictions, and, significantly, for the first time it brings us poetry that needs no words, melody, or rhyme, a poetry already longed for by Whitman.

P o e t i s m i s n o t l i t e r a t u r e. In medieval times even legal codes and school grammars were written in verse. Tendentious ideological verse with its "contents and plot" is the last surviving remnant of this kind of poetry. The beauty of our poetry has no intentions, no grand phrases, no deep meaning, no apostolic mission. A game of beautiful words, a combination of ideas, a web of images, if necessary without words. It calls for the free mind of a juggler of ideas, who has no intention to apply po-

etry to rational axioms and contaminate it with ideology; rather than philosophers and pedagogues, modern poets are clowns, dancers, acrobats, and tourists. The sweetness of artificiality and the spontaneity of feelings. Communication, poem, letter, lovers' conversation, improvised drinking sprees, chitchat, fantasy and comedy, a quick card game light as air itself, memories, good times when people laugh: a week of colors, lights, and scents.

P o e t i s m i s n o t p a i n t i n g. Painting, having rejected all anecdotal aspects and avoided the dangers of decorativism, has started out on its way toward poetry. As poetry became visual (in the work of Apollinaire and Marinetti and in Birot's "poetry of the open air" as well as in his films), so painting, having emancipated form and color in cubism, ceased to imitate reality, for it was not able to compete with photojournalism, and instead set out to m a k e p o e t r y b y m e a n s o f o p t i - c a l f o r m . O p t i c a l w o r d s as devised in the language of flags. Similar to the international system of traffic signs. Abstraction and geometry, a perfect and infallible system that inspires the modern mind. Emancipation from the picture frame, started by Picasso and Braque, has subsequently led to a total s u p p r e s s i o n o f t h e t a b l e a u. The poetic picture is the picture of book illustration, photography, photomontage.

The new poetic language is heraldry: t h e l a n g u a g e o f s i g n s. It works with standards. (For example: *Au revoir! Bon vent, bonne mer! Adieu!* Green light: go! Red light: stop!)

P o e t i s m i s n o t a n - i s m, at least not in the narrow sense of the word as it is currently understood. For there is no -ism in today's art. Constructivism is the method of all productive work. Poetism — we repeat — is the art of living in the most beautiful sense of the word, a modern Epicureanism. It offers an aesthetic that is in no way prohibitive or pedantic. Nor does it wish to mold the life of today or tomorrow according to some abstract rules. There is no moral code, except for that created by the friendly relationships of common living, person to person — an amiable, tolerant etiquette. -Ism, after all, is not a very precise word: -isms do not mean what they say, and to explain them literally, almost etymologically and philologically, would be sometimes terribly foolish (as for example in the case of cubism). Poetism and constructivism are not to be understood in any other way than as a means toward giving a name to a method, a view, a denomination, a simple name (as in the case of socialism, communism, liberalism, etc.).

69

P o e t i s m i s n o t a r t, that is, art in its current romantic sense of the word. It is ready t o l i q u i d a t e e x i s t i n g a r t c a t e g o r i e s, to establish the reign of pure poetry, exquisite in its multifarious forms, as multifaceted as fire and love. It has film at its disposal (the new cinematography), as well as avionics, radio, technical, optical, and auditory inventions (optophonetics), sport, dance, circus and music hall, places of perpetual improvisation where new inventions are made every day. It corresponds fully to our need for entertainment and activity. It is able to give art its due without overestimating its importance, knowing that it is certainly not more precious than life. Clowns and dadaists taught us this aesthetic skepticism. Today, we do not assign a place to poetry in books and albums alone. Instruments of enjoyment, sailing boats are modern poems as well.

It is axiomatic that man has invented art, like everything else, for his own pleasure, entertainment, and happiness. A work of art that fails to make us happy and to entertain is dead, even if its author were to be Homer himself. Chaplin, Harold Lloyd, Burian,[1] a director of fireworks, a champion boxer, an inventive and skillful cook, a record-breaking mountain climber — are they not even greater poets?

P o e t i s m i s , a b o v e a l l , a w a y o f l i f e. It is a function of life and at the same time the fulfillment of its purpose. It is the author of general human happiness and well-being, unpretentiously peaceful. Happiness is a comfortable home, a roof over one's head, but it is also being in love, having a good time, laughing, dancing. It is a noble teacher. Stimulating life. It relieves depression, worries, irritations. It offers spiritual cleansing and moral health.

Life, with its tedium of work and its daily monotony, would be meaningless, an empty shell, without an animating heart, without resilient sensibility, and without poetry. It is poetry that thus becomes the sole purpose of a meaningful life, conscious of itself.

Not to understand poetism is not to understand life!

Humanity has emerged from the war tired, troubled, bitterly robbed of illusions, unable to feel desire, to love, to lead a new, better life. Poetism (within its limits) wants to cure this moral hangover and psychological shock, as well as the malaise of its aftermath, as exemplified, for example, by the case of expressionism. It grows out of a constant human need, free of pretensions and artistic humbug. Poetism knows that one of the greatest values embraced by mankind is human individuality harnessed to the disci-

70

pline of the collective fellowship of man, his happiness and the harmony of his inner life. It puts a new face on the historical ideal of happiness. Poetism revises all values, and, at the time of the twilight of all idols, it has appropriated l y r i c a l v a l u e as its very own and true golden treasure.

It is essential to live the modern global creed to its fullest. Only a truly modern man is a whole man. Romantic artists are defective individuals. *Être de son temps.* For art is the most direct manifestation of the handwriting of life.

Today, the world is controlled by money, by capitalism. Socialism means that the world should be controlled by reason and wisdom, economically, purposefully, usefully. Constructivism is the operative mechanism of such a control. But reason would cease to be wise if it were to suppress the domain of sensibility in the process of its rule over the world: instead of multiplication, it would bring impoverishment to life, since the only asset important for our happiness is the wealth of our feelings, the infinite realm of our sensibility. And it is here that p o e t i s m intervenes and comes to the rescue in the renewal of our emotional life, our joy, and our imagination.

It is by means of these lines that we are for the first time trying to put in words the aims of a movement brought to life by several modern Czech authors. It seems that the time has arrived to define what poetism really means, especially since this word, which has entered common parlance during the one year of its existence, has often been used as well as abused by critics who often had no idea what it is all about.

Poetism was born as a result of the collaboration of several Devětsil authors and is, above all, a reaction against the ideologically colored poetry ruling the roost in our country. Resistance against romantic aestheticism and traditionalism. Jettisoning of existing "art" forms. We have set out to explore the possibilities not capable of being satisfied by paintings and poems in film, circus, sport, tourism, and life itself. And so poetism gave birth to v i s u a l p o e m s , p o e t i c p u z z l e s a n d a n e c - d o t e s , t o l y r i c a l f i l m s . The authors of these experiments—Nezval, Seifert, Voskovec,[2] and, with your permission, Teige as well—wish to savor all the fruits of poetry, cut loose from a literature destined for the scrap heap, a poetry of Sunday afternoons, picnics, luminous cafés, intoxicating cocktails, lively boulevards, spa promenades, but also the poetry of silence, night, quiet, and peace.

Translator's Notes
1. Vlasta Burian (1891–1962) was a well-known Czech comic film actor of the prewar period.
2. The poets Vítězslav Nezval (1900–1958) and Jaroslav Seifert (1901–1986; received the Nobel Prize for Literature in 1984) were major proponents of the poetist movement. Jiří Voskovec (1905–1981) was a theater and film actor, playwright, and creator of popular political satire in the Liberated Theater, in partnership with Jan Werich (1905–1980); from 1950 on, he lived in the United States.

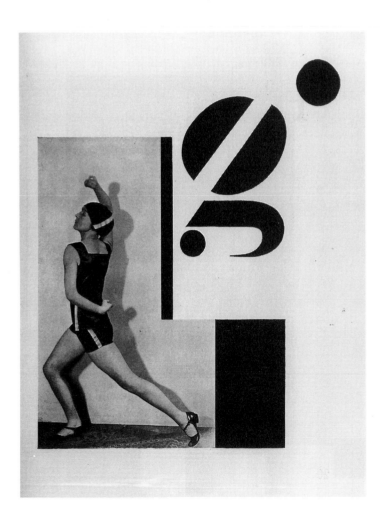

TYPOGRAPHY

Polana Bregantová
(Translated by David Chirico)

EARLY EFFORTS

Karel Teige formulated his typographic credo in 1927 in his study "Moderní typo" ("Modern Typography"). It is the first article in which Teige reflected on Czech and European efforts to create a new typographic style, and in which he evaluated his own experiences in typography.[1] "Moderní typo" was published in Prague in the monthly *Typografia,* in whose pages Teige was soon to introduce the ideas of the European constructivists László Moholy-Nagy, Jan Tschichold, and El Lissitzky. Their programmatic texts did not, however, provoke stormy polemics, as one might have expected from a conservative and specialized magazine.

While professional typographers were to criticize the typographic work of Teige and his friends well into the 1930s, the Czech cultural community accepted the modern typographic style with relative tolerance. This was much to the credit to modern Czech publishers, who dared every now and then to offer their readers books with covers by painters from the Devětsil circle: Otakar Mrkvička, František Muzika, Adolf Hoffmeister, Jindřich Štyrský, Toyen, and Karel Teige. As early as 1925, Devětsil published its books with Jan Fromek's Odeon. Odeon employed Teige from the very start as a principal author and typographer, translator, and unpaid editor. Before the demise of Devětsil at the end of 1931, Odeon had published about 130 books, which represent Czech book constructivism.

Several of the basic principles that Teige not only announced in his essays but also put into practice had already been recommended (and realized) years before by Karel Dyrynk, a leading figure in Czech classical typography. Already in 1909 he had emphasized the need to assess the content of a work and its aim, and to choose type and format accordingly, because "every detail must be solved according to a single plan"; the typographer should try "to make the outer form of the book mirror its inner content."[2] Dyrynk drew in turn on the programmatic essay by the critic F. X. Šalda, "Kniha jako umělecké dílo" ("The Book as a Work of Art"), printed in *Typografia* in 1905, in which Šalda articulated the general principles of the unity of a book's content and form.[3] More important for this discussion is, of course, Šalda's 1903 lecture "Nová krása: její genese a charakter" ("The New Beauty: Its Genesis and Character"), which, according to the Teige expert Vratislav Effenberger, anticipated the line of development that was later to dominate the work of the interwar avant-garde: constructivism and poetism in the 1920s, and functionalism in the 1930s, both of which were to influence

architecture and urbanism and penetrate almost all spheres of culture, including typography.[4]

"MODERNÍ TYPO"

When he wrote "Moderní typo," Teige already had two years of intensive collaboration with Fromek's Odeon behind him (figure 1); he was equipped with a more extensive and comprehensive knowledge of Soviet book constructivism and of the elementary typography of the Bauhaus than anyone else in Bohemia. In "Moderní typo" he reviewed his development up to that time and hinted at further possibilities of typographic creation. "Constructivist typography and graphic arts," wrote Teige in the introduction, "are in many ways contrary to the ideals and rules of that modern typography whose father is William Morris" (189). He saw the decorativism of the Secession, archaism in book design, and collectors' snobbism as "the three stumbling blocks that have so far hindered . . . modern book design" (191)—that which constructivist typography must take pains to avoid. He completely rejected the decorativism of Secession typefaces and emphasized the principles of easy readability and appropriateness of type to text, established eighteen years earlier by Karel Dyrynk. Teige was well aware of the influence of advertising typography, which had introduced the Grotesque type as well as a

1. Karel Teige, cover for the Czech translation of Guillaume Apollinaire's book *Prsy Tiresiovy* (*The Breasts of Tiresias*) (Prague, 1926). Ústav dějin umění Akademie věd České republiky (ÚDU AVČR; Institute of Art History of the Academy of Sciences of the Czech Republic), Prague. Photo by František Krejčí.

2. František Muzika, cover for Vítězslav Nezval's book *Básně noci* (*Poems of the Night*) (Prague, 1930). ÚDU AVČR, Prague.

3. Karel Teige. A proposal for the reform of Herbert Bayer's typeface, showing the changes he made to the letters *a, g, k, x;* 1929. From *ReD* 2, no. 8 (1929): 257. ÚDU AVČR, Prague.

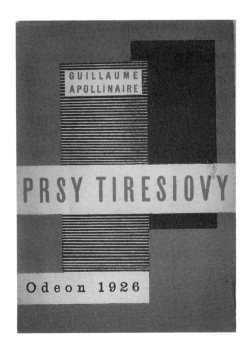

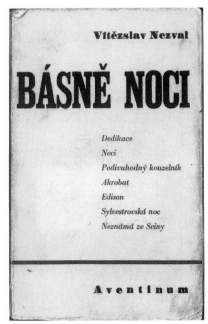

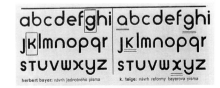

few simple and easily readable types from the nineteenth century into book typography (figure 2).[5] He did consider the typeface Universal Grotesque, designed and theoretically justified by Herbert Bayer, as aesthetically appropriate.[6] Teige attempted to modify four of the letters of Bayer's type and published the results in the magazine *ReD* (figure 3). He was also interested in the then-fashionable idea of using only lowercase letters in all types, thus eliminating capital letters.[7] He introduced this idea as a theoretical possibility for philological and economic reasons, but did not try to implement it in practice.

Teige articulated the requirements of a readable and simple type in his six principles of modern typography; later he would comment on and attempt to develop these even further:

1. Liberation from tradition and prejudice: overcoming archaism and academicism, eliminating all decorativism. Ignoring academic and traditional rules that are not optically justified, being mere fossilized formulas (e.g., the golden section, unity of type).

2. Selection of types with clearly legible, geometrically simple lines: understanding the spirit of each type and using them according to the nature of the text, contrasting the typographic material to emphasize the contents.

3. The perfect grasp of the purpose and fulfilling the brief. Differentiating between the purpose of each typographic task. Advertising billboards, which should be visible from a distance, have different requirements than those of a scientific book, which are again different from those of poetry.

4. Harmonious balancing of space and arrangement of type according to objective optical laws; clear, legible layout and geometrical organization.

5. Utilization of all possibilities offered by new technological discoveries (linotype, emulsion print, photo typesetting), combining image and print into "typofoto."

6. Close collaboration between the graphic designer and printer in the same way it is necessary for the architect to collaborate with the building engineer, the developer, and all those who participate in the realization of a building; specialization and division of labor combined with the closest contact among the various experts.

The conclusion to Teige's most important study of typography is made up of notes on his own work. He considered book covers to be similar to posters with their striking colors and basic geometric figures, where orthogonal surfaces are best served by orthogonal forms and where the circle acts as the figure most pleasing to the eye.[8]

Teige's conception invites comparison with the postulates of El Lissitzky from 1923.[9] The principles of the Bauhaus, which were also an inspiration to Teige, were formulated in 1925 by the pioneers of elementary typography László Moholy-Nagy and Herbert Bayer in collaboration with El Lissitzky, Kurt Schwitters, and Jan Tschichold. Teige has a number of points in common with the conceptions of both the Bauhaus and El Lissitzky, such as functionality and usefulness of each new text arrangement, respect for the laws of optics, and response to the constantly escalating "optical requirements" of man. He emphasizes the social function of the book, its usefulness, its use of technical progress, and the collaboration of the graphic artist with the printers. His six commandments represent the theoretical culmination of the development of one branch of modern Czech typography in the 1920s.

At the beginning of the 1930s, Karel Teige wrote an article with the characteristic title "Konstruktivistická typografie na cestě k nové formě knihy" ("Constructivist Typography on the Way to New Book Design"), in which he recapitulates its evolution so far. In the conclusion, he summarizes what constructivism has been striving for in the 1920s and what functionalism will fully realize in the 1930s: "Constructivist typo, in its approach to the design of a book, poses these questions: what? — for whom? — why? and only a synthesis of answers to these questions is an answer to the question — how?"[10]

In the wake of Teige's theoretical models, other members of Devětsil attempted to ponder contemporary typography. The painter Otakar Mrkvička, who created a series of book covers with Teige for Odeon and for the Komunistické nakladatelství (Communist Publishing House), also understood the cover as a poster for a book, a poster that not only should fulfill a commercial goal but should above all "make the spectator into a reader, be a synthetic expression of the content, suggest the character of the book, and organize the spectator's psyche."[11]

The theoretician Artuš Černík took his departure from the elementary typography of the Bauhaus. His ideas do not represent a coherent system, but they preceded Teige's study "Moderní typo" on the pages of *Typografia* by several months.[12] Another

of Teige's colleagues from Devětsil, the architect, poet, and book illustrator Vít Obrtel, took a more polemical approach to Teige's typographic model (figure 4). In his gloss "Obálková terminologie" ["Book Cover Terminology"], he made a fine distinction by stating that even though "the constructivist book cover does not exist,"[13] he did not mean to distance himself from the principles of Constructivist book design in terms of aesthetic expression, but only from Teige's terminology. Obrtel, who had a creative mind completely different from that of Teige, was to take his critique even further; two years later he accused Teige of plagiarism and lack of inventiveness.[14]

A FORM DISCOVERED

What was Teige's actual typographic work like in the 1920s? His early work, analyzed in more detail above by Karel Srp, was concluded in 1925 with the design for Jaroslav Seifert's collection of poems *Na vlnách TSF.* (*On the Waves of the Telegraph*). Unlike Vítězslav Nezval's *Pantomima* (*Pantomime*), which reads more like a pasted-together family album of Devětsil than a conventional book, Seifert's collection was the first attempt by Teige to master the book as a whole, from cover to print run. On this score, Teige writes in "Moderní typo" that the aim of both collections was for typography to "complete the poetic process and transpose the poems into the visual sphere" (197). In some poems, which are independent typographic compositions, Teige made use of conceptions from Apollinaire's *caligrammes* and Marinetti's *parolibere;* in others, inspired by the example of Pierre Albert-Birot, he created poem-posters.[15]

In the typographical poems of Seifert's collection *Na vlnách TSF,* poetism entered Czech typography for the first time. Poetism was an original Czech movement, originat-

4. Vít Obrtel, title page and frontispiece for Vítězslav Nezval's book *Akrobat* (Prague, 1927). ÚDU AVČR, Prague.

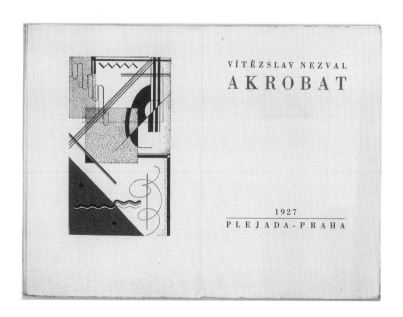

5. Karel Teige and Otakar Mrkvička, cover for the Czech translation of Guillaume Apollinaire's book *Sedící žena* (*La Femme Assise*) (Prague, 1925). ÚDU AVČR, Prague.

ing in the collections by the poets Vítězslav Nezval, Konstantin Biebl, and Jaroslav Seifert, as well as taking its cues from the lifestyle of the Devětsil generation of the mid-1920s. Poetism enriched the theoretically elaborate and rationally calculated constructivist book designs by changing the rules of the game and by adding new typographic material and photomontage. These additions distinguished poetism's designs both from the austere books produced by the Bauhaus workshop and from the compositions of the Hungarian Lájos Kassák, the Dutchman Piet Zwart, and contemporary Polish typographers.

Teige collaborated with the painter Mrkvička from the beginning of the twenties. In 1925 they cooperated in the design of the bright and colorful covers for Apollinaire's *Sedící žena* (*La Femme Assise;* figure 5) and *Zavražděný básník* (*Le Poète Assassiné*), which move beyond the conception of Teige's earlier cover designs. Here Teige the constructivist had given way to Mrkvička's free style of painting. On the covers, drawn type predominates, as is characteristic for this period; machine type appears only after 1926, accentuated by cool orthogonal compositions of broken colors.

Teige dealt differently with lettering in the constructivist illustrations for Nezval's *Abeceda* (*Alphabet;* figures 6 and 7). "I tried to create a 'typophoto' of a purely abstract and poetic nature, setting into graphic poetry what Nezval set into verbal poetry in his verse." Both letters and images were "poems evoking the magic signs of the alphabet," commented Teige in "Moderní typo" (198). The combination of photographs of the dance creations of Milča Mayerová with letters made up of black-and-white geometrical surfaces is coolly artistic. These are not illustrations in the traditional sense of the word, for while they are an integral component of Nezval's quatrains, they could well exist quite independently of them.

In the illustrations to the poems of Konstantin Biebl's *Zlom* (*Break*) and *S lodí jež dováží čaj a kávu* (*With a Ship Importing Tea and Coffee*), Teige made use of the technique of typomontage (figures 8–11). He combined pink and yellow surfaces with black lines, letters, typographic symbols and signs, and occasionally even whole words, evoking a sense of distance and exoticism. He considered these collections as unified wholes, including the use of the colophon.

Their sober antithesis is the design for the covers and title pages of Proust's *Hledání ztraceného času* (*A la Recherche du Temps Perdu*), in which Teige used purely typographic devices to arrive at a mature and considered constructivist design, charac-

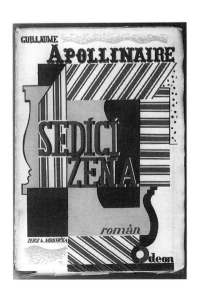

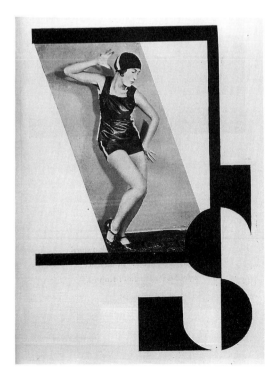

6. Karel Teige, illustration for Vítězslav Nezval's book *Abeceda* (Alphabet), showing the letter *G,* 1926. The Wolfsonian–Florida International University, Miami Beach, Florida.

7. Karel Teige, illustration for Nezval's *Abeceda,* showing the letter *S,* 1926. Wolfsonian-FIU, Miami Beach.

teristic of the end of the 1920s. Teige's carefully thought-out designs were also used for the design of the covers and typography of the three volumes of *ReD,* which became a leading European avant-garde review under his direction from 1927 to 1931.

At Odeon, Teige published the three-volume edition of *Mezinárodní soudobá architektura* (*International Contemporary Architecture*) and the two-volume set of studies *Svět, který se směje* (*A World of Laughter*), in 1928, and *Svět, který voní* (*A Perfumed World*) in May 1931 (with the date 1930 on the title page). The latter two covers clearly reveal a shift in Teige's typography: while the cover of the first volume codifies the photomontage compositions of the mid-1920s, including unmistakable elements from the era of poetism, the cover of the second is produced using rigorously typographic means. The lettering is set together in a block, accentuated by a frame and moved to the lower edge of the cover. This method, with its emphasis on the horizontal articulation of the surface at the expense of the vertical, along with the condensation of textual elements, is typical of Teige's work in the late twenties. The restrained use of typographic devices, which had liberally ruled the whole surface of the book cover constructions in preceding years, points toward the rigorousness of functionalism in the thirties.

The termination of *ReD* in 1931 closed one stage in the history of the Czech interwar avant-garde, the period of efforts by the generation of Devětsil to create a distinctive style in all areas of life and art. The new typography developed and, to a certain extent, exhausted the conceptions of constructivism, which was to transform itself into functionalism during the following decade.

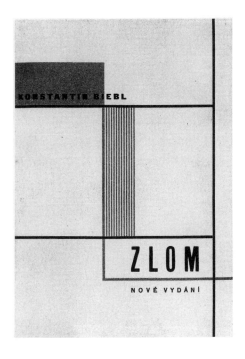

81

8. Karel Teige, cover for Konstantin Biebl's book *Zlom* (*The Break*) (Prague, 1928). ÚDU AVČR, Prague.

9(a)–(d). Karel Teige, four typographical illustrations for Biebl's *Zlom*. Black-and-white reproductions from original color illustrations. ÚDU AVČR, Prague. Photo by František Krejčí.

a.

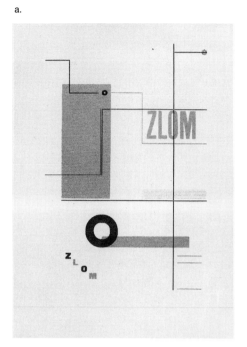

b.

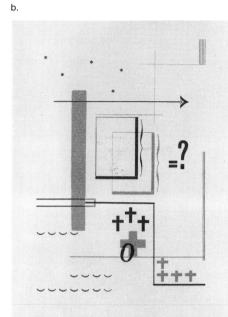

c.

d.

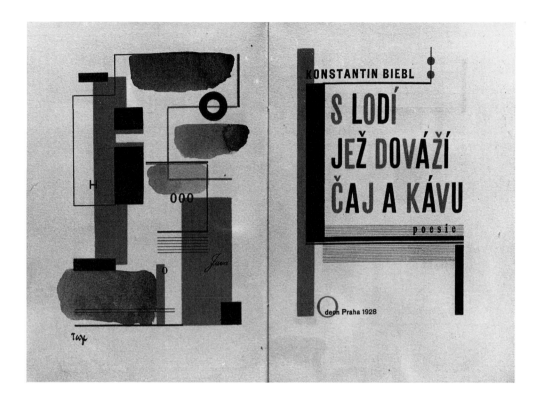

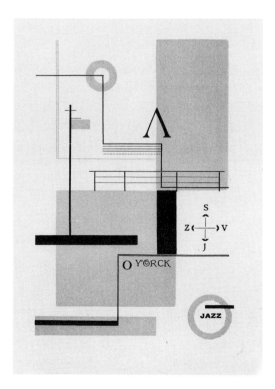

10. Karel Teige, frontispiece and title page of Konstantin Biebl's book *S lodí jež dováží čaj a kávu* (*With a Ship Importing Tea and Coffee*) (Prague, 1928). ÚDU AVČR, Prague. Photo by František Krejčí.

11. Karel Teige, typographical illustration of Biebl's *S lodí jež dováží čaj a kávu*. ÚDU AVČR, Prague. Photo by František Krejčí.

THE SURREALIST BOOK

From 1931, when Teige began to work as a freelance artist for the publishing house Fr. Borový, he designed about thirty book covers that suited both the typographic trends of the time and the ambitious editing policy of the publisher. The graphic appearance of the books published by Fr. Borový underwent fundamental changes at the start of the 1930s, when the publishing house was radically modernized. It was then that Julius Fürth, director of the Fr. Borový firm, engaged the painter and book illustrator František Muzika, along with other graphic artists, for a long-term collaboration. Teige's contribution to the graphic profile of the publishing house does not compare quantitatively with that of Muzika, but each of the two old Devětsil colleagues represented modern typography in his own way, translating the results of the avant-garde search for new forms into contemporary norms. At the start of the 1930s, Muzika had gained rich typographic experience as graphic director in an equally progressive Prague publishing house, called Aventinum. Like Teige, he was influenced at the beginning of his graphic career by the poetics of early Devětsil, and he gradually became known as an authority in book design. Throughout, he always concentrated on the fundamental element of book architecture, the type.[16]

Teige's book art of the thirties was actually overshadowed by that of František Muzika, and even more so by that of Ladislav Sutnar (figure 12). In particular, Sutnar's work

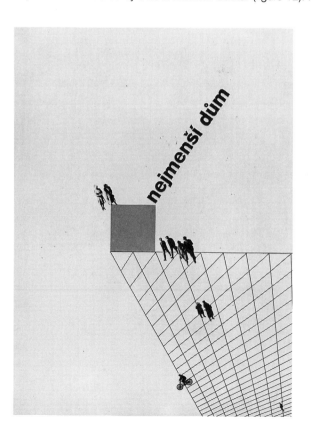

12. Ladislav Sutnar, cover for his book *Nejmenší dům* (*The Minimum House*) (Prague, 1931). ÚDU AVČR, Prague. Photo by František Krejčí.

for the publisher Družstevní práce marked out the direction to be followed by Czech functionalist typography, which he conceived of as a universal model for graphic design. Sutnar, who was not only a painter but also a graphic designer, industrial designer, and columnist, was active in Bohemia in a wide range of branches of applied art. (In the United States, where he emigrated in 1939, he worked mainly in the field of graphic design.) Teige had great respect for Sutnar, despite his very different aesthetic and ideological position, and gave an appreciative lecture on the occasion of Sutnar's exhibition in 1934.[17]

Teige's covers for the publisher Fr. Borový, with their simple photomontage composition and characteristic diagonal arrangement, tend to be reminiscences of the 1920s, such as he supplied for the volumes of the popular educational edition Knihy dalekých obzorů (Books of Distant Horizons). Teige also devoted much attention to the collection of eight volumes of poetry and novels by Vítězslav Nezval, published during the thirties at Fr. Borový. Each volume is arranged as an integral whole, conceived in detail, and designed in a unified style. In the photomontage covers from 1932 to 1934 — *Skleněný havelok* (*The Glass Havelock;* figure 13), *Zpáteční lístek* (*Return Ticket;* figure 14), and *Sbohem a šáteček* (*Goodbye and a Kerchief*) — there is a noticeable shift in his treatment of type.

13. Karel Teige, cover for Vítězslav Nezval's book *Skleněný havelok* (*The Glass Havelock*) (Prague, 1931). ÚDU AVČR, Prague.

14. Karel Teige, cover for Vítězslav Nezval's book *Zpáteční lístek* (*Return Ticket*) (Prague, 1933). ÚDU AVČR, Prague.

When we compare Teige's typography of the 1930s with that of other members of his generation, it becomes evident that much of the earlier avant-garde experimentation had by that time become part of routine graphic design. Teige, however, was already envisioning a new form of book, a new typographic expression, treating textual elements almost with the dynamism of an advertisement as his covers recall the striking arrangement of the large display windows of shops of his day on the streets of large towns. However, the force of Teige's typographical gestures does not reduce their legibility or the clarity of what is to be perceived and read, beginning with the first glance at a page or cover. It is only on deeper examination of the overall graphic solution that we uncover the visual framework that is hinted at. And only after the whole book is read can the hidden meanings of the optical poems of the new generation become clear. In composing these optical poems for book covers and collages, Teige did not have to resort to conventional narrative representation. His later optical poems became more serious and thus lost some of the immediate magic and appeal of the searching élan of his youth, the time of Devětsil.

The new edition of *Pantomima* in 1935 was an opportunity to confront the poetist verses of Nezval with the graphic structure of surrealism (figure 15). The new cover recalls distantly Štyrský's original of 1924. Its typographic design, almost sarcastic in its restraint, is, propitiously, enlivened inside the book by Teige's small-scale collages. As can be seen from his careful designs, the positioning of the individual collages was not left to chance. Teige paid exceptional attention to Nezval's books. Here we appear to meet with a new conception of the link between word and image. Teige's collages do

15. Karel Teige, cover for Vítěz-slav Nezval's book *Pantomima,* 2nd ed. (Prague, 1935). ÚDU AVČR, Prague.

16. Karel Teige, cover for Vítězslav Nezval's book *Žena v množném čísle* (*Woman in the Plural*) (Prague, 1936). ÚDU AVČR, Prague.

17. Karel Teige, title page and frontispiece for Nezval's *Žena v množném čísle.* ÚDU AVČR, Prague. Photo by František Krejčí.

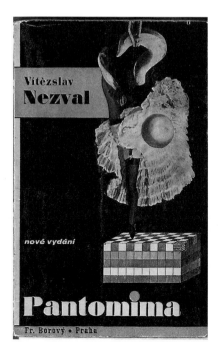

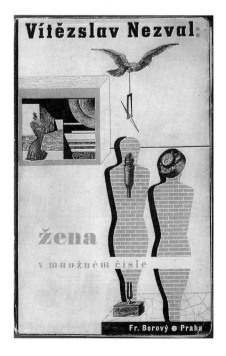

not play the role of illustrations only; they function, rather, as equally powerful poetic phenomena on their own behalf.

Neviditelná Moskva (*Invisible Moscow*) appeared in 1935. On its cover one can observe for the first time the motif of a closed space, containing a hidden secret, barely suggested. *Žena v množném čísle* (*Woman in the Plural;* figures 16–18) includes—also for the first time—a simple prism containing an image within (i.e., a collage), which appears in modified form in other Nezval collections as well. In both collections of his writings from 1936 (the second is *Praha s prsty deště* (*Prague with Fingers of Rain;* figures 19–21), and in the second edition of *Most* (*The Bridge,* 1937), Teige's collages are reproduced in the frontispiece, on the title page, and as independent illustrations. The small collages in the half-title, which are graphic depictions of the publisher's emblem or the author's initials, function as vignettes. The link between collages and text is again largely an expression of a loose relationship between content and typographical design, rather than a literal interpretation of the text. In his surrealistic motifs and their mutual interpenetrations—just as in their technique—Teige evokes Max Ernst's "surrealist comic," *Une semaine de bonté,* which first appeared in Paris in May 1934 in five volumes and a limited run of 828 copies.

The series of individualistic and equally excellent designs from the 1930s was completed by Teige's cover for the fourth edition of Nezval's *Básně noci* (*Poems of the Night;* figure 22). Teige's surrealistic orientation is also evidenced by the dark collage on the cover for three lectures by André Breton that appeared under the title *Co je surrealismus?* (*What Is Surrealism?*) in Brno in 1937.

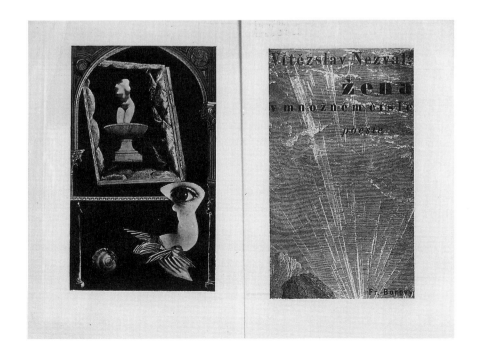

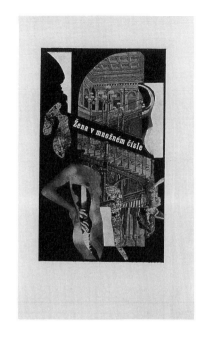

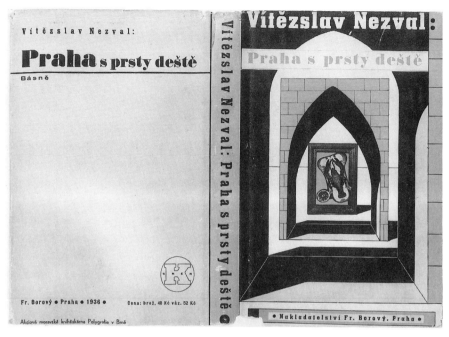

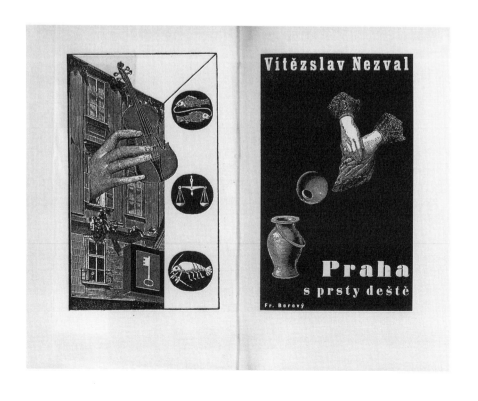

18. Karel Teige, illustration for Nezval's *Žena v množném čísle*. ÚDU AVČR, Prague.

19. Karel Teige, front and back covers for Vítězslav Nezval's book *Praha s prsty deště* (*Prague with Fingers of Rain*) (Prague, 1936). ÚDU AVČR, Prague.

20. Karel Teige, frontispiece and title page for Nezval's *Praha s prsty deště*. ÚDU AVČR, Prague. Photo by František Krejčí.

The remainder of Teige's typographic work points to an area of interest that occupied him most during the thirties, namely his cultural-political activities. These are revealed in a series of texts that he wrote himself or edited for the Knihovna Levé fronty (Library Series of the Left Front) editions. They are presented in sober, pure typographic designs without any specific graphic intention, conforming well to the character of cheap brochures for indigent lovers of reading.

A paradoxical epilogue to Teige's extensive book art can be found in several covers for the novels of Egon Hostovský and for *The Collected Works of F. X. Šalda,* produced between 1947 and 1963. Other works, mainly routine, were produced by Teige at that time in large quantities for the Prague publishing houses Melantrich and Brázda, which were also his main source of income during the last years of his life. These should by no means be overlooked; but they are also proof of a certain artistic resignation in this sphere of his life's work.

His accomplishments, which include his typographic work, were condemned to oblivion in the Communist Czechoslovakia of the fifties. While Šalda's writings continued to appear with Teige's designs, Teige's name no longer appeared in the colophon. That time seemed to wrest a new meaning from Teige's prophetic formulation of the previous decade: "Let us create products so precise and so adapted in all their func-

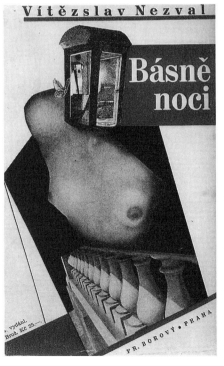

21. Karel Teige, illustration for Nezval's *Praha s prsty deště.* ÚDU AVČR, Prague.

22. Karel Teige, cover for Vítězslav Nezval's book *Básně noci* (*Poems of the Night*), 4th ed. (Prague, 1938). ÚDU AVČR, Prague.

tions to social utility that today, a day marked by the battle between reaction and progress, our work will be attacked by the reaction, defamed, mocked, and refused, only to become a self-evident part of cultural common property, only for our authorship to be lost and forgotten in its self-evidence." [18]

Typography was the territory in which Teige experimented and constantly tested his artistic potential. His extensive work on books is an inspiration for further iconographic analyses and interpretations. With its inner lyricism, it is a profoundly original contribution to European modernist typography.

Notes

1. Principal articles by Teige from this period: "Moderní typo," *Typografia* 34 (1927): 189–198, hereafter cited parenthetically in the text; "Moderní typografie" (Modern typography), *Rozpravy Aventina* 7, no. 3 (1931): 20; "Konstruktivistická typografie na cestě k nové formě knihy" (Constructivist typography on the way to new book design), *Typografia* 39 (1932): 41–44, 57–61; "O fotomontáži" (On photomontage), *Žijeme* 2 (1932–1932): 107–112, 173–178; "Fototypografie. Užití fotografie v moderní typografii" (Phototypography: The use of the photograph in modern typography), *Typografia* 40 (1933): 176–184; "Soumrak fotomontáže?" (The twilight of photomontage?), written under the pseudonym Karel Weiss, *Typografia* 41 (1934): 92–94.

 For a basic bibliography of studies of the typographic work of Karel Teige, see P. Bregantová, "Teigova koncepce knihy" (Teige's conception of the book), in *Karel Teige 1900–1951*, ed. Karel Srp, exhibition catalogue, Prague Municipal Gallery (Prague, 1994), 46. More recent studies are K. Passuth, "Meeting in Typography: Teige and Kassák," *Umění* 43 (1995): 66–73; K. Sierman, "La grafica al servizio dell' 'Utopia'" (Graphic design in the service of Utopia), in *Karel Teige, Architettura, Poesia, Praga 1900–1951,* ed. M. Castagnara Codeluppi (Milan, 1996), 63–72; Bregantová, "Poznámky k Teigeho typografii čtyřicátých let: korespondence s nakladateli" (Notes on Teige's typography in the 1940s: Correspondence with publishers), *Umění* 43˙(1995): 169–173.

2. K. Dyrynk, *Krásná kniha a její technická úprava* (Beautiful books and their graphic design) (Prague, 1909), 14.

3. F. X. Šalda, "Kniha jako umělecké dílo," *Typografia* 16 (1905): 5–7.

4. V. Effenberger, *K dějinám knižní architektury. Teige — grafik* (Toward a history of book architecture: Teige — Graphic artist), *Knižní kultura* 1 (1964): 78. For the lecture, see F. X. Šalda, "Nová krása: její genese a charakter," *Volné směry* 7 (1903): 169–178, 181–190.

5. The painter and book illustrator František Muzika, Teige's colleague from Devětsil, even considered that the rehabilitation of the types of the nineteenth century remained the main and permanent principle of typographic constructivism. See Muzika, *Krásné písmo ve vývoji latinky* (Beautiful type in the development of roman characters) (Prague, 1963), 476.

6. See H. Bayer, "Pokus o nové písmo" (An attempt at a new type), *Typografia* 34 (1927): 42–43.

7. Karel Teige, "Návrh reformy Bayerova písma" (A proposal for the reform of Bayer's typeface), *ReD* 2 (1928–1929): 257. See also Teige, "A + a = a. K článku J. Tschicholda" (A + a = a: On an article of J. Tschichold), *ReD* 3 (1929–1931): 113–114; Teige, "Vyřadit velká písmena?" (Away with capital letters?), *Levá fronta* 1, no. 1 (1930): 4; no. 2, 4–5; no. 3, 4–5.

8. A detailed account of the significance of the circle in typography in the twenties can be found in K. Srp, "Obraz a slovo. Karel Teige a ikonografie Devětsilu" (Image and word: Karel Teige and the iconography of Devětsil), *Ateliér* 6, no. 8 (15 April 1993): 2.

9. Lissitzky's eight commandments, published in 1923 in the work "Topographie der Typographie" (The topography of typography), *Merz* 2, no. 4 (1923); n.p. were to be the motto of his study "Kniha z hlediska zrakového vjemu. Kniha vizuální" (The book from the point of view of visual perception: The visual book), *Typografia* 36 (1929): 173–180.

10. Teige, "Konstruktivistická typografie," 61.

11. O. Mrkvička, "Kniha a plakát" (Book and poster), *Život* 8 (1929): 84–87.

12. A. Černík, "Konstruktivistická typografie" (Constructivist typography), *Typografia* 33 (1926): 275–278.

13. V. O. [Vít Obrtel], "Obálková terminologie" (Book cover terminology), *Plán* 1 (1929–1930): 126.

14. V. Obrtel, "Informace nebo iniciativa?" (Information or initiative?), *Rok. Kulturní leták* (The Year: A Cultural Pamphlet), October 1931, 4. Obrtel's remarkable architectural, typographic, and poetic work is collected primarily in his *Vlaštovka, která má geometrické hnízdo. Projekty a texty* (A swallow in a geometrical nest: Projects and texts), ed. R. Švácha and R. Matys (Prague, 1985), and in the exhibition catalogue *Vít Obrtel (1901–1988). Architektura, typografie, nábytek* (Vít Obrtel [1901–1988]: Architecture, typography, furniture), ed. R. Švácha (Prague, 1992).

15. See F. Šmejkal, "Český konstruktivismus" (Czech constructivism), *Umění* 30 (1982): 226.

16. For a more detailed account of František Muzika's book design, see P. Bregantová, "Knižní výtvarníci fy Borový" (Book artists of the publishing house Borový), in the exhibition catalogue *Topičův dům. Nakladatelské příběhy 1883–1949* (The House of Topič: Stories of the publishing house, 1883–1949) (Prague, 1993), 26–32. The book illustrations of František Muzika are covered by F. Šmejkal in *František Muzika. Kresby, scénická a knižní tvorba* (František Muzika: Drawings and works for stage and book) (Prague, 1984), 149–208.

17. Karel Teige, "Ladislav Sutnar a nová typografie" (Ladislav Sutnar and the new typography), *Panorama* 12, no. 1 (1934): 11–16.

18. Ibid., 13.

MODERN TYPOGRAPHY

/ 6

Karel Teige
(Translated by Alexandra Büchler)

Note: Widely spaced passages represent emphasis in the original.

Originally published as "Moderní typo" in *Typografia* 34 (1927): 189–198.

Modern typographic methods, described and labeled as "constructivist" — that is, methods that apply constructivist concepts in the area of typography and book production — have taken root in our country over the past few years. Spontaneous demand for "constructivist" graphic design is becoming more and more common, and customers ask printers to use it especially in the case of commercial and advertising material, such as posters, leaflets, brochures, catalogues, letterheads, and press advertising. They can see that constructivist design makes their promotional material clear, easy to read, noticeable, and effective, thus fulfilling its commercial function. Constructivist book design is becoming just as popular, and the modern Czech book industry boasts a remarkable number of interesting contemporary realizations, not just on book covers, title pages, and colophons but in the entire layout and typographic arrangement of the text. There are a number of books that, as a whole, represent a truly new form of book design. As printers can observe, constructivism is today a significant movement, which in any case deserves close attention. It is therefore necessary to grasp the essence and principles of this movement precisely and correctly, to be able to avoid the errors, mistakes, imitations, and other examples of quasi-constructivist design, which are becoming alarmingly widespread due to several eclectic epigons, who apply certain modern forms and methods in a superficial and meaningless manner, with no rhyme and reason and without any justification. With this unreasonable approach, they threaten to compromise the serious and revitalizing efforts of true constructivism. What we need today, above all, is the application of strict criteria to distinguish true, pure constructivism from the decorative, formalistic pseudo-constructivism that borrows forms from constructivist artworks, using them irrationally, unfunctionally — that is, decoratively. There is a need for accurate criticism capable of distinguishing the correct and the pure from the inadequate and false, and able to tell something intrinsically modern from what appears to be so only on the surface.

Constructivist typography and graphic arts are in many ways contrary to the ideals and rules of that modern typography whose father is William Morris. The English Pre-Raphaelites, led by their apostles J o h n R u s k i n and W i l l i a m M o r r i s, began to preach the return to handcraft production at a time when crafts were experiencing a serious decline or disappearing altogether, which was also a time of the most serious decline of taste and aesthetic sense. This was caused by the introduction of machine production at the beginning of the Industrial Revolution, which brought about

a substantial drop in production quality as machines provided consumers with cheap but deeply unattractive and inferior goods that were a bad imitation of crafted objects. The aim of the Arts and Crafts movement, and above all their apostles J o h n R u s - k i n and W i l l i a m M o r r i s, was to renew medieval artisanship, to elevate crafts to the sphere of artistic creation on the one hand, and on the other — by joining art with craftsmanship and artisan work — to give artistic creation a certain social justification. Today it is a widely known fact that such an idealistic and admirable endeavor was an error and a fallacy, that it was foolish to try to stand in the way of industrial production, which was bound to win, having reached an advanced stage in which standardization, economic and rationalized planned serial mass-production, can offer products that are cheaper, but also more functional and technically and aesthetically more perfect, than handcrafted products. The most masterly work of a wheeler or a saddler cannot compete in perfection and in its practical and aesthetic qualities with the elegance of modern automobiles.

Yet the attempt to popularize art by joining it with crafts had a paradoxical outcome: the application of artistic criteria to craft production of objects of daily use resulted not in the popularization of art but in making craft objects more aristocratic and costly. Modern architects were faced with the urgent duty to reject Ruskin's aesthetic errors and fallacies relating to architecture and interior design. Today's constructivist architects pay no heed to the problematic achievements of the past decades of decorativism and "art-and-craftism."

What has happened in the area of arts and crafts applies also to typography. The decline of typography in the nineteenth century was just as tragic as the decline of the crafts. When Morris appeared with the seductive and worthy slogan of revival, the English Arts and Crafts movement found itself at the beginnings of a renaissance of book printing. Ruskin, Walter Crane, and William Morris founded a printing workshop where they created their beautiful books. For them, however, a beautiful book meant a return to the Middle Ages, an ideal they set against monotonous, grey, badly articulated and designed typography, which tired the reader's eye, its narrow margins making the characters appear not as a black drawing on white — with the black highlighted, reflected, and relieved against the white background — but rather as white tissue emerging from a black sea, where the spaces clashed with the reading eye and dominated the grisaille of the background and against a print whose excessively economic production

did nothing for the reader's eye or for his taste. Against all this Morris wanted to achieve a return to medieval typographic work. He followed the example of incunabula with their sharp contrast of form and color, and his printed works came close to medieval missals in their appearance. To achieve that, Morris traced and modified old types, arriving at fantastic Gothic and fashionable Roman type designs. His typographic work was then further developed by art nouveau, the so-called free style that resulted in the most extravagant typographic design executed with no regard for the tectonic aspect of the book.

Thus the modern renaissance of typographic culture was threatened at its very beginnings by two dangers: the d a n g e r o f a r c h a i s m and the d a n g e r o f art nouveau's eccentric, illogical, f a n t a s t i c , a n d w i l l f u l d e c o r a - t i v e m a n i a . We witness both these fallacies at the beginnings of the movement, which aimed to create modern Czech fine books; on the one hand, there was the art nouveau extravagance of the circle around the *Moderní revue* (*Modern Review*), promoted by Arnošt Procházka, and on the other, the archaic design of Vilém Mrštík's *Pohádka máje* (*Fairy Tale of May*) by Zdenka Braunerová. Modified by the passage of time, these dangers are still present today; the temptation of archaism or pseudo-classicist academism and the temptation of illogical pseudo-modern decorativism threaten the most recent typographic work. The idle fashions emerging from the schools of decorative arts are to be blamed. And there is a third danger: the danger of excessive bibliophilia and collectors' snobbism. The movement, seeking to renew the tradition of fine book typography, was supported by sympathetic book lovers and collectors who were certainly able to give it substantial backing. But the collecting mania, chasing after unique prints, s t o o d i n t h e w a y o f a p o p u l a r i z a - t i o n o f f i n e b o o k d e s i g n , supporting everything that gave the book an exclusive and luxury character, usually expressed by excessive decorativeness. Constructivist typography must therefore avoid these three stumbling blocks that have so far hindered the development of modern book design.

And this is precisely what can be criticized about Morris's work: its archaism and arbitrary imagination, the way he modified old types according to his fantasy. Today we are convinced that it would have been better if he had modified his imagination, adjusting it to the possibilities of the most perfect old types, selected with a critical, careful eye and deliberation. T h e r e i s n o r e a s o n w h y a b e a u t i -

ful form that has been widely used and suits our
needs should be changed, if it is objectively impossible to improve on
it. It is wickedly uneconomical to change the shape of furniture to suit changing fash-
ion: any change that does not bring an objective and essential perfection should be
avoided. A perfect shape remains changeless for centuries. That is why Peignot Jr. has
made such a substantial contribution to new typography by recasting old, almost per-
fect types, such as Garamond, Plantin, Elzévir, Didot, or Nicholas Cochin. After Morris,
art nouveau artists and architects inclined toward the Arts and Crafts movement de-
signed new types that could not compete with classic ones as to their shape and legi-
bility; these were design fantasies that have by now lost their charm. We can find
stocks of such fantastic art nouveau types or fakes that deform and distort classical al-
phabets in every printing workshop: Viennese Grotesque, Colibri, Bernhard Antique,
Medieval, Gensch, Behrens, Tieman, Ehmke, Linear Antique, Watteau, Perkeo, Lo, Her-
old, etc. They are unattractively designed types, at odds with contemporary cultivated
taste, types that are on their way out. On the other hand, there is no satisfactory selec-
tion of suitable, perfect types. The decorative Arts and Crafts types have excluded
themselves from the development of typography: after all, for centuries, true develop-
ment and progress has moved toward a simple, clearly legible geometric form. From
the capricious flowers of Gutenberg's Fraktur, which had been already simplified, stan-
dardized, schematized, and horizontally extended by Dürer to make it more legible and
optically connective, typography further developed toward Plantin's types, and from
there to Didot, who turned Plantin's regularity into clear, attractively curvaceous lines.
There were many reasons why Gothic and Fraktur letter forms had to fall; among other
things, they were essentially ornamental and bizarre, and their peculiar character sim-
ply had to give way to Didot's clear form of architectural beauty.

Today, from a chaotic variety of types, we select those that are perfectly con-
structed. During wartime requisitioning of metal, printers gave up their stocks of the
most beautiful old but worn types and kept their questionable treasures, the fashion-
able, far from beautiful, mostly German-manufactured types. Yet modern typography
requires beautiful, austere, simple, lapidary, and well-balanced types of geometric con-
struction, free of any superfluous appendages, hooks, and curlicues. Some classic
types possess truly majestic proportions and harmony worthy of the Parthenon, or of
the work of Ingrés or Beethoven. We understand that such perfectly constructed types

are something we have no right to change without careful thought, something we are only allowed to perfect further. The ultimate question of critical conscience is how perfection could be further perfected.

The first task of modern typography is to r e v i s e a v a i l a b l e t y p e s and s e l e c t o n e s t h a t a r e s u i t a b l e a n d p r o p e r l y d e - l i n e a t e d. Types must then be c h o s e n t o s u i t t h e t y p e s e t t e x t, to achieve a c o r r e s p o n d e n c e b e t w e e n t h e c h a r a c t e r o f t h e t y p e a n d t e x t, so that the printed form would be the result of its function and contents. Every type has its character, a living, active personality, an accent that may be difficult to define but is easy to understand, as in spoken language. The light, supple, rhythmical curves of italic scripts are like something improvised, soft, and lyrical next to the austere, monumental Grotesque, Egyptienne, or Empire types that signify architectural weight and static calm. We could speak of a sense of the magic of form as developed throughout centuries of education. Therein resides the very meaning of typographic intuition and clarity of vision. For us, certain curves, balances, and structures bear an almost esoteric significance. Some typographic shapes have an evocative, associative power: we know that a single strong typographic sign can contain the whole message of a particular poster.

It was advertising typography and its advancement that made the e f f e c t i v e - n e s s o f o p t i c a l r e l a t i o n s h i p s b e t w e e n v a r i o u s t y p e s t y l e s clear to us. Advertising typography, subjected to the dictate of its purpose, determined by industry, ignored aesthetic as well as "calligraphic" academic or decorative prejudice. It simply served the elementary requirement of promotional functionalism, seeking out types legible at a distance, simple in their geometric protoform, such as Egyptian (an army design from the time of Napoleon I) and Grotesque, as well as Empire and Second Empire types. Advertising typography was also enriched by several kinds of stencil lettering, which was increasingly simplified and composed of geometrical archetypes — the square, triangle, and circle — from which the connecting lines had disappeared, with the mass of the characters arranged next to each other without being connected but still remaining clear. Apart from that, advertising typography and posters utilized c o n t r a s t s o f l i g h t (black and white) and c o l o r i n t h e o p t i c a l a r t i c u l a t i o n o f s p a c e. Typographic-synoptic layout was thus cultivated not so much in book printing but rather in advertising and occa-

sional printed matter. Grey lettering had been turned into a colorful symphony full of contrasts. Typography has ceased to be a mere auxiliary mediator, a joining link between the contents and the reader; it is no longer an interpretation and reproduction but an independent construction, precisely by virtue of its ability to grasp the optical significance of typographic shape, size, color, and composition. It does not interpret or reproduce the given text but constructs it optically, using it as a basis for the creation of a visual composition. To this aim it u s e s f r e e l y a l l t y p e s , s i z e s , d e - g r e e s , g e o m e t r i c a l s h a p e s , a n d b a s i c c o l o r s , achieving elasticity, variability, and freshness of the typeset text. Besides, advertising has created a p e r f e c t c o m b i n a t i o n o f t y p o g r a p h y a n d p h o t o g r a - p h y , producing what Moholy-Nagy calls t y p o f o t o . Typo: communication by means of the printed word. Foto: communication by means of the image of what is visually comprehensible. Typofoto: visually most exact and complete communication.

Posters and even neon advertising use all possible techniques — contrasting shapes and colors, creating a synoptical typography that is not satisfied merely with conveying the content but creates its own visual message. In the case of advertising and commercial typography working with synoptic forms and compositions, it became clear t h a t t h e b l a n k s p a c e h a s i t s o w n s t r o n g a e s - t h e t i c v a l u e , which functions in relation to the printed areas, that it is an active factor, not only a neutral background, just as modern architects and sculptors understood that empty spaces and openings — for example, windows — are not just passive gaps but active plastic agents, and that only through a careful balancing of these equivalent positive and negative values can one achieve the required equilibrium. Advertising, the visiting card and signature of business, has become concerned with making the right impression. It wanted to surprise with the novelty and intensity of proportions as well as with visual composition. It used, without prejudice, all the available modern means, inventions, and possibilities of communication. It used typography that was not mere reproduction and illustration but an autonomous visual realization of the text. In most cases it could do without any decorative ballast or fashionable gimmicks. Where it reached for an image, it preferred using photography and photomechanical images to drawings, woodcuts, etc. It preferred simple, impersonal types that find better application than unusual, original "artistic" scripts with all the bad characteristics of illegible handwriting. It preferred to utilize existing types rather than have individual lettering custom-made for the purpose.

Advertising and industrial typography for posters and brochures worked its way to clean shapes that were the r e s u l t o f a p e r f e c t l y f u l f i l l e d f u n c - t i o n; that is, their form was j u s t i f i e d a n d f u n c t i o n a l. It did not let itself be misguided by the prejudice of tradition and by academic and decorative aesthetic sensibilities. Modern book typography can learn a useful lesson from it. Sometimes, of course, even advertising typography succumbed to the decorative vogue of the time and its promotional function was sacrificed to aesthetic demands.

Modern typography, having learned a lesson from the achievements of promotional and advertising design, must free itself from artistic, decorative, and academic prejudice. It must not be afraid to defy the ideals of snobbish bibliophiles. We do not want rare books; what we demand is that the modern book become a perfect work of typography available at an accessible price. Many applied art fantasies of the last decade were at our expense, making the book more costly and trying our patient eyesight. Today we know that reading badly written books is not half as damaging as reading books that are badly designed. The first is a waste of time, the second wastes our eyesight. Nearsightedness is a damning verdict on bad typography and the only people it benefits are opticians who get rich on it. The issue is not to treat nearsightedness, but to prevent it. Not small type but bad typography, unsuitable composition, and type forms with all manner of curlicues have a detrimental effect on eyesight. That is why the very first requirement for modern typography is order, good work, and legibility. That is nothing new, yet this simple requirement is often not heeded.

Typography is visual communication. Its rules must therefore be based on optical rules. The modern way of seeing, educated by urban civilization and by the spectacle of contemporary life, new color spectra and strong colors ordered geometrically and orthogonally, is characterized by heightened perceptiveness. The angle of vision is widening. Posters achieve s i m u l t a n e o u s c o m m u n i c a t i o n b y m e a n s o f a s u i t a b l e l a y o u t o f t h e i r s u r f a c e and the use of v a r - i e d t y p e that makes it possible to r e g u l a t e c o h e r e n t r e a d i n g. The modern way of seeing is sophisticated, capable of rapid accommodation, penetrating, fast on its feet. We need to realize that today's books are read by eyes differently organized and trained than those that used to read incunabula. And these eyes demand that the book be constructed not according to decorative fashion but as an a r t i c u l a t e d, r h y t h m i c a l, c o m p r e h e n s i v e v i s u a l s y s t e m,

100

e a s y t o o r i e n t o n e s e l f i n, in the same way a letter sorter, the keyboard of a piano, typewriter, or calculator, catalogues, price lists, and transport schedules are perfect visual systems.

We need to adjust the unchangeable or little-changing laws governing our ways of seeing, perceiving, and reading to the demands of a modern trained eye. We need to try out the possibilities of modern typography without the fallacies of archaism and decorativism, and to subject its products to visual justifications and requirements. To use all the suitable types, s y m b o l s, l i n e s, a r r o w s, a n d s o o n not as fashionable ornaments but as e l e m e n t s a r r a n g e d i n a c o m p o s i - t i o n t o a c h i e v e a g r e a t e r v i s u a l c l a r i t y a n d l e g i b i l i t y.

From the elementary laws of optics we can learn about book formats and their standardization, about the layout of the page and the proportions of text in relation to the margins, about the balance between black and white, the mutual influence of colors and their complementary and spatial effects. Modern painting can offer typography, which is after all also a visual discipline, significant lessons. It is the so-called objectless and abstract painting that has abandoned any imitation of the subject and wants to be nothing but a balance, a harmony of colors and shapes, mostly geometrical, on the plane of the canvas, something like a music of colors—painting that realizes its balance and harmony according to optical laws and laws governing the interrelationship of colors and shapes, and, having discovered the possibilities of decimal balance, as I would call it, has, as a result of multiple forces, found other forms of equilibrium than symmetry, multifaceted and active. The abstract beauty of modern painting achieved as a result of much experimentation is akin to balance on extremely sensitive scales, where it is necessary to administer color and shape values in doses proportional to their quality and quantity, and where the slightest change would upset the equilibrium achieved. Modern abstract painting deals with its material (color) and its spatial arrangement in a manner as elementary as the way in which a technician or a mechanic works with his own material, dealing with it according to its factual, scientifically tested qualities, according to the physical and psychological laws of color and its appearance, its physical, physiological, and optical qualities that are unconditional, objective, and constant. The composition of colors and shapes in a modern painting is governed by objective (unfortunately as yet only superficially explored) laws. It is possible to realize

101

color harmony only in accordance with these laws, which are as binding as the laws of chess. And just as the laws of chess do not exclude imagination, invention, and originality, just as there are an infinite number of possible moves in chess, these o p t i - c a l l a w s u s e d i n t h e c o n s t r u c t i o n o f t h e p i c t u r e p l a c e n o l i m i t a t i o n s o n t h e l i v e l i e s t i m a g i n a t i o n , i n - t u i t i v e i d e a s , i n v e n t i o n , a n d o r i g i n a l i t y , allowing for an infinite number of the most diverse solutions. On the contrary, an imagination that obeys such laws becomes more flexible and cultivated, avoiding many errors. Such laws are not manacles but regulators.

What has been said about modern abstract painting applies, of course, in full to modern typography, as balance on canvas is the same in its nature as balance on the printed page. The same proportions and geometrical composition, the same contrast of black and white, and the same relationships of colors. And the same need for clarity of arrangement, for legibility. Even the influence of modern literature, especially of modern poetry, on typography needs to be mentioned here, although there is no space to explain it in detail. We shall therefore mention only the most significant facts. Mallarmé simplified the laws of the poetic, written word, creating poems of precise lines and crystal-clear graphic arrangement, and abolishing punctuation. In his book *Un coup de dés jamais n'abolira le hasard* he used a special typographic layout. Marinetti, in his *Parole in libertà,* arrives at a true typographic revolution. He demands that as an expression of modern spirit the book should break traditional typographic harmony — that is, the monotony and symmetry that are at odds with the ebb and flow of the poetic text rippling on the page. He demands the use of a variety of colors and types, the selection of which, as in the case of posters, should be dictated by legibility, coherence, and simultaneity of visual perception — that is, by the aims intended by the poet. G u i l - l a u m e A p o l l i n a i r e realizes that modern poetry is no longer Verlaine's "music above all," that it is read, perceived visually and not aurally, and therefore is an optical entity. He takes this visual aspect of poetry even further, composing his poems in special patterns, called "ideograms." Later, some Czech poets such as the proponents of "p o e t i s m," Seifert and Nezval, take the visualization of poetry even further, creating visual poems in which image and poem merge by means of photography, photomontage, or typography.

102

Modern book typography is also influenced by language reforms and changes in spoken and written language brought about by the impact of literary works, as well as by the interaction of foreign languages. Modern times need an international language of communication, and along with it an i n t e r n a t i o n a l, g e n e r a l l y a c - c e p t e d l e t t e r f o r m a t. The German Gothic script has disappeared and so will, sooner or later, the Russian, Greek, Chinese, and Turkish scripts, causing, of course, certain structural changes in the relevant languages. At the same time our own alphabet will have to be revised: there is a remote but certain movement toward the construction of a communication alphabet based on a different principle, which would correspond better to the structure of words, as has been suggested by Moholy-Nagy in his article "Zeitgemässe Typographie" ("Contemporary Typography"). But these changes are still far away. Industrial economy with its slogan "time is money" demands the introduction of a universal phonetic alphabet. As it will not be sufficient to eliminate our capital letters to achieve this aim, some typographers, such as H. Bayer, have been trying to create a u n i v e r s a l d e s i g n w i t h o u t c a p i t a l s a n d l o w e r c a s e s e r i f s a n d m i n u s c u l i. Let us mention here that the anthology *Fronta* is the first significant publication printed consistently without capitals. Bayer's type, used by the author of this essay several times for book cover design, will have to be further refined, but it is already a justified new form aiming to perfect type in the sense of desirable simplification. Progressive simplification is the meaning of long-term development. Discarding ornaments. Simplifying the range of characters. Several centuries ago, French typography used 250 symbols, while today it uses 150 and these are still too many. A typesetting machine with a complicated keyboard is a monster.

Let us reiterate what constructivist typography means and presupposes:

1. L i b e r a t i o n f r o m t r a d i t i o n a n d p r e j u d i c e : o v e r c o m i n g a r c h a i s m a n d a c a d e m i c i s m, e l i m i n a t i n g a l l d e c o r a t i v - i s m. Ignoring academic and traditional rules that are not optically justified, being mere fossilized formulas (e.g., the golden section, unity of type).

2. S e l e c t i o n o f t y p e s w i t h c l e a r l y l e g i b l e, g e o m e t r i c a l l y s i m p l e l i n e s : understanding the spirit of each type and using them according to the nature of the text, contrasting the typographic material to emphasize the contents.

3. The perfect grasp of the p u r p o s e a n d f u l f i l l i n g t h e b r i e f . D i f f e r - e n t i a t i n g b e t w e e n t h e p u r p o s e o f e a c h t y p o g r a p h i c t a s k . Advertising billboards, which should be visible from a distance, have different requirements than those of a scientific book, which are again different from those of poetry.

4. Harmonious b a l a n c i n g o f s p a c e a n d a r r a n g e m e n t o f t y p e a c c o r d i n g t o o b j e c t i v e o p t i c a l l a w s ; c l e a r , l e g i b l e l a y - o u t a n d g e o m e t r i c a l o r g a n i z a t i o n .

5. Utilization of all possibilities offered by new technological discoveries (linotype, emulsion print, photo typesetting), c o m b i n i n g i m a g e a n d p r i n t i n t o "t y p o f o t o ."

6. C l o s e c o l l a b o r a t i o n b e t w e e n t h e g r a p h i c d e s i g n e r a n d p r i n t e r in the same way it is necessary for the architect to collaborate with the building engineer, the developer, and all those who participate in the realization of a building; s p e c i a l i z a t i o n a n d d i v i s i o n o f l a b o r combined with the c l o s - e s t c o n t a c t among the various experts.

Finally, I would like to add several comments on my own practice in the area of "polygraphy" (as it is called in Russia) or book design, examples of which are published in this issue. I see the book cover, which I design usually in collaboration with O. Mrkvička, as the p o s t e r f o r a b o o k ; and, as any publisher will confirm, that is its true commercial purpose. It is therefore desirable for the cover to make a strong impact. This will be achieved by an e n e r g e t i c a n d a c t i v e e v o c a - t i o n o f a b a l a n c e b e t w e e n c o l o r a n d f o r m ; the requirement of strong impact eliminates monotonous symmetry. For the strongest impact of this desirable effective balance on a poster, I usually favor b a s i c c o l o r s and g e o m e t r i c a l s h a p e s , as I believe that o r t h o g o n a l f o r m s are best suited to balancing an orthogonal plane: the square and the oblong, with the circle offering itself as the shape most pleasing to the eye. For realization I choose all the *photomechanical media* fitting the particular task: block making, halftone, gravure, photolithography, photomontage. In recent years linocut book covers have become very fashionable. But linoleum is suitable for floor covering, not for graphic design, where its lack of line precision presents a problem; it is simply a poor substitute that should be rejected today when, ten years after the war, zinc plates are no longer unaffordable. The

modern taste will naturally prefer the photomechanical process to linocut or woodcut, which, with their lack of precision and handcrafted character, do not correspond to the nature of books, which are also not handwritten but mechanically printed. Our distrust of woodcut or linocut on book covers is borne out by the ugliness of their formal treatment, leading to sketchiness and decorativism, and by the illegibility of the hand-cut letters. Instead of flowers and curlicues cut in lino we have to demand a harmonious, clean, and strictly immaculate design with the legibility and effectiveness of a poster. The same applies to the t i t l e p a g e, which also acts as a p o s t e r f o r t h e b o o k. Its visual structure and composition, the selection of type and colors, should become a v i s u a l t r a n s c r i p t o f t h e b o o k ' s l i t e r a r y c o n t e n t. The colophon, bibliographically the most important page, should be a detailed identity certificate and therefore requires w e l l - a r r a n g e d r u b r i c s. Any ornaments, stars, or crosses, typeset or drawn, are out of the question here. The page is arranged by composing the type, and this composition can be emphasized by strong lines, arrows, basic geometrical shapes, or a suitable contrast of colors. T h e t y p o g r a p h i c r e a l i z a t i o n o f t h e t e x t is conditioned by the nature, rhythm, and flow of the text itself. In the design of Nezval's *Pantomima* (*Pantomime*) of 1924, and Seifert's collection of poems *Na vlnách TSF* (*On the Waves of the Telegraph*) of 1925, it was important for the typography to complete the poetic process and transpose the poems into the visual sphere.[1] In Nezval's *Abeceda* (*The Alphabet*), a cycle of poems based on the shapes of letters, I tried to create a "typofoto" of a purely abstract and poetic nature, setting into graphic poetry what Nezval set into verbal poetry in his verse, both being poems evoking the magic signs of the alphabet.

In selecting type I am often limited by the stocks held at the particular printing plant the publishers ask me to work with, and often forced to accept ones that are not entirely suitable, especially when my task is to create typography for poetic texts, which require a complicated visual image and a rich typesetting material full of contrasts. For advertising and commercial typography, the best types are simple but strong versions of Grotesque combined with thick lines, which emphasize the plasticity of the typeset text.

Note

1. *Na vlnách TSF* is translated here literally as *On the Waves of the Telegraph*. Actually the term *TSF* includes radio and, more generally, wireless technology. *Ed.*

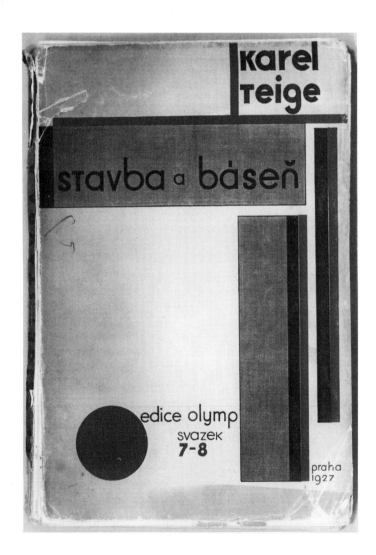

BEFORE AND AFTER THE MUNDANEUM: KAREL TEIGE AS THEORETICIAN OF THE ARCHITECTURAL AVANT-GARDE

Rostislav Švácha

(Translated by Alexandra Büchler)

KAREL TEIGE AND ARCHITECTURE

Karel Teige became an internationally known member of the Czech architectural avant-garde primarily as a consequence of his polemic over Le Corbusier's Mundaneum project, which was widely publicized between 1929 and 1931 and again by George Baird in 1974.[1] Accordingly, Teige did not become known as a practicing architect—something he never really was—but as a theoretician and critic of architecture, as a thinker, playing as crucial a role in the development of the Czech avant-garde as did Adolf Behne in the German scene, and Sigfried Giedion in the intellectual development of the Swiss and European avant-garde in general. Karel Teige's role in the Czech context consisted of formulating a program that he followed to the letter, insisting that others do the same. Any deviation from the set direction was rejected without second thought. Apart from his dogmatic stance, it was also his aim to make sure that the Czech avant-garde kept abreast with the international scene, not so much in providing architectural form with the attributes of a modern style (which Teige considered to be secondary almost from the beginning), but in serving as a means of achieving immediate social and political goals. In Teige's Marxist view, social and political development would inevitably lead to socialism and eventually to communism.

In promoting his program, Karel Teige often became embroiled in heated polemics, even with architects who wished to be equally modern and progressive. By and large, at least in the twenties and early thirties, he behaved as a blind doctrinaire, but occasionally he was willing and capable of adjusting his views and hypotheses when he recognized that they were not supported by everyday reality. Some of Teige's errors—above all, his unlimited confidence in the standardization and industrialization of construction processes—regrettably survived his era and continued to exert a negative influence on the architecture of socialist Czechoslovakia in the period between 1948 and 1989.[2] It is principally for this reason that Czech historians of modern architecture today approach Teige's ideological legacy with suspicion, and those politically inclined to the right dismiss his contribution altogether. However, viewed from a more objective and tolerant standpoint, the transparent logic and distinctive poetic charm of his arguments have lost nothing of their power even in our day.

Until the summer of 1922, architecture was peripheral to Karel Teige's activities. In the texts written between 1919 and 1922, he occasionally mentioned Czech cubist architectural projects (figure 1)—in particular the work of Vlastislav Hofman—which he

came to view later with less and less sympathy, finding them as dated as he found the whole cubist movement started by Picasso.[3] Together with his friends from the Devětsil group, Teige was developing the concept of a "new proletarian art . . . a kind of social-ist Gothic," which would have artists cast off the elitist conceit they had hitherto em-braced and humbly come down to the level of everyday life; it was an art that would evoke in all people a sense of brotherhood and love for ordinary things.[4]

It appears plausible that Teige's future interest in architecture was foreshadowed by some kind of biblical vision of "building the world," based on Christian symbolism that had appeared in texts and images by the first members of Devětsil.[5] His later inter-est in Le Corbusier's purism also indicated a positive attitude toward the qualities of structurality, objectivity, plasticity, and constructivity, which he found in the poetry of Jules Romains, in the prose of Charles-Louis Philippe, and in the magical realism of Henri Rousseau's paintings. It may be conjectured that Teige embraced the view ex-pressed in the writings of the art critic F. X. Šalda, from whose book *Boje o zítřek* (*Battles for Tomorrow,* 1905) he later often quoted, that the raw reality of modern life is of a more fundamental value than any artistic movement, including the most modern ones.[6] His dislike for anything that appeared to be haughty, conceited, lordly — that is, "monumental," as Teige would later describe it — was strongly reminiscent of the cri-tique of the aristocratic principle formulated at the end of the nineteenth century in the interest of a further development of democracy by the philosopher and first president of the Czechoslovak Republic T. G. Masaryk (1850–1937). Masaryk, however, would

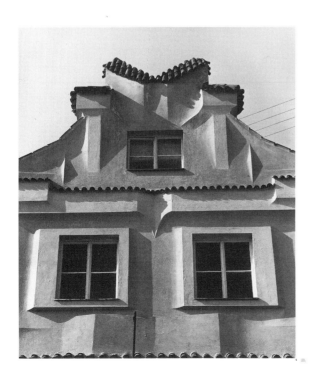

1. Pavel Janák, reconstruction of the Fára House in Pelhřimov, 1913–1914. Detail. Photo by Pavel Štecha.

have hardly sympathized with Karel Teige's communist convictions.[7] Teige remained faithful to his principle of valuing life above art and maintained an aversion toward everything elitist even as his views on other matters were changing.

PURISM

Karel Teige's system of ideas went through one such fundamental transformation in the summer of 1922, when, in June and July, he made a trip to Paris. He wanted to get firsthand knowledge of the latest trends in French art, the directions of which until that time he could only guess from magazine reproductions.[8] Once in Paris, he also decided to collect new material for two *Devětsil* publications; the *Revoluční sborník Devětsil* (*Revolutionary Anthology of Devětsil,* 1922), which until his visit to Paris had still reflected some of the already-fading concepts of proletarian art, and the collection *Život* (*Life*) 2 (1922–1923; figure 2), which had also intended to devote its pages to the program of proletarian art and magic realism, but whose direction was eventually changed by its chief editor, Jaromír Krejcar.[9] It was undoubtedly also Krejcar, the author of the 1921 project for a market hall in the Prague quarter of Žižkov (designed as a pair of American skyscrapers), who, from 1922, became Karel Teige's closest friend among architects and who convinced him of the necessity to become acquainted with the work of the pioneers of purism. In fact, Amédée Ozenfant and Le Corbusier eventually supplied important drawings and texts for the collection.

After studying the late work of Picasso, Gris, and Jacques Lipchitz, Teige came to realize that cubism had not exhausted its artistic potential and that it was indeed pos-

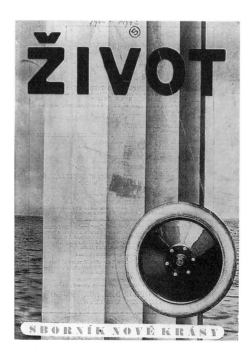

2. Bedřich Feuerstein, Jaromír Krejcar, Josef Šíma, and Karel Teige, cover for the anthology *Život* 2 (*Life* 2, subtitled *An Anthology of the New Beauty*) (1922–1923). Photo by Ústav dějin umění Akademie věd České republiky (ÚDU AVČR; Institute of Art History of the Academy of Sciences of the Czech Republic), Prague.

sible to develop it further. Somewhat unexpectedly, he concluded that this could be done by making it more "scientific"—by extending its logic, rationality, and rigor. An exemplary result of such a scientific transformation of cubism, according to Teige, was Ozenfant's and Le Corbusier's painterly and architectural purism.[10]

Before his summer visit to Paris in 1922, Teige had generally rejected modern technology, American culture, and the cult of engineering; that is, the "technological megalomania" of prewar futurism and machine civilization. Art had seemed to him to be a more humanistic discipline than was science and technology. Behind this shift in focus from a "new proletarian art" to Le Corbusier's purism—a movement that appeared to have been created by an engineer using modern industrial production—was an equally sudden and surprising apotheosis of science as the solid foundation of all human endeavor. From that point on, Karel Teige decided that his architectural program, too, would be based on science.[11]

From around the mid-1920s, Teige began to see science as a discipline characterized by logical and rational thinking that seeks the way toward the future, using hypotheses (and utopian projects) to be tested by means of mathematical calculations and experiments.[12] Such an idea of science was well in advance of the prevailing notions of inductive positivism, generally taught in Czech schools at the time when Teige was a student. Indeed, Simone Hain hypothesizes that here Karel Teige reached the position of Carnap's or Schlick's logical positivism;[13] yet such a connection was never mentioned in his writings, and it is furthermore doubtful that as a committed Marxist he would have been inclined to take such a stance.

It is more likely that architecture, and above all Le Corbusier's work, became the focus of his interest because it was the one art form that suited his new criterion of seeing science and rationalism as the true basis of modern life; it came closest to Flaubert's motto, "L'art de demain sera impersonnel et scientifique," which Teige repeatedly cited after 1922.[14] Of course, there were other art forms as well in the early twenties that developed the "scientific" qualities of purist constructivity and plasticity, such as the paintings of Ozenfant and Gris or the sculptures of Lipchitz. For some time, Teige thought that purism could provide the basis on which these individual art forms could recover their recently lost stylistic unity. This is what he appeared to be suggesting in articles written at the end of 1922 and—as Otakar Máčel has pointed out—also in his contributions to the architectural journal *Stavba* (*Building*) written in the following year.[15]

It was in the spring of 1923 that the twenty-two-year-old Karel Teige was invited to edit *Stavba,* a journal oriented toward purism and constructivism, by such prominent architects as Oldřich Tyl, Oldřich Starý, Alois Špalek, and Ludvík Kysela, who shared his views on essential matters despite belonging to an older generation. What the young editor found interesting in purism was its tendency toward "concretization," toward incorporating elements of reality into abstract geometrical schemes.[16] He noticed it in the paintings of the French purists, and he may have also detected it in the works of Czech purist architects Josef Chochol, Bedřich Feuerstein, Vít Obrtel, Evžen Linhart, and others during the decade between 1914 and 1924 (figures 3 and 4). In Teige's view, the purely abstract paintings by Kasimir Malevich, Piet Mondrian, or Theo van Doesburg were too removed from reality, becoming nothing more than purely decorative objects. He applied the same criteria to the architectural work of the De Stijl group, which he found lacking. The only young Dutch architect with whom Teige sympathized was J. J. P. Oud.[17]

In the winter of 1923–1924, Karel Teige's first brief comment critical of Le Corbusier appeared in *Stavba.* In "K nové architektuře" ("Toward a New Architecture"), Teige wrote that Le Corbusier was "too much of a Frenchman not to betray his traditional roots in classicist harmony, and not to refer to historical examples."[18] A year later, a similar assessment of Le Corbusier's classicism appeared in a *Stavba* editorial, "Náš názor na novou architekturu" ("Our View of the New Architecture"); *Stavba*'s architects intended to find the way to a new unity of form, but unlike Le Corbusier, they would be guided by the notion of a unifying scientific principle rather than by an "abstract geometrical order."[19] Although the article had been undoubtedly written by several au-

3. Bedřich Feuerstein and Bohumil Sláma, crematorium in Nymburk, 1922–1924. Postcard.

4. Evžen Linhart, project for worker's row houses, 1923. National Technical Museum, Prague. Photo by Jan Malý.

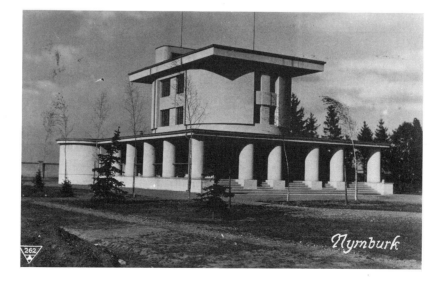

112

thors — including Oldřich Tyl, who also helped create the giant Trade Fair Palace in Prague's Holešovice (figure 5) — its style certainly pointed to Karel Teige.[20] And anticipating Teige's violent attack on Le Corbusier's Mundaneum project was the editorial "K soutěži na Památník odboje a Žižkův pomník na Vítkově" ("On the Competition for the Resistance Monument and for Žižka's Memorial on the Vítkov Hill"), published in January 1924. The anonymous author, whose style yet again betrays Karel Teige's hand, rejected all forced monumentality masquerading, for example, as a medieval castle, instead suggesting that the best solution for a memorial was a simple, functional building: "It is impossible to force architecture to accept any other type of monumentality than that which is inherent to it, into which it had been born and which is a natural outcome of a successfully completed task."[21]

CONSTRUCTIVISM AND POETISM

Like other European avant-gardists, Karel Teige raised his voice against official art institutions from the beginning. He disliked museums, academies, the discipline of art history, schools of applied arts, and even art itself. For example, he considered Gropius's Bauhaus to be nothing else but a modern version of such a school of applied arts.[22] Above all, he rejected the notion of "Art," which he described in 1922 as "one of the unfortunate achievements of European civilization." He was willing to accept art only on the condition that it would be reborn from a new social premise, an idea he adopted from Ilya Ehrenburg's constructivist book *Yet It Does Move*.[23] This dislike of "official" art may have lurked behind the uncertainty that Teige began to entertain about Le Corbusier's work. One can sense his preoccupation with the question of whether an archi-

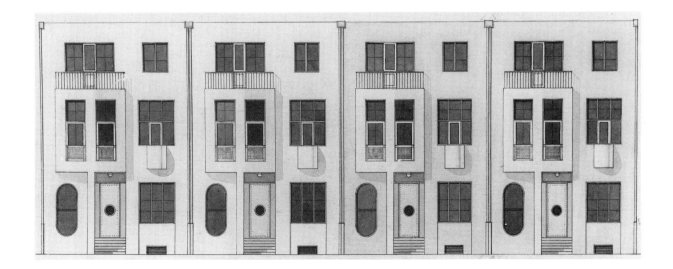

tect, who is meant to work as rationally as an engineer or scientist, is at all entitled to include artistic intervention in his method of design. If the modern architect sincerely holds as true the maxim "form follows function," he should have no need for an a priori harmony of shapes or a preestablished geometrical order — in other words, no need for "architecture" in Le Corbusier's sense of the word.

Karel Teige's doubts about the legitimacy of the artistic nature of architectural work were confirmed by Adolf Behne, who at the beginning of 1924 quoted the Soviet engineer Lapshin: "There is no art of construction, no architecture per se, only a unified, strictly scientific process of building." [24] This view, characteristic of the productivism of Alexander Rodchenko, Vladimir Tatlin, and Aleksej Gan's circle, led Teige to the conclusion that it might be necessary to liquidate all artistic aspects of architecture. The title of Teige's well-known article published in 1925 — "Konstruktivismus a likvidace 'umění'" ("Constructivism and the Liquidation of 'Art'") — suggests that he wanted to abolish "Art" there and then. Yet he did not in fact reject art in its most fundamental sense; indeed, he believed that it was precisely art — but only as *new* art — that had the capacity to satisfy the inherent human need for poetry and lyricism. For this new type of art he, together with the poet Vítězslav Nezval, at the end of 1923 coined the term "poetism," hoping that the essential aims of the program of poetism would be ultimately realized by painting and poetry. The new program of architecture, however, was to be strictly scientific, that is, constructivist. Thus, architecture would become science, a logical and rational blueprint for modern life. [25]

During 1924, Karel Teige added another pair of complementary concepts to the polar duality of poetism and constructivism. In "Naše základna a naše cesta" ("Our Base and Our Path"), published in 1924, he wrote about the opposites of nature and

5. Oldřich Tyl, competition entry for the Trade Fair Palace in Prague, 1924. Reproduced from *Stavba* 3 (1924–1925): 73.

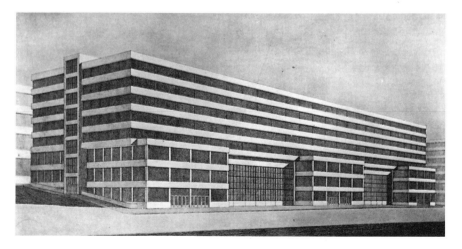

civilization, sentiment and intellect, imagination and rational thinking, freedom and discipline, poetry and construction, intimacy and publicity.[26] Even the title of Teige's collection of essays from 1927, *Stavba a báseň* (*Building and Poem*), was symptomatic of his way of thinking at the time (figure 6). Reasoning via dualisms had been part of European philosophy since antiquity, and in Teige's time practically all modern artists employed it in their theoretical reflections, but he was original in his attempt to provide it with a sociological basis. He was convinced that in the last analysis, all the opposites had their parallel in the battle between traditional art and avant-garde "new art" and, by extension, between the old world of capitalism and the new world of communism. As plausible as this may sound in retrospect, he had little evidence for his hypothesis. But it would be interesting to find out how far Karel Teige relied for his system on the prewar generation of Czech cubists, such as the theoretician Vincenc Kramář and the architects Pavel Janák and Vlastislav Hofman, who in turn inherited their dualistic way of thinking from the Viennese art historian Alois Riegl and the Berlin theoretician of expressionism Wilhelm Worringer. It is known that Janák's prewar philosophy operated within a framework of conceptual dualities such as object–subject, matter–mind, functional–artistic, and so on. He had developed it through his argument against the austere and stark buildings designed by the founder of modern Czech architecture, Jan Kotěra, whom Janák criticized for an excessive concern with constructivist tectonics, function, and social content and whose work he thought lacked the true qualities of architecture as art (figure 7).[27]

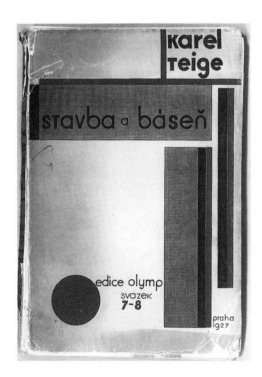

6. Karel Teige, cover for his own book *Stavba a báseň* (*Building and Poem*) (Prague, 1927).

7. Jan Kotěra, museum building in Hradec Králové, 1909–1913. Reproduced from Otakar Novotný's book *Jan Kotěra a jeho doba* (*Jan Kotěra and His Times*) (Prague, 1958), tab. 184.

8. Josef Havlíček and Jaroslav Polívka, Habich Department Store in Prague. Facade detail, 1927–1928. Reproduced from Josef Havlíček and Karel Honzík, *Stavby a plány* (*Buildings and Plans*) (Prague, 1931), 82.

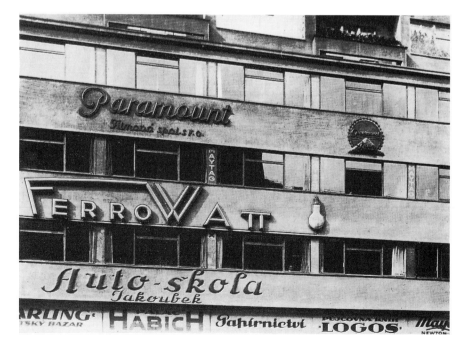

As a theoretician of architecture, Karel Teige would have most likely sided in this polemic with Kotěra. Teige's definition of architecture as science revived the subject of Kotěra's and Janák's polemic within the Devětsil group itself, whose leading architects — Bedřich Feuerstein, Josef Havlíček (figure 8), Karel Honzík, Vít Obrtel, and even Teige's court architect Jaromír Krejcar — did not choose to embrace his extreme vision of architecture as pure science.[28] In principle, they were probably very much attracted to Teige's program of poetism and conceivably charmed by his dreams of "magical cities of new poetry," but they did not understand why their work should not be allowed to combine the principles of constructivism with those of poetism.[29] Why not follow the example of Krejcar's project of the Olympic Department Store (1925–1926; figure 9), which was essentially constructivist but which at the same time expressed the beauty of a modern metropolitan boulevard in the spirit of Nezval's or Seifert's poetist poetry?

Objections to Karel Teige's scientific dogma were most effectively articulated by Karel Honzík and Vít Obrtel (figure 10). According to Honzík, even the most rigorous adherence to the principle of science presupposed feelings, intuition, and imagination — that is, the "artistic" element that would have to be considered by even the most scientifically inclined architect if he were to decide between two entirely functional floor plans or variants of construction.[30] Teige eventually accepted Honzík's arguments and incorporated them into his own theoretical system, starting with the 1928 essay "K teorii konstruktivismu" ("On the Theory of Constructivism"); at the same time, however, he adopted a hostile stance toward Obrtel, whose emphasis on the needs of the individual clashed with his own collectivist ideal of "noble" or "perfect" uniformity, derived from Le Corbusier's theory of standards and norms.[31] Obrtel's argument that the program of scientific architecture would fail to satisfy the spiritual needs of man and the "human desire not only to work but also to sing" led Teige conclude that Obrtel attempted to meet individual human needs with some kind of spurious artistic intervention, a kind of superfluous "artistic extra plus."[32]

This debate unfolded against the background of rivalry between the Devětsil group and *Stavba* magazine.[33] While Karel Teige was in agreement with *Stavba* as far as scientific architecture was concerned, none of the older architects associated with the magazine shared his communist convictions. Isolated by the quarrel over aesthetics in Devětsil and the quarrels on politics in *Stavba,* Teige tried to find kindred spirits outside

Czechoslovakia. In the fall of 1925 he traveled to Moscow and Leningrad (now again St. Petersburg), where he collected so much material and established so many contacts that he became the best-informed expert on contemporary Soviet culture and architecture outside the Soviet Union.[34]

Members of the editorial board of *Stavba,* insisting on the apolitical character of the journal, distanced themselves from the euphoric rhetoric with which Teige described the world's first "scientifically" organized society in his essay "Konstruktivismus a nová architektura SSSR" ("Constructivism and the New Architecture in the USSR"), published in the magazine in 1926.[35] That there were two versions of his essay "K teorii konstruktivismu" is also significant. Teige succeeded in smuggling the thesis that rational and scientific architecture becomes a critique of the irrationally arranged capitalist order into the 1928 version published in *Stavba,* but not until its reprint in the 1930 book *Moderní architektura v Československu* (*Modern Architecture in Czechoslovakia*) did he couch his arguments in proper revolutionary Marxist terminology (figure 11).

In his contacts with the West, Karel Teige became interested above all in the work and activities of the left-wing circle of constructivist architects, such as Hannes Meyer, Mart Stam, Hans Wittwer, and El Lissitzky, around the Swiss magazine *ABC.*[36] He translated Stam's and Meyer's articles for *Stavba* and for his own review *ReD,* and in 1930 he accepted Meyer's invitation to deliver a series of lectures at the Bauhaus on typography and the sociology of architecture.[37]

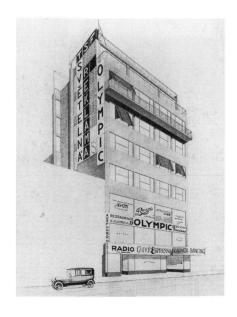

9. Jaromír Krejcar, project for the Olympic Department Store in Prague, 1926. Private collection, Prague.

10. Vít Obrtel, project of a villa on a classical theme, ca. 1934–1935. National Technical Museum, Prague. Photo by Jan Malý.

THE MUNDANEUM AFFAIR

As Simone Hain and Jean-Louis Cohen have already pointed out, Karel Teige's anti-art and anti-aesthetics stance was essentially aesthetic.[38] Yet if Teige had any thoughts on the question of aesthetics at that time, he failed to clearly formulate his own ideal. He could express brilliantly what he disliked about architecture, but when it came to justify the architecture he promoted, he was interested more in general tendencies and principles than in its concrete forms. Even so, Hain and Cohen recognize Teige's explicit anthropocentrism, affirmed again and again in his pronouncements about man being the measure of all things, and in his praise for buildings resembling the human body in their constructive arrangement: "There are no load-bearing walls; the skeleton is inside with a thin skin on the surface," as he wrote in his essay "Constructivism and the Liquidation of 'Art.'"[39]

It does not seem important in this case why Teige chose to formulate an "anthropomorphic" program quite distinct from popular opinion, which held that the main feature of constructivism should be its emphasis on the tectonic elements of a building as expressed in its facade. The vision of a building skeleton covered with a thin skin—ex-

11. Karel Teige(?), cover for his own book *Moderní architektura v Československu* (*Modern Architecture in Czechoslovakia*) (Prague, 1930).

12. Karel Teige, cover for his own book *L'architecture moderne en Tchécoslovaquie* (*Modern Architecture in Czechoslovakia*) (Prague, 1947), which includes a photograph of Jaromír Krejcar and Zdeněk Kejř's Czechoslovak Pavilion at the Paris International Exhibition, 1937.

pressed in Gothic cathedrals, Perret's house on rue Franklin,[40] Tyl's project of the Trade Fair Palace of 1924 (see figure 5), or projects by the brothers Rasch in the 1929 book *Wie bauen?* (*How to Build?*)[41] —indubitably characterized the most important viable candidates for Karel Teige's architectural program. Teige also favored the image of buildings assembled entirely from prefabricated parts,[42] foreshadowing the architecture of Krejcar's 1936–1937 pavilion in Paris (figure 12), which to some extent anticipated current examples of high-tech architecture, as well as a far simpler, essentially purist vision of bare, unadorned architectural volumes, whose face is "matter-of-fact, moderate, sober, ascetic,"[43] such as Adolf Loos's houses or the facade of Krejcar's building designed for the Association of Private Clerical Workers in the Prague quarter of Vinohrady, built in 1930–1931 (figure 13). The latter was valued by Teige for being the "result of its floor plan, nothing more," as he described it in 1933.[44]

Most pertinent for Teige's "aesthetic" was his growing admiration for the buildings of Meyer, Stam, and the Vesnin brothers as well as some of Krejcar's, while at the same time he came to value Le Corbusier's work less and less. In his debate with his Czech opponent Vít Obrtel, he took a position similar to that of Stam or Meyer, whose architecture satisfied him not only in terms of its material features but also spiritually; Le Corbusier's, in contrast, irritated him aesthetically with its artistic "extras." The impact of Le Corbusier's third visit in Prague in October 1928 on Karel Teige's thinking (before their final quarrel) is not entirely clear. At that time, the great Parisian architect in his usual arrogant manner voiced criticism mixed with words of praise for the new works of Czech constructivist architecture, including Krejcar's Olympic Department Store and Oldřich Tyl and Josef Fuchs's Trade Fair Palace. The Prague press interpreted Le Corbusier's statements as evidence of the failure of Teige's theories.[45] In response, Teige published his interview with Le Corbusier in the review *Rozpravy Aventina* (*Aventinum Conversations*). Here Le Corbusier, inspired by his meeting with the Czech poet Vítězslav Nezval, defined architecture as poetry. Teige himself admitted that architecture might become poetry, but only if it "is developed on a constructive basis."[46]

The critique of Le Corbusier's Mundaneum, published in *Stavba* in 1929, marked the end of any similar conciliatory gestures.[47] It was actually part of a wider campaign, which was led by Mart Stam, Hannes Meyer, and El Lissitzky,[48] aimed either directly against Le Corbusier or more generally against the aestheticizing, nonfunctional principles of his work. What these critics, including Karel Teige, objected to was Le Corbu-

sier's readiness to use classicist rules in his composition — to control proportions by means of the golden section — and his reluctance to abandon monumentality.

It should be remembered that the avant-garde had assumed a critical attitude toward architectural monumentality ever since Sant' Elia's futurist beginnings. Teige himself sometimes accepted certain aspects of monumentality as an aesthetic quality, as long as it could be interpreted as an expression of the inner strength of a work of modern art or as part of a functional architectural project. Even as late as 1930 — that is, after his attack on the Mundaneum project — he still praised the "monumental asceticism of form" in Chochol's purist drawings from 1914 (figure 14).[49] However, he was not willing to accept monumentality in modern architecture, especially in its association with the traditional metaphors of the palace and the temple, and as employed by the historicist architects of the nineteenth century. Thus he was certain to attack Le Corbusier's conception of the Mundaneum as a contemporary version of an ancient Mexican temple compound.

Teige considered monumentality of this kind to be a fallacy and a conceit. He rejected it not only for being uneconomical and therefore asocial, but also for dragging modern architecture back into the fold of traditionalism and historicism. As early as his 1927 essay "Hyperdada," Teige found monumental architecture to be unwittingly absurd and therefore deserving of ridicule. In the frivolous spirit of poetism, he labeled it

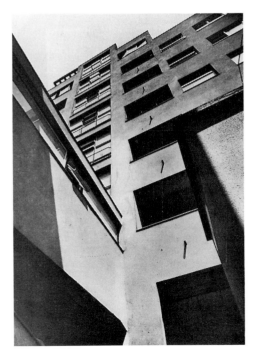

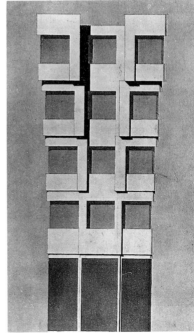

13. Jaromír Krejcar, Association of Private Clerical Workers Building in Prague, 1930–1931. Reproduced from Karel Teige's book *Práce Jaromíra Krejcara* (*The Works of Jaromír Krejcar*) (Prague, 1933), 37.

14. Josef Chochol, study of a facade, 1914. Reproduced from *Časopis československých architektů* (*Journal of Czechoslovak Architects*) 22 (1923): 67.

derisively as dadaist.[50] Later, as his political radicalism grew more virulent — a development induced to a large extent by the first devastating effects of the Great Depression — his views on monumentality acquired a decidedly moralistic, admonishing tone. Viewing Le Corbusier's project through the lens of his radicalized consciousness in 1929, Teige fulminated against its "mastodontic bodies of monumentality,"[51] which negated all rules of constructivist "instrumental" architecture and thus offended him in principle, aside from its historicizing aspects. Teige also saw the monumentality of the Mundaneum as above all a symptom of Le Corbusier's inability to break his ties with the historicism of the old capitalist world. Thus, not unexpectedly, in 1931 Karel Teige accompanied the Czech translation of Le Corbusier's "In Defense of Architecture," published in the review *Musaion,* which patiently explained that beauty did not always have to be identified with functionality, but also responded to a profound and basic human need, with a much sharper attack on the master in a rather vulgar Marxist tone.[52]

THE MINIMUM DWELLING AND THE *KOLDOM*

Karel Teige's family home at 14 Černá Street was rebuilt during the years 1927–1928 by Jaromír Krejcar (figure 15), who stripped the facade of all its original neo-Renaissance features, until it came to resemble an austere building in the Empire style, somewhat reminiscent of Schinkel's drawings of English factories of 1826. This is not surprising, since Teige saw the Empire style as anticipating purist architecture, moreover valuing it as the style of the French Revolution.[53]

The new reinforced concrete roof addition, designed by Krejcar, consisted of two residential floors. On the upper floor (figure 16), occupied by Karel Teige and his companion Jožka Nevařilová, Krejcar created a pair of independent two-room flats that shared a terrace, a small kitchen nook, a toilet, and a bathroom. The salient feature of this arrangement was the absence of anything even remotely resembling a marital bedroom or a space for a double bed.[54]

Teige's 1932 book *Nejmenší byt* (*The Minimum Dwelling*) bears witness to his obsessive hatred of the "bourgeois" institution of marriage.[55] In his view, each adult should live independently in a small but architecturally well-designed residential cell. Women, who in the era of industrial production were to join men in the labor force, would not be burdened with a second shift of household chores and cooking, functions to be taken up by collective canteens and laundries. The upbringing and edu-

15. Jaromír Krejcar, reconstruction of Karel Teige's own house in Prague, Černá Street, 1927–1928. Photo by Jan Malý.

16. Jaromír Krejcar, plan of the flats for Karel Teige and Jožka Nevařilová on Černá Street in Prague, 1927–1928. District Building Archives, Prague 1.

17. Jan Gillar, project of a settlement with minimal flats in Prague-Ruzyně, 1932. Archival photo from ÚDU AVČR, Prague.

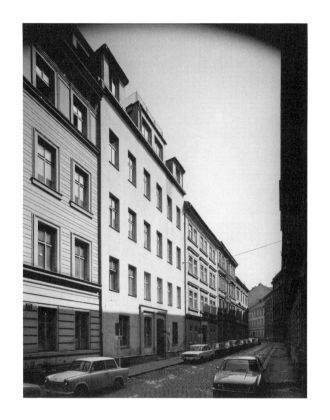

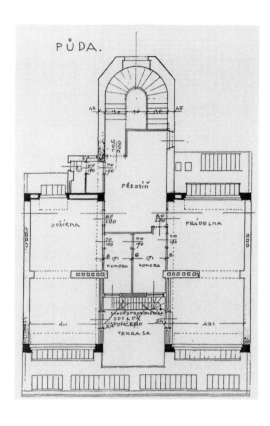

cation of children were to be handled by professional caretakers in nurseries and kindergartens, rather than by the parents themselves. A set of such residential cells or "minimum dwellings," concentrated in one building equipped with services and recreational facilities, was given the designation of a collective house or *koldům* in Czech, after the Russian *koldom.*

At first glance, Teige's visions of the minimum dwelling as a place for collective living may appear to have been imported from the Soviet Union. And indeed, they are very similar to Moisei Ginzburg's concept of "social condensers" — that is, architectural accelerators of social development — as well as the notions put forward by Nikolai Miliutin, the author of the book *Sotsgorod;* Miliutin's views coincided with Teige's down to his rejection of the institution of marriage.[56] Yet at the time when he was rebuilding his house with Krejcar's help, Teige never wrote of the discussions that took place in the Soviet Union during the twenties on the subject of collective living, and it is unlikely that he actually knew about them. After all, the debate on the disintegration of marriage, women's emancipation, and the impact of these changes on the reform of residential architecture had its origins in the West rather than in the Soviet Union. They were partly based on the dream of Fourier's phalanstery, the prototype of all *koldoms,* partly on his extensive readings of anarchist and Marxist literature, on the texts written by the German feminist Clara Zetkin, and, above all, on Engels's *Origin of the Family* (1884).

In the Czech context, women's emancipation, the crisis of the institution of marriage, and the need for children to be brought up in a professionally guided collective were discussed by, among others, the anarchist Louisa Landová-Štychová in the paper *Socialista* (*The Socialist*), to which both Teige and Krejcar contributed around 1923.[57] In fact, Teige's companion Jožka Nevařilová was also a passionate supporter of his theories on collective living. A brilliant translator of French and German who worked in the Ministry of Social Welfare, she tried to have the *koldom* concept applied in the design and construction of homes for socially disruptive youngsters.[58]

Teige's apartment scheme was used as a model by the architect Jan Gillar in his projects for collective houses for the workers' cooperative Včela in 1931, as well as in his design for a housing estate in the Prague suburb of Ruzyně in 1932 (figures 17 and 18). His French School complex in Prague Dejvice, built 1932–1934, may be considered the most faithful application of Karel Teige's program of scientific architecture (figure 19). Gillar actually reproduced Krejcar's original floor plan without any alterations in

TYP A

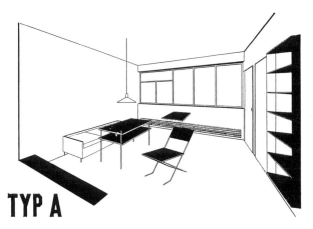

TYP A

18. Jan Gillar, minimal flats for a settlement in Prague-Ruzyně, 1932. Reproduced from *Stavitel* 13 (1932): 43.

"Top: An apartment of two independent rooms with a common hall. Inserted between the two rooms is a toilet and a kitchenette. Bottom: The principle of this minimum dwelling is *One room for one adult.* The dwelling cell consists of two combined rooms (16.80 m²). Inserted between the dwelling cells is a small kitchenette and a toilet (in case the unit is to be occupied by a married couple). Children are naturally living in separate children's homes. In the case of the dwelling being occupied by two single persons, that is, as a *bachelor arrangement,* the kitchenette is replaced by another toilet. A minimum dwelling of this type is the *transitional stage* to *real collective housing.*" Karel Teige, Nejmenší byt (*The Minimum Dwelling*) (Prague, 1932), 231.

the second house that Teige shared with Nevařilová in a small apartment block on U Šalamounky Street. Gillar also sketched the perspectives of the interiors, and it was built to his austere design in 1937–1938 (figures 20–23).[59] Even Karel Teige's weekend house, set in the woods near the village of Nový Vestec and also designed by Gillar (1939),[60] was to be conceived as a small *koldom,* with three sleeping cabins on the upper floor and a larger hall for communal activities on the ground floor (figures 24 and 25). In the end, however, lack of funds forced Teige and Gillar to moderate their plans.

Karel Teige's vision of the *koldom* was undeniably collectivist, yet it was also meant to guarantee every individual the freedom to enjoy the peace and quiet of each separate cell undisturbed.[61] The program had a number of naive aspects, including the total lack of interest in the organization of the *koldoms'* self-administration, as if they were to be automatically occupied by communes as comradely as that of Devětsil.[62] Teige's contemporaries, even those who designed buildings based on the *koldom* model, were equally aware of the weak points in his dreams of the minimum dwelling and collective living.[63] Vít Obrtel, for example, considered them more a surrender to the terrible conditions created by the Great Depression than models of future ideal communities. Krejcar warned that they should not be imposed on an unprepared population. Even Teige himself admitted that the operation of *koldoms* should be first tested experimentally in buildings of a similar type, such as the impressive sanitarium-spa Machnáč in Trenčianské Teplice, designed by Krejcar between 1930 and 1932 (figure 26).[64]

In practical terms, the evolution of the *koldom* principle was more gradual. For example, in the competition launched by the Včela cooperative in 1931, Ladislav Žák tried to design a collective house with flexible residential cells that would eventually be

19. Jan Gillar, French School in Prague, 1932–1934. ÚDU AVČR, Prague.

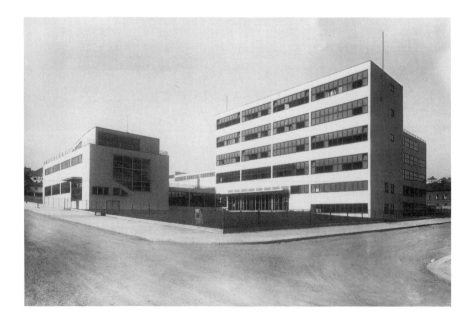

20. Jan Gillar, Karel Teige's house on U
Šalamounky Street in Prague, 1937–1938.
District Building Archives, Prague 5.
Photo by František Illek.

21. Jan Gillar, plan of the flat of Karel
Teige and Jožka Nevařilová in Karel
Teige's house on U Šalamounky Street,
Prague, 1937–1938. Reproduced from
Architektura 2 (1940): 237.

22. Jan Gillar, design for Karel Teige's apartment in his house on U Šalamounky Street in Prague, 1937–1938. National Technical Museum, Prague.

23. Karel Teige's apartment in his house on U Šalamounky Street. Photo by Olga Hilmerová, 1951.

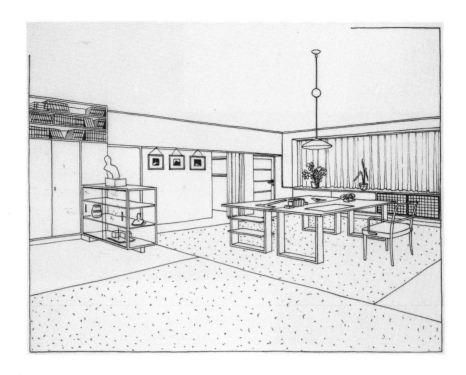

able to "evolve" from ordinary family flats toward Karel Teige's ideal (figure 27).[65] The *kol-doms* in Litvínov (1946–1957; figures 28 and 29) and Zlín (1948–1950; figure 30), the construction of which was made possible by the political changes in postwar Czecho-slovakia, were based on the principle of choice between family flats and single cells. Both were designed by architects from Karel Teige's circle of friends: the Litvínov *koldom* by Václav Hilský and Evžen Linhart, the one in Zlín by Jiří Voženílek from the PAS Group.

FUNCTIONALISM AND SURREALISM

Karel Teige saw the *koldom* consisting of minimum dwelling cells and common collective service facilities as the only truly progressive form of modern living. Its opposite was the family house, which he viewed as an expression of bourgeois individualism and the pathological desire to be "original." To consider designing such an outdated model of dwelling was declared by Teige to be degrading for any avant-garde architect.[66] Karel Teige saw the construction of the first collective housing of this type in the USSR as a proof that *koldoms* were indeed the correct solution to society's progression toward communism. News of the Soviet regime's actions against those who supported the demise of the family—which also put a stop to the construction of further *koldoms*—must have been a bitter disappointment to him.

However, it was the outcome of the international competition for the Palace of the Soviets in Moscow in 1932 that gave him a real shock. Teige could not believe that the representatives of the first "scientifically" administered society in the world—the "laboratory of history," as the Soviet Union was called among Czech left-wing intellectuals— would unilaterally and authoritatively decide that their country was to be represented

24. Jan Gillar, project for Karel Teige's weekend house in Nový Vestec, 1939. Northeast elevation. National Technical Museum, Prague.

25. Jan Gillar, floor plans for Karel Teige's weekend house in Nový Vestec, 1939. Drawing by Rostislav Švácha.

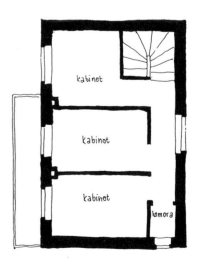

26. Jaromír Krejcar, Spa for the Association of Private Clerical Workers in Trenčianské Teplice, 1930–1932. Postcard.

27. Ladislav Žák, Hajn Villa in Prague-Vysočany, 1932–1933. Terrace. National Technical Museum, Prague. Photo by František Illek.

28. Václav Hilský and Evžen Linhart, Koldům Communal House in Litvínov, 1946–1957. Photo by František Illek.

29. Václav Hilský and Evžen Linhart, interior of the two-story living room in the Koldům Communal House. Photo by František Illek.

30. Jiří Voženílek, communal house in Zlín, 1948–1950. Photo from the archives of the State Gallery, Zlín.

not by scientific constructivist architecture or by Le Corbusier's modernist project, and even less by the monumental constructivist creations of the VOPRA (Association of Proletarian Revolutionary Architects) brigade (Alabyan-Simbirtsev), but instead by J. V. Zholtovsky's old-fashioned, academicist, antiquarian scrap heap of a neoclassicist project.[67]

Already in 1932, Teige saw the rise of neoclassicism in Soviet architecture as a symptom of a "worse and hitherto hidden evil." He agreed with the anonymous coauthor of the newsletter *Rok* (*The Year*) — probably the young theoretician of surrealism Bohuslav Brouk — who pointed out that in the USSR, the interests of the international proletariat were increasingly subjected to the interests of the Soviet state: that is, of the Stalinist bureaucratic apparatus.[68] Brouk's book on psychoanalysis from 1932 provided Teige with new critical arguments against monumentality in architecture. Its characteristics, adopted by the Soviet palace-type buildings — gravity, dignity, affectedness, Freud's "Vater-Imago" — were described by Brouk as a kind of decorum or mask aimed at acquiring power and achieving hegemony.[69] Teige began to consider monumentality through the prism of psychoanalysis and surrealism already in certain passages in *Nejmenší byt;* he developed this approach fully in his excellent 1936 book *Sovětská architektura* (*Soviet Architecture*) and in an even more brilliant introduction to Ladislav Žák's book *Obytná krajina* (*The Inhabited Landscape*), published in 1947. This time, he did not see monumentality as an old-fashioned subject of ridicule (as in his essay "Hyperdada") or as a manifestation of uneconomical and asocial squandering of public funds (as in his critique of the Mundaneum), but as an instrument of power used by the ruling class to subject and intimidate a degraded and deceived people.[70]

In his condemnation of the vulgar palatial spaces of the Moscow metro, voiced in 1937, he spoke as a true surrealist: "When the train with its beautiful modern carriages

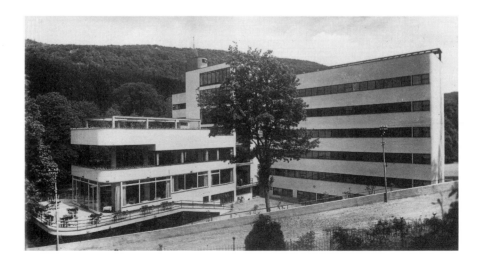

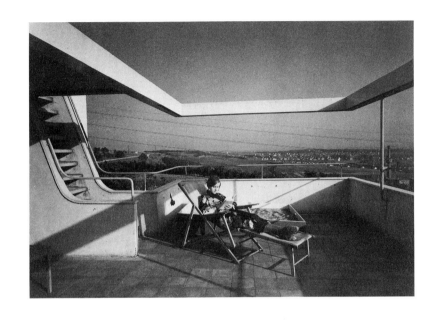

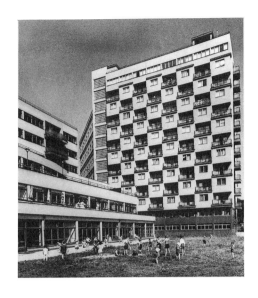

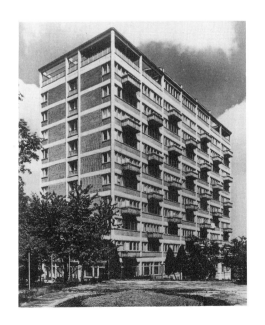

stops at a station decorated with Grecian columns, the impression is that antiquity merges with the present, as if in a dream."[71]

From the mid-1930s on, his attacks on Stalinist academicism, which he did not hesitate to compare with the academicism of Hitler's Third Reich, went hand in hand with his radical left-wing criticism of Stalin's dictatorship. In 1938 Teige issued a particularly strong condemnation of the Moscow political show trials and their supporters in Prague.[72]

Although he knew that the causes of the fall of constructivist architecture in the USSR were primarily political, Teige started to ask himself whether constructivism itself was to blame; that is, whether its program was overly reductionist and dogmatic. He concluded that to that point, the constructivist project had erred on the side of overemphasizing its role in satisfying man's material needs, while paying no attention to his aesthetic and spiritual needs. Architecture, as defined in his *Sovětská architektura,* must never relinquish its scientific base; but equally important, it must broaden the scope of its aims to serve the needs of the human subconscious. It is science that teaches architects to meet these needs, and it is also science that teaches them to approach their goal with the requisite rationality; even a revised concept of architecture would remain sufficiently scientific, becoming psychoanalysis interpreted in Marxist terms. By such a process, the sciences of human physiology would be conjoined with the sciences of the human mind, causing the excessively utilitarian version of constructivism to be transformed into a vehicle of a truly scientific functionalism.

It is in *Sovětská architektura* that Karel Teige for the first time applied to his entire architectural program the term "functionalism," which he had used earlier only to describe constructivist methods of design. By taking into consideration man's psychic world and the "psychic indexes" immanent in all things, functionalist architecture would in the end succeed in reconciling the contradictions between the rational and the magical, technology and nature, reality and dream, attaining what Teige's new Parisian friend André Breton had postulated in 1930 to 1932 as the key aims of surrealism. It became obvious to Teige that functionalism and surrealism could not be considered a pair of clear polar opposites, as was the case with constructivism and poetism in the twenties, but that they actually converged into a single object of thought.[73]

Surrealist rhetoric, similar to that found in *Sovětská architektura* and later in Teige's introduction to Žák's *Obytná krajina,* appeared after 1936 in texts by Karel Janů, Jiří

Štursa, and Jiří Voženílek of the PAS Group, as well as in writings of the Brno-based architect Jiří Kroha.[74] These were architects who at the beginning of the thirties participated in activities organized by the antifascist Left Front and the Association of Socialist Architects, and who put into practice Teige's program of scientific architecture. Their early projects and buildings had displayed a decidedly austere character (mainly as an expression of the moral outrage of the left against the debilitating social effects of the Great Depression), but they decided after 1936 to enrich their buildings with a more emotional and "artistic" face. A typical example of this new approach is the Volman Villa in Čelákovice (1938) by Janů and Štursa (figure 31).

Yet Karel Teige's own apartment building on U Šalamounky Street, designed by Jan Gillar in 1937–1938, showed little sign of the call to create a psychologically more successful architecture. It remained exactly what Teige had criticized in Jaromír Krejcar's early projects in 1933, and in the Paris metro stations in 1937: the "result of the floor plan, nothing more . . . an architecture without architecture."[75]

The result of this intellectual transformation is that in Karel Teige's late writings, culminating in his 1947 introduction to *Obytná krajina,* the end of monumentality became the end of architecture as such, or at least its gradual reduction to its instrumental essence. Finally, Teige arrived at his late belief; namely, that the human need to experience the world as a poem could be satisfied only by man's return to nature, by the regeneration of landscape through regional planning and the creation of surrealist parks and woodland areas dotted with sculptures by Arp and Giacometti. In that sense, too, monumentality in architecture was seen in *Obytná krajina* as a historically conditioned cause of man's alienation from nature. According to Teige, it was surreal-

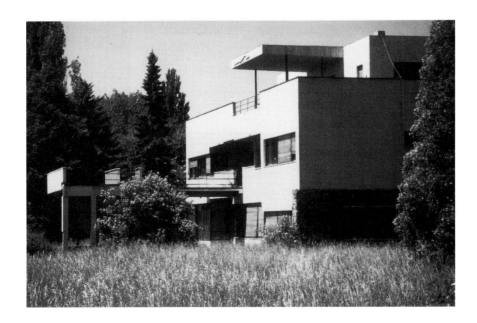

31. Karel Janů and Jiří Štursa (PAS Group), Volman Villa in Čelákovice, 1938. Photo by Rostislav Švácha.

ism that allowed this gap to be closed: "Today, the aim is for the Earth and nature to become Man's dwelling without palaces and temples, without architecture."[76]

POSTSCRIPT

Czech housing estates built of prefabricated concrete panels, constructed all over the country from the fifties to the eighties, were also "without architecture" (figure 32). Yet they completely perverted Karel Teige's humanist ideal of "architecture-instrument" and turned it into a monstrous and inhuman caricature of architecture itself. But that had already happened, without his participation.

32. South Town prefabricated concrete panel housing estate in Prague, 1980s. Photo by Miloslava Čeňková.

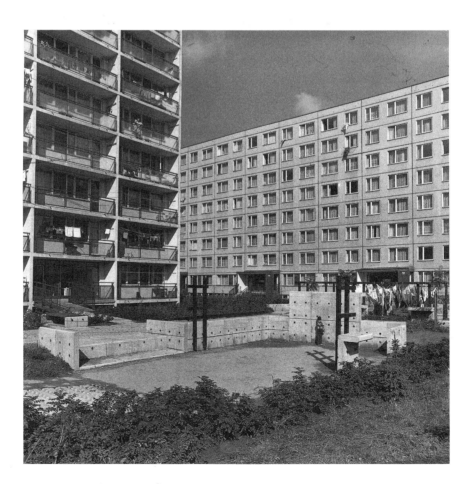

Notes

1. Karel Teige's contributions as a theoretician of architecture are discussed primarily in the following works: O. Máčel, "Karel Teige und die tschechische Avantgarde" (Karel Teige and the Czech avant-garde), *Archithese* 6 (1980): 20–25; R. Švácha, "Karel Teige and the Devětsil Architects," *Rassegna* 15, no. 53/1 (1993): 7–21; Švácha, "Karel Teige jako inspirátor moderní architektury — Karel Teige jako stavebník" (Karel Teige as the inspirer of modern architecture — Karel Teige as builder), in *Karel Teige 1900–1951,* ed. K. Srp, exhibition catalogue, Prague Municipal Gallery (Prague, 1994), 81–95; M. Castagnara Codeluppi, "La libertà necessaria," in *Karel Teige, Archittetura, Poesia, Praga 1900–1951,* ed. Castagnara Codeluppi (Milan, 1996), 11–24. On the Mundaneum project, see "Karel Teige's 'Mundaneum' (1929) and Le Corbusier's 'In Defense of Architecture' (1929)," introduction by G. Baird, *Oppositions,* no. 4 (1974): 79–108.

2. The program of industrialized housing in architecture, assembled from standardized prefabricated panels, was promoted primarily by Karel Teige's friends Karel Janů and Jiří Voženílek of the PAS Group (the Architectural Working Group). Both assumed high political offices after the Communist takeover in February 1948. My thanks to Vladimír Šlapeta for bringing the role played by these architects to my attention.

3. See Karel Teige, "Výstava scénických a kostýmních návrhů Vlastislava Hofmana k A. Dvořákovým *Husitům*" (Exhibition of Vlastislav Hofman's stage and costume design for A. Dvořák's *The Hussites*), *Kmen* 3 (1919–1920): 242; Teige, "Výstava společnosti architektů" (Exhibition of the Society of Architects), *Červen* 4 (1921): 142.

4. Karel Teige, "Obrazy a předobrazy" (Figures and prefigurations), *Musaion* 2 (1921): 52–58; Teige, "Nové umění proletářské" (New proletarian art), in *Revoluční sborník Devětsil* (Revolutionary anthology of Devětsil) (Prague, 1922), 5–18. The latter was reprinted in *Avantgarda zhámá a neznámá* (Avant-garde known and unknown), ed. S. Vlašín (Prague, 1971); quotation, 1: 272.

5. Karel Teige, "Novým směrem" (In a new direction), *Kmen* 4 (1920–1921): 569–571; cf. the New Testament, 1 Corinthians 3.10–17.

6. F. X. Šalda, *Boje o zítřek* (Struggles for tomorrow) (Prague, 1905). Teige's thinking was influenced above all by Šalda's essay "Nová krása, její geneze a charakter" (The new beauty, its genesis and character, 1903), published in that volume. On the importance of Šalda's work for Czech art, see P. Wittlich, *Prague: Fin de siècle,* trans. M. de la Guardia (Paris, 1992), in French and English.

7. T. G. Masaryk, *Demokratism v politice* (Democratic principles in politics) (Prague, 1912). On Masaryk, see H. G. Skilling, *T. G. Masaryk: Against the Current, 1882–1914* (New York, 1994). Teige defined his stance toward Masaryk in his booklet *Surrealismus proti proudu* (Surrealism against the Current) (1938; rpt., Prague, 1993), 43–44.

8. Karel Teige, "O nové umění ve Francii" (For a new art in France), *Čas* 32, no. 148 (28 June 1922): 4; no. 150 (30 June 1922); 3–4.

9. See R. Švácha, A. Tenzer, and K. Spechtenhauser, *Jaromír Krejcar 1895–1949,* exhibition catalogue (Prague, 1995), especially 39–45 (in Czech and English).

10. Karel Teige, "Kubismus, orfismus, purismus a neokubismus v dnešní Paříži" (Cubism, orphism, purism and neocubism in contemporary Paris), *Veraikon* 8, nos. 9–12 (1922): 98–112.

11. It is not clear whether Karel Teige thought of "science" as resting on genuine scientific knowledge or as instead merely something done in laboratories by men in white coats.

12. See especially the second version of Karel Teige's article "K teorii konstruktivismu" (On the theory of constructivism), in his *Moderní architektura v Československu* [Modern Architecture in Czechoslovakia], MSA 2 (Prague, 1930), 242–255.

13. S. Hain, "Karel nel Paese delle Meraviglie: I conflitti teoretici degli anni Trenta," in Castagnara Codeluppi, *Karel Teige,* 117–128.

14. Karel Teige, "Purismus" (Purism), *Život* 2 (Prague, 1922 [published 1923]), 124–136; Flaubert is quoted on 124.

15. O. Máčel, "La critica e i suoi strumenti: Karel Teige e Stavba, 1923–1927," in Castagnara Codeluppi, *Karel Teige,* 91–99.

16. Karel Teige, "Výstavy v Praze" (Exhibitions in Prague), *Stavba* 2 (1923–1924): 202–203; Teige, "Malířství a poesie" (Painting and poetry), *Disk* no. 1 (November 1923), 19–20.

17. Karel Teige, "De Stijl a holandská moderna" (De Stijl and Dutch modernism), *Stavba* 3 (1924–1925): 33–41. Cf. M. White, "Spiritual Hygienists: Van Doesburg, Karel Teige, and the Concept of Progress," *Umění* 43 (1995): 63–65.

18. Karel Teige, "K nové architektuře," *Stavba* 2 (1923–1924), 179–184, reprinted in his *Stavba a báseň* (Building and poem) (Prague, 1927), 53–62; quotation, 61.

19. Klub architektů–redakce Stavby, "Náš názor na novou architekturu," *Stavba* 3 (1924–1925): 157–158. For an English translation, see G. Peichl and V. Šlapeta, *Czech Functionalism, 1918–1938* (London, 1987), 163.

20. Oldřich Tyl was probably the instigator of an interesting call for the use of psychoanalysis in the study of human orientation in space. See his "Výstavba měst projevem současného života" (Urban development as an expression of contemporary life), *Stavba* 9 (1930–1931): 8–9; for an English translation, see M. Masák, R. Švácha, and J. Vybíral, *The Trade Fair Palace in Prague* (Prague, 1995), 22.

21. "K soutěži na památník odboje a Žižkův pomník na Vítkově," editorial, *Stavba* 2 (1923–1924): 165–167.

22. Karel Teige, "Staatlisches Bauhaus," *Stavba* 2 (1923–1924): 200–202.

23. Karel Teige, "Umění dnes a zítra" (Art today and tomorrow) in *Revoluční sborník Devětsil,* 187–202, reprinted in Vlašín, *Avantgarda známá a neznámá,* 1:365–381; quotation, 380.

24. Adolf Behne, "Umění v Rusku" (Art in Russia), *Stavba* 2 (1923–1924): 172–174; Lapshin is quoted on 174.

25. Teige, "Malířství a poesie"; Teige, "Poetismus," *Host* 3, nos. 9–10 (1924): 197–204 (for English translation, see above).

26. Karel Teige, "Naše základna a naše cesta," *Pásmo* 1, no. 3 (1924): 1–2.

27. See R. Švácha, "Die Kunstauffasungen der Architekten" (Artistic conceptions of architects), in *1901–1925, Kubismus in Prag,* ed. J. Švestka and T. Vlček (Stuttgart and Dusseldorf, 1991), 202–211.

28. See F. Šmejkal and R. Švácha, eds., *Devětsil: Czech Avant-Garde Art, Architecture, and Design of the 1920s and 1930s,* exhibition catalogue (Oxford and London, 1990).

29. Karel Teige, "O humoru, clownech a dadaistech" (On humor, clowns, and dadaists), *Sršatec* 4, no. 38 (1924): 3–4; no. 39, 2–3; no. 40, 2–4.

30. K. Honzík, "Toporná modernost" (Awkward modernity), *Pásmo* 2 (1925–1926): 43–44; Karel Teige, "*Pásmo* 2, vol. 2, no. 3," *Stavba* 4 (1925–1926): 163–164; Honzík, "Estetika v žaláři" (Aesthetics in jail), *Stavba* 5 (1926–1927); 166–197.

31. Karel Teige, "K teorii konstruktivismu," *Stavba* 7 (1928–1929): 7–12, 21–24. Cf. R. Švácha, ed., *Vít Obrtel (1901–1988). Architektura, typografie, nábytek* (Vít Obrtel, 1901–1988: Architecture, typography, furniture), exhibition catalogue (Prague, 1992) (in Czech and English).

32. Karel Teige, "Plán" (The plan), *Stavba* 7 (1928–1929): 139–141. The quotation from Vít Obrtel is from "Úvod k neokonstruktivismu" (Introduction to neoconstructivism, 1929), reprinted in his *Vlaštovka, která má geometrické hnízdo. Projekty a texty* (A swallow in a geometrical nest: Projects and Texts), ed. R. Švácha and R. Matys (Prague, 1985), 117.

33. See Švácha, Tenzer, and Spechtenhauser, *Jaromír Krejcar,* 65–73.

34. See O. Máčel, "Paradise Lost: Karel Teige and Soviet Russia," *Rassegna* 15, no. 53/1 (1993): 70–77; J. L. Cohen, "Karel Teige e la crisi del costruttivismo russo," in Castagnara Codeluppi, *Karel Teige,* 155–168.

35. Karel Teige, "Konstruktivismus a nová architektura v SSSR," *Stavba* 5 (1926–1927): 19–32, 35–39; the editorial is on 32.

36. See Karel Teige, ed., *Mezinárodní soudobá architektura* (Contemporary international architecture), MSA 1 (Prague, 1929): see esp. his "Doslov" (Postscript), 165–166.

37. Karel Teige, "K sociologii architektury" (On the sociology of architecture), *ReD* 3 (1929–1931): 163–223.

38. See Hain, "Karel nel Paese della Meraviglie," and Cohen, "Karel Teige."

39. Karel Teige, "Konstruktivismus a likvidace 'umění,'" *Disk,* no. 2 (1925): 4–8.

40. Karel Teige, "Dílo bratří Perretů" (The work of the Perret brothers), *Stavba* 2 (1923–1924): 130.

41. Heinz and Bodo Rasch, *Wie bauen?: Bau und Einrichtung der Werkbundsiedlung am Weissenhof in Stuttgart 1927* (Stuttgart, 1929). See also Karel Teige, "Industrializovaná architektura" (Industrialized architecture), *ReD* 2 (1928–1929): 216–217.

42. Karel Teige, "Moderní česká architektura" (Modern Czech architecture), *Veraikon* 10, nos. 11–12 (1924): 113–133; Teige, "Obývací stroje" (Residential machines), *Stavba* 4 (1925–1926): 135–146.

43. Karel Teige, *Práce Jaromíra Krejcara* (The work of Jaromír Krejcar) (Prague, 1933), 36.

44. Ibid.

45. Karel Teige responded to the polemic of Prague anti-constructivist newspaper writers, who were encouraged by Le Corbusier's opinions on the new Prague architecture, in "Polemické výklady" (Polemical explanations), *Stavba* 7 (1928–1929): 105–112.

46. Karel Teige, "Le Corbusier v Praze" (Le Corbusier in Prague), *Rozpravy Aventina* 4, no. 4 (1928): 31–32; English translation in Masák, Švácha, and Vybíral, *The Trade Fair Palace in Prague,* 40–42.

47. Karel Teige, "Mundaneum," *Stavba* 7 (1928–1929): 145–155. Cf. G. Baird, "A Critical Introduction to Karel Teige's 'Mundaneum' and Le Corbusier's 'In the Defense of Architecture,'" *Oppositions,* no. 4 (October 1974): 80–81; K. Frampton, *Modern Architecture: A Critical History* (London, 1985), 160, 251–252. A. Kubová, "Le Mundaneum, erreur architecturale?" in *Le Corbusier: Le passé à réaction poétique,* ed. P. Saddy, exhibition catalogue (Paris, 1988), 48–53.

48. M. Stam, "M-umění" (M-art), trans. J. Nevařilová, *ReD* 2 (1928–1929): 122–123 (originally published in *Bauhaus*); H. Meyer, "Stavět!" (To build!), in Teige, *Mezinárodní soudobá architektura,* 80–84; El Lissitzky, "Idoly i idolopoklonniki" (Idols and idolaters), *Stroyitelnaya promyslennost* 5 (1927–1928): 11–12, 854–858. Lissitzky's article is discussed by Máčel, "Paradise Lost."

49. Teige, *Moderní architektura v Československu,* 106.

50. Karel Teige, "Hyperdada," *ReD* 1 (1927–1928): 35–39.

51. See Teige, "Mundaneum," 155.

52. Le Corbusier, "Obrana architektury" (In defense of architecture), *Musaion* 10 (1931): 27–52; Karel Teige, "Odpověd Le Corbusierovi" (Answer to Le Corbusier), *Musaion* 10 (1931): 52–53.

53. Teige, "Nové umění proletářské"; Teige, *Moderní architektura v Československu,* 6–9.

54. See Švácha, "Karel Teige jako inspirátor moderní architektury," 85–88.

55. Karel Teige, *Nejmenší byt* (Prague, 1932), 151, 163, 319, 323–342.

56. N. A. Miliutin, *Socgorod* (Prague, 1931), 56–58. On Ginzburg's concept of the "social condenser," see esp. Stanislaus von Moos, *Le Corbusier: Elements of a Synthesis* (Cambridge, Mass., 1982), 143–144.

57. See "Zemínová contra Štychová" (Zemin contra Štych), *Socialista* 1, no. 10 (13 May 1923), supplement *Socialistka* 1 (Socialist women). On the relationship between Devětsil and "the beautiful Louisa Štychová," see the memoirs of Jaroslav Seifert, poet, Nobel Prize winner, and onetime close friend of Karel Teige, *Všechny krásy světa* (All the beauties of the world), (Prague, 1993), 289, 317.

58. See J. Nevařilová, "Názory o výchově" (Views on education), *Jak žijeme, Magazín Družstevní práce* (How We Live, Journal of Cooperatives' Work) 1 (1933–1933): 243–247; Nevařilová, "Ústavy pro mládež" (Young people's homes), *Sociální pracovnice* (Social Worker) 16 (1947): 101–110. Cf. Švácha, "Karel Teige jako inspirátor moderní architektury," 95.

59. Švácha, "Karel Teige jako inspirátor moderní architektury," 88–91.

60. Ibid., 92–93.

61. See K. Srp, "An Avant-Gardist's Solitude," *Umění* 43 (1995): 5–8.

62. See also E. Dluhosch, "'Nejmenší byt,' the Minimum Dwelling," *Rassegna* 15, no. 53/1, (1993): 30–37; Dluhosch, "Karel Teige a nezdar levé avatgardy" (Karel Teige and the failure of the left avant-garde), *Umění* 43 (1995): 9–17.

63. The debate about collective housing is discussed in greater detail in my book *The Architecture of New Prague, 1895–1945,* trans. Alexandra Büchler (Cambridge, Mass., 1995), 308–311.

64. Teige, *Práce Jaromíra Krejcara,* 74–103.

65. L. Žák, "Průvodní zpráva hesla 'Evolution'" (A comment on the slogan "Evolution"), *Stavitel* 12 (1931): 89. Cf. Karel Teige, "K soutěži na nájemné domy s malými byty pro dělnický spolek Včela v Praze" (On the competition for small apartments for the workers' association Včela in Prague), *Stavitel* 12 (1931): 76–92.

66. Teige, "K sociologii architektury."

67. Karel Teige, "Dvorec sovětov v Moskvě" (The palace of the Soviets in Moscow), *Žijeme* 2 (1932–1933): 20–21.

68. A.R. (pseudonym of Bohuslav Brouk?), "Má SSSR zájem na světové revoluci?" (Is the USSR interested in world revolution?), *Rok,* October 1931, 2; the leaflet was published by Vít Obrtel. See Švácha, Tenzer, and Spechtenhauser, *Jaromír Krejcar,* 124–127.

69. Bohuslav Brouk, *Psychoanalysa* (Prague, 1932), 9–19, 66, 91.

70. Karel Teige, *Sovětská architektura* (Prague, 1936); Teige, "Předmluva o architektuře a přírodě" (Prolegomena on architecture and nature), in *Obytná krajina* (The inhabited landscape), by Ladislav Žák (Prague, 1947), 7–21. For a detailed discussion see R. Švácha, "Surrealismus a architektura" (Surrealism and architecture), in *Český surrealismus 1929–1953* (Czech surrealism, 1929–1953), ed. L. Bydžovská and K. Srp (Prague, 1996), 268–279.

71. Karel Teige, "Velkoměsto a podzemní dráha" (The metropolis and the metro), *Světozor* 37 (1937): 158–159, 182; quotation, 159.

72. Teige, *Surrealismus proti proudu,* 23.

73. Here I disagree with Jaroslav Anděl, who overemphasizes the autonomy of the two movements. Cf. Anděl, "The 1930s: The Strange Bedfellows, Functionalism and Surrealism," in *The Art of the Avant-Garde in Czechoslovakia, 1918–1938,* ed. Anděl and C. Alborch, exhibition catalogue (Valencia, 1993), 292–385. See also H. Císařová, "Surrealism and Functionalism: Karel Teige's Dual Way," *Rassegna* 15, no. 53/1 (1993): 78–88.

74. For further discussion, see Švácha, "Surrealismus a architektura."

75. Teige, *Práce Jaromíra Krejcara,* 17, 36; Teige, "Velkoměsto a podzemní dráha," 158.

76. Teige, "Předmluva o architektuře a přírodě," 19.

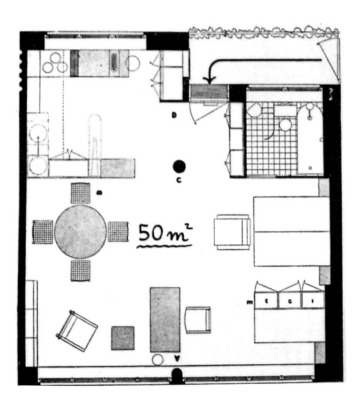

50 m²

TEIGE'S MINIMUM DWELLING AS A CRITIQUE OF MODERN ARCHITECTURE

/ 8

Eric Dluhosch

The minimum dwelling is the slogan of the architectural avant-garde; it wants
to be the answer to the facts of the ongoing housing shortage. We answer this
slogan by pointing out from the start that the minimum dwelling is not properly
understood as a small dwelling for a small person! This is not the idea.

—KAREL TEIGE, *Nejmenší byt*

THEORETICAL FOUNDATIONS

The epigraph above aptly encapsulates Teige's position on the question of the minimum dwelling, not as a reduced version of a small bourgeois apartment, nor as a cottage on its own garden plot, but as a new type of dwelling: a collective house for a new human type, the proletarian. With these words, Teige also throws down the gauntlet before the "establishment" of modernism, chief among them such figures as Le Corbusier, Walter Gropius, Mies van der Rohe, J. J. P. Oud, and Bruno Taut.

Nejmenší byt (figure 1) was published in 1932, though parts were written earlier.[1] In effect, it was Teige's conscious effort to influence as well as criticize the program of the Third CIAM Congress, which took place in Brussels in 1930, and which Teige attended as a delegate of the Czechoslovak national group; he himself perceived it as many books in one.[2] The text covers a number of subjects, ranging from the history of housing to a detailed description of many examples of modernist solutions of various housing types of that time, with the conclusion dedicated exclusively to Teige's own vision of the future minimum dwelling, that is, the "Collective Dwelling."[3] Unfortunately, it has not yet been translated into English, an omission that is both regrettable and inexcusable.

Rather than providing the reader with a chapter-by-chapter synopsis of the 376 pages of dense text and numerous illustrations, I will attempt to elucidate the basic premises on which Teige builds his argument for a new approach to the question of the minimum dwelling for the "classes of the existential minimum,"[4] as well as the theory on which Teige constructs his vision of a new approach to housing in modern architecture.

Most of his philosophical and ideological convictions are well presented in the introduction (they are discussed in more detail in Rostislav Švácha's contribution to this volume, above). *Nejmenší byt* is actually a lengthy manifesto of Teige's "theses" on housing; he announces up front that the book does not simply attempt to provide a historical overview of modern architecture's accomplishments concerning the question of housing but is "primarily dedicated to addressing the problem of popular, proletarian housing in all its sociological, economic, technical, and architectural aspects" (21).[5] Its comprehensive treatment of the complex problem of popular housing, its merciless analysis of existing capitalist solutions to minimum housing, and its deep understanding of the economic, social, and technical factors determining the architecture of the

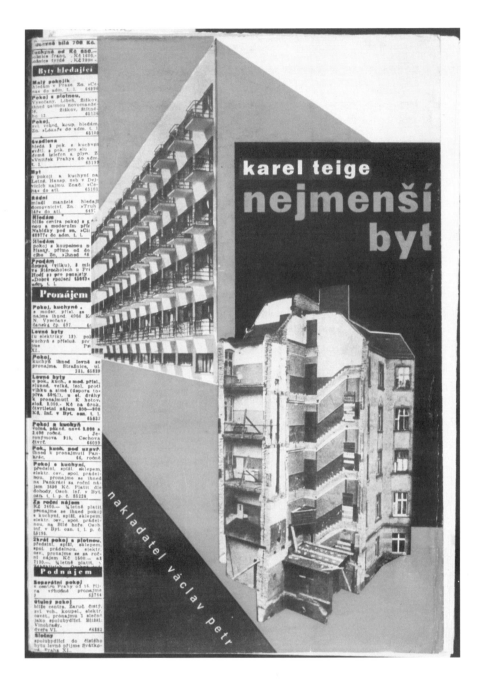

1. Karel Teige, cover of his book *Nejmenší byt* (*The Minimum Dwelling*) (Prague, 1932). Unless otherwise noted, all reproductions are from this book, courtesy of the Wolfsonian–Florida International University, Miami Beach, Florida.

minimum dwelling make it arguably one of the best documents dealing with the subject of modern housing published in the thirties.

Let us examine in more detail some of the aspects of Teige's theoretical propositions on modern architecture in general and housing in particular, which reflect his radical left avant-garde worldview. It should be kept in mind that many if not most of the members of the artistic and architectural avant-garde of the twenties and thirties declared themselves as standing on the left, or at least being in sympathy with the position of the left, which at that time meant sympathy with or adherence to a Marxist point of view. Teige differs from his contemporaries only in his extreme radicalism — at least during the first three decades of his life — and in the consistency of his belief that the utopia of a classless society under communism was not only practically feasible but historically inevitable.[6]

Using an explicitly Marxist method of analysis, Teige does not approach the question of housing primarily by trying to stipulate a new "modernist" typology of house plans. Instead, he stresses the need for fundamental sociological research into the causes and precedents of the continuing housing crisis, linked to technical progress as the only force capable of realizing in material, built from the insights gained by the study of the underlying historical and social currents driving progress. On the technical level, Teige views the housing question mainly as a problem of how to determine "social needs and their satisfaction by rational mass production" (21).

Accordingly, he asserts that it is not enough merely to narrate the history of the question of housing; this description needs to be complemented by scientifically vetted socioeconomic data. Even though the information collected by existing methods of statistical analysis may have only limited utility, such methods nevertheless provide at least an organized set of quantitative data that can be verified and criticized by any technically literate professional.[7] Naturally, one must look for the inherent bias in all statistics produced by the bureaucracy of a bourgeois social order, which tends either to gloss over glaring inadequacies in housing by manipulating categories or to suppress certain aspects of the housing shortage altogether. Hence, the study and evaluation of statistics must be complemented by a careful review of all the diverse housing solutions offered past and present, as well as by analyzing their origins in their historical context, in order to discover overt as well as covert trends in their evolution.

Convinced that each historical era contains in its manifestations implicitly or explic-itly the seeds of the next, higher level of development, Teige believes that the solution to the contemporary housing question is actually immanent in the earlier solutions, though they are often misunderstood or misapplied by certain modernists, who make the mistake of taking the existing socioeconomic order as a more or less permanent given. That error, together with their belief that they can create works apparently free of ideology, tended to distort their perspective and make them view as an unchangeable datum the family-based organization of the conventional floor plan, at a time when the bourgeois family was already undergoing radical change and indeed disintegration.

Given the presumed inevitability of a socialist future, statistics and the Marxist inter-pretation of historical data make planning indispensable to guide all action, including ac-tion in the fields of housing policy and design. Here we are confronted by the need not only for planning on the scale of the single house or the settlement, but for planning of the economy as a whole, since in Teige's view only in a planned economy can the re-quired number of dwellings for its workers be built in a fixed period of time.

According to Teige, statistics "catch mostly facts which are [already] conse-quences" (23); that is, they are a *diagnostic* tool (figure 2). However, diagnosis is not enough: architects must pay equal attention to *prognosis* as well in determining the fu-ture of housing in their work. Research to uncover the causes of the perennial persis-tence of housing shortages for the poor is only the first necessary step; prognosis also requires a rigorous sociological analysis, based on the scientific formulation of historical laws that "not only recognize reality, but also act as an instrument for its change" (22). This insistence on linking history, sociology, and technology as mutually interdependent factors in the genesis of housing policy is evident in all of Teige's writings on architec-ture and represents one of his major contributions to the theory of modernism in that field.

While directing his harshest attacks against the capitalist order for its failure to pro-vide decent housing for its lowest income strata, Teige is also highly critical of previous attempts of nineteenth-century socialist thinkers — William Morris, Jeremy Bentham, John Ruskin, and others — who attempted to deal with the problem of housing for the working classes from a more or less philanthropic point of view. He sees these efforts as nothing else than "utopian communism, prescientific socialism, and American phi-lanthropism," all derived from arguments planted in the soil of "fallacious national eco-

2. Statistical material displayed during the exhibition *Proletářské bydlení* (*Proletarian Housing*), compiled by Levá fronta, 1931 (p. 99).

 Panels: Top left, "72% of all working wage earners in Prague have an annual income of less than 10,000 crowns (kč) [ca. $30], i.e., less than the so-called existential minimum." Top right: "The Relationship of Wage to Rent. Who can pay 20% of his or her income for a one-room apartment with a kitchen in a new building in Prague?" Bottom left: "Mortality by Age Group, 1910–1927. The youngest suffer most. Reasons: undernourishment, poor living conditions, insufficient earnings, debilitating physical labor of breast-feeding mothers, tuberculosis, and *unhygienic apartments.* Bottom right: "Main causes of mortality. No. 1: Every fourth death is caused by tuberculosis. . . . No. 6. Victims of mining disasters." Other causes listed are not clearly legible, even in the original illustration.

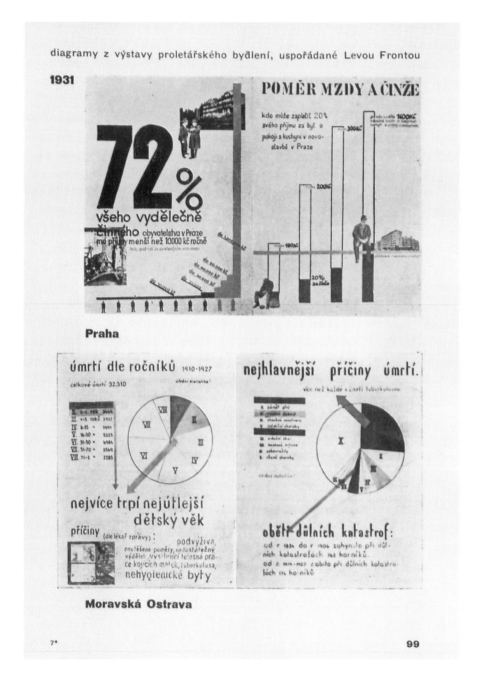

146

nomical theories of organized state capitalism, ultra-imperialism, Fordism, etc.," or, in other words, from "petit-bourgeois socialism" (22).

Modernist innovators—such as Le Corbusier or Hendrikus Berlage, among others—do not fare much better. Both are accused of trying to sell their grandiose planning schemes to big finance capitalism, by offering to their masters "a new opium" to keep the masses asleep; namely, the magic formula for industrial efficiency, "Fordism" (23).[8] In such accusatory passages Teige justifies applying the scientific dialectical method to housing, rather than accepting a more gradual and piecemeal approach to the problem. In other words, he advocates revolution, mandating the *destruction* of the old and the subsequent *construction* of the new. In this context, it might be interesting to compare Teige's position on the matter of destruction/construction to that of his Russian contemporary El Lissitzky, who expressed a similar view in 1930.[9]

Because Teige relies on the dialectic of the "thesis" of destruction and its "antithesis" of construction, the early chapters, which trace the history of popular housing from medieval times to the twentieth century, must be considered merely as a prelude to the book's final "synthesis," which is wholly dedicated to the development of a rationale, as well as a detailed program, for the worker's collective dwelling (figure 3). He conceives the collective dwelling not only as a "negation of hitherto existing forms of dwelling" (24), or the destruction of the old, but as ultimately destined to become the material realization of the construction of a new living culture for socialist man and women alike.

3. Josef Havlíček and Karel Honzík, project for a communal house with minimal flats, called Koldom, in Prague, 1930. Archival photo, Archiv des Instituts für Geschichte und Theorie der Architektur an der ETH Zürich (Archive of the History and Theory of Architecture at the Technical University in Zurich).

In Teige's own words, "this is the reason why everything that will be already exists in an embryonic state in that which is[,] . . . as an antithesis to that which is now and that which is of a lower degree of quality, as well as an antithesis to be overcome by its own higher quality" (25). What is this "higher quality"? For Teige, the sociological answer can be found in the disappearance of the traditional family as an active and productive economic unit, "where the division of labor and the resulting inequalities between man and woman, parent and child . . . will be overcome" (25).[10]

In practical design terms, the highly differentiated functions of the bourgeois dwelling must be recast to distinguish between the basic existential needs of the individual, man or woman, and the needs of the collective. For example, the bourgeois individual kitchen in each apartment disappears from the list of essential functions included in the plan of a worker's dwelling, to be transformed into a communal kitchen, serving the collective in a separate facility. Living room, parlor, dining room, and children's rooms are equally relegated to the realm of collective services, as are sports, education, and recreation facilities. In this respect, Teige's prescription follows very closely the models proposed by his Soviet counterparts. There are also some differences, however, which will be discussed in the latter part of this essay.[11]

Teige's definition of the dwelling as a "social act" is therefore in its essence correct, as is his definition of dwelling "as a space, serving not only the biological functions of rest and protection from the inclemencies of the weather" but also linked with "certain economic, production, and cultural functions" (28).

He does not deny that modern architecture has made (often unwittingly) important contributions to addressing the problem of housing, but in his view that simply supports his point that only the complete destruction of the existing social and economic order will allow for the full utilization of modern technology and construction, whose potential will unfold in the new socialist order. This line of thinking makes it possible for him to arrive at a different prognosis than that of his less doctrinaire Western colleagues, whom he accuses of having drawn the wrong conclusions from their extensive and often valuable research, remaining regrettably blind to its radical implications.[12]

As described in a companion essay in this volume (see Spechtenhauser and Weiss), Teige accuses the CIAM (Congrès Internationaux d'Architecture Moderne) of including in its proceedings only the stylistically formal and essentially apolitical features of modernism, while suppressing or altogether excluding a truly sociological rethinking

of the very assumptions that had been hitherto accepted as the only basis for the design of housing in the capitalist world. He argues to the contrary:

The architectural avant-garde are only those who not only wish to "build modern" but also struggle for a new thinking, and who know that the misery of the housing conditions [of the poor] can be overcome only when the material and spiritual distress of their living conditions is overcome as well. A *flat roof* or *steel furniture* [figure 4] is not the ultimate goal of avant-garde architecture, but can merely be seen as a formalistic fetish. (24; emphasis in original)

Teige firmly believes that a truly modern architecture is inextricably linked to political struggle and cannot remain neutral vis-à-vis the question of housing for the working class. Political struggle furthermore implies the questioning of accepted bourgeois historical categories, which Teige saw as firmly enshrined in the retarding influence of academicism. For academicism does not dare to attempt a truly "scientific" (read Marxist) critique of existing approaches to the theory of architecture in the broadest sense, and more narrowly to the question of housing for the poor. Whenever such a critique is actually attempted, whether by the CIAM or the academy, it is always piecemeal, provisional, and conditional. It is piecemeal in never considering the possibility of a complete and radical restructuring; provisional, in accepting as given certain aspects of existing housing solutions; and conditional, in assuming the continued existence of the social and political order of capitalism.

Shorn of its Marxist jargon, Teige's astute observations on future changes in the realms of work, leisure, education, and culture in general serve as a timely remainder that the underlying dialectic of his *analytical* thinking is essentially sound and close to unfolding reality. His *prognostic* capabilities, however, are befogged by his utopian faith in the inevitability of historical events taking the course of a Marxist-inspired socialist "classless society."[13]

FORM AND FUNCTION AS THE EXPRESSION OF SCIENCE AND TECHNOLOGY

A consideration of the generative influences on plan organization and layout must also include the question of *form* versus *content*. Teige considers outward form as merely an "optical phenomenon," which may or may not capture the surface character of a

4. Comparison of international modern furniture designs (p. 207).

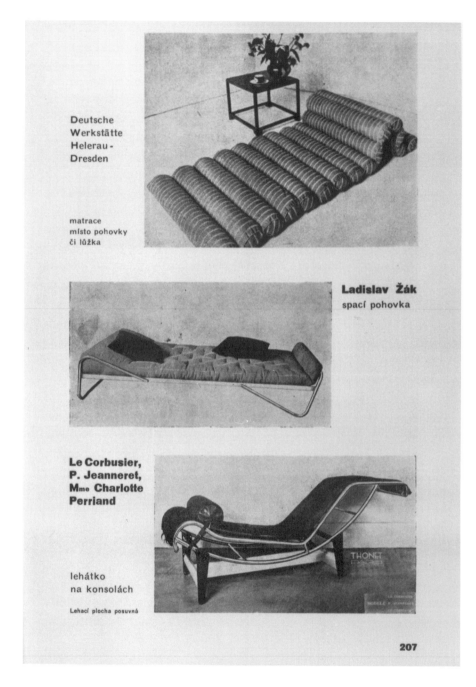

Deutsche
Werkstätte
Helerau -
Dresden

matrace
místo pohovky
či lůžka

Ladislav Žák
spací pohovka

Le Corbusier,
P. Jeanneret,
Mme Charlotte
Perriand

lehátko
na konsolách

Lehací plocha posuvná

207

150

building or object; it does not necessarily reveal the exact constitution of the underlying "structure." [14] In that sense, qualitative change does not necessarily manifest itself explicitly in terms of new form. A deeper analysis is required, best exemplified by the study of the floor plan: it is an important diagram of underlying social conventions, as realized by the disposition of its elements, since "architectural form is a way of organizing constructed space, which makes concrete a given context" (29).

One of the most influential factors in the genesis of new forms is technology, particularly the manufacturing of mass consumption items. In striving for higher quality and indeed perfection, norms and standards become mandatory—not the norms and standards equated with mindless repetition, but those defining the desired level of quality and performance of each item produced in quantity for a mass market. Many such mass-produced objects fall short of their potential high quality because many of the objective, technically feasible, and functionally desirable standards become distorted by the exigencies of extraneous factors, commercial or political; "as soon as a most useful, most utilitarian, and most economical type has been elaborated, the influence of the superstructure and governing ideology grows, exacting its influence on this form, as form under this influence transcends its practical significance" (30).

Teige denies that form can be analyzed in the abstract. [15] Instead, he sees abstractly reified form ensuing from the "psychology of the idle classes," who produce certain forms (and their aesthetic or stylistic cast) for the purpose of influencing the psyche of the masses by their magnificence, size, opulence, and myth-making power—in short, by ornament. "The influence of architectural form on psychic life is not immanent; it is complex and develops by being contingent on practical life and sociological factors of significance. It is for these reasons that the aesthetic traditions of the past cannot satisfy those of today" (30).

Talk of technology, norms, standards, and the rejection of "form" as ornament inexorably leads to the notion of function. Teige does not fall into the trap of crass utilitarianism when discussing the role of function in housing. In fact, "an exact functional solution is something else than the satisfaction of given—if you like—atavistic and retrograde requirements, or a compromise with respect to existing circumstances" (31). He recognizes functionality in design as a contingent factor, depending as much on the satisfaction of, say, statistically determined user requirements as on the architect's interpretation of these requirements in the context of environmental, socioeconomic, cultural, and other factors.

Function provides the architect merely with the raw material with which to synthesize these factors and to orient his perspective toward accommodating future developments engendered by prospective social changes and needs: to the extent that "function combined with social needs determines an architectural solution, architecture creates new functions and awakens new needs" (31). Hence, unlike the architect-technician of the Soviet avant-garde, Teige's functionalist architect remains a creator, albeit not of new forms but of new contents.

The formalist architect presents the user with a closed "form," conceived as an "artistic" statement of an individual working within the confines of a certain "style." In contrast, Teige's functionalist architect presents the user with an open "perspective," conceived as the result of his or her deep analysis of the technical material and sociological prospects needed for their realization, that is, as an aid for the dweller "to grasp the revolutionary perspectives [of architecture] as well as . . . awaken actively new and higher cultural needs" (31). In that sense, Teige's functionalist architect is a political activist, who must act with force and initiative in the drive toward the architectural accommodation of a more perfect social order. By definition, such a "functionalism" does not exclude psychological, emotional, or even poetic factors. On the contrary, these are seen as indispensable to Teige's dream to make all of life into poetry.

This functionalism is not the same as the *neue Sachlichkeit* of the German avant-garde, or the constructivist functionalism of the Soviet avant-garde. Teige conceives it more as a stimulating force, destined to awaken "positive emotional forces" in the psyche of the dweller, to be perceived as nothing else but the awakening of a new sense of beauty as an "epiphenomenon of function" (31).

Perhaps it is in this definition of function that Teige's sociological observations appear most richly and poignantly. Instead of seeking the genesis of modern form exclusively in a regurgitation of art-historical categories, he sees form as the result of a confluence of historical developments, productive forces, and sociological conditions, all of which contribute to the transformation of certain aspects of utility (i.e., quantity) into new manifestations of poetic beauty (i.e., quality). As the "beautiful" objects of the past have lost their original utility, they invariably atrophy into "pure" decoration, to be admired by the superannuated "good taste" of the "idle classes and aestheticizing academics" (32), or to impress the confused taste of the gullible masses.

This "immanent" redefinition of beauty occurs in part as work is transformed from handicraft to industrial mass production. Thus architecture too has to become more familiar with the processes of a changed base of modern, industrially based production capabilities, and hence more scientific, to the point that it "ceases to be a pure art and becomes more of a building science" (32). Again, Teige does not mean that architecture does not produce beauty, but merely that technology has forced it to operate beyond the existing, limited framework of the aesthetic canons of architecture-as-art. In other words, it has to come to terms with the new imperatives of mechanization and industrially driven mass production, which are inexorably taking over building construction as well. Hence "architecture changed from a decorative art to something that is neither art nor decoration" (32).

We might note parenthetically that postmodernism is a perfect example of the attempt to maintain the fiction of architecture-as-art. It delights in esoteric "quotations" of historical styles and ornaments, while at the same time utilizing the most advanced methods of modern industrial capacity to replicate these "quotations" by computer-driven automatic machines and providing the interiors with the most up-to-date mechanical and hygienic services enclosed within the outward form of this or that "quoted memory." [16] Teige succinctly describes this paradox:

An architecture that wants to be a "new art" perpetuates this tradition [of academic aestheticism], in spite of telling us that it fights against idealistic architectural ideas. This is, however, nothing other than an inconsequential and opportunistic denial: a negation that is actually not at all a negation, and that overlooks the contradictions between architecture-as-art and technical development. It is a denial lacking resolution, and leads inexorably to historicizing eclecticism. (32)

This passage was originally meant as a criticism of "socialist realism," which began to emerge in Soviet architectural production during the thirties; but it applies equally to Western efforts to impose a sense of false monumentality on buildings that are neither components of Greek temples nor the palaces of the merchant aristocracy of Florence or Rome. The criticism, directed against the pompous monumentality of French social housing — designed, for example, by Ricardo Boffil — is echoed in Teige's critique of Vienna's worker's housing during the twenties and thirties as well as Erich Mendelsohn's *Gewerkschaftshaus* in Berlin, both of which he calls "luxury estates of

the worker's aristocracy and bossism" (68). Teige also sees monumentalism as a trick to deceive the workers into believing that they have finally reached the prestige level of their former oppressors, if only by a facade.[17]

Teige believes that a new monumentality is justified by the power inherent in technology only in large civil engineering works, such as grain elevators, dams, and transportation structures—for example, the Dnieprostroi hydroelectric dam. However, in proletarian housing there is no need for any monumentality, old or new, as it should be primarily conceived in terms of the proper *social type* to govern its design and production rather than in terms of some extraneously derived "metaphor" using this or that style as a vehicle of its formal expression. Hence, housing design should be aimed above all at synthesizing all possibilities for the improvement of life, in concert with the evolution of social factors in a progressive society, such as changing family relations, work, leisure, and so on. It should also counter the bureaucratic and legal impediments put in the way of free development of new housing types: laws and regulations, then as now, tend to favor the interests of the propertied classes. Teige defines the relationship between science, technology, culture, and housing as follows: "To the extent that the economic factor is in the last instance decisive, we can see that there exists a structural connection between the categories of social activities of a given era. Cultural activity is an epiphenomenon of the economic base, but economic tendencies do not, as such, have an exclusive culture-creating power" (34).

Given the mutual interaction and reciprocal influence of ideology and culture on science and technology, architectural creation is not assumed to reflect these relations in a simple or direct way; but it can significantly influence their course by acting within the orbit of their dynamic, dialectical interactions. Its role is to assist in the emancipation of humanity from enslavement by false ideologies and to create an environment that provides a positive setting for the release of positive social and cultural energies, hitherto wasted by serving exploitative models of social production or acquiescing in restrictive habits of social oppression.

This may also be the reason why Teige foresees that technology under capitalist conditions will encounter increasingly severe limitations. These are created extraneously as false cultural and economic criteria interfering with its development.[18] Teige concludes his introduction with a rather pessimistic prognosis: "After the apotheosis of technical culture, it is in our days that we experience the ideology of technical retreat.

What is setting in is a systematic curtailment of technical civilization[;] . . . thus it is not surprising that the industrialization of architecture and housing construction has experienced only insignificant advances. . . . The defamation of the machine has become fashionable" (34).[19]

THE COLLECTIVE DWELLING AS A CRITIQUE OF SUBSIDIZED HOUSING

For Teige, the primary force behind the search for a new housing type is sociological. He sees as inevitable (in Marxist terms) the emergence of such a new type for the working classes, a type that would become the architectural container in which society would be transformed from the realm of necessity to the realm of freedom, liberating men and women from the constraints of the bourgeois family and freeing women in particular from the drudgery of unnecessary housework. The implementation of this program of liberation from traditional sexual, social, and economic chains implies the radical collectivization of all formerly private household functions, such as cooking, cleaning, child rearing, entertaining, and sleeping together in a "stale" marriage bed, as well as education and leisure. Technically, the reorganization of the dwelling plan of the new collective housing type was to be accomplished by "rationalization and industrialization of construction, standardization, and mass production" (40).

Unlike in a market economy, where the house not only is a home but also represents an investment and a repository of surplus capital, Teige's proletarian dwelling becomes a pure social good, owned by the producers — that is, the workers collectively — with no intrinsic value beyond the expenditure of material and intellectual resources necessary to provide everybody with what they require, individually and collectively, for shelter. In that sense it becomes a true "minimum dwelling": no surplus value is attached to its completed stage, except the intangible element of social satisfaction, made tangible by socialism.

It is on the question of what is socially adequate or necessary that Teige parts company with his Western avant-garde colleagues. He fundamentally objects to many of the much-publicized proposals for minimum dwellings of the twenties and thirties because these designs were in essence nothing more than reduced versions: "minimal apartment reproductions of rental barracks on a higher level" (41). To be sure, Teige recognizes many of the positive features of the housing program of the modern move-

ment, such as the insistence on proper orientation, access to sun and light (figure 5), good ventilation, modern kitchen and bathroom equipment, central heating, and so on. All these he considers essential to *any* modern housing program; but to become truly efficient, housing had to be considered not only technically and operationally but also more broadly as an integral element in the transformation of society from capitalism to socialism. The result of this transformation, according to Teige, would be the emergence of a new type of housing, which he proposed to be represented by a new type; the collective dwelling (figures 6 and 7).

In the course of criticizing the development of bourgeois notions of what minimum housing should be — that is, a miniaturized nuclear family household (with the woman relegated to the kitchen) — Teige touches on an interesting feature of the development of the so-called minimum dwelling; namely, the concurrent proletarianization of the lower middle classes, who are made to believe by advertising and architects alike that modernity alone (as manifested by gleaming appliances, hot water in the kitchen and bathroom, etc.) is worth the "investment" in essentially barracklike standard minimum-size floor plans.[20] He observes correctly that the housing shortage in capitalist countries is in fact a misnomer, since the actual shortage is not in market price dwellings but only in the category of *affordable* dwellings for the low-income classes. Hence, it is a problem not of supply but of equitable distribution. Merely to shrink the size of conventional single-family housing, or to reduce the cost of construction by cheaper mate-

5. Jan Gillar, sun angles and shading patterns for the Ruzyně Housing Project, near Prague, 1930. Diagram shows shadows cast by buildings: winter: 21 December; equinox: 21 March and 21 November; summer: 21 June (p. 285).

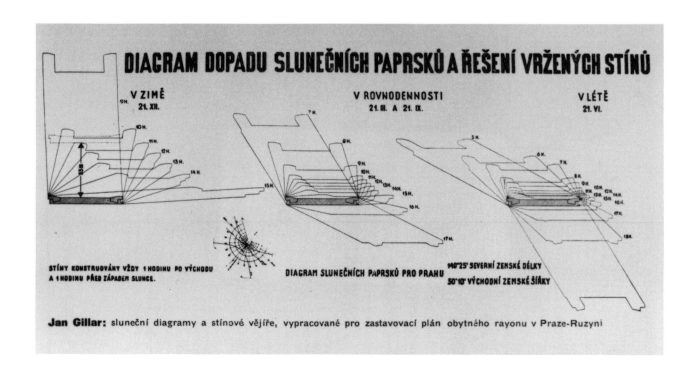

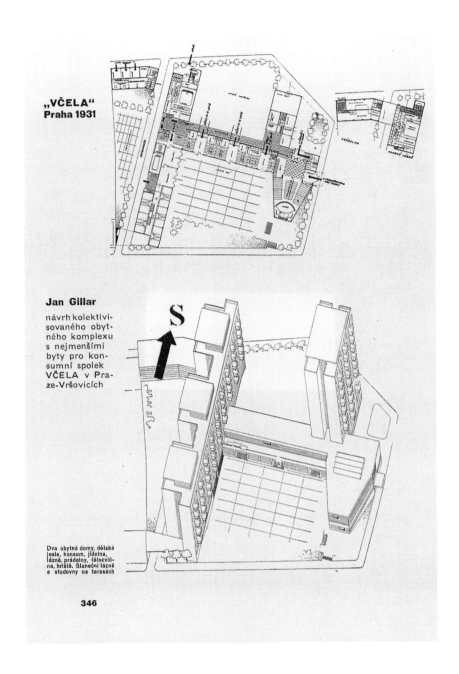

**„VČELA"
Praha 1931**

Jan Gillar

návrh kolektivi-
sovaného obyt-
ného komplexu
s nejmenšími
byty pro kon-
sumní spolek
VČELA v Pra-
ze-Vršovicích

Dva obytné domy, dětské
jesle, konsum, jídelna,
lázně, prádelny, tělocvič-
na, hřiště. Sluneční lázně
a studovny na terasách

346

6. Jan Gillar, competition entry for a housing complex with minimum flats in Prague-Vršovice, commissioned by the Consumer Cooperative VČELA (Bee), 1931 (p. 346).

Complex includes two high-rise slabs for dwellings, child care center, grocery store, common dining facilities, baths. Sun bathing, spa, and study spaces are located on the roof terraces.

7. Jan Gillar, competition entry for a housing complex with minimum flats in Prague-Vršovice, 1931 (p. 347).

Top: Ground-floor plan. Center: "Dwelling cabins (or cells). Temporary solution: A two-room apartment with facilities, 2–3 beds; the rooms are furnished as combined living-bedrooms." Bottom: "Final solution: Two dwelling cabins (or cells), ca. 13 m², with a separate entrance for each dweller, but common sanitary facilities for either a couple or two bachelors."

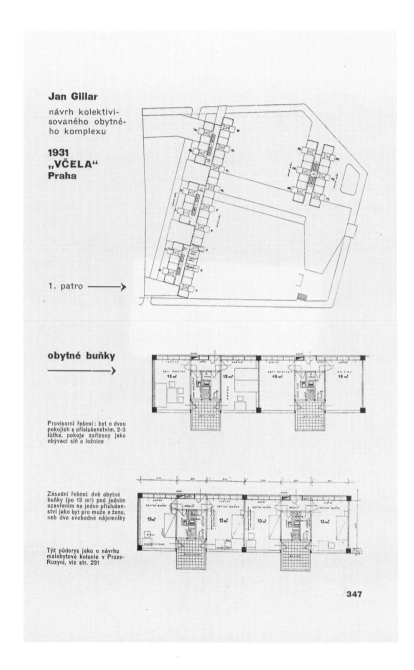

Jan Gillar

návrh kolektivi-
sovaného obytné-
ho komplexu

**1931
„VČELA"
Praha**

1. patro ⟶

obytné buňky
⟶

Provisorní řešení : byt o dvou
pokojích s příslušenstvím, 2–3
lůžka, pokoje zařízeny jako
obývací síň a ložnice

Zásadní řešení: dvě obytné
buňky (po 13 m²) pod jedním
uzavřením na jedno příslušen-
ství jako byt pro muže a ženu,
neb dva svobodné nájemníky

Týž půdorys jako u návrhu
malobytové kolonie v Praze-
Ruzyni, viz str. 231

347

rials and by eliminating ornament, and then call the result "modern" housing is both deceptive and ineffective (figure 8). The housing question is "a social phenomenon and cannot be explained solely on the basis of population dynamics, but has its roots in the *structure of the population*[;] . . . it is a crisis of class origin, not only the proletariat, but the lower middle class as well" (47; emphasis in original).

Apart from these general social considerations, Teige discusses with great clarity the relationship of wages to the cost of affordable housing. Here, he develops an interesting argument on the negative effects of rent control and housing subsidies, widely accepted as valid for mitigating housing shortages in the liberal democracies of the West. He bases his argument on an analysis of the much-vaunted "success" of social housing built in Vienna during the 1920s and 1930s by the Social Democrats. He brands the whole experiment as a case of "social dumping" of labor income, in that lowering rents and subsidizing the costs of housing construction were essentially instruments for keeping general wages low, thus allowing Austria to compete internationally against higher-wage countries (which at that time included Czechoslovakia), thereby assuring higher profits for its capitalist entrepreneurs at the expense of Vienna's own working class. Thus rent control actually represents an "export premium for industry, since it can export cheaper goods owing to lower wages" (49). Not only do lower rents artificially distort wages, but once the workers are enticed to occupy subsidized housing they are made captives in their "low-rent" apartments; they find it difficult to move or look for a better job in places without subsidized housing.[21]

Another part of the deception was the financing of Vienna's so-called low-cost housing with "public" money. Hidden taxes effectively saddled the working class with covering 80 percent of the cost of the new public housing; construction workers also bore indirect costs of low wages paid by private builders, who eventually profited handsomely from these estates. For these and other reasons, too numerous to mention here, Teige labels Vienna's experiment "petit bourgeois socialism," where so-called social housing is a reform that sustains the status quo. It leaves untouched a much larger problem; namely, the need to provide full employment at wages high enough to allow the workers to choose their housing freely rather than having to rely on private charity or municipal benevolence to bestow favors on them.[22]

Teige further asserts that subsidizing housing *construction* out of public funds and taxes is usually designed primarily as a means to support the well-being of the building

8. Evžen Linhart and Jan Rosůlek. Design for row housing of the open corridor type, with small apartments, 1930 (p. 226). "A. Apartment floor area 47.60 m², 2–3 beds. B. Design for an apartment with a balcony, with varying wide and narrow cross-section." Legend: *pokoj* = room; *přeḍs.* = hall; *kuch.* = kitchen.

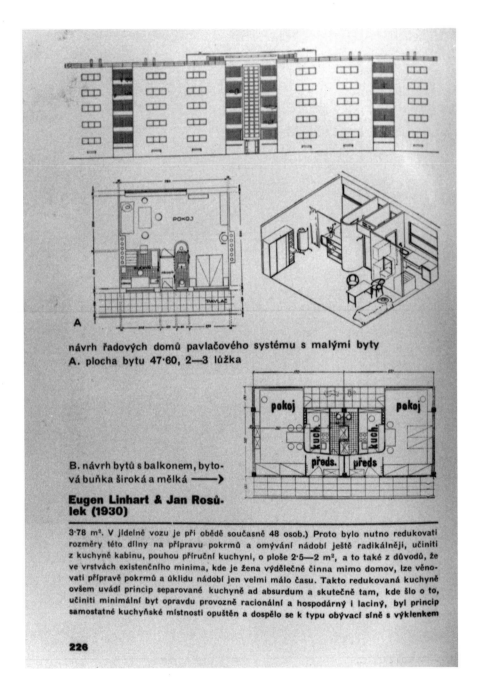

návrh řadových domů pavlačového systému s malými byty
A. plocha bytu 47·60, 2—3 lůžka

B. návrh bytů s balkonem, bytová buňka široká a mělká ——>

Eugen Linhart & Jan Rosůlek (1930)

3·78 m². V jídelně vozu je při obědě současně 48 osob.) Proto bylo nutno redukovati rozměry této dílny na přípravu pokrmů a omývání nádobí ještě radikálněji, učiniti z kuchyně kabinu, pouhou příruční kuchyni, o ploše 2·5—2 m², a to také z důvodů, že ve vrstvách existenčního minima, kde je žena výdělečně činna mimo domov, lze věnovati přípravě pokrmů a úklidu nádobí jen velmi málo času. Takto redukovaná kuchyně ovšem uvádí princip separované kuchyně ad absurdum a skutečně tam, kde šlo o to, učiniti minimální byt opravdu provozně racionální a hospodárný i laciný, byl princip samostatné kuchyňské místnosti opuštěn a dospělo se k typu obývací síně s výklenkem

226

industry — especially during recessions — rather than that of the poor. Indeed, true low-cost construction would not have to be subsidized, for it would be able to deliver the product as an affordable item on the open market even to those with low incomes. In addition, "these subsidies have never been able to reach the poorest of the poor . . . because the price of even the least expensive apartment [or house] is higher than their ability to pay" (49).

The conclusion of this economic and sociological critique is that most, if not all, of the solutions offered at that time by the avant-garde of modern architecture should be regarded more as palliatives than as serious answers to the question of the minimum dwelling. Their value lies primarily in their application of new materials and methods of construction to the design of rationalized and mechanized conventional housing types, not in breakthroughs in concept or form. Thus Teige recognizes the valuable contributions of such masters as Le Corbusier, Walter Gropius, and Mies van der Rohe while at the same time severely criticizing their conceptual approach.

TEIGE AND THE AMERICAN SINGLE-FAMILY DETACHED HOUSE

Teige never visited the United States. For this reason, and driven by Marxist leanings that impelled him to concentrate his attention on events in the Soviet Union, his understanding of the situation in the United States came essentially from secondhand reports, given in meetings and articles, by colleagues who had visited America.

The disastrous effects of the U.S. stock market crash of 1929 were not immediately felt in Europe, but they were equally devastating on the economies of all its countries, Czechoslovakia included (figures 9 and 10).[23] This reinforced the bias of the left wing of the Czech avant-garde against anything emanating from the most powerful bulwark of capitalism, the United States. Nevertheless, Teige is not entirely negative in his assessment of the American housing situation. For example, he admits that the United States is a "high wage" country, where the workers (if they are able to find work) can afford housing vastly superior to European housing in its spaciousness and equipment.[24]

He is less positive in the analysis of the single-family detached house, which he cannot make himself accept as a valid solution to the problem of the minimum dwelling under any circumstances, regardless of its popularity among members of the American working class. Teige dismisses their preference as mere "cottage dreams," asserting

9. 1830–1930–? (p. 53). Homeless in a European city.

"The jungle of housing misery in the slums and on the periphery of all European cities, cities of today's culture and civilization, world-class cities of light, the other side of splendid appearance and the sumptuous monumentality of the boulevards and grand villa districts. New construction and slum clearance do not eliminate but (on the contrary) produce the growth of such housing cesspools and sharpen the class contrast in the distribution of housing space."

that "even a modernized small family house, a ridiculous caricature and miniature edition of a villa, is not an advance in the solution of the housing question; the [single] family house is in principle a reactionary housing type, a remnant of agrarian medieval times" (52). Teige's primary objection to the single-family home is clearly not practical but political, since he believes that "it practically and psychologically strengthens in its occupants the ideas of private ownership and family . . . and thus feeds the roots of opportunistic individualism" rather than the socialist ideal of cooperative collectivism; "and so, in spite of everything, the single-family house persists as a sentimental fetish, . . . buoyed up by advertising and official propaganda as the ultimate fulfillment of everybody's dream of the ideal home" (52).

The same advertising and the same propaganda never mention, however, the burden put on the wage earner by his obligations to pay the land rent called property taxes, endless mortgage payments at high interest, and unceasing repair and maintenance bills, not to mention the time spent tending the garden and backyard. Such demands make the owner an obedient and fear-ridden dependent of his employer, who ultimately "owns" the "my house is my castle" (Teige uses English in the original) by proxy, if not directly through having advanced the loan for the mortgage—with interest, of course.[25]

1830 — 1930 — ?

Džungle bytové bídy ve vyděděných čtvrtích a na předměstí všech evropských měst, měst dnešní civilisace a kultury, měst světa a světla, rub splendidní výstavnosti a monumentálního přepychu bulvárů a vilových čtvrtí. Stavební ruch a asanace měst neruší, nýbrž produkují ve zvýšeném množství takové bytové kloaky a zostřují třídní kontrast v rozdělení bytového prostoru

162

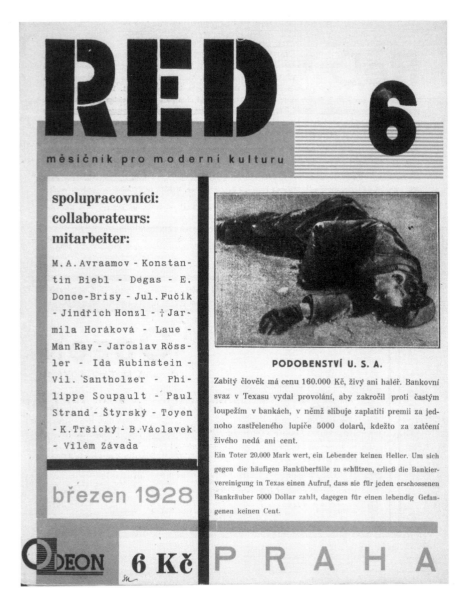

10. Cover of *ReD* 1, no. 6 (March 1928). Caption below picture reads: "A Portrait of the U.S.A."

Text below picture (in both Czech and German): "A dead man has a value of 160,000 kč, a live one not a cent. The Bankers Association of Texas has issued a proclamation with the aim to prevent increasingly frequent bank robberies. It promises to pay a reward of $500 for shooting a bank robber dead, but for the arrest of a live one they will not pay a nickel."

Teige concludes that "The housing question is a social question and therefore its solution is not without difficulties for the ruling class: Attempting to solve the housing problem by humanistic and philanthropic methods is never a truly altruistic venture, since all these philanthropic efforts still have to—one way or the other, directly or indirectly—be made eventually profitable. Such a solution turns out to be either an illusion or a fraud," and "because the housing question, in particular the housing crisis, is inextricably linked to the current economic system, it cannot be liquidated unless the system itself is liquidated and replaced by a new system" (51)—socialism.

TEIGE'S CRITIQUE OF MODERNIST HOUSING OF THE 1920S AND 1930S

Given this background, it may be useful to examine Teige's quarrel with the founding fathers of the Modern Movement in architecture, attempting to separate his legitimate objections to their approach to the question of the minimum dwelling from ideologically colored posturing.

The story of Teige's quarrel with Le Corbusier, also known as the "Mundaneum affair," is well known and need not be repeated here.[26] His opposition to the program of the CIAM is discussed in Spechtenhauser and Weiss's essay in this volume (which should be considered as supplementary to the following discussion). Less well known is Teige's profound criticism of specific housing designs by the same masters of modern architecture, produced in the twenties and thirties. Seen in the context of the critical material contained in *Nejmenší byt,* the Mundaneum affair clearly represented merely one instance in a long series of polemical arguments criticizing and rejecting the concepts and designs of many of the well-publicized housing proposals of the twenties and thirties.

Let us look at some of the examples of this polemic. Nearly four decades before Philippe Boudon published his critical book *Lived-In Architecture: Le Corbusier's Pessac Revisited* (1969),[27] Teige wrote: "This colony has a peculiar history. Even today it is uninhabited, a modern Pompeii, gradually falling into disrepair. Its history reads like a Balzac novel" (70). As Boudon would later make clear, the history of the design and construction of Pessac was indeed worthy of dramatization, albeit not in the manner of Balzac but more as a comedy of errors of Voltairian dimensions. Though Teige held no brief for the garden city concept, he considers Pessac's only positive feature the fact

that it "is the only garden city with high architectural qualities [of its individual houses]; . . . the rest is without architectural merit" (70).

Teige's criticism anticipates to a large extent the "participation" phase of modernism (so popular in the late 1960s and early 1970s among the young) by gauging correctly the worker's reaction to Le Corbusier's utopian scheme: "Let us have no illusion! The workers, whose lucid shrewdness I sometimes admire, will be horrified by these houses: they will call them boxes" (70).[28] Teige further correctly surmises that the only people ready to admire this project would be the aristocracy and the intellectuals, or perhaps the intellectual aristocracy of the architectural press.[29] Teige predicts that the intellectual elite of the modern movement in architecture will "translate" Le Corbusier's ideas by "combining two, three, or four of the plans and offer houses of 90, 135, and 180 square meters in the luxury market" (72), preferably as grand villas for the rich.[30] He aptly illuminates one of the hidden paradoxes of the design solutions labeled "minimum housing" by Le Corbusier and others; "one starts with a small house, which is rationalized, and arrives at a big house, three times the original plan, because the small house is [already] too expensive for people earning a minimum wage" (72) and thus may just as well be produced in a luxury edition. In a curious reversal, those large houses are subsequently publicized as models for the "solution" of low-income housing problems.

As the later history of the development of modern prototypes for public housing makes clear, Teige recognized but underestimated the desire of the lower-income classes to emulate the lifestyles of the rich, even if this sometimes meant the sacrifice of essential services or additional floor space (figure 11). He hoped that this desire to catch up with the rich would be eliminated by eliminating the rich in the new socialist order. The rejection of the modernist program by Stalin in 1936 forced him to revise this expectation. Stalin evidently had a better understanding of his worker's "shrewdness" than did Teige. A stark division between visceral perceptions of reality and anarchistic longings of a poetic soul for a socialist utopia pervades all of Teige's writings on architecture, and those on the minimum dwelling in particular.

Few of the prominent architects of the modern movement proposing minimum dwelling projects escape Teige's sharp critical eye. Take J. J. P. Oud. Teige considers his high-rises "outdated," both technically and in their plan layouts, and in fact far behind American designs of skyscraper solutions for both hotels and housing. As in

11. Ladislav Žák, a proposal for the conversion of an old building into small apartments, 1929 (p. 244).

Captions: "1. Demolish wall between kitchen and the adjacent room and reduce size of kitchen: in place of a single [large] room there is created a space with differentiated functions, such as sleeping, living, and dining nooks. The hall becomes the bathroom, ventilated through a closet. 2. A similar reduction of the old partition wall in a larger apartment produces similar differentiated nooks."

America, Oud's high-rise dwellings are affordable only for the well-off, certainly not for lower-income groups. Teige further criticizes their "poor orientation, insufficient sun exposure, overbuilt blocks, and excessive density" (81).

Teige's criticism of these modernist proposals does not stop at the house as such, but extends to a detailed criticism of site planning and urban design. Here, too, we find a mix of genuine admiration of the technical innovations proposed and a condemnation of their sociopolitical context.

CRITICISM OF LE CORBUSIER'S NEW CITY PROPOSALS

Departing from sociological as well as historical analysis of the transformation of the traditional town into the modern metropolis, Teige projects this change into his Marxist utopia of the dissolution of the contradictions between city and country. It is embodied in his vision of the new socialist city, where the "natural bond" between man and nature, and thus the disruption of the "natural equilibrium between the forces of nature and habits of life[,] . . . will be restored by the reorganization of productive forces on a global scale, to arrive at a social order that will transport humanity from the realm of necessity to the realm of freedom" (362).

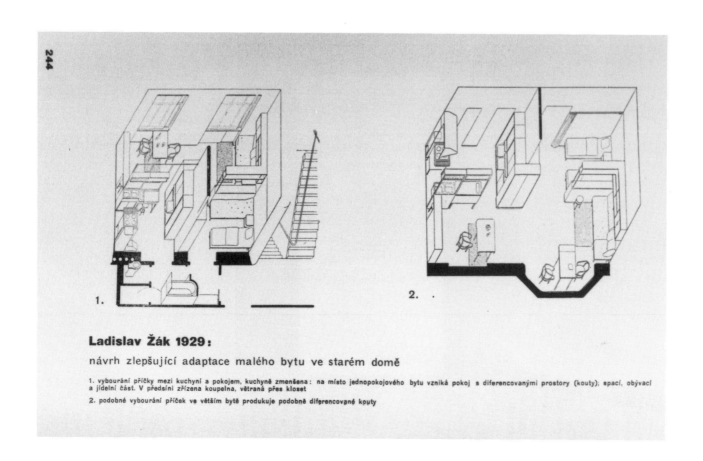

244

Ladislav Žák 1929:

návrh zlepšující adaptace malého bytu ve starém domě

1. vybourání příčky mezi kuchyní a pokojem, kuchyně zmenšena: na místo jednopokojového bytu vzniká pokoj s diferencovanými prostory (kouty): spací, obývací a jídelní část. V předsíni zřízena koupelna, větraná přes klozet.
2. podobné vybourání příček ve větším bytě produkuje podobně diferencované kouty

166

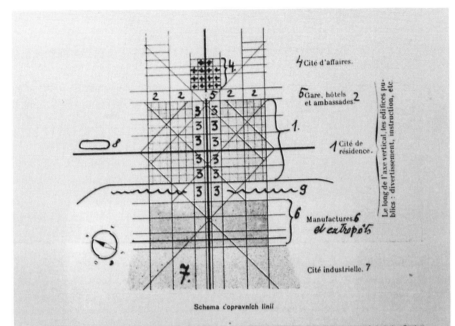

Schema dopravních linií

1 = obytný okrsek, nadhustota: 1000 obyv. na hektar, při svislé ose v centru obytného okrsku veřejné budovy

2 = okrsek hotelů a vyslanectví

3 = veřejné budovy

4 = obchodní City, křížové mrakodrapy obsazení: 3200 obyv. na hektar.

5 = nádraží

6 = dílny, manufaktury, skladiště

7 = pásmo velkoprůmyslu

8 = sport

9 = zelené pásmo s universitním městem a stadiony

Zářící Město jest sidlištěm 1,500.000 obyvatel

„Zářící město" je zajímavé ve srovnání s Le Corbusierovým projektem „Une ville contemporaine" z r. 1922 (velkoměsto pro 3,000.000 obyvatel) a s „Plan Voisin" především tím, že vysunuje obchodní mrakodrapovou City mimo geometrické centrum. Pod zřejmým vlivem sovětské výstavby socialistických měst aplikuje tu Le Corbusier mechanicky princip pásmového města, „socgorod", vypracovaný Miljutinem a jeho spolupracovníky, na velkoměsto finančního kapitalismu. V sovětských plánech nových měst je basí a východiskem výroba: průmyslové a zemědělské pásmo, u „Zářícího města" je osnovným elementem b y d l e n í. „Zářící město", jako všechna v e l k o m ě s t a kapitalismu, je oderváno od venkova, není spojeno se zemědělstvím. S principem pásmového města je v rozporu velmi důrazně vyjádřená akademická vertikální osa souměrnosti, a rovněž arabeskovitý zastavovací způsob v obytném okrsku. Volná arabeska zastavovacího plánu poskytuje sice četné plastické efekty, avšak, oproti jednořadovému zastavění, má četné praktické nevýhody: nestejnoměrné vzdálenosti protějších průčelí, nestejnoměrné osluněni; pravoúhlé zálomy domovních řad vrhají nepříznivé stíny. Dopravní třídy a autostrády jsou na mnohých místech vedeny těsně podél domovních řad.
Le Corbusier vypracoval rovněž aplikaci systému „Ville Radieuse" na rekonstrukci Moskvy.

Le Corbusier & Pierre Jeanneret: Ville Radieuse
Zářící Město

1929—31

138

12. Le Corbusier and Pierre Jeanneret, Ville Radieuse, 1929–1931 (p. 138). Critique of Le Corbusier's plan.

Text below illustration: "The Ville Radieuse is interesting in comparison with Le Corbusier's Une ville contemporaine of 1922 (a metropolis of three million inhabitants) and the Plan Voisin, most of all, because it pushes the commercial skyscraper city beyond the geometrical center. [This solution is] clearly influenced by the Soviet development of their new socialist cities, [except that] Le Corbusier applies in an overly mechanical manner the principle of the linear city 'sotsgorod,' worked out by Miliutin and his collaborators, to the metropolis of finance capitalism. In the Soviet plans for their new cities, the basic point of departure is *production;* industrial and agricultural zones; in the Ville Radieuse the main element is housing. The Ville Radieuse, like all metropolises of capitalism, is severed from the country and not integrated with agriculture. The principle of the linear city is [also] in conflict with a very much emphasized academic vertical axis of symmetry and the arabesque pattern of the residential district. The free arabesques of the buildings may well offer a number of plastic effects, but, compared to [continuous] linear buildings, they have many practical disadvantages: uneven distances between opposite facades, irregular solar exposure, right-angle breaks in the housing rows that cast bothersome shadows. The traffic arteries and freeways are in many cases much too close to the [facade] lines of the housing rows.

"Le Corbusier has also developed an application of his Ville Radieuse concept to the reconstruction of Moscow."

167

While he agrees with the program of modernism with respect to its rejection of the English garden city concept as a romantic illusion, designed to divert attention from the real problems of the modern metropolis, Teige sees the various solutions proposed during the 1920s and 1930s by the leaders of the Modern Movement in architecture as equally deficient, in that none of them attacks the problem on a truly regional basis (Frank Lloyd Wright's Broadacre proposal notwithstanding).[31] Instead these leaders are satisfied to offer mostly partial answers to selected problems, such as provision of sunlight, air, controlled local traffic circulation, and so forth. He decries their universal acceptance of the constraints imposed by the capitalist order, even in cases in which the proposals are offered as (philanthropic) solutions by social democratic or liberal welfare programs.

The best way to understand Teige's ambivalent attitude vis-à-vis CIAM-sponsored urbanism is to look at some detail at his criticism of Le Corbusier's Ville Radieuse (figure 12). As documented in other essays in this book, Teige both admired and rejected the great master throughout his involvement with modern architecture during the twenties and thirties. He concedes that circumstances forced Le Corbusier to take his point of departure for solving the problem of the contemporary city from existing conditions in France and the rest of Europe, and the givens imposed by the concentration of capital and political power in the modern metropolis. For example, he slyly observes that under the liberal democratic system it was impossible to plan beyond the horizon of short-term parliamentary election cycles and that "after all, it is understandable that Le Corbusier proposes that a Ministry of Public Works should be established, independent of the powers of parliament" (121); he thus in fact proposes a kind of economic dictatorship by the modernist elite with Le Corbusier as its patron saint.[32]

Continuing in his criticism, Teige shrewdly exposes Le Corbusier's dilemma as he attempts to solve the problem of traffic pollution by proposing a hermetically sealed, artificially lit, ventilated, and heated house as one answer and the placement of solitary skyscrapers in open space as another. Teige correctly states that each solution may be conceptually and technically ingenious, but each is also troubling for reasons beyond the matter of cost: "how will this affect a human biologically in a circumstance where he or she is put daily for eight [or more] hours into an artificial environment, cut off from natural influences in an absolutely sealed off space. Does he become a cave dweller?" (127).[33]

168

As to Le Corbusier's famous urban proposals, Teige credits him with "the most consequential and most broad-minded intellectual work in urbanism . . . above all his proposed concept for the contemporary city for three million inhabitants, the Une Ville Contemporaine of 1922, and the project for the reconstruction of the center of Paris, the Plan Voisin of 1925" (136). Teige tempers his enthusiasm with two major criticisms. He points to both Le Corbusier's "technocratic romanticism" and — in the main thrust of his attacks on the master — Le Corbusier's insistence that architecture is art, that is, his architectural formalism. Teige suspects that Le Corbusier's technocratic romanticism is actually a ruse to avoid confronting the political dimensions of his urban proposals by simply declaring that the modern city is the inevitable result of its technical transformation from the premachine era into a modern, technology-driven urban machine. Indeed, Le Corbusier's famous remark that "the house is a machine to live in" reflects a similar view.

However, Teige suspects that in the end Le Corbusier does tacitly admit that the modern city is dominated by the need to accommodate capital: he places the business center in the most concentrated part of his projects, while avoiding excessive densities elsewhere by building skyward with high-rises and by extending the center outward toward the periphery.[34] Teige perceives a contradiction in this strategy, since by expanding in a fanlike manner, the "center" ceases to be well defined; all ends up essentially as a more or less dispersed periphery, lacking clear boundaries on either its interior or exterior limits. Moreover, the cunning device of offering the center to "finance capital, the banks, the captains of industry, and international economic interests," while allowing residential uses to approach in wedges close to the center, seems to bear out Teige's suspicion that Le Corbusier was not as politically naive or neutral as he pretended to be in his writings. The goals of such an arrangement of land uses should be clearly recognized: it is a shrewd means to increase land values both in the center and along the new traffic arteries radiating outward, which thus "become a gold mine for land speculation" (137).

Furthermore, the small proprietors of the dispersed, small parcels of the future central business area are forced to sell their properties at controlled or depressed prices to the same banks that were also expected to finance future development for the large corporations for which the center has been reserved. As a consequence, the small proprietors are effectively pauperized, while large capital is profiting at each end of the

transaction. To secure a low price for the properties to be bought out, bonds were to be issued at the assessed value of the small parcels *before* the publication of the plans for the development of the new center, and *before* the rise of land values expected to follow their approval by a compliant city administration. Moreover, the banks not only hold the collateral of these bonds but also use this collateral to finance the speculative cycle of new development, thus reaping enormous profits for themselves and their large corporate holding companies during all phases of these transactions.[35] Teige notes, "Le Corbusier's Ville Radieuse and his urban theories in general . . . are a clear expression of an architectural ideology, closely linked to the interests of financial capital: his radical technical ideas are timidly adapted to the framework of today's social structures and economic conditions" (137).

According to Teige, Le Corbusier's slogan "architecture or revolution" is a deception as well.[36] It was really meant as a warning to the ruling classes that if they fail to provide more decent housing for the workers, then the workers will be "compelled to make revolution" (143). Read this way, the misleading slogan confirms in Teige's mind Le Corbusier's essentially antirevolutionary position, actually intended to forestall a disruption of the status quo rather than to support genuine change and thus giving the lie to the notion that he was politically naive.[37] On the contrary, Teige considers him extremely shrewd in publicly professing to be deeply dedicated to the improvement of the housing conditions of the poor, while at the same time privately courting high-ranking members of the establishment and promising handsome profits to be made in vast land speculation shell games.[38]

If one assumes that Le Corbusier did not intend to court the speculator, the results are the same. Because he intentionally or unintentionally ignored the effects of his architectural and urban innovations on the organizational and productive structures needed to implement his schemes, Le Corbusier is accused by Teige of "technical utopianism." That is, he may be offering certain valuable lessons of possible new and technically interesting solutions, but at the same time he fails to draw the correct conclusions regarding their effect on the social and political order in which these productive solutions are to be implemented. Or, expressed somewhat differently, his utopianism stems from a "misreading of the capacities of the prevailing social order to accommodate the more visionary aspects of his proposals" (144). In that sense, "Le Corbusier operates with superficial and illusory pseudo-theories, while others substi-

170

tute for theory the analysis of statistics of traffic, housing, taxes, hygiene, and so forth. That is, they use a thermometer as a substitute for a diagnosis" (148).

Speaking of the problem of the contradictions between the city and the village (a mandatory Marxist theme), Teige accuses his Western avant-garde colleagues in general and Le Corbusier in particular of completely ignoring the problem. Their only solution is to herd "millions of country folk into a few big cities" (265). Their proposals for quasi-urban "modern" settlements substitute for a real, comprehensive solution of the problem on a global scale, while at the same time ignoring the urgent need for improving country life by mandating modern facilities for education, hygiene, culture, and housing in backward villages.

WHAT TYPE OF HOUSING FOR THE NEW CITY?

In a separate chapter, Teige refers to the great debate during the Third CIAM Congress on the question of high- versus low-rise housing, high-density versus dispersed dwellings, single-corridor versus double-loaded streets, flat versus pitched roofs, and, most important, the issue of single-family versus collective housing. He condemns on principle all partial solutions; as we have already seen, he believed that none can become truly effective unless implemented within the framework of an overall comprehensive plan. Thus he categorically rejects the CIAM resolution of 1935 (see also Spechtenhauser and Weiss, below), which he brands as

not being a resolution at all, [since] . . . to make a decision on this question would be premature . . . [and] apart from its technical aspects an important role is played by social, psychological, and biological moments as well. . . . The question of the minimum dwelling and its appropriate constructed form cannot — by the way — be posed in all its complexity as a question of the utility of high-, medium- or low-rise houses. That would mean to solve the problem on the wrong track. (267)

This is a good place to return to the discussion of Teige's criticism of Le Corbusier's high-rise solutions for the Ville Radieuse. By eliminating the traditional urban corridor street from his scheme, Le Corbusier is forced to consider a conceptual alternative, which he finds in placing single, freestanding high-rises in a parklike landscape. But instead of exploring the environmental and rationally grounded planning conse-

13. Le Corbusier and Pierre Jeanneret, Ville Radieuse, 1930. "Analysis of sun angles with respect to the arabesques of the housing sector of the Ville Radieuse" (p. 139).

"Dwellings oriented south, southeast, east, or west. A housing row that has both facades oriented toward the sun has apartments on both sides of the central corridor. In places where the facade is without sunlight, apartments are only on one side of the side corridor."

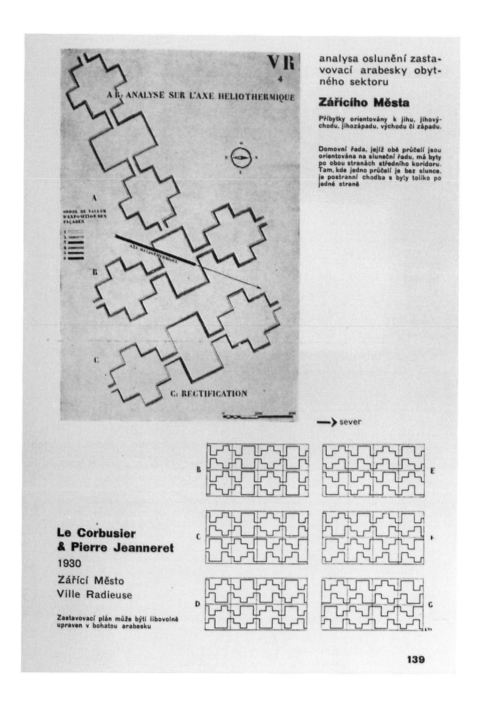

analysa oslunění zasta-
vovací arabesky obyt-
ného sektoru

Zářícího Města

*Příbytky orientovány k jihu, jihový-
chodu, jihozápadu, východu či západu.*

Domovní řada, jejíž obě průčelí jsou
orientována na sluneční řadu, má byty
po obou stranách středního koridoru.
Tam, kde jedno průčelí je bez slunce,
je postranní chodba s byty toliko po
jedné straně

**Le Corbusier
& Pierre Jeanneret**
1930
Zářící Město
Ville Radieuse

Zastavovací plán může býti libovolně
upraven v bohatou arabesku

139

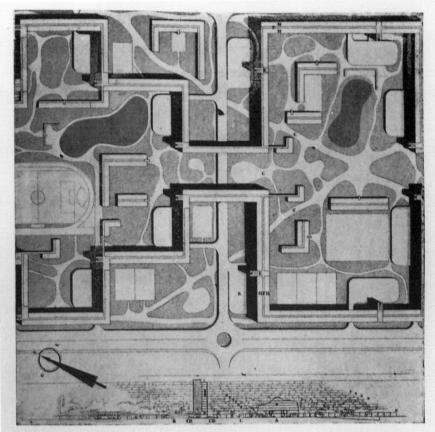

Obytný element: standardisován, doprava: konstrukce na pilířích umožňuje volně trasované cesty pro pěší, dopravní ulice jsou zdviženy (I. patro), obytné ulice ve vnitřku bloku, orientace: volná, uzavřené rohy však omezují slunečnost bytů. Celková plocha ulic 9%, volné plochy 91%, počet obyvatelů na 1 ha 1000

Schema zastavovacího plánu obytné čtvrti Zářícího Města

Dlouhé řady 10—12 patrových domů, zalomené do ortogonální arabesky s rozmanitými variacemi. Nestejnoměrná orientace průčelí k slunečním stranám vede k střídání tří-traktového systému (se středním koridorem) a systému s postraní chodbou. Obytné domy jsou hotelového systému. Domy na pilířích, veškera půda vrácena zeleni a chodcům. Obytnou čtvrtí vede síť dopravních tříd šachovnicově, ve vzdálenosti 400 × 400 m. Uprostřed mezi obrazci zastavovací arabesky sady, školy, dětské domovy, sportovní prostranství a plochy pro parking aut, bezprostředně u vchodů k liftům

1930 Le Corbusier & Pierre Jeanneret: Ville Radieuse

141

14. Le Corbusier and Pierre Jeanneret, Ville Radieuse, 1930. Site-planning scheme for a residential sector of the Ville Radieuse (p. 141). *Translation:*

Residential Element: standardized, *transportation:* the piloti construction system allows for a free [disposition] of the routing of pedestrian ways, vehicular streets are raised (to the level of the first floor), residential street inside the blocks, *orientation:* loose, however, closed corners limit access to sunlight to [some] apartments. Overall area of streets: 9%, open spaces 91%, number of inhabitants per hectare is 1000.

Schematic of the site development plan of a residential district of the Ville Radieuse

The long rows of 10- to 12-story houses are inserted into the orthogonal arabesques in sundry variations. The uneven orientation of the facades toward the sunny side leads to alterations of the system of rows with central corridors as well as those with single side corridors. The dwellings are of the hotel type. The houses on piloti return all surface spaces as green areas for pedestrians. The residential district is penetrated by a grid-like transportation network, spaced at 400 × 400 m. In the center, among the pattern of the arabesques, are located public gardens, schools, children's creches, sports areas and parking close to the elevator entrances.

173

15. Walter Gropius, ten-story boarding-house-type housing, 1930 (p. 261).

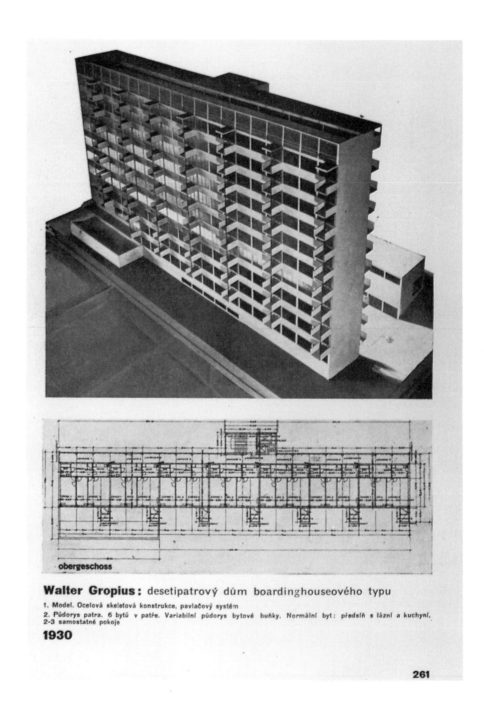

obergeschoss

Walter Gropius: desetipatrový dům boardinghouseového typu

1. Model. Ocelová skeletová konstrukce, pavlačový systém
2. Půdorys patra. 6 bytů v patře. Variabilní půdorys bytové buňky. Normální byt: předsíň s lázní a kuchyní, 2-3 samostatné pokoje

1930

261

quences of this new relationship between building and open surround, he chooses instead "orthogonally conceived, irregular arabesques . . . which result in a site plan of presumably richer architectural effect"; he arranges the houses "as stage sets, just in order to prevent the appearance of monotony for its own sake (267)" (figure 13).[39] According to Teige, this has a number of deleterious results for the final design. For example, the zigzagging of the footprint deprives a number of windows of direct sunlight and introduces costly corners for no apparent reason save aesthetic play with form (and it also produces additional shaded areas for the corner apartments by turning them at right angles to the sun-oriented side of the facade).

Apart from the zigzag "arabesques" of the houses, Teige also criticizes their excessive length, requiring endless corridors that make communication from elevator to apartment much more cumbersome than the former direct access to each apartment from a regular street (figure 14). Thus Le Corbusier "eliminates from the plan of his city the traditional corridor street, and [effectively] transforms the corridors in his houses into actual streets, but [ends up] with bad ventilation and no natural light" (269). This is the same "techno-romanticism" for which Le Corbusier was faulted in connection with his proposal for the hermetically sealed house; thus the Ville Radieuse represents an equally defective approach with its "streets in the air."

Walter Gropius does not fare much better. For example, Teige exclaims:

there again, we witness how the architect deforms the achievements of technical and architectural progress in the interests of the ruling class. . . . Gropius may point out that for the choice of future housing form, political evolution and the evolution of a [new] worldview will be decisive; however, he does not derive from this statement the professional consequences in his work and is [instead] content with escaping to the future through a diplomatic back door. (270)

The reason for this frontal assault is Gropius's inclusion of the traditional kitchen in his housing schemes (figure 15), as for example in his design of bachelor flats in the Spandau-Haselhurst Project near Berlin (Stahlhochhaus mit zentralem Gesellschaftsraum, 1930). Believing that the traditional bourgeois family should be eliminated as a design assumption from all progressive minimum dwelling housing solutions, Teige is uncompromising on this point.

16. Josef Polášek, a housing colony in the city of Brno, 1931–1932 (p. 123).

Top: "Housing rows (5 rows of 4-story houses)." Center: "Open space between the rows." Bottom: "Row of 4-story houses with a single-story structure placed at right angles, facing the main street. This is a group of 4-story houses in a linear arrangement. The space in between the rows is closed by the low-rise row, with stores along the main street. The apartments are facing south and west. 190 single-room apts., 40 single-room apts. with toilet, 8 two-room apts. Central automatic laundry and children's playgrounds."

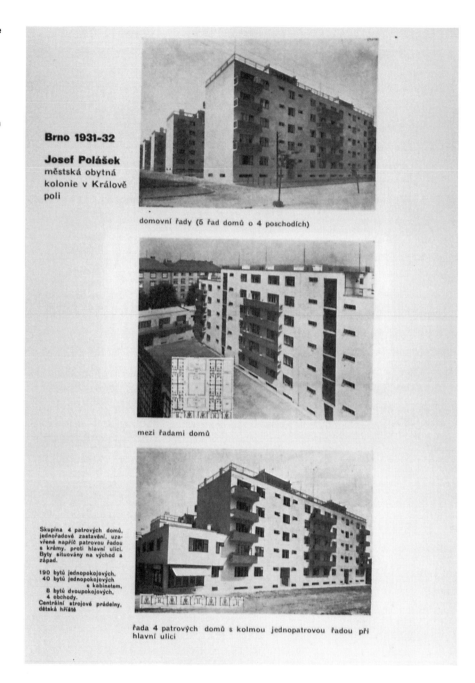

Brno 1931-32

Josef Polášek
městská obytná
kolonie v Králově
poli

domovní řady (5 řad domů o 4 poschodích)

mezi řadami domů

Skupina 4 patrových domů,
jednořadové zastavění, uza-
vřené napříč patrovou řadou
s krámy, proti hlavní ulici.
Byty situovány na východ a
západ.

190 bytů jednopokojových,
40 bytů jednopokojových
s kabinetem,
8 bytů dvoupokojových,
4 obchody.
Centrální strojové prádelny,
dětská hřiště

řada 4 patrových domů s kolmou jednopatrovou řadou při
hlavní ulici

THE NEW WOMAN IN THE NEW HOUSING

The rationale for eliminating the kitchen is contained in Teige's radical views on the liberation of women from all housework drudgery and homebound activities. The inclusion of collective facilities in all future housing implies the full integration of women in all productive activities of society as equal partners with men. That process also includes eliminating the "stale" marriage bed, as women will become liberated sexually from the bonds and bondage of bourgeois marriage; each partner in a sexual relationship is to be assigned his and her own bedroom in the new collective house (or at least separate beds in a single bedroom, if that is the only economically feasible solution.[40] Obviously, such a changed economic and sexual relationship would have had to be accounted for in the plans of any avant-garde housing scheme. Failure to do so made all the plans of the elders of the avant-garde seem to Teige like "old wine in new bottles." The only feature of Gropius's solution which Teige prefers to that of Le Corbusier is the elimination of any kind of "arabesque" from the design, and his strict adherence to the more rational *Zeilenbau* (linear block) concept (figure 16).

In a similar vein, Bruno Taut is singled out by Teige as committing a serious error in what he otherwise considered to a be a splendid book (*The New Dwelling*). Taut states that "the woman is the creator of the modern household" and coins the phrase "der Architekt denkt, die Hausfrau lenkt" (the architect proposes and the housewife disposes) (quoted, 312). Teige finds this remark not only somewhat condescending toward modern woman but also a poor foundation for conceiving a typology of advanced solutions for modern housing in general and for the minimum dwelling in particular.

As proof of his contention that the kitchen is on the way out as the center of the house plan even during his own time, Teige points to examples of residential hotels and boardinghouse types in Europe and the United States as being actually far more advanced in their conception than the vaunted proposals of the leaders of the avant-garde of modern architecture (figures 17 and 18).

TECHNOLOGY, THE FAMILY, AND THE CITY

The preceding discussion suggests three critical agents of change for the conception of a radically new housing program; technology, the family, and the contemporary city.

With respect to technology, Teige is in general agreement with most if not all of his contemporary avant-garde colleagues; he sees the technical modernization of the

177

17. Arthur Loomis, Hotel Skelton, New York (p. 297). Top: "A typical central corridor traverses all wings of the building." Bottom:"Floor area: 41.62 m²; central corridor, bedroom and living room, bathroom and dining nook. There is no cross ventilation."

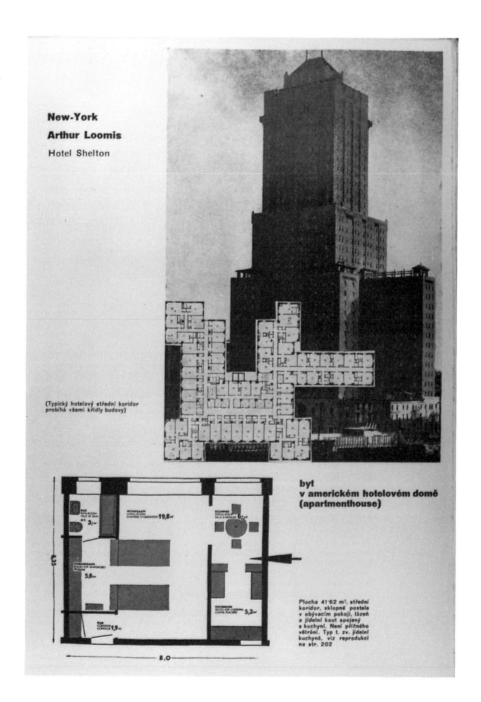

New-York

Arthur Loomis

Hotel Shelton

(Typický hotelový střední koridor probíhá všemi křídly budovy)

byt
v americkém hotelovém domě
(apartmenthouse)

Plocha 41'62 m², střední koridor, sklopné postele v obývacím pokoji, lázeň a jídelní kout spojený s kuchyní. Není příčného větrání. Typ t. zv. jídelní kuchyně, viz reprodukci na str. 202

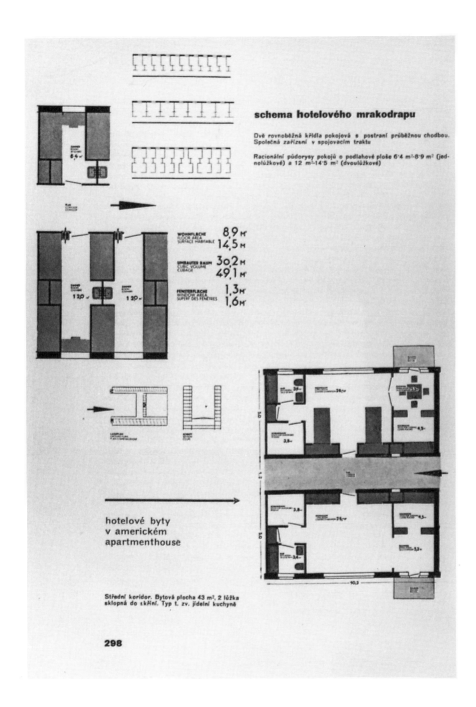

schema hotelového mrakodrapu

Dvě rovnoběžná křídla pokojová s postraní průběžnou chodbou. Společná zařízení v spojovacím traktu.

Racionální půdorysy pokojů o podlahové ploše 6·4 m²–8·9 m² (jednolůžkové) a 12 m²–14·5 m² (dvoulůžkové)

WOHNFLÄCHE FLOOR AREA SURFACE HABITABLE 8,9 м 14,5 м

UMBAUTER RAUM CUBIC VOLUME CUBAGE 30,2 м 49,1 м

FENSTERFLÄCHE WINDOW AREA SUPERF. DES FENÊTRES 1,3 м 1,6 м

hotelové byty
v americkém
apartmenthouse

Střední koridor. Bytová plocha 43 m², 2 lůžka sklopná do skříní. Typ t. zv. jídelní kuchyně

298

18. Scheme for an American Hotel-Skyscraper (p. 298).

Top: "Two parallel wings with rooms served by a single corridor on one side. Common facilities are located in the connecting tract. Rational floor plan of the rooms 6.4 m²–8.9 m² (single beds) and 12 m²–14.5 m² (double beds)." Bottom: "Hotel-type apartments in an American apartment building. Central corridor. Area 43 m²; two folding beds. So-called eating kitchen."

house — in new materials, modern service equipment, and rationalized methods of construction — as not only necessary but inevitable. He also agrees that the benefits of technical progress can be assured to all strata of society only by means of industrially based mass production, that is, prefabrication and the industrialization of the construction process. The influence of these factors on the plan are clear and are accepted by Teige as part of his functionalist argument in the technical sense, even though, as we have seen, he disagrees with the *neue Sachlichkeit* in its purely technocratic interpretation of the translation of utility into design.

It is on the subject of the family as the foundation of social structure that Teige parts company with the dominant modernist conception of housing during the 1920s and 1930s. He offers statistical evidence that even during his own time "a large part of society lives either compulsorily or voluntarily a family-less life," and that "in today's economic world the family is not [anymore] the basic unit, but the exception . . . even though it is [still] the foundation on which is built the ruling ideology and morality." Hence, the emphasis on the family is an artificial construct of bourgeois propaganda. The actual situation should be characterized by the persistence of "economic backwardness [of the lower strata of society], outdated methods of child rearing, sexual banality, and the devaluation of the status of the individual [especially women] in the family household," producing a "peculiar mentality, which is inimical to the progress of a living human culture; indeed it is hostile to it" (160).

Translated in terms of his new conception of the notion of modern dwelling, Teige sees as the only solution the eventual abolition of the traditional family-centered dwelling, including a radical rethinking of the functional allocation of its discrete spaces within both the individual and the collective areas of the overall plan (figure 19).[41] At the core of this transformation from an individualistic, family-centered to a collective lifestyle–centered housing type is the necessity of liberating women from the bondage of home-centered drudgery. "The slave of the household and the kitchen; laundry; maid, cook, gardener, child supervisor, while at the same time factory and office worker — all in one person — a woman who devotes all her time to the family hearth after doing her work for pay outside *remains a serf of the institution called family*" (161; emphasis in original). Table 1 illustrates Teige's point.

Teige tries to prove that modern men and women actually spend most of their time outside their home — at work, shopping, eating out, in school, at entertainment,

and so on—in effect using the home primarily as a place to sleep, as dormitory with a kitchen attached. Still, "official social services and housing subsidies try to salvage as much as possible that remains to be salvaged," with "the warm hearth of a family remaining as a fetish of ruling morality" (161).

To seek a solution to the problem of the kitchen by offering a rationalized version—for example, the "Frankfurt Kitchen"[42]—is "nothing else but self-deception" (162). It solves nothing. On the contrary, it makes the situation worse by transforming the kitchen from its former status of the social center of family life to a "factory" for food production, based on Fordist principles of assembly line efficiency. As the woman-cook is effectively isolated from the rest of the family, her status is reduced to the level of a servant.[43] Teige believes that in order to find the time to live a truly cultured life—to "read, educate herself, take up sports, and participate in public life" (162)—a woman needs more than just a modern kitchen and a washing machine. The only way to ensure her equality is to revise the whole concept of marriage and give up the illusion of the traditional household as the social generator of the modern house plan.

19. Karel Kupka, Furnishing a Minimum Flat (50 m²), 1928. First prize in the competition of the Svaz českého díla (Association of Czech Work). Realized by the Czech Company SBS (p. 218).

K. Kupka, 1928: zařízení nejmenšího bytu (50 m²) První cena ze soutěže Svazu Čs. Díla. Provedla bytová společnost SBS

Table 1

Dwelling Use by Frequency of Occupation (including domestic production)

	Morning	Afternoon	Night
An agrarian economy			
(medieval type, 3–4 generations)			
Male (grandfather)	at home	at home	at home
Female (grandmother)	at home	at home	at home
Children	at home	at home	at home
Townspeople and middle classes			
Man	at work	at home	at home
Wife	at home	at home	at home
Children	in school	at home	at home
In proletarian conditions			
(dwelling reduced to lodging — ceases to be dwelling)			
Man	at work	at work	at home
Wife	at work	at work	at home
Children	in school	in school or at work	at home

Source: Karel Teige, *Nejmenší byt* (Prague, 1932), 62.

182

While the kitchen is considered a redundant item of the modern house plan, the conventional bedroom with its marital double bed is for Teige pure anathema. He condemns it as "a hatching place of lowly forms of bourgeois sexual life, the stage of Strindbergian dramas, a roosting place, the picture of shocking erotic banality and decadence," informing the reader that "the nuptial bed breeds contagion and is the breeding place of quarrels, as well as a source of family perturbances and . . . thousands of neuroses" (163). His answer, of course, is to eliminate the joint bedroom, replacing it with separate rooms for each partner in a sexual relationship (not necessarily married). Preferably these are standard living "cells" in a collective house, where each individual can pursue both his or her private as well as communal activities unfettered by the bondage imposed by owning and operating a traditional family household. This is Teige at his youthful radical best.

TEIGE'S UTOPIA OF DWELLING IN NATURE
AND THE POETRY OF LIFE

It is on the question of the city, or more precisely on the relationship between city and country, that we discover a more mature and less doctrinaire Teige fourteen years later in his 1947 essay "Předmluva k architektuře a přírodě" ("Prolegomena to Architecture and Nature").[44]

It is also in this essay that Teige attempts to achieve a synthesis between his earlier radical Marxist utopianism and his subsequent preoccupation with transmuting the socially conditioned and culturally imposed formal manifestations of the "external model" into a psychosomatic and voluntarily generated poetic visions of the "inner model," as the dream images of the unconscious mind enter the life of modern reality as "lived poetry" (see in this volume Teige's "Inner Model," below, and Lenka Bydžovská's "Avant-garde Ideal of Poiēsis"). History is not excluded from the genesis of these psychic revelries; instead it becomes transmuted "magically" by what Teige calls the "principle of bliss"—the eternal longing of humanity to regain a deeply buried, archaic lost paradise that keeps trying to assert its presence even in the materialistic chaos of the secularized and mechanized boredom of modern life. Its consciously constructed analytic component is subsequently absorbed into the surrealist's dream as part of the regulating forces of the Freudian unconscious.[45]

It is difficult to unravel the complexity of Teige's mixture of Hegelian idealism, Marxist determinism, and—surprisingly—Buddhist transcendentalism in this limited over-

183

view. As a secularist, Teige assures us from one corner of his mouth that "the notion of a primitive state of humanity as paradisiacal was lost by the institution of [the power of] the secular state," which as a Marxist he sees as a desire "to reinstitute 'paradise on earth' as lying behind the intention [of Communism] to eliminate a class-based society" (*Studie*, 257). But from the other side of his mouth he issues a warning that the "realm of freedom" cannot be achieved merely by changing the economic relationship between labor and capitalist surplus production; humanity must be effectively liberated from drudgery by machine production "in exchange for intensive leisure." Only such a higher, politically and socially more inclusive cultural goal will lead to a state "where we will live the free rhythm and free verses of the giddy poetry of a [truly] liberated life" (*Studie*, 278).

In a most interesting departure from the religion of Marxism, Teige uses the teachings of Buddha to illustrate the futility of establishing an "architectural" image for humanity's minimum dwelling, for according to the sage, "freedom consists of leaving the home" and thus making the whole of nature man's true abode. However. it is not wild nature that Teige imagines to shelter poetic life but "composed," humanized nature, "which will become an extension of man and the work of his spirit" (*Studie*, 278). In that sense, it will not be "architectural" in the formal, constructed sense — that is, subjected to the abstract schemas of formalistic architectural styles or the "abstract schemas transposed from other fields . . . that negate nature" — but will work by "heightening the real and natural elements as symbols of what we call creative, plastic composition," combined or merged with "the symbols of the web of our dreams" (*Studie*, 284).

In other words, architecture enters this "park in a park" not with pompous palaces, cathedrals, and other monumental edifices (clearly a veiled reference to Le Corbusier's Mundaneum project), but as an enhancement of all the positive life-enhancing manifestations of nature into which plastic objects are placed. Architecture acts not in opposition to nature but to "transform this or that selected natural space . . . into a dreamlike imagery of 'surrealist' space."[46] It becomes a surrealist landscape that, by the sheer force of its "magical" existence, will act as its own "dialectic justification." This "magical" transmutation of empirical "facts" by the creative unconscious also offers Teige the opportunity to elaborate on his idea of the connection between abstract theory and its practical realization in the real world: "Practical realization is not and will

never be a literary snapshot of a theoretical idea, since the unity of theory and practice is not mechanical, but dialectical" (*Studie,* 288). And, emphasizing the point in more esoteric, Buddhist terms, Teige speaks of the "Tao of heaven and earth, which enters the human heart in the most quiet hours of concentration and deliverance . . . and thus awakens in us the capability to express our most profound feelings as lived poetry" (*Studie,* 287).

The implications for the practical implementation of this new earthly Eden can be traced through three major models of landscape architecture: Italian, French, and English. In Italian landscape design, nature and architecture are balanced, but architecture exists as a kind of "artificial," albeit well-integrated, element of the composition; in the French park, architecture dominates nature by forcing its shapes to resemble tectonic elements of an abstract geometric order, alien to wild nature.

In contrast, the English landscape garden is "composed nature."[47] Its elements are not subjected to the will of formal elaboration by artificial architectonic objects, or the straitjacket of geometric notions of optical perspective and symmetry, but are essentially imaginative rearrangements of natural space by "selection, transposition, and the concentration of selected "ideal settings" (*Studie,* 290). The result is an intensification and enhancement of a formerly dispersed landscape into a "composed" tableau, thus offering the inhabitant of such a landscape an almost dreamlike, ideal image of nature — not something to be merely looked at but a place to "dwell in."[48] It is this recomposition of existing reality by the urgings of the "inner model" that sets Teige's utopia apart from the usual telescoped extensions of social or technocratic utopias of, say, the futurists or the constructivists.

Referring back to his earlier sociological differentiation of dwelling functions into individual and collective realms, Teige now sees nature rather than architecture as providing the setting for the union of these two formerly separate spheres. The key to this reconciliation is "the sacred right to be lazy," or, expressed differently, the need to overcome man's domestication by the discipline of superfluous arduous labor. "Free" time makes possible the development of spontaneously inspired spiritual activities that stir the imagination and free it from the constraints of vulgar utilitarianism and wasteful consumerism, so that humanity can enter a world of "miraculous empirical reality" (*Studie,* 285).

This new "composed landscape" is not to be understood as an improved version of a contemporary amusement park, with its nerve-grating "happenings" intended to relieve the boredom of existing working life with noise, vulgarity, and crude "popular" diversions. It is instead a serene, parklike setting dedicated to the rejuvenation of both body and soul by inspiring peace and contemplation in a population whose life would thereby be liberated from "the constraints of ceaseless drudgery" as they are led "to a higher cultural level of existence, where the principle of [poetic] bliss" will be able to become reality "in an autonomous, plastic, and fantastic ensemble of stone, vegetation, and water, realizing poetic space in natural space"—that is, "mythicized nature" (*Studie,* 285). The idea of "composed nature" allows Teige to conceive of science integrated into utopia without becoming its dominant force; the process may be compared to a somewhat similar phenomenon of the past, when the machine transformed raw materials into finished products for a mass market by eliminating backbreaking human labor in almost all processes of production. However, in the next, higher stage, Teige excludes from his nature–technology symbiosis the intrusion of mindless consumerism and thoughtless waste of resources: leisure is transformed into a new culture of poetic living. Thus, workers achieve not a "caricature of utopia, but its true soul" (*Studie,* 285).

It is in this synthesis of Teige's three categories—technology, the family, and the city—that he transforms the dialectics of Marxist economic materialism into a Marxist-based but transcendentally interpreted "magic" dialectic. Even though it takes as its point of departure historical materialism, and even though it proceeds from the thesis of the class struggle to the antithesis of revolution, it ultimately ends up in the synthesis of life as poetry, for "we do not live to dwell; it is well to live economically and cheaply in order not to be obliged to skimp on cultural needs. Spiritual culture is, on the ladder of human values, higher than so-called dwelling culture, and each genuine culture is economical, not wasteful" (*Studie,* 270).

In the end, the real minimum dwelling turns out not to be high-rise or low-rise, with or without kitchen, or urban versus rural, but becomes the new "barrel of a socialist Diogenes" (*Studie, 270*). In Teige's writings, the contradiction between city and country is not glossed over, as it is in artificial garden cities or Le Corbusier's grandiose Ville Radieuse, but is resolved by merging technical culture with poetic idea, liberating humanity by reconciling man with nature and thus freeing both man and nature. Teige tells the

story of the famous Chinese landscape painter Tao-Be, who, by entering his own painting of a landscape on a wall, forever disappeared in it to become part of its irresistible magic allure, created by the genius of his own imagination (*Studie,* 289).

Perhaps it is this vision of the future and not the pedantic quarrels with the functionalists, constructivists, rationalists, and other modernists that distinguishes Teige from his avant-garde counterparts of the twenties and thirties. It transcends the gloomy predictions of the "death of modernism" to let his legacy endure beyond the momentary triumph of this or that ideological shibboleth of our confused but exciting twentieth century.

Notes

1. Cf. Teige's essay "Minimální byt a kolektivní dům" (The minimum dwelling and the collective house), *Stavba* 9 (1930–1931): 28–29, 47–50, 65–68; translated below. *Nejmenší byt* (The minimum dwelling) (Prague, 1932) will be cited parenthetically in the text.

2. Teige explains in its postscript that "*Nejmenší byt* was written during the fall of 1931 on the basis of a plan conceived in 1930. . . . [It] was sent to the publishers on 5 January 1932. . . . In July the text was broken up by the editors and the illustrations were severely reduced in number, because if each chapter had been illustrated in detail [as intended by Teige], the book would have had to be published in two separate volumes" Teige, (376).

 Teige presented a lecture on the subject of the minimal dwelling during the Third CIAM Congress in Brussels, which contains many of the points made in his subsequent book. See also in this volume Klaus Spechtenhauser and Daniel Weiss, "Karel Teige and the CIAM: A History of a Troubled Relationship."

3. The book's chapters are 1. Introduction, 2. The Housing Misery, 3. The International Housing Shortage, 4. Modern Housing Architecture in Czechoslovakia, 5. The Face of the Contemporary City, 6. Housing and the Household in the Nineteenth Century, 7. The Evolution of Housing Types and Contemporary Housing Reforms, 8. Model Housing Settlements and Housing Exhibitions, 9. The Modern Apartment and the Modern House, 10. The Minimum Dwelling, 11. Low-, Medium-, or High-Rise Houses? 12. Modern Site Development Methods, 13. Toward New Forms of Dwelling, 14. The Contradiction between Country and City, and 15. Postscript.

4. The expression "classes of the existential minimum" is a literal translation of the Czech *vrstvy existenčního minima.* Essentially, it means "housing for the poor," and that alternative translation is used hereafter.

5. In the postscript Teige states that "*Nejmenší byt* is designed as a monograph of a broader reach than that of books hitherto published on modern housing and dwelling culture. It proposes to pose the problem of housing in a fundamental and high-principled manner . . . by many-sided analysis . . . and is intended to second the work of the CIAM" (375–376).

6. This mixture of his belief in the infallibility of the method of the "science" of dialectical materialism and his romantic dream of "life as poetry" makes Teige a fascinating personality, in many ways similar to Le Corbusier, who also combined these two seemingly contradictory streams in his psyche. This may also be the reason why these two romantic realists, or realistic romantics, loved/hated each other so much. Their complex relationship is best demonstrated by Teige's quarrel with Le Corbusier about the latter's Mundaneum design for Geneva.

7. Le Corbusier actually held a view similar to Teige's on statistics: "Statistics are the Pegasus of the town planner. They are tedious things, meticulous, passionless and impassive. All the same they are a jumping-off ground for poetry, the base from which the poet may leap into the future and the unknown, although his feet remain planted on the solid groundwork of figures, graphs, the eternal verities" (*The City of To-morrow and Its Planning,* trans. Frederick Etchells, 3rd ed. [Cambridge, Mass., 1971], 107).

8. "Fordism" was admired in Europe for its industrial assembly-line efficiency, as introduced by Henry Ford in his automobile factories in the United States, which boosted production and reduced the price of his mass-produced automobiles. Speaking to students of architecture at the Cranbrook Academy, Le Corbusier waxed enthusiastic on Fordism:

In the Ford factory, everything is collaboration, unity of views, unity of purpose, a perfect convergence of the totality of gestures and ideas. . . . With the help of Ford, I reason thus: Architecture? The construction of shelters. For whom? For men. That is the program. How to express this program in an accessible reality? By techniques. Make plans. Plans which are legalizable today with existing materials and machines, and which answer the essential needs of man. (ibid., 168)

9. Levá fronta (Left Front, a club of cultural workers and intellectuals of the left) was founded in Prague in October 1929, one year before Lissitzky published his book *Russland: Eine Architektur für Weltrevolution.* Teige had published his essay on constructivism in July 1928, "K teorii konstruktivismu" (On the theory of constructivism), *Stavba* 7 (1920–1929): 7–12. To what extent Lissitzky and Teige knew of each other's work or developed their positions independently has yet to be determined.

10. Little did Teige know that the radical transformation of the family would be realized in its most extreme form not in the classless society of communism but instead in the highly stratified class societies of capitalism. The traditional family has disintegrated most thoroughly in the most advanced bastion of capitalism, namely the United States, despite efforts to arrest this trend.

11. Again, one is struck by the prescience of these predictions, if applied without their ideological gloss into our own situation. Rather than arising in some collectivist utopia of the future, retirement communities, luxury condominiums, and voluntary collective cooperatives in the democratic West have adopted many of the programmatic features of the radical left's utopian dream of the "collective house."

12. We might note that Teige's position went beyond the "art is dead" pronouncements of El Lissitzky, Tatlin, and other followers of the Vchutemas line, in that he never completely

disavowed the possibility that architecture could become something more than pure "construction."

13. Teige's acumen extends even to his prediction of the emergence of a transient "lodger" society in the United States: "During the time of their work contract, specialists will live in hotels, close to their workplace, and their permanent home will be their vacation house" (278). Increasingly, large corporations provide temporary lodgings for their peripatetic (or itinerant) personnel in hotels, guest houses, furnished apartments, or lodging houses. The entrance of the professional married woman, working in a different place than her husband, has led to similar arrangements.

14. Teige's emphasis on underlying structure obviously brings him close to the theories of the structuralists, who like him maintain a Hegelian component in their thinking. However, he does not use the term "structuralism," stating that "form signifies for us not appearance, or adding decoration, but *existential form,* that is, the manner in which a certain object exists or a certain process unfolds, without which a certain object or a certain process cannot manifest itself" (29; emphasis in original).

15. Teige categorically rejects the point of view of Wilhelm Worringer, who sees form first as a function of empathy and, on a higher level, as the will to abstraction — i.e., the will to interpret sensation intellectually in order to extract meaning from the confusion of the complexities of the perceived world of nature and objects. Cf. Worringer, *Abstraction and Empathy,* trans. Michael Buelock (New York, 1953).

16. In 1996, seven years after the "Velvet Revolution," the most written-about contribution of Western architecture to the Prague architectural scene is an apartment building by Frank Gehry, nicknamed "Ginger Rogers and Fred Astaire," built in a country that not only missed most of the films by these two Hollywood stars, but hardly did any architectural dancing of its own during their heyday. After six years moving to their German masters' tune of *entartete Kunst,* the Czechs had forty years of Soviet "socialist realism."

17. If one chooses to ignore the facades of these housing "palaces," an examination of the floor plans of Vienna social housing, Soviet workers palaces, or — for that matter — Boffil's Marne la Valleé pastiche reveals the banality and miserliness of the spatial accommodations provided for these new worker "aristocrats."

18. To a large extent, this prediction has come true, especially during the closing decades of this century. Concerns about environmental deprivation, rampant consumerism, and overproduction of useless items are beginning to impose internal as well as external limitations on the future development of technology. Often neglected are the most urgent needs of humanity, among which housing is clearly primary and least satisfied by the new capabilities of industrial technology.

19. Indeed, we are encountering a new Luddite movement, this time initiated not by jobless workers but by the bored bourgeoisie, who cannot see that it is not technology, not the machine, but the contradictions of their social order that have created their malaise.

20. In making these points, Teige actually relies very heavily on American sociological writing (e.g., the *American Journal of Sociology;* see 44), and even quotes Will Rogers from a *New York Times* article: "The [U.S.] Department of Agriculture has hit upon the brilliant idea of de-

stroying every third bale of cotton [to ease unemployment], but the main defect [of this idea] is the fact that there are too many people [looking for jobs]. Why not shoot every third person and prosperity of business and industry will return" (quoted in *Nejmenší byt,* 46).

21. It is interesting to observe that the loudest cries for rent control even today are heard from so-called leftist advocates for the poor, who believe that they are advancing the welfare of their wards. To quote Teige on this matter: "The attempts to solve the housing crisis by the abolition or mitigation of rents and other attempts to establish a desirable 'correct' relationship between the level of the tenant's income and of the proportion of his income to be spent on rent are often the result of an inaccurate understanding of the economic fundamentals of the housing question" (49).

22. Teige also correctly points out the fallacy of supplying low-income groups with "minimum apartments" based on standardized minimum plans that cannot be upgraded. In his own words:

 the Vienna apartments are a well-studied example of a minimal solution of a conventional bourgeois apartment. Housekeeping functions are simplified, but not abolished. . . . [I]nstead, money is spent on pompous facade decorations . . . with impossible entrance tunnels and towers[,] . . . a medieval fortress, rather than a worker's abode — all of which belongs to the lowest manifestation of an eclectic, formalistic architecture . . . with 1,400 apartments in the Karl Marx Hof without bathrooms! (95)

23. It should be noted, however, that the economic situation in the Czechoslovak Republic was substantially better than that of Germany. The currency did not collapse, nor did the social order degenerate into fascism, even though serious labor unrest in the 1930s brought the country to the brink of anarchy.

24. In fact, Teige uses the existence of high wages in America to support his argument against rent control and housing subsidies: "it is necessary to remind ourselves that the housing shortage is least burdensome and relatively weak not in times of low and legally restricted rents, but in times and countries of relatively high wages, particularly America" (52).

25. I vividly remember a joke made by William Wurster during one of his Berkeley lectures concerning ownership of housing in America: "Americans buy money to borrow a house."

26. See "Karel Teige's 'Mundaneum' (1929) and Le Corbusier's "In the Defense of Architecture" (1927)," with introduction by George Baird, *Oppositions,* no. 4 (October 1974): 79–108.

27. Philippe Boudon, *Lived-In Architecture: Le Corbusier's Pessac Revisited,* trans. Gerald Onn (Cambridge, Mass., 1972).

28. M. Frugès, the developer of Pessac and owner of a packing company, conducted a survey of public reactions to Le Corbusier's Pessac scheme, with the following results: "Enthusiastic," 1 percent; "Sympathetic," 2 percent; "Hesitant," 2 percent; "Worried and stupefied," 40 percent; "Convinced that I had gone mad," 55 percent. He commented, "It was probably those in the last category who coined the sobriquet *Rigolarium* to describe this complex of novel structures; for in France, as everyone knows, everything is ultimately a *rigolade,* a joke" (quoted in ibid., 12).

29. M. de Monzie, minister of public works, visited Pessac on 13 June 1926, "accompanied by numerous important persons from Paris. . . . Both here and in Marseilles Le Corbusier received help from high places; this belies the impression given in his writings, where he claims to have encountered implacable opposition at all times" (ibid., 14). This also belies the complaints of Le Corbusier that he had to fight all levels of government against almost insurmountable odds to push through his ideas.

30. As examples of such a "translation" from low cost to luxury, Teige cites Le Corbusier's Villa Garches and Villa Poissy, where the traditional bourgeois floor plan is perfected, but remains typologically a "functionally differentiated house, the traditional household home." He urges the reader, "Just leaf through an album showing the designs of Le Corbusier (*Collected Works, 1910–1930*) and you will see a collection of the latest achievements of housing culture ad nauseam for the bourgeoisie" (*Nejmenší byt,* 158).

31. Le Corbusier agrees: "There are millions of houses. They are garden cities, a creation of the late nineteenth century, approved, favored, sanctified by capitalism. Garden cities are the floodgates of the great torrent of accumulated rancors. With this gigantic multitude, with these mountains of claims and demands, they have made dust scattered to the four winds, inert ashes: the dust of men. The egoistic and biased social laws have had their life prolonged as a result." See *When the Cathedrals Were White,* trans. Francis E. Hyslop (New York, 1964), 173.

32. During a lecture on this trip to the United States, Le Corbusier advocated a strong role by government to implement his grandiose schemes: "We shall have to think about that [i.e., the clearance of blighted urban areas] some day, through the organization of cooperatives or real estate syndicates, or through strong and paternal governmental measures (with all the energy of the father who knows what the children should do" (ibid., 191).

33. Teige similarly pillories the global commercialization of canned food, which is produced not to supply daily nutritional needs in as healthy a form as possible, determined by locality, season, and taste, but to increase consumption in mass markets for maximum profit. Thus, in another example of the technical transformation of pre–machine era production into modern mass production, "The large food conglomerates simply dictate to people their menu" (*Nejmenší byt,* 128).

34. In his *City of To-morrow,* Le Corbusier argues that instead of raising the height of buildings from four to six stories, as Haussmann did, he would with much higher skyscrapers increase the value of the land to be built on by more than twenty times! "The moral is that we must not say . . . what immense sums would have to be sunk in all this expropriation and reconstruction," but rather, "what an opportunity for capital for almost incredible amounts would he created by such an attempt at revaluation! . . . The Minister of Finance could find immense financial resources in the very centre of Paris" (295).

35. Le Corbusier proceeds to give a detailed explanation of how to maximize profits in the implementation of his proposals for replanning Paris:

If a decree were passed for the general expropriation of the centre of Paris, the value of the land would stand at a certain figure which we will call A. . . . The construction of a "Business City" at once raises this value A to 5A, and the increase in density would make this 4 × 5A. Thus there is a new value, twenty times the original value, A, out of which compensation can be paid. . . . We have only to erect our sixty-story buildings and this new and immense wealth is at our disposal. (ibid., 296)

36. A succinct indirect reply to this accusation can be found in Le Corbusier's *City of To-morrow:* "Things are not revolutionized by making revolutions. The real Revolution lies in the solution of existing problems" (301).

37. Le Corbusier rejects all accusations of advocating this or that political line by stating that "the aim of this work has been the unfolding of a clear solution; its value depends on its success in that direction. It has no label, it is not dedicated to our existing Bourgeois-Capitalist Society nor to the Third International. It is a technical work" (ibid., 301).

38. Teige goes on to accuse Le Corbusier of obstructing progress on principle by opposing nationalization or municipal ownership of land for center city development, and by asking the state to put into place new laws and code requirements friendly to his designs; "Le Corbusier puts himself unambiguously into the camp of private interests" while agreeing that actual development of his schemes should be left to private entrepreneurs (143).

39. Le Corbusier does not deny that his design decision to include the "arabesques" is based on aesthetic rather than utilitarian considerations; "leaving hygienic considerations on one side for the moment, it may be admitted, aesthetically speaking, that the proximity of geometrical forms of dwellings to the picturesque forms of vegetation produces a much-needed and satisfying combination in our urban scene" (*The City of To-morrow,* 236).

40. Note the plan of Teige's own apartment in Prague. For most of his adult life he had relationships outside marriage — in his last decade, with two women — to which both partners evidently consented freely.

41. Teige recognizes that this process should be gradual and mostly voluntary. He considers Western boardinghouses, hotels, and bachelor suites as part of this transition and as a kind of "precursor" of the collective house of the future. Its implementation should be made palatable to the masses by presenting vigorous propaganda in favor of collective living and by reconstructing economic relations along socialist principles in the political realm.

42. Margarete Schütte-Lihotzky (born in Vienna, 1897) worked between 1926 and 1930 with Ernst May in Frankfurt, where she designed her well-known "Frankfurt Kitchen" along modernist principles of work efficiency, clean lines, and new materials. The kitchen was exhibited at the 1927 Werkbund Exhibition *Die Wohnung* (The Apartment) in Stuttgart. See Karin Kirsch, *The Weissenhofsiedlung: Experimental Housing Built for the Deutscher Werkbund, Stuttgart, 1927* (New York, 1989), 207; Eve Blau, *The Architecture of Red Vienna, 1919– 1934* (Cambridge, Mass., 1998).

43. Teige quotes J. E. Koula, who makes an interesting observation on the matter of the value of work in the kitchen: "Women . . . tried to curtail the complex apparatus of housekeeping in order to utilize their abilities better; for the learning capacity of a modern woman is as a rule

higher than that of a maid, laundry woman, and in the best cases even the cook, and therefore they do not consider it economical to earn their living by running a household" (quoted in Teige, *Nejmenší byt,* 162).

44. Karel Teige, "Předmluva o architektuře a přírodě," in *Obytná krajina* (The inhabited landscape), by Ladislav Žák (Prague, 1947), 7–21. This essay is reprinted in vol. 3 of Teige's *Výbor z díla* (Selected works), edited by Jiří Brabec, Vratislav Effenberger, Květoslav Chvatík, and Robert Kalivoda: *Osvobozování života a poesie; Studie ze čtyřicátých let* (The liberation of life and poetry: Studies of the forties) (Prague, 1994), 257–290. This edition is hereafter cited parenthetically in the text as *Studie.*

45. There is no evidence that Teige studied Jung, but one is nevertheless struck by the similarity of Jung's "collective unconscious" and Teige's urge to recover the "lost paradise of a golden age" by the somnambulant mechanisms of the "Inner Model," which will be realized "by its opposite, its negation"; ibid., 257.

46. Note the great affinity between Teige's "reserved" open space and Heidegger's *Lichtung.*

47. Teige bases his notion of a "composed landscape" on Žák's program for a new regional planning concept; see "Předmluva o architektuře a přírodě."

48. Here Teige anticipates Heidegger's notion of the "opening" for "beingness." See Otto Piggler, "Der Denkweg Martin Heideggers" (The intellectual path of Martin Heidegger), in *Fundamentalontologie als Gründung der Metaphysik* (Pfiffingen, 1990), 46–66.

THE MINIMUM DWELLING AND THE COLLECTIVE HOUSE

Karel Teige

(Translated by Alexandra Büchler)

Note: Widely spaced passages represent emphasis in the original.

Originally published as three articles, "Minimální byt a kolektivní dům," in *Stavba* 9 (1930–1931): 28–29, 47–50, 65–68.

1. THE SOCIAL AND ECONOMIC ROOTS
OF HOUSING SHORTAGES

Today, the idea of a minimum dwelling is becoming central to modern architecture and has even been adopted by the contemporary architectural avant-garde as its battle cry. No doubt, the reason that it has become such an urgent problem is the housing crisis and poverty in European cities that have persisted for many decades, ever since large portions of the population began concentrating in places of industrial production. Particularly after the war, this shortage has turned into an unprecedented housing crisis, when a large army of homeless or inadequately housed people was created for a number of reasons, which all have their origin in the behavior of the capitalist economy and as such represent an inevitable phenomenon accompanying the development of capitalism. Each modern industrial boom eventually causes a vertiginous urban population explosion accompanied by migration of rural inhabitants into industrial centers (roughly reversing the ratio of urban to rural population, which in medieval times was 9 to 1, within the span of one century).

It should be remembered that the housing shortage cannot be exclusively blamed on growing city populations being poorly served by the building industry, but that it is caused by concomitant changes of a social and industrial nature. It is a well-known fact that in many cases housing supply may even exceed demand, at least for those who can afford the required rent, while for the poorest classes the housing crisis persists unchanged. The reason for this is that all attempts to solve the housing problem have so far dealt with it mainly from the point of view of the balance between supply and demand on the part of those with the requisite buying power, but have failed to bring about an effective resolution that would have led to the reduction of these housing shortages. Urban housing shortages have therefore continued to persist, not because of the numerical growth of city populations at large but chiefly because the economically weak groups within the total population of each large city have experienced enormously disproportionate growth, with a concurrent growth of an aggregate working class, underpaid and often incapable of finding work to survive. In other words, this means not just general population growth as such, but overpopulation caused exclusively by today's production modes.

And just as the housing shortage is essentially a shortage of dwellings attainable for the poorest—that is, the majority of the overall class structure—so population

growth is not merely a simple question of overpopulation — that is, of growing needs not satisfied by human production — since the birth rate has not increased to the point where production and social wealth would be inadequate to meet all the needs of the population. As an abstract concept, population law applies only to animals, provided that there is no interference from man as producer. Every mode of production begets its own population laws, and in today's economic system, the existing relative overpopulation is — in fact — determined by the prevalent order and its trends, even when the birth rate is beginning to drop and mortality and suicide rates are on the increase (again, as a result of poor social conditions), thus eventually leading to an absolute drop in population levels.

Incidentally, the current level of modern industrial development has the capacity to guarantee the production of a sufficient quantity of goods to meet the needs of all people, which proves that the housing shortage is not a simple result of the growth of cities, but is really caused by attendant social conditions; that is, relative overpopulation, proletarianization of the middle class, and pauperization of the working class, as well as by the periodic crises of the economic system. Hence, it is a phenomenon closely linked to the accumulation of capital and the growth of its systemic structure. After all, we must not forget that by and large, even today the building stock existing in large cities is sufficient and would be capable, to a large extent, of doing away with the housing shortage, provided that it were used rationally and economically.

To the extent that the housing shortage is not a primary social evil but rather the manifestation of secondary social phenomena, caused by the existing economic system, it should be recognized that it cannot be solved merely by increasing supply, that is, by building more and more new dwellings. Neither can it be resolved by the building of cheap housing, or by means of socially or politically motivated legislation — as, for example, by introducing laws protecting tenants or by regulating the building industry. The fact that the dwellings offered by the market are not accessible to those who are inadequately housed or homeless is not a question of the absolute level of rents, but of the unfavorable ratio between rents on the one hand and wages and salaries on the other. At present, the lowering of rents has always caused a drop in wages (and it should be noted that from the point of view of social policy and national economy, a rental relationship between tenant and landlord cannot be equated with a wage relationship between worker and employer, since the rental of an apartment does not

represent the same type of transaction as the sale and purchase of labor; rather, it represents the simple sale of goods). It is a known fact that housing shortages were at their lowest not at a time of low rents regulated by means of tenant protection legislation, but at times of relatively high wages. It was during the relatively long-lasting prewar period of low unemployment, when America and, to some extent, the colonies absorbed European overpopulation, with tens of thousands emigrating overseas from rural and urban areas every year. Relatively high wages meant that apartments were accessible at prevailing market rents, which in turn strengthened the internal market in individual countries. Owing to circumstances and the operative conditions prevalent at the time, the process of pauperization was slowed down considerably as well. It is a well-known fact that the workers' struggle for higher wages and shorter working days has always been a strong stimulus for technical progress.

Today, at the time of a general industrial and agricultural crisis, the forces retarding the process of pauperization have effectively ceased to act; the level of wages has dropped while at the same time the numbers of unemployed and underemployed is rapidly growing. In such a situation, characterized by a substantial drop in the level of economic activity and a corresponding reduction of the living standard of the working class, it is not possible to resolve the housing shortage by the same means as those applicable at times of economic prosperity and high wages. Today, the question of a dwelling that would meet an existential subsistence minimum has to be posed completely differently: it is not simply a question of building cheap rental housing, for the housing shortages have been caused precisely by the lowering of the overall level of the so-called existential subsistence minimum. The official (untaxed) existential minimum is — in fact — not really an actual minimuy; that is, a minimum covered by the minimum wage. On the contrary, it may be viewed instead as a minimum corresponding to the maximum of a worker's wage. Thus, even at a minimum wage determined by the most essential physiological minimum needs — that is, at a level at which it is barely possible to survive without dying of malnutrition and hunger — even the cheapest independent dwelling becomes an inaccessible luxury. Statistics tell us that during the economic boom of 1928, Czechoslovakia came fourteenth in terms of average wage, that is, almost last compared to other European countries. This means that nearly a third of the population has to survive on a lower income than the official tax-free minimum, which means that today 300,000 out of 2.5 million Czech workers are unemployed,

and even more are underemployed, because (according to last year's statistics of the National Welfare Insurance Office) 1,445,000 workers earn less than 100 Kčs [korunas] weekly and 896,000 workers less than 150 Kčs.[1] Therefore, the climate in which we are trying to resolve the housing crisis as well as the problem of the minimum dwelling — or rather, a dwelling for the class living at minimum subsistence level — is particularly difficult.

As we have shown at the beginning, the causes of the housing shortage are inherent in the current economic order, which means that the problem can be resolved only by replacing the existing order with a new one. To think about the minimum dwelling today implies that we have to try to see the solution of the housing problem outside the context of existing construction practices and current ways of building, as well as basing it on a different economic system.

2. INTERNATIONAL CONGRESSES OF MODERN ARCHITECTURE AND THE QUESTION OF THE MINIMUM DWELLING

Several CIAM communiqués pointed to the need for modern architecture to examine the problem of the minimum dwelling, regardless of existing building laws and regulations. An exhibition scheduled for the Brussels Congress that deals with the development of residential areas and shows minimum dwelling floor plans is also intended to include proposals prepared without consideration of existing building regulations. The committee organizing the Third Congress asked the individual national groups to supply not only reports on the objective housing conditions of the classes living at an existential subsistence minimum but also so-called ideal proposals, which would be able to be realized in the future without regard to their social, economic, and technical aspects; at the same time, they were asked to itemize contemporary economic and legal obstacles standing in the way of a rational solution to the problem. Even Le Corbusier's opinion poll, addressed to the Congress, poses its questions regardless of existing regulations, which now place a handicap on the possibility of a full utilization of contemporary technology. The Congress press release also stresses the point that the main task of the Congress is to postulate and formulate, as its first priority, significant problems "even if an immediate solution may not be possible." That is why the Congress welcomes proposals that are not definitive, or may even be misconceived, but that in

some ways will stimulate further research. To sum up: It is not an expression of technocratic utopianism to pose the problem of a new — that is, minimum — dwelling in an elementary manner, as a purely experimental problem, regardless of all the various aspects not directly relevant to the problem and its associated production routines, and regardless of legal, social, and financial obstacles growing out of today's conditions of social organization and its inherent antagonisms. On the contrary, it is important to stress that no architectural, scientific, or technical problem can be separated from socioeconomic issues, and that any hypothesis concerning tomorrow's architectural solutions must, at the same time, be in full accord with a scientifically precise prognosis of socioeconomic development.

In principle, the problem of the modern minimum dwelling needs to be stated in its elementary form and posed within its social framework as a problem of general planning and as a question of satisfying basic human needs as far as living style is concerned. Thus, the standard dwelling should meet the everyday biological, social, and cultural needs of the masses. At the same time it is essential to reject any differentiation of dwelling types based on degree of wealth or the subjective preferences of their inhabitants.

The International Congresses of Modern Architecture [CIAM] do understand their mission correctly: they should not be guild gatherings, but they should be what the official congresses (such as this year's International Congress of Architects in Budapest) are not, or are incapable of being: working organizations instead of representative bodies; foci of international collaboration; laboratories of new architectural ideas. It is their mission to solve important problems posed by the current stage in the development of a new architecture and by the authentic needs of contemporary social development. In fact, this is how the mission of the congresses was defined by its first, Founding Congress held in 1928 in La Sarraz, Switzerland. The Second Congress, held in 1929 in Frankfurt, set itself the task of discussing the problem of the "minimum dwelling." An exhibition of small apartment floor plans was organized, in which Czechoslovakia was not able to participate, because, as is generally known,[2] "in our country we have made the problem easier by not solving it at all, something that has led to the proliferation of trailer colonies and wooden shacks on the one hand, and the building of expensive public edifices on the other."[3] Statistics on so-called low-cost housing in Prague, collected between 1923 and 1928, show that out of a total of 41,778 flats, 2,944 were

attic flats and 2,271 basement flats; 10,132 consisted of a single room while 14,496 had two rooms. Out of the total of all small flats, 21 percent are either in the attic or in the basement, as are as many as 35 percent of one-room flats. Since 1923, in Greater Prague the number of one-room flats increased twenty-five times and fifteen times for two-room flats. None of these, however, may be considered as desirable "minimum flats" providing a maximum of sun and fresh air; they are instead properties plainly intended to generate maximum profits as their level of rent bears no relation to the quality of these dwellings, regardless of the "human right" of their tenants to a healthy environment.

Czechoslovak architecture has so far failed to deal with this social situation and its problems in a systematic and planned way, and only this year's competition for conceptual solutions for minimum-size house plans has brought about some interesting experimental results. The outcome of the congresses should therefore have a stimulating influence, especially as concerns our own situation. This year's Congress in Brussels continues to work on solutions for minimum dwellings. The next Congress, which is to take place in Moscow in 1931, will still focus on problems of residential architecture but ought to shift its attention to town planning problems as well. No firm decision has actually been made on the theme of this Congress as yet, but the following suggestions have been put forward to date: "Toward an Organic City," "Constructive City," "Collective Living and the Socialist Amalgamation of the City and the Country."

3. THE "MINIMUM DWELLING" WITHOUT A FAMILY HOUSEHOLD

To be able to think about the problem of a minimum subsistence flat, one needs to be aware of the distinctive lifestyle of the minimum subsistence class, the proletariat. Above all, we need to realize that this class is at the same time the class destined to create a new society, a new human domain invested with an international, universal character, a class that makes no claim on special rights, that is, a class that for the first time in history stands for perfect uniformity in matters of lifestyle and housing needs. Beyond that, we have to realize that the existing ways of living in family houses or rental apartments do not correspond to the lifestyle of this particular class.

First of all, the existing dwelling-household is a type that mirrors the social and family conditions of the bourgeoisie. In any case, the bourgeois household and family

is based on capital and can only be fully developed as part of a property-owning class. Thus, without property ownership, there is no reason why the household and the family (considering the subordinate position of the woman) should continue to persist. Members of the minimum subsistence class simply do not have the resources for the proper establishment of a family-based household. With the proletariat, the mutual relationship between woman and man, as well as their relationship to the children, has nothing whatever in common with bourgeois family relationships.

With the rise of the patriarchal family, the task of running a household lost its public character and became a private service function. It was only when modern industry magnanimously opened the way for the working woman to enter public production that women were forced out of the family into the labor market and the factory, frequently ending up as their families' breadwinners. A woman who once and for all leaves the household to join industrial production has asserted her claim to a place in public life, but cannot be expected at the same time to assume a double responsibility, a double workload. It follows that she has to be liberated from such chores as cooking, cleaning, washing, sewing, and the care of children. This collapse of the family-based household and its economy is not a social evil in itself. On the contrary, it is a precondition for achieving full equality between men and women and a logical circumstance in the lifestyle of the new class.

Supposing that woman's emancipation is a precondition for all women to be brought back into production, it is clearly necessary to abolish the individual [bourgeois] family and its household as a separate economic unit. The private household economy must therefore be transformed into a public industrial undertaking, and the care and upbringing of children must equally become a public affair. If contemporary architects, who are duty bound to cooperate in these matters in their efforts to reform housing and housekeeping, frequently appeal for the help of women who are managing such households (see Bruno Taut: *Der Architekt denkt, die Hausfrau lenkt!*), it seems necessary that in the design of [truly] innovative housing, different from the traditional household type, they should appeal for the help of working-class women, who know that in spite of all the laws that gave them voting rights, marriage reform, etc., a woman is still a servant in her home, debilitated by household chores, tied to the kitchen and the children's room, exploited and drained by grotesquely sterile, picayune, irritating, and exhausting work.

Women will only become truly emancipated when the single-family household-based economy is abandoned and households are transformed collectively into a large industrial concern. Today's hotels and, above all, various popular catering establishments, canteens, crèches, and kindergartens represent the embryonic state for the development of this new [proletarian] lifestyle and are the o n l y m e a n s t o w a r d w o m e n ' s e m a n c i p a t i o n. Like all the other material preconditions for a new society (socialism), they have been brought about by capitalism but are still quite rare in our country (for example, boardinghouses are an exception among today's urban residential buildings), representing in most cases either ineffective welfare establishments or commercial ventures with all the attendant deformations and negative aspects of speculation and profit-seeking. "Socialism and any total, lasting democracy are not possible without the independent participation of women in all public and political life in general, as well as permanent employment in the interest of the state in particular" (Lenin). It is therefore necessary to abolish the private family economy along with the traditional family household, where energy is wasted in laborious work for private consumption, and to return all the work energy consumed until now by the single-family household to the body politic, its production and culture.

It would therefore be entirely wrong, irrelevant, and false if we attempted to meet the needs of the minimum subsistence class by means of minimum dwellings based on the single-family economy. Aside from recognizing the distinctive character of the working class (in that its family relationships are fundamentally different from those of a bourgeois family), we need to mention the transient character of the working-class population for whom their own family house, or furniture in rented accommodation, in effect presents a burden. (For literature relevant to the study of these issues, see Walter Gropius, paper presented at the Second CIAM Congress; Engels, *The Origins of Family, Private Ownership, and State* [1884], *The Housing Question* [1872], *Position of the Working-Class in England* [1892]; Lenin, *The Great Initiative;* and "The Thesis on Housing" prepared by the Association of Soviet Architects, OSA, for the magazine *Sovremennaya Arkhitektura* [*Contemporary Architecture*]).

4. COLLECTIVE HOUSES

Considering the factors mentioned above, so-called ideal proposals for modern as well as minimal dwellings will have to be formulated in the following way: minimum dwell-

ings have to be conceived as r e s i d e n t i a l c e l l s f o r i n d i v i d u a l
a d u l t s. Such cells should be grouped together in large residential "beehives."
These collective houses would thus be roughly comparable with existing large hotels,
boardinghouses, full-service apartments, or workers' hostels, all of which are housing
variants catering to a particular class and which depend on where the line is drawn be-
tween collective and centralized facilities and allocation of individual living space. In de-
signing desirable collective houses we would probably draw this line in such a way that
all the economic aspects of housing would be centralized, collectivized, and industrial-
ized, and the formula for the individual minimum dwelling space would be essentially re-
duced to the provision of a sleeping cabin.

The individual cell would thus become a truly minimum dwelling, since everything
not related directly to the functions of that space would be eliminated: it would not be
a dining room, study, workroom, or salon; neither would it be a place for work or social-
izing, but instead it would become a space for sleep, rest, and the development of pri-
vate spiritual and emotional life. The cohabitation of two people in one unit would be
categorically excluded. Physical and intellectual work would take place in workshops
and study rooms, social life would find its accommodation in clubs, while physical cul-
ture would find its home in communal sports facilities, swimming pools, playgrounds,
etc. A beehive of such minimum cells for individuals would be complemented by spa-
cious collective kitchens, dining rooms, buffets, laundries and drying rooms, club halls,
lecture halls, reading rooms — which in aggregate would be calculated to serve approxi-
mately one to three thousand inhabitants in a single complex, including children's ac-
commodations and gardens of appropriate size.

In principle, it is necessary to consider such collective houses as enormous resi-
dential compounds and as buildings accommodating an unusually great number of
people (considering today's conditions), that is, as multistory buildings or — if you like —
skyscrapers. Only by increasing the number of stories will it be possible to maintain
sufficient open green areas between the individual blocks without falling into the well-
known error of garden cities, namely, the exorbitant distance between home and
workplace and the subsequent burden placed on transportation systems. In large, high
buildings, comfort is more economical, since central organization is easier and thus
can be managed to greater advantage. It is not only the hotel-type organization of the
domestic economy in large buildings but, above all, the provision of modern ventilation

and heating systems (as, for example, the system designed by Gustave Lyon), without which the reduction of the size of living spaces would not be possible. It is by such means that we arrive at the notion of a vertically developed garden city. The housing of each individual, man or woman, in a collective house therefore entails a rigorous reduction of existing housing designs. And not just that, it ultimately necessitates a complete transformation of "quantity into quality." Current reforms of housing, starting with the development from the castle, palace, and chateau and continuing by way of the modern bourgeois apartment to the luxury dwelling (*maison de plaisance* and *hôtel particulier*) and eventually to the minimum home, are merely quantitative changes. Such quantitative changes, brought about by architectural and technological progress (rationalization of the apartment layout, mechanization of its operation, and revision of its dimensions), have reached a point where quantity is transformed into quality, and where the traditional —albeit minimum —household has been superseded at the very time of revolutionary change, of a radical break, and a time when it has become possible to conceive of a dwelling comprising a large number of residential cells served by a centralized and industrialized housekeeping economy, including collectivized social services and public child care. In other words, we arrive at an entirely new type: a factory for living.

Such a minimum dwelling is not a mere reduction of the bourgeois or middle-class apartment, nor is it an improved version of a lower-class or working-class dwelling. It is a revolutionary answer to the housing problem. If a minimum dwelling that continues to conform to the traditional household type typifies a return to the most conservative of lifestyles, both architecturally and in terms of its comfort, it equally represents a step back in comparison with today's modern apartments of the affluent classes: the dining kitchen returns in the form of a technically perfected living room with a kitchen recess, and the presence of the marital bedroom simply means that we cannot rid ourselves of certain ways unsuitable to the life of modern man and woman. The collective house, on the other hand, represents an enormous progress in the culture of housing, offering hitherto unattainable comforts to the collective and its inhabitants. The solution of the problem of the collective house revolutionizes architecture, since it signifies that the problem of housing is being solved at a higher level of historical and social development.

The minimum apartment in a collective house is therefore not simply an emergency solution. It represents a principle combined with a general operational application, at least with respect to [the needs of] the class living at the level of minimum subsistence and the needs of the new society. This principle is mini-mum dwelling = modern dwelling, requiring a uni-fied, standardized housing type for everyone.

5. CURRENT OBSTACLES

As for the current obstacles standing in the way of a generous and rational solution to the problem of the housing crisis and of working-class housing in general, it needs to be stated that all such obstacles have their economic and social causes. Obstacles created by outdated construction laws and regulations can be removed to the extent that they are based on outdated but still-surviving ideas and views. However, to the extent that they are the legal expression of existing ownership interests — that is, an interest in profitable yields from land and property, the maximum exploitation of a given building site, or the opportunities of mortgage interest gains (the need to build houses "for eternity" and not only for the time span of one generation, which would be the practical thing to do) — such obstacles will be difficult to overcome within the limitations of the existing social order.

As far as the most serious socioeconomic obstacles are concerned, we repeat that housing shortages cannot be removed simply by constructing new buildings and operating them privately, since any home affordable to those living at today's deplorable but real level of minimum subsistence would not be profitable even if it were to be built with the worst materials and lacked any comfort whatsoever. Housing cooperatives consisting of members lacking financial means must be considered as a self-contradictory paradox as well.

The housing crisis could be significantly alleviated only by building houses financed from public, communal, or state funds, with rents set according to an individual's income, while the unemployed and those without any means would be housed for free. The battle waged against the housing crisis in the context of current social welfare policies has no hope of success under present conditions, since local and state government budgets do not have the financial means to cover the required expenditures. We know that the ratio of money spent on welfare, education, and health on the one hand,

and the defense budget, etc., on the other, is increasingly favoring the latter. This clearly shows that there is no sympathy to solve the housing crisis by such means.

6. ON LE CORBUSIER'S QUESTIONNAIRE

Several comments need to be made on Le Corbusier's CIAM opinion poll.

Even Le Corbusier makes the point that today's building regulations stand in the way of a far-reaching and vital initiative that would allow for a radical transformation of the outdated organism of cities; they curtail the maximum utilization of technological possibilities, while at the same time pretending that the architectural revolution brought about by modern technology can be considered as a fait accompli in developed countries. [He recognizes] that there is a need at the present to study the impact of new discoveries in the field of physics, public hygiene, chemistry, and biology on modern architecture; and that, ultimately, we need to know how the c o n t e m p o r a r y s o c i a l p h e n o m e n o n w i l l b e m a n a g e d ("comment tend a s'a-ménager le phénomène social contemporain"). Le Corbusier therefore poses a number of questions to (a) medical practitioners (air, noise, sunlight, and artificial light), (b) physicists (heating and air-conditioning installations, soundproofing, temperature control, solar radiation), and (c) architects. Although Le Corbusier does not include any particulars in his questions on the problem of the contemporary "social phenomenon," it needs to be said that if we want to approach the housing question — which is essentially a social question — in a systematic manner, this problem should be given first priority instead of being considered only "subsequently."

What is this contemporary phenomenon? Le Corbusier defines it as a "new social state brought about by the machine." Defined more precisely, it is today's state of social development, namely the same o l d society, divided into two classes (which differ fundamentally from one another according to their position in the division of labor and their relationship to the means of production, as well as the degree to which they benefit from common wealth), representing spheres with opposing interests and an antithetical sense of historical mission: the last antagonistic expression of the social production process. The "intelligent arrangement of social life in large cities," which Le Corbusier assumes will become reality in the foreseeable future, can be achieved by nothing less than a fundamental social transformation, which needs to be carried out comprehensively and definitively not just within large cities but on a worldwide scale as well. It will

then be possible to resolve the housing question in the broader context of a variety of different economic and social transformations, the most important being the abolition of the difference between the city and the country.

Le Corbusier demands answers that ignore the actual conditions relating to the building industry and extant building regulations. Indeed, it is not possible to answer his questions by means of this or that abstract law, for they can be only considered in relation to specific present or anticipated changed future economic and social conditions. Unless the prognosis for the development of architecture in the near future is to be based on precise diagnosis and prediction of social developments, we will remain in the realm of barren utopianism. It is unrealistic to prognosticate future radical progress in architecture on the basis of revolutionized modern technology alone, without accounting for parallel changes in social structure at the same time. Conversely, if we correctly understand everything that determines the minimum dwelling sociologically, and if we take into consideration all its functions on this basis, we will as a matter of course obtain not only its resultant solution but its architectural formula as well. Only if we think about the new housing in accordance with its social functions, will we be able to recognize whether specific proposed architectural solutions are correct or not.

Le Corbusier sees the house of the future as a h e r m e t i c a l l y s e a l e d s t r u c t u r e: sealed off from external air and temperature by double walls made of transparent or opaque material, suitable for any climate, ventilated and heated by means of air maintained at a constant temperature and humidity ("circuit d'air fermé"), with windows that cannot be opened. Since he considers l i v i n g i n i s o - l a t e d h o u s e h o l d s (whether in family homes or apartment blocks) a s a m o d e t h a t i s a r c h i t e c t u r a l l y p a s s é a n d o n e t h a t c a n n o t b e s u s t a i n e d i n t h e f u t u r e, he assumes that the house of the future will be a large vertical complex serviced by a system of elevators. We can imagine this building as a perfected type of the *immeuble-villas* Le Corbusier designed some time ago.

Le Corbusier's questions related to the architectural solution of this building type are as follows:

208

1. WHAT WOULD BE THE IDEAL NUMBER OF FLOORS TO MAKE THE BEST USE OF SUCH A RESIDENTIAL COMPLEX, FROM THE MECHANICAL AS WELL AS AR-CHITECTURAL POINTS OF VIEW?

The question of the absolute height of a building cannot be answered in general terms. The advantages of a particular height are always given uniquely in relation to the value of the building plot. Even if we do not take into consideration today's market price and even if we assume all the land to be in communal ownership, the value of a plot would still vary according to its location, because in certain densely populated areas plots will be more valuable, creating a need to build upward, while elsewhere there will always be a surplus of low-value land that will allow for horizontal development. The price, or rather the objective and productive value of land given by its natural characteristics (fertility, mineral resources, medicinal springs, etc.), will always codetermine the height and density of building, even if we do not take into consideration today's market prices inflated by speculation. National, or rather pan-European, economic and settlement planning attaches certain quality attributes to certain areas in accordance with their natural characteristics. Thus, it will be necessary to take these factors into consideration for all land to be used in the most advantageous manner, which also means not building on land that may be suitable for another, better use and making sure that housing and urban development do not occupy land of agricultural value or rich in natural resources.

Concerning the question of a technically feasible height of buildings, we can cite the results of research recently carried out by the American Institute of Steel Construction in New York. Their findings show that the technical possibilities far exceed the height of skyscrapers built today, but, when they consider the profitability of such buildings, height becomes dependent on the value of the building plot. The curve of profitability rises with the height of the building up to a point beyond which a higher building would be less profitable and less convenient. The actual technical limit of the feasible height of a skyscraper is, however, much higher. Assuming improved elevator mechanisms, it is possible to set the technical limit at 600 meters. Thus, technically speaking, according to the report of the institute, a skyscraper of that height must be considered as realizable.

2. WHAT IS THE MAXIMUM LENGTH OF THE CORRIDOR BETWEEN THE ELEVATOR AND APARTMENT ENTRANCE?

The introduction of horizontal "travelators" and moving sidewalks in corridors could make this distance quite long. Its limit would probably be a certain ratio of corridor width to room depth, and we may also assume that a long corridor would become narrower the further it is from the elevator, as we can observe in American hotels.

3. PRESUPPOSING THAT THE COMMUNAL HOUSEHOLD ECONOMY IS GOING TO BECOME MORE AND MORE WIDESPREAD, INCLUDING CHILD CARE (HALLS OF PHYSICAL CULTURE, DINING ROOMS, KITCHENS, LAUNDRIES, ETC.), HOW LARGE SHOULD BE THE AREA ALLOCATED TO ONE PERSON IN A MINIMUM, ME-DIUM, AND SO-CALLED BOURGEOIS DWELLING?

This question should be answered in the sense that — in our opinion — we should consider only o n e t y p e a n d s i z e o f d w e l l i n g , n a m e l y t h e m i n i m u m d w e l l i n g a s a m i n i m u m - m a x i m u m a p a r t - m e n t , its size to be strictly determined by people's biological needs and allowed to vary only according to the climatic conditions of a particular region and other similar factors. It would be unthinkable for these popular residential complexes to differentiate the apartments according to the social position and wealth of their inhabitants, not least because of the fact that the collective house is a t y p e o f a c c o m m o d a - t i o n d e t e r m i n e d b y t h e c l a s s it is intended for, and thus suitable only for the "minimum subsistence–level class," the proletariat, and also because it best responds to its lifestyle. The affluent classes would refuse to live in collective housing, even if it offered luxury apartments, since their type of accommodation (villa or chateau) suits them best. There, the burden of running such households is left on the shoulders of the numerous servants and so the p a t r i c i a n v i l l a i s t h e p e r f e c t a c c o m m o d a t i o n f o r t h e w e a l t h y c l a s s e s , that is, for their social and family life. Apart from that, only a private villa makes it possible to accommodate the subjective requirements and peculiar whims these classes normally inflict on the design of their residences. The objection that this way of living is extremely uneconomical does not apply here, as the act of dwelling for these classes, which cling to their traditions and prejudices, is not a matter of economy but of a display of ostentatious luxury. That is also the reason why modern architecture must consider the task of

designing luxury dwellings to be beneath its dignity, for the guiding principle of its architectural organization is rational economy. The modern luxury dwelling—that is, the "simple modern" interior of a luxury house or apartment—never corresponds to any real need or necessity, for there is no real need to be frugal. We all know that wealthy people pay fortunes for so-called simple modern furniture and that to them simplicity of architecture is not a question of necessity but of fashion.

Apartments in collective houses cannot be differentiated like the first, second, or third class on the train. It is imperative to consider only one size of dwelling, the same for everyone, providing first-class comfort but third-class lack of luxury, a dwelling that would meet the needs of all members of a class that has no specific demands or pretensions. Only this class will find collectivized and standardized housing not only acceptable but also desirable. That is why only the objective requirements of this class can become the determining factor for architectural solutions. One residential cell allocated to one adult, a dwelling devoid of any common service elements, a sleeping cabin, a cell for private, emotional life and for solitary moments can be of truly minimal dimensions. The size of 3 m × 3 m or 3 m × 4 m may be considered as sufficient with large windows looking into a garden (possibly equipped with glass that lets through ultraviolet rays), to avoid a sense of confinement induced by small spaces.[4] The level of comfort would be determined purely by the level of common wealth.

4. GIVEN MAXIMUM INSULATION AND THE SATISFACTION OF ALL ARCHITECTURAL AND CIRCULATION REQUIREMENTS (AUTOMOBILES WOULD NOT BE PARKED BY THE SIDE OF THE ROAD BUT IN SPECIAL UNDERGROUND GARAGES SITUATED BELOW THE HOUSES, NEAR THE ENTRANCES TO THE ELEVATORS)— WHAT SCHEMATIC FORM OF RESIDENTIAL COMPLEX WOULD BE THE MOST SUITABLE ONE (WITH THE SHORTEST POSSIBLE ACCESS PATHS, MAXIMUM GREEN AREAS, MINIMUM WALKING REQUIRED INSIDE THE HOUSE AND IN THE STREETS)?

First of all, parking will probably not play such an important role in large cities of the future, for we may assume that the automobile, which represents a luxury means of personal transport inside cities, is going to disappear from urban areas altogether. The automobile is a luxury item not only because of its price but because it is essentially uneconomical, using excessive horsepower for the transport of a relatively small number

of people, and also because it takes up too much space, both on the road and when parked. We can assume, on the other hand, that a large proportion of cargo, personal, and express transport will happen underground. The various stations of the underground would be linked by a network of moving sidewalks. Aside from that, we all know that automobile fumes kill the trees along roads, and therefore are most likely harmful to humans as well.

So far, the most advantageous building scheme has proven to be the freestanding row house system (*Zeilenbau*), which brings direct sunlight to all apartments, cross-ventilation for all rooms, and free circulation of air between the rows of buildings. Underground transport would be laid out on a grid pattern underneath these residential cities (possibly with diagonal connecting lines taking care of express transport). The boulevards serving vehicular traffic above ground — which would be substantially decreased — would run perpendicular to the rows of the blocks. Rows in each particular district would be of the same height and the same distance from each other. Entrances to the underground would be situated on the boulevards; intersections and squares above ground could be eliminated along with the traditional corridor street. Shops, cafés, cinemas, theaters, etc., would be situated along the boulevards and close to the underground stations. Moving most of the transport underground would thus eliminate street noise with its debilitating effect on people's nerves, resulting in a quiet city.

5. KEEPING THE ABOVE IN MIND AND TAKING INTO CONSIDERATION THE MOST SUITABLE MODES OF BUILDING, WHAT WOULD BE THE IDEAL POPULATION DENSITY PER HECTARE IN THE RESIDENTIAL DISTRICTS OF THE CITY? SHOULD MODERN URBANISM AIM TO REDUCE, OR ON THE CONTRARY INCREASE, POPULATION DENSITY?

The problem of population density must be posed differently in the case of old cities, with their traditional ways of building, than in the case of newly planned cities. In old cities, high population density represented a social and hygienic evil, as well as posing problems for housing and the organization of street traffic. In currently existing city conditions, public hygiene experts set the density at a maximum of 350 persons per hectare.

In a city where all health requirements are met, where all apartments receive sufficient sunlight and ventilation, where all inhabitants enjoy a reasonable living standard,

and where no children are accommodated in large collective houses, it would be possible to recommend an i n c r e a s e i n p o p u l a t i o n d e n s i t y and a corresponding reduction of the overall area of the city. It is further necessary to determine the limit at which a higher frequency of short-distance transport would be more rational than a lower frequency of long-distance transport. (It is well-known that the electrification of our railways was abandoned because the relatively low frequency of rail traffic in our country makes steam locomotives more economical. Electric railways become more economical only with high-frequency traffic.)

Assuming the validity of all these factors (ideal health and safety provisions, a decent living standard of the population, good health care, nutrition, and exercise), a rational building system would therefore allow for a substantial increase in population density. One item that needs yet to be determined is the desirable ratio between the following two factors: small percentage of built-up areas versus high population densities and increased number of floors versus extended green areas between building rows.

7. COLLECTIVE HOUSES AND CONSTRUCTION POLICY
IN THE SOVIET UNION

In conclusion, we need to state that the s t u d y o f a r c h i t e c t u r a l f o r m s o u t s i d e t h e f r a m e w o r k o f t o d a y ' s c o n s t r u c t i o n l a w s a n d r e g u l a t i o n s , a n d s o c i o e c o n o m i c c o n d i t i o n s , c l e a r l y c a n n o t b e i s o l a t e d f r o m t h e a n a l y s i s o f s o c i a l d e v e l o p m e n t . In today's economic system, and particularly at a time of a deep economic crisis, such architectural principles cannot be realized on a large scale, but only in the form of single "exemplary" (or "experimental" "showcase") projects. Although s u c h e x p e r i m e n t s a n d a n y a s s o c i a t e d a p p r o a c h e s w i l l n o t s u c c e e d i n r e m o v i n g t h e c u r r e n t h o u s i n g s h o r t a g e , such explorations and research are c e r t a i n l y u s e f u l a n d n o t w i t h o u t m e r i t , and thus—strictly speaking—not entirely speculative. In the Soviet Union, the idea of the collective house is being born as a result of new, immediate, and very specific socioeconomic needs, and as part of the establishment of new urban designs; the so-called socialist cities, which are structurally quite different from their capitalist counterparts (in that they amalgamate the city with the country, as well as industry with agriculture). There, all new ar-

chitectural forms are the product of the imperative of new socioeconomic needs and so are the above-mentioned new urban and housing types. These new needs exist in a country with a new social and economic system. The treatment of these residential and urban problems in practice and on a large scale most assuredly depends on [parallel] developments in science and architecture, but the development of a science of architecture depends — in turn — even more on the conditions and the needs of society, its economy and technology.

New specific needs arising in a society help to advance scientific progress more than years of pure speculative work. (The invention of the railway, that is, the transfer of the steam engine principle to rails, happened in response to developments in heavy industry and to the increasing need for long-distance cargo and personal passenger transport. Had the railway been invented experimentally and speculatively several centuries earlier, the invention would have had no practical application, since no industrial preconditions for its use existed at that time). In the same way, the collective house and the new city — until recently an architectural utopia — will be elaborated and will find their practical application only in today's Soviet Union. There, according to the five-year plan, the economic development calls for the participation of some 60,000 foreign engineers, while construction on a giant scale has resulted in the engagement of many prominent European architects to work in the USSR (Hannes Meyer, head of the All-Soviet Institute for Experimental Construction; Le Corbusier with his Centrosoyuz; and Ernst May, who is moving to Moscow on 1 October 1930).[5] Taking into account the stagnation of building activity in Western countries, t h e W e s t e r n a r c h i t e c - t u r a l a v a n t - g a r d e h a s t o r e a l i z e t h a t t h e d e s i g n o f t h e c o l l e c t i v e h o u s e w i t h s t r i c t l y s t a n d a r d i z e d i n - d i v i d u a l l i v i n g s p a c e s i s t h e m o s t p r e s s i n g t a s k f o r a r c h i t e c t s , and that this concept has already found wide-ranging applications in the newly built Soviet cities of t o d a y .

In view of this fact and in view of the Fourth Congress to take place in Moscow in 1931, the architectural avant-garde should, in organizing the congresses, p r o - n o u n c e a n y o t h e r r e s i d e n t i a l t y p e (apartments and houses with their own households, large and small) a s o u t d a t e d a n d s u p e r - s e d e d , and should instead devote all their energy to the s i n g l e u r g e n t t a s k of developing designs for standardized dwelling spaces for individuals in large

214

residential complexes (collective houses or house-communes), which is the only type that will definitively put an end to the housing crisis and misery in a new socioeconomic order.—-And this is also the reason why the architectural avant-garde should not define its task of eliminating housing shortages and solving the housing question without at the same time paying attention to all the social and political preconditions, on which — in the end — the actual solution of the housing question will depend.

JULY 1930

Notes

1. It needs to be taken into consideration that in our country, women constitute one-third of the blue-collar labor force, and women's wages are normally lower by 30 percent or more than men's wages.
2. *Index* 1, no. 11: *Stein Holz Eisen* (Stone, Wood, Steel), no. 13 (1930).
3. B. Fuchs and J. Polášek in *Index.*
4. The floor space of cabins on transatlantic ships is usually 7.5–9.5 m², and 14 m² for luxury cabins.
5. Ernst May, city architect of Frankfurt, published an article in the *Frankfurter Zeitung* in July of this year [1930], bidding farewell to Germany. Here he stated that he considers his task in Frankfurt as completed (?) and that he was leaving for the USSR not for political but for professional reasons, as this is where he is being given the opportunity to engage in development work on a gigantic scale. Issue 7 of the magazine *Das Neue Frankfurt* brings the news that City Architect May will take most of his Frankfurt colleagues with him to the USSR. The team, twenty-five strong, includes names such as Mart Stam,
W. Heberbrandt, G. Schroeder, W. Schultz, W. Schwagenscheidt, Grete Schütte-Lihotzky, Schmidt, W. Schütte, W. Bangert, the graphic designer Hans Leitikov, and others. Ernst May will be working in Moscow as the director of urban planning and Mart Stam and Schmidt as directors of residential planning.

CIRPAC

sešit československé skupiny

mezinárodních kongresů

moderní architektury

a) malobyt • b) moderní okna

stavitel

měsíčník pro architekturu

revue mensuelle d'architecture

monatsheft für baukunst

(XIII) 1932

KAREL TEIGE AND THE CIAM: THE HISTORY OF A TROUBLED RELATIONSHIP

/ 10

Klaus Spechtenhauser
and Daniel Weiss
(Translated by Eric Dluhosch)

Various occurrences of recent times indicate that the International Congresses for Modern Architecture, an organization representing the most active forces from all countries in the field of modern architecture, was confronted by an increasingly unavoidable question—the question whether and how extensively this organization should remain aloof from the increasingly intensifying political struggles within the various capitalist countries. . . . [S]hould the CIAM follow primarily the will of its younger members from the various national groups and transform itself into an organization of socialist architects on an openly admitted Marxist basis, or should it attempt to continue pursuing its activity as a politically independent organization?

— HANS SCHMIDT, *"Zur frage der politischen haltung der CIAM"*
("On the Question of the Political Position of the CIAM," 1934)

ARCHITECTURE AS PUBLIC CONCERN

One of the main reasons for the continuing interest in the intellectual biography of Karel Teige may be found in his activities concerning architecture. In this connection, his theoretical work — articles in journals and anthologies and his polemics during the twenties and thirties — is generally considered of central interest.[1] We find another aspect of his work equally remarkable: namely, Teige's attempt not to remain a captive of pure theory of architecture, but to develop organizational and personal networks in order to be able to propagate his ideas as a matter of public concern. His editorial activities in *Stavba* or *ReD* must, therefore, be seen as closely connected to his initiatives to found artistic and architectural groups such as Devětsil or Levá fronta. These ought to be regarded not merely as professional organizations, but above all as attempts to socialize theory and stimulate artistic-architectural discussion. Teige interpreted "publicity" always as a critical act, frequently as "counterpublicity." It is therefore not surprising that he tied his ideas to those of the radical left not only in his theories but also concretely, in practice. He has too often been mischaracterized as a lonely prophet, preaching in the desert, particularly in connection with his well-publicized polemic against Le Corbusier.

Given that in Teige's theories the artist does not occupy an authoritative and central position and that architecture represents not an unchangeable but rather a socially negotiable system, interaction and exchange of ideas must be considered his central agenda. It is in this sense that Simone Hain calls Teige's concepts a heterogeneous mixture, a kind of "philosophical eclecticism" with activism and empiricism as its basic components, which in turn find their practical translation in "political partisanship."[2]

Teige's activities within the Congrès Internationaux d'Architecture Moderne (CIAM) have so far not been sufficiently noticed and thus offer a good point of departure for developing this line of argument in more detail.[3] From 1928 on, CIAM followed Teige like a shadow. While he formed practical alliances with the organization, he formulated his own distinct positions that might go against the views of its members, leading him to alternate between indirect agitation and open conflict. At first glance, his contacts with the CIAM may appear to have been rather infrequent or even marginal, but they were — if we consider the congress as the caretaker of modern architecture — remarkably telling, since they put Teige in direct contact with the leading personalities and

thus the major positions of the international avant-garde. If, furthermore, we take into account Teige's self-evident position as the emissary and representative of the modern movement in Czechoslovakia—indeed, according to Simone Hain, as the "critical controlling instance and driving force of the European avant-garde"[4]—his distancing himself from the CIAM becomes understandable as an expression of his basic position.

In the following, we will attempt to extract from the chronology of contacts a distinct thematic thread and shed a more focused light not only on Teige's own thinking but on overall CIAM doctrine as well.[5]

SUPERFICIAL CONSENSUS

Opinions within the CIAM were never as unanimous as they appeared from the outside or as they have been characterized retrospectively by writers focusing on the heroic phase of modern architecture (figure 1).[6] Ideological and personal differences erupted quite frequently, though often the appearance of group consensus was maintained— mainly because the members wished to project the most homogenous and determined position possible against the prevailing academic currents. Conversely, the CIAM did not want to be considered as merely another professional organization of

1. Cover of the special issue "CIRPAC" of *Stavitel* 13, no. 3 (1932). Archive des Instituts für Geschichte und Theorie der Architektur an der ETH Zürich (gta; Archive of the History and Theory of Architecture at the Technical University in Zürich), CIAM-Archive, Zürich.

modern architects — as, for example, the Ring in Germany — but advanced the claim that its congresses should be considered the true meeting place of all its members. Thus, aside from the consolidation of organizational and personnel matters, questions concerning the contents of the work sessions as well as the particular social conceptions of its individual members were central to the agenda of the meetings. Opinions varied from the very start. During the formulation of the declaration of principles at the Founding Congress in La Sarraz (1928), profound disagreements arose, primarily over Le Corbusier's work program, in which he attempted to impose his own definition of a formal canon for modern architecture.[7] However, following the wishes of the majority, it was decided that not architectural but technical, economic, and social questions would occupy a central position in subsequent meetings.[8]

The year 1934, during which Hans Schmidt wrote the article quoted in the epigraph,[9] also marks the turning point in the orientation and structure of the congress. The early social-reform phase, marked by the initiatives of German, Dutch, and Swiss delegates, was superseded during the preparations for the Fourth Congress in favor of more empirical work, dedicated to the subject of the "functional city." Groups as well as individuals who favored a socialist position subsequently came under increasing pressure in the CIAM.

It was at this point that the already strained contacts with the Czechoslovak CIAM Group were broken off, only to be reestablished in 1935 by the Brno architect František Kalivoda under completely different auspices. The *spiritus rector* of the first phase of CIAM-Czechoslovakia was Karel Teige. Actually, it was Cornelius van Eesteren who recommended Teige as early as the preparatory phases of the Founding Congress of La Sarraz as the most competent person under consideration. Teige quickly advanced from the position of a common press representative to that of the premier delegate and theoretical mastermind of the Czechoslovak delegation.[10] One reason for Teige's interest in the CIAM may have been his hope to find there a suitable stage for imposing his theoretical concepts on architecture in an international setting. However, fundamental differences developed very early, with the result that true cooperation with the leaders of CIAM was never really achieved. Later, Teige cited economic rather than ideological reasons for his reduced involvement, but this appears implausible, given his thematic emphasis, from the end of the twenties onward, on putting social and political conditions in architecture at the center of his concerns.[11]

ESTABLISHING MODERN ARCHITECTURE

By the year 1928 modern architecture had established itself as a force to be reckoned with in Europe. Le Corbusier was at the peak of his fame; in Germany, supported by the Social Democrats, the Neues Bauen made its breakthrough, especially in the field of housing; in Holland progressive architects were commissioned to tackle new city planning projects; and the Modern Movement had established its place even in general reference works (figure 2).[12]

In Czechoslovakia as well, the new currents managed to prevail. However, on the international level, and in comparison with the attention given to the rest of Europe, CIAM paid relatively little attention to the intensive building activities and theoretical discussions in Czechoslovakia. Thus, the Czechs were represented neither in the preparatory phases of the CIAM Founding Congress nor in the formulation of its program. This is surprising, since candidates well-qualified to act as contacts were known. For example, as early as 1927 Karel Teige received an invitation from Hugo Häring to attend the Congress of Architects in Stuttgart,[13] and the protest letter initiated by the Swiss Werkbund and Sigfried Giedion, objecting to the jury decision in the Geneva League of Nations Headquarters Competition, also circulated among Czech personalities, including Jaromír Krejcar.[14]

2. Karel Teige, cover for his own book *Mezinárodní soudobá architektura* (*International Modern Architecture*) (Prague, 1929).

The Czech scene was first seriously considered during the search for delegates for the various country groups (figures 3 and 4). Even though the Czech delegation was listed in the official program with Karel Teige as correspondent, in fact no Czech went to La Sarraz.[15] The founding of an active country group, despite Giedion's urging, did not take place until shortly after the Second Congress in Frankfurt.[16] Substantial contributions from Czechoslovakia were hardly expected at that time. Giedion made many efforts to involve the founding fathers of the Modern Movement and the leading personalities of modern architecture in Germany, France, and Holland, but he negotiated with Teige and Krejcar merely on matters of organization, not content.

CREATING A NETWORK OF LEFT ARCHITECTS IN CZECHOSLOVAKIA

Karel Teige blamed his absence from the Frankfurt Congress (24–26 October 1929) on scheduling difficulties, which he did not specify in detail in his correspondence with the CIAM Secretariat in Zurich.[17] Instead, his energies were occupied at the end of October with preparations for the founding of Levá fronta (Left Front), a newly formed associ-

3. Letter from Jaromír Krejcar to Karl Moser, 1928. gta, CIAM-Archive, Zürich.

4. List of the participants of the First Congress of the CIAM in La Sarraz, which includes the names of Karel Teige, Jaromír Krejcar, and Oldřich Starý. Handwritten notes by Le Corbusier, 1928. Fondation Le Corbusier, Paris.

ation of Czech intellectuals of the left.[18] As one of its principal initiators, Teige pursued two main goals in Levá fronta. First, he made an effort to unite the avant-garde of the left, which had fragmented along personal and theoretical lines during the so-called quarrel of the generations.[19] Second, he believed Levá fronta should take a position against the present "sticky situation of cultural, social, and political oppression," which Teige diagnosed as being caused by the impending economic crisis.[20]

The driving force of this new organization soon became represented by the architectural section, which formed their own faction, Architektonická sekce Levé fronty (The Architectural Section of the Left Front or ASLEF), in September 1930.[21] The views of ASLEF, especially the members of its most radical wing (Jan Gillar, Peer Bücking, Josef Špalek, Augusta Müllerová), corresponded closely to those of Karel Teige, who increasingly came to regard his architectural studies as a tool of active social criticism. Therefore, it is not surprising that he chose the members of the Czechoslovak CIAM Group from the membership roster of ASLEF and that he declared his ideological position quite unambiguously in his letter to Sigfried Giedion, reporting that "within the Left Front an architectural section has been established whose intention it is to occupy themselves primarily with the problems of housing as well as with questions concerning sociological aspects of architecture."[22]

The activities of this architectural section culminated two years after its founding with the organization and realization of the Congress of Left Architects (Sjezd levých architektů), which took place between 29 October and 1 November 1932 in Prague. During this congress participants decided to form a independent organization of left-oriented architects, which led to the founding of the Association of Socialist Architects (Svaz socialistických architektů, or SSA) on 10 February 1933. After the congress a compendium of the proceedings was published that contained all the speeches as well as its ratified resolutions.[23] The editor of this publication was Karel Teige, who had become actively involved in the SSA and who did not regard it only as a national organization; rather, he imagined it as an international opposition group.[24] The importance that Teige attached to its mission is evident in the assessment of his activities up to that time: "If you compare the work accomplished by the conference with the results of the International Congresses for Modern Architecture, as well as comparing its compendium with the publications of those congresses . . . , you will realize that our conference and our compendium are certainly not of less import than the work of the

congresses organized by the leading authorities of the international avant-garde." [25] Karel Teige thus placed the Association of Socialist Architects on the same level as the CIAM, with the obvious difference that the ideas of the SSA were programmatically at odds with those of the CIAM. [26]

FROM ARCHITECTURAL TO SOCIOLOGICAL CRITICISM

During the Second Congress of the CIAM, the delegates devoted their attention to the subject of the dwelling for the existential minimum. [27] Architecture as a discipline, as well as individual architects, pursued different paths to solve the problem of housing for the lower classes. During the early phases of socialist theory, the question of housing as a function of production and employment structures was a point of departure for criticizing the capitalist system as such. [28] To be sure, the representatives of the bourgeois point of view tended to connect the housing problem to social questions as well, but they did not, in principle, foresee a radical change of the existing social order. In some instances, the bourgeoisie even used housing reform as a means to mollify the restless laboring class, since they were primarily interested in technocratic initiatives, which were intended to defuse the housing crisis within the framework of existing conditions. It was actually Le Corbusier who took the most extreme position, stating emphatically that "it is a question of building which is at the root of the social unrest of to-day; architecture or revolution." [29]

Even the Frankfurt CIAM Congress was essentially under the spell of such theories. Walter Gropius, in his keynote speech, defined "housing for the existential minimum" as a question of "a basic minimum of air, light, and space required by man," while Víctor Bourgeois took the position that the reduction of the habitable area of the dwelling depended primarily on an operationally correct design, thus apparently linking his program to F. W. Taylor's theory of scientific management. [30] In his letter to Giedion explaining his absence, Karel Teige admitted that the architects in Czechoslovakia had so far done very little work in this field and that "the most important achievements of our own modern architecture consisted of a few good office buildings and commercial projects, and, as always, single-family villas for the rich!" [31] He was responding to Giedion's request to send to Frankfurt plans for minimum dwellings, which were to be published in the congress proceedings (figure 5), as well as being included in the planned traveling exhibition. At first glance, Teige's answer may seem somewhat strange, for

224

only half a year earlier he had included examples from Czechoslovakia in his survey of international new architecture, which would have been quite suitable to show in Frankfurt as well.[32]

However, in this context it may be well to remember that Teige's intensive preoccupation with social questions and their architectural consequences started in earnest only around that time. Previously, his architectural writings had reflected primarily constructivist ideas, which implicitly referred to social categories but in general paid homage first to such abstract entities as function, hygiene, modernity, and technical progress. This is evident, for example, in his polemical attacks on Le Corbusier's recent projects and writings.[33] Even though Teige attempted to clarify his own position by confronting the "hero" of the Czech modern movement and by putting some distance between himself and Le Corbusier's aesthetic imperative, his writings clearly are founded primarily on a moralistically supercharged stylistic critique of monumentality and academicism (figure 6). Hence, architectural rather than social progress determined Teige's argumentation in these early texts.

His participation in the activities of the Third CIAM Congress in Brussels (27–29 November 1930) shows how far Teige's theories had become hardened in the interven-

5. Cover of *Die Wohnung für das Existenzminimum* (*The Dwelling for the Existential Minimum*) (Frankfurt, 1930). gta, CIAM-Archive, Zurich.

225

6. Top: (*Left to right*) Karel Teige, Le Corbusier, Jan E. Koula, and Oldřich Tyl on the roof of Tyl's YWCA hostel in Prague, 1928.

Bottom: (*Left to right*) Karel Teige, Jan E. Koula, Madame de Mandrot, Oldřich Tyl, and Le Corbusier on the roof of the Tyl's YWCA hostel in Prague.

Handwritten titles by Karel Teige, 1928. Reproduced by permission of Olga Hilmerová, Prague.

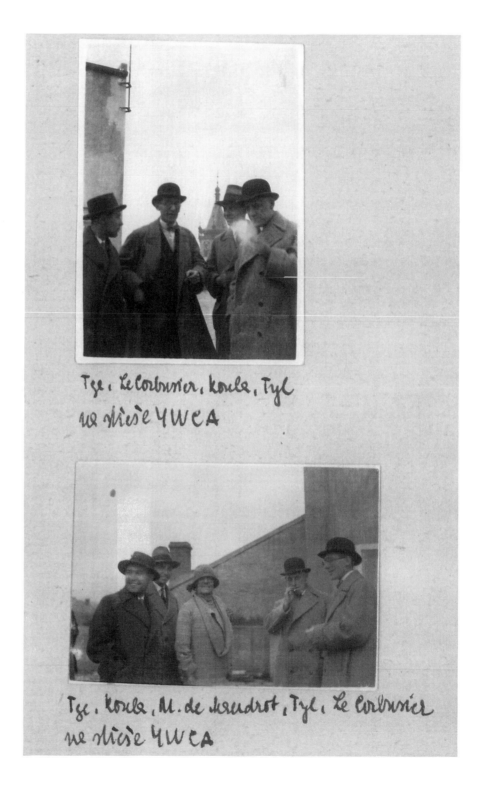

ing year. Questions of economic and social causes of the housing problem, which had been largely excluded from the Frankfurt Congress,[34] were now to be extensively discussed, directly as a result of Teige's contribution. His extensive study of the housing problem in Czechoslovakia was supplemented by housing projects developed by members of Levá fronta.

ACTIVE PARTICIPATION AND COLLECTIVE HOUSING

During May 1930, with preparations for the Third Congress in full swing, Teige reported to Giedion that he had finally succeeded in forming a group in Prague and Brno that would be willing to take part in the work of the CIAM. Indeed, participation by the Czechs in Brussels was lively, and not only by Teige.[35] Questionnaires that had been distributed by the secretariat before the congress were answered in great detail, and Teige delivered a lecture titled "New Architecture and the Housing Question in Czechoslovakia" during the *Journées de l'habitation minimum,* which took place immediately prior to the congress.[36] The contributions of the Czechoslovak group were in general met with an enthusiastic response (figures 7 and 8). Equally, their country report "Position of the Czechoslovak Group on the Problem of the Minimum Dwelling," presented during the preparatory phases of the congress, was praised as "exemplary" and copies were sent to the other country groups.[37] Because of his active cooperation, Teige himself received an offer to compile a contribution for the congress publication.

The basic orientation of the Teige delegation is best characterized by the projects Koldom (Josef Havlíček and Karel Honzík, 1930) and CIRPAC (Jan Gillar and Josef Špalek, 1930; figures 9 and 10), which were included in the congress exhibition and later published as illustrations in *Rationelle Bebauungsweisen* (figure 11).[38] The original intention was to add a third project to these two examples.[39] Both reflect Teige's concept of housing at that time. The notion of the collective house occupied the center of Teige's interest; he regarded it as the only possible way for solving existing housing needs, and in its next stage he foresaw it would be an important element contributing to the total reconstruction of society.

Teige formulated his ideas on collective dwelling for the first time during early 1930.[40] The immediate impetus for the design of both these projects was competition, initiated by the city of Prague during the spring of 1930, to provide ideas for urban rental houses with minimum dwellings.[41] The jury's decision to ignore both the Koldom

227

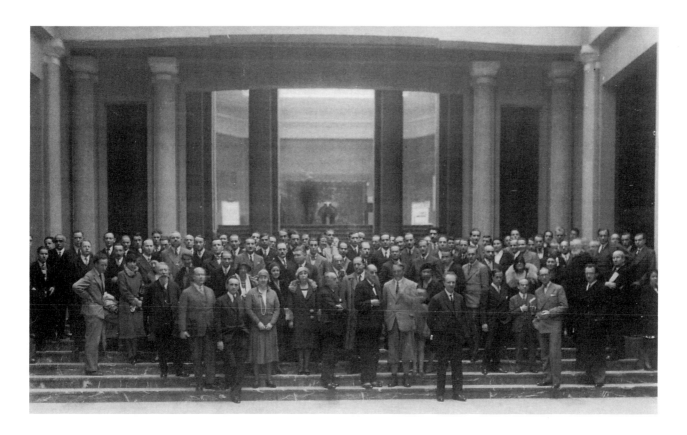

7. Group photograph of the members of the Third Congress of the CIAM in Brussels, 1930. Reproduced by permission of Olga Hilmerová, Prague.

8. List of participants of the Third Congress of the CIAM in Brussels, including the names of Karel Teige and Karel Hannauer, 1930. gta, CIAM-Archive, Zürich.

and the CIRPAC projects, even though they alone presented a genuine solution for collective houses and thus envisioned radically new possibilities, was vigorously criticized both by Levá fronta and by Karel Teige.[42]

In the end, it was this extreme position that led Teige to go beyond compiling an annotated summary of the individual country reports, as originally requested; he also added his fundamental criticism of the form and manner in which the subject of housing for the lower classes had been dealt with in general by the CIAM. At the core of his argument was the assertion "that the question of housing is not only a question of housing *construction,* but essentially one of housing *distribution*" (emphasis in original).[43] From this point of departure, he further criticized the concept of the existential minimum and observed categorically that it described in "euphemistic" terms a condition somewhere between a "*minimum vivendi*" and a "*modus non moriendi.*" Moreover, a lowering of the costs of housing construction and the call for lower rents tend to promote a kind of "social dumping" under present circumstances, since they depended not only on technical rationalization but equally on a general reduction of wages. It was Teige's opinion that neither the resources of the private sector nor subsidies from the state or local municipalities would be adequate to reduce costs sufficiently to give the lowest-income groups access to newly constructed apartments. Upgrading old city quarters, with their inadequate sanitary facilities, has in most instances contributed to a further exacerbation of the housing shortage by squeezing out their original inhabitants, who could not afford even the cheapest of the apartments now available. In conclusion, Teige emphasized the "necessity of a *new collective housing type* for the working classes" (emphasis in original), to be derived from the lifestyle of the working class as such. While Teige repeatedly drew on the research results of the various country groups, he integrated these into his own theory only to support his insistence on drawing a clear line between it and the central postulates of the Modern Movement.[44]

Describing the situation in Czechoslovakia at that time may help to highlight the radical nature of Teige's position. The well-established independent trade union co-operative movement models of mass housing — which were considered as normal in German-speaking countries, which were supported by the housing policies of the Social Democrats, and which had become there a subject of critical discussion — were extremely rare in Czechoslovakia; Brno was the only notable exception. While modern architecture was able to gain a foothold in commercial inner-city projects and suburban

villas, it did not succeed in the general area of housing policy. Instead, planning concentrated on the enhancement of prestigious infrastructure projects for the capital city of Prague, such as the new government administrative district on the Prague Letná Plain, or the representative works of Jože Plečnik in the Prague Castle complex.

In such circumstances, the Koldom and CIRPAC projects not only remind us in their typology of the designs of the Soviet avant-garde but display, after all has been said, a similar utopian attitude. In fact the Czech economy produced its own monuments, such as the Trade Fair Palace in Prague, Bata's shoe city Zlín, and — as a supreme demonstration of its industrial power — Jaromír Krejcar's futuristic pavilion for the 1937 World Exhibition in Paris.

9. Jan Gillar and Josef Špalek, project for communal houses with minimal flats, called CIRPAC, in Prague, 1930. Reproduced from *Stavitel* 11 (1930): 85.

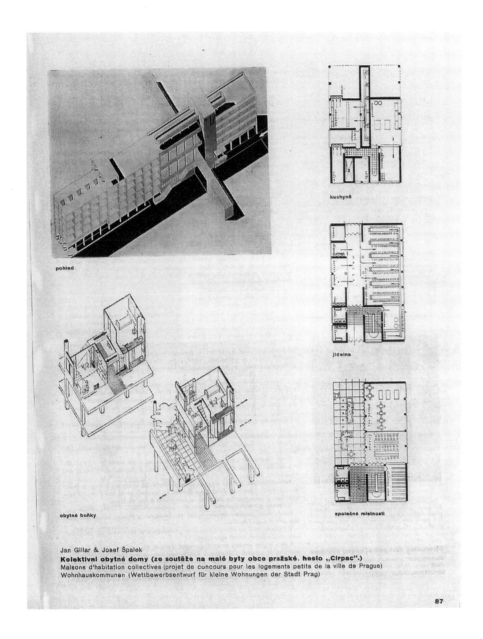

kuchyně

jídelna

pohled

obytné buňky

společné místnosti

Jan Gillar & Josef Špalek
Kolektivní obytné domy (ze soutěže na malé byty obce pražské, heslo „Cirpac".)
Maisons d'habitation collectives (projet de concours pour les logements petits de la ville de Prague)
Wohnhauskommunen (Wettbewerbsentwurf für kleine Wohnungen der Stadt Prag)

87

10. Jan Gillar and Josef Špalek, project for a communal house with minimal flats, called CIRPAC, in Prague, 1930. Reproduced from *Stavitel* 11 (1930): 87.

231

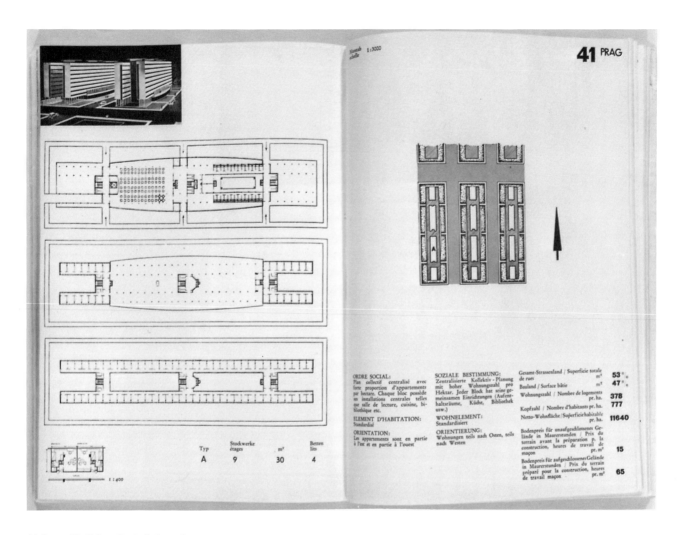

11. Pages 40–41 from the Anthology of the Third Congress of the CIAM in Brussels, *Rationelle Bebauungsweisen* (*Rational Building Methods*) (Stuttgart, 1931), with Havlíček's and Honzík's Koldům project, 1930. gta, CIAM-Archive, Zürich.

and 14), which also contained a translation of Hannes Meyer's programmatic essay "Bauhaus und Gesellschaft" ("The Bauhaus and Society").[61] Shortly after Teige's visit to the Bauhaus, or possibly even during his stay there, Teige wrote the essays "K sociologii architektury" ("On the Sociology of Architecture") and "Architektura a třídní boj" ("Architecture and the Class Struggle"). It was in these articles, dated December 1929 and January 1930, respectively, that Teige sharpened his earlier propositions in the direction of a consistent Marxist theory of architecture that, in the end, may be traced back to his direct contact with the intellectual climate of the Bauhaus. Hannes Meyer showed great interest in Teige's reflections and issued an invitation as early as March 1930 for another visiting lecture course on this subject.[62] His high regard for Teige is further evident in his proposal for Teige's appointment to the Bauhaus. After Meyer's sudden dismissal on 1 August 1930, he wrote Teige: "I know only too well how deeply we share our intellectual Marxist ideals," requesting as an act of solidarity that Teige refrain from further cooperation with the Bauhaus.[63]

The extent of the broad support enjoyed by Hannes Meyer among left-oriented Czech circles is demonstrated by their vehement protests against his dismissal. In no other country did this decision meet such forceful opposition: extensive articles in professional journals and the daily press criticized its political motives, and various organizations sent protest letters to the city administration in Dessau.[64] It was Klaus-Jürgen Winkler who emphasized correctly that this was not merely a show of sympathy but in large part the expression of exaggerated expectations about how Meyer would respond. It was thought that "compared to his behavior so far," he ought to "take a more resolute position and assume a leading role among progressive architects."[65] The extent to which Hannes Meyer had come under pressure from his own cohorts is made clear in his hectic exchange of letters with Karel Teige, who also accused him of being too ready to compromise in his public position.[66] In CIAM circles, the dismissal of Hannes Meyer elicited a completely different reaction. The meeting of delegates at the close of September 1930 refused "after lengthy debate" to respond to Hannes Meyer's request for their support.[67] It also should not be forgotten that it was Walter Gropius who actively participated in dismissing Meyer.[68] Hannes Meyer's rise in left-oriented Czech circles to the status of a symbolic figure can be traced to his extensive lecture travels (figure 15), which were designed to reach an "interested outer circle."[69] From 1929 onward he regularly visited Czechoslovakia, where he presented lectures and es-

tablished personal contacts. This led to close ties that he maintained even during his later residence in the USSR. His activities there were followed with great interest, since developments in the Soviet Union were studied closely and systematically, as well as being subjected to extended synthetic elaboration by the Czechoslovak left.

The results of the Competition for the Palace of Soviets did, however, lead to a lessening of the general euphoria in avant-garde circles, as Teige's disappointed reaction exemplifies.[70] What had been initially thought an exceptional, singular slip was a few years later confirmed to be a more serious permanent trend by Teige's close friend Jaromír Krejcar, who spent the years 1934–1935 in the Soviet Union. His reports on the worsening conditions for modern architecture and the beginning of Stalin's purges contributed a great deal to the sobering up of left-oriented intellects in Czechoslovakia. Therefore, it is not surprising that Hannes Meyer, describing his last visit to Czechoslovakia during January to February 1936, registered an increasing "opposition to the architecture of the USSR."[71] A similar trend can be observed in attitude of Teige, who, disappointed by the events taking place in the Soviet Union after 1934, increasingly lost interest in architecture and chose instead surrealism as the new area in which to develop his theories.[72] One last time, in his 1936 monograph on architecture in the

15. Zdeněk Rossmann(?), poster for Hannes Meyer's lecture "sovietská architektúra bývanie umenie a život" ("Soviet Architecture, Housing, Art, and Life") Bratislava, 1934. National Technical Museum, Prague.

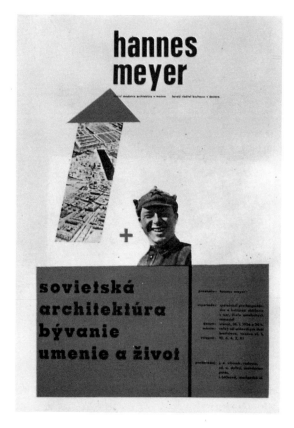

USSR (which was his last comprehensive work on architecture before 1947), Teige expressed once more his hope for a change of direction; this was followed shortly after by his radical critique of Stalinism itself.[73]

Levá fronta, which acted as the link connecting Hannes Meyer and the Czechs, also organized most of his lectures. In a questionnaire, circulated in 1932, it was Levá fronta as well that provided Hannes Meyer with an ideal platform to formulate his concept of architecture "in the service of a socialist idea." The questions seemed to be tailored exclusively to him: focusing on the position of the architect in the class struggle and his relationship to art and society, they lead directly to the conclusion that the architect must "join the front of the revolutionary proletariat as an active fighter."[74]

THE CRISIS OF CIAM: BREAKING THE TIES

The years 1934 and 1935 were years of crisis for the CIAM. The assumption of power by the National Socialists in Germany and the Stalinization of art in the Soviet Union increasingly deprived modern architecture of its base. In addition, the world economic calamity was having a delayed effect on Europe and thus on its construction sector as well, which until 1934 still acted as the main driving force of an internal boom in most of its countries. Many architects suffered from a loss of work; others went into exile. Within the CIAM, positions became increasingly polarized. The political and economic shocks lead to discussions about structures and goals. The principal initiator of these discussions about principles was Walter Gropius, who sent a circular in April 1934 to all members, as a "trumpet call of a responsible presidium," exhorting them that especially during these "difficult times" exchanges among the various country delegations ought to be intensified.[75] During the meetings of delegates in London (May 1934) and Amsterdam (June 1935), the leadership of the congress demanded a radical reorganization of its structure and the reactivation of its dormant country delegations, especially that representing Czechoslovakia. With the announcement of the Amsterdam Meeting of Delegates, Giedion's attitude toward dealings with the Teige group took a different turn as well: "I would have liked to have written this letter to you, really, before we draw any conclusions in Amsterdam."[76]

The leadership troika Giedion–Gropius–van Eesteren may have used these attempts to establish a new orientation at least in part to foster their own agenda, as they put together — behind closed doors — policies and activities for steering and disci-

plining the congress according to their own plans.[77] For example, the secretariat was to be elevated from its honorary status to a real central administrative body. This move was primarily aimed at containing the influence of the exponents of the left wing, which the CIAM leaders considered a thorn in their side.[78] As a consequence of Gropius's report on the precarious position of the CIAM, the discussions of the meeting of delegates in London led logically to a "Statement of the Congress Concerning Political Questions"; it included the stipulation that the CIAM was to be regarded as a professional organization, basing its discussions on technical issues, and "which—as such— should not occupy itself with politics."[79] This formulation provided the official response to the question posed by Hans Schmidt that was quoted in our epigraph. It was obviously a position far removed from the ideas of Teige, who had written shortly before: "The architectural avant-garde, that is, those who did not consider a flat roof or stainless steel furniture as an end in itself, or as a venerated fetish, but rather saw problems of housing, the city, and dwelling design connected to social and political problems— this avant-garde is duty bound to be also active in politics on behalf of progress in architecture."[80]

Thus, the social-reformist phase of the CIAM had definitely come to an end. The new line is most clearly revealed in a letter by Walter Gropius, in which he describes his planned activities in England: "I have resolved, . . . as far as possible, not to start with social housing for workers, but to make a breach into the class of the wealthy. The English architects are in the process of making the same mistakes that we have made in other countries, namely to identify the new architecture *à tout prix* with cheap construction. . . . I am convinced that the workers will accept the new line only after the bourgeoisie has come to terms with it."[81]

Contacts with Teige's group had almost entirely ceased after the extraordinary congress in Berlin in 1931.[82] The CIAM leadership had not failed to notice that the disappointing lack of cooperation by some of the country groups signified not merely a certain feeling of fatigue or resignation but a different orientation. This recognition led to a reversal of the earlier policy of striving for as many members as possible in favor of a reducing the organization to an active inner core, ultimately willing to follow the official CIAM line.[83] The London meeting of delegates issued a warning that those country groups that failed to attend regularly would be cut off in the future. The subsequent meeting of delegates in Amsterdam dealt with this problem as well, and the Czechoslo-

vak CIAM Group was mentioned as being one of the most complicated cases.[84] Mart Stam disagreed, observing that "the Czechoslovak section is working quite diligently and that the nonparticipation of the Czechs is, in fact, the fault of the CIAM." He was subsequently asked "to establish new contact with the group" during his impending trip to Czechoslovakia.[85] Stam's advocacy is not surprising, since he and Teige had become quite close, both in their ideology and their general architectural ideas. Already a year earlier, Stam had become concerned about the discord that he perceived to exist between Prague and the Zurich Secretariat and tried to find out its causes. He declared his intention to establish closer ties with the Czech group, whose work he found "of great interest."[86] During his visit, Stam met Teige, gave lectures, and intensified his contacts with colleagues in both Prague and Brno. Besides Teige he also met Bohuslav Fuchs and Jiří Kroha, whose sociological studies on housing had captured his interest.[87] But, in fact, Stam's mission did not lead to any improvement in the relations between Teige and the CIAM. Moreover, Mart Stam was a somewhat surprising choice to send to Czechoslovakia, since he was viewed by both Giedion and Gropius as past instigator of (political) disturbances within the CIAM.[88]

CZECHOSLOVAKIA AND CIAM: TWO COUNTRY GROUPS

CIAM attempted not only to reactivate the old country groups but also to gain new reliable members, who would be capable of starting a complete reorganization of their country groups. Already at the close of 1934, Gropius recommended that the organization "get in touch with Honzík on behalf of Czechoslovakia."[89] Indeed Karel Honzík, who had repeatedly expressed his skepticism toward Teige's positions in the past, joined František Kalivoda and Bohuslav Fuchs in writing to Gropius of the formation of a new group to represent Czechoslovakia in CIAM.[90] One cannot ignore the fact that at this time, Teige's central role as organizer, theoretician, and ambassador of the Czech architectural avant-garde had effectively came to an end. It was the young Brno architect and graphic artist František Kalivoda who captured the limelight and who prevailed in gaining the support of the CIAM leadership for his appointment as secretary and chief delegate of the Czechoslovak country group.[91] The primary force behind Kalivoda's activities was the prominent Brno architect Bohuslav Fuchs. It is very likely that Fuchs wanted to prevent the international isolation threatened by Teige's radicalism and subsequent silence.

241

Teige did not react to the changed situation until May 1936. He admitted that the original group had already ceased their cooperation before the Fourth CIAM Congress, but he asserted his "absolute lack of confidence concerning the founding of a new branch, as intended by Mr. Kalivoda," while at the same time himself offering to reactivate contacts.[92] This interference led to a prolonged quarrel, during which the Prague and Brno groups challenged their respective legitimacy. Even though Giedion attempted to effect a reconciliation of the rival factions, hoping for "the participation of all Czechoslovak architects with an objective attitude toward cooperation," and though he tried to mediate their conflict during the meeting of delegates in La Sarraz (9–12 September 1936) and the Fifth Congress in Paris (28 June–2 July 1937), Teige's group—in contrast to the architects in Brno—did not make any further substantial contribution to the work of the CIAM.[93] Repeated attempts by Bohuslav Fuchs to settle the quarrel did lead to a softening of the opposing stands, but further developments were cut short by the occupation of Bohemia and Moravia in March 1939 by Hitler's Germany.

After the CIAM resumed activities following the Second World War, its contacts with Czechoslovakia were again characterized by discord. The conflict was exacerbated by the accusations of the Prague group that František Kalivoda had collaborated with the Nazis.[94] However, the CIAM leadership left no doubt their refusal to interfere with internal personal and political differences within individual country groups, stating that "the CIAM cannot and will not judge in questions of collaboration."[95] The separate existence of two groups—one in Prague and the other in Brno—was, as even Teige admitted, "justified neither by practical nor ideological reasons," and he claimed that Kalivoda was "the sole obstacle to their unification."[96] The situation remained confused and the participation of Czechoslovakia fragmented increasingly into individual actions. For example, it is very likely that Jaromír Krejcar went to the Sixth CIAM Congress in Bridgwater (7–14 September 1947) mainly in the hope to negotiate a longer stay in England. Teige, on his part, put a distance between himself and the CIAM; despite his frequent meddling in architectural questions, he at the same time made it clear to Sigfried Giedion that he had shifted the focus of his activities to painting and photography.[97] The Brno group continued to concentrate, as it had already done before the war, on regional and national planning studies. However, these were now developed in close cooperation with state planning institutions.[98] While the Brno group produced regular contributions to the CIAM right up to the date of its dissolution in the fifties, Teige was

242

cut off from any further international contacts after the Communist takeover in Czecho-slovakia in February 1948.

FUNCTIONAL ARCHITECTURE

In retrospect, Teige's relations with the CIAM can probably be best characterized as a case of troubled communications, which at the same time sheds light on the ideological differences within the international avant-garde. The observation that the Modern Movement had never been a homogenous phenomenon is, of course, not original. Many recent references on the various tendencies deviating from the CIAM doctrine of the "international style" emphasize the avoidance of a one-sided dogmatic historiography. However, most of these studies are limited to the investigation of stylistic matters and fail to clearly differentiate terms in the delicate conceptual divide between aesthetics and politics. Particularly with respect to the subject of the avant-garde, we think that such terms as "social," "socially relevant," "left," or "political" are still used too vaguely. Even during contemporary discussions concerning the social relevance of architecture, which took place within a rather diffuse framework, all the various positions had become somewhat blurred; thus from the standpoint of the late twentieth century they have become, in the end, virtually interchangeable.

For example, the primarily aesthetically motivated socialist pathos of a Sigfried Giedion remained largely captive to a kind of revolutionary pioneering mood, characteristic of the period immediately after the First World War.[99] That Giedion lacked understanding of real politics is demonstrated by the two letters of protest sent by the CIAM leadership to Stalin personally, after the jury decision in the Palace of Soviets Competition. They wrote, "Le verdict du comité du Palais des Soviets est une insulte directe à l'esprit de la révolution russe et à la réalisation du plan quinquenal."[100] In fact, this was a complete misreading of the situation—the choice of the jury was "not based on . . . lack of knowledge, but [was] a confirmation of a definite course, which was consciously directed against the new architecture," as Hans Schmidt made quite clear in a letter to van Eesteren; moreover, this naive intervention of the CIAM leadership placed Western architects working in the Soviet Union in a very difficult situation.[101] Rather than relying on vague terms and proceeding by the usual analysis of manifestos, writings, and buildings we instead have approached the concrete interactions between individual personalities and the extant discourse about culture, politics, and society by

examining organizational structures and the behavior within institutions, such as the CIAM.

We wish to conclude by taking up once more the subject of fundamental ideological differences as they relate to the notion of "function." The functionalist concepts of the Modern Movement in architecture included right from their beginnings the notion of certain social tendencies and thus implicitly an element of active political orientation — an element that needs to be interpreted in different ways. The Czech linguist Jan Mukařovský formulated the strictly utilitarian, technocratic worldview of certain exponents of the avant-garde as follows: "The comparison of an architectural creation with a machine (Le Corbusier) may well represent a poignant formulation of a temporally determined tendency aimed at maximum functional clarity in architecture, but this can in no way be accepted as its timeless characterization."[102] Karel Teige was inspired by the theories of the Prague structuralists and understood "function" not merely as an invariable constant but as a historically variable category: "Architectural form, like any other form, is a complex function of many variable elements and changes depending on modifications of its content and surrounding."[103] He manifests here not merely a polyvalent conception of "function" but one that is based on a dynamic and explicitly sociologically grounded model of thinking, in which "purpose is not something rigid or given," nor something that is being "justified for its own sake."[104] Teige denies espousing some ultimate truth; instead, his theories take as their point of departure the view that society is in a state of permanent change.

He and other radical members within the CIAM defended the position that when content and function are tied to a certain social context, reforms by means of architecture can be realized only if they take place in their respective host society, but they can never be effected by architecture alone. It was for these reasons that they posited active political engagement as a fundamental condition of any change: the utopia of "pure" functional design was usually tied to the hope of a self-generated transformation of the capitalist system. This meant that political and aesthetic reforms moved together in a linear fashion. And it was precisely in the middle of the thirties, when the stagnation of the various social movements became markedly evident, that these movements implicitly tied functional architecture to its theories of liberation; as a result, these initiatives for social reform increasingly ended up as self-referential aesthetic gestures.[105]

Isolated by fascism on one side and Stalinism on the other, the CIAM took refuge in a neutral internationalism and tried to anticipate one and all objections by emphasizing that "the movement for a new architecture . . . has developed independently from this or that political structure."[106] Once these tendencies are taken into account, it is not surprising that no love was lost between the CIAM leadership and Teige and his circle, not only because of their sharp disagreement over "the dwelling for the existential minimum" but equally because of their very different theories of a "functional city."

Notes

1. See Simone Hain, "Karel in Wonderland: The Theoretical Conflicts of the Thirties," in *Karel Teige. Architettura, Poesia, Praga 1900–1951,* ed. M. Castagnara Codeluppi exhibition catalogue (Milan, 1996), 311–315.

2. Ibid., 312.

3. To date, the only article dealing with Czech contacts with the CIAM at some length is Vladimír Šlapeta, "Funkcionalismus a skupina CIAM v Československu" (Functionalism and the CIAM Group in Czechoslovakia), in *Památková péče a ochrana přírody v Jihomoravském kraji. 30 let Krajského střediska státní památkové péče a ochrany přírody v Brně* (Historical heritage care and protection in the South Moravian lands: Thirty years of the regional center of state heritage care and protection of nature in Brno) (Brno, 1989), 74–96. A short version is available in German, "Öffnet die Fenster nach Europa für eine neue Architektur — Der Funktionalismus und die CIAM-Gruppe in der Tschechoslovakei" (Open the windows to Europe for a new architecture), *Stadt, Monatshefte für Wohnungs- und Städtebau* 29, no. 5 (1982): 26–47, 61–65. While Šlapeta offers a detailed chronology of events, he does not deal in great detail with conceptual controversies.

4. Hain, "Karel in Wonderland," 311. Rostislav Švácha emphasizes Teige's extraordinary role as well: "Perhaps only the German Adolf Behne and the Swiss Sigfried Giedion were, on the wider international scale, figures of a comparable format"; see "Karel Teige and Czech Modern Architecture," in Castagnara Codeluppi, *Karel Teige,* 305–310; quotation, 306.

5. We rely heavily on original documents from the following archives: Archiv des Instituts für Geschichte und Theorie der Architektur (gta) an der ETH Zürich (Archive of the History and Theory of Architecture at the Technical University in Zürich; hereafter cited as gta, CIAM-Archive, the estate of Sigfried Giedion; Literární archív Památníku národního písemnitví (PNP) v Praze (The literary archive of the Museum of Czech Literature in Prague, hereafter cited as PNP), estate of Karel Teige; Bauhaus-Archiv, Berlin, hereafter cited as BHA, holdings Karel Teige, correspondence Walter Gropius. We have not yet been able to consult the following archival materials in Brno: estates of Bohuslav Fuchs, František Kalivoda, Josef Polášek. Concerning CIAM in general, see Martin Steinmann, ed., *CIAM; Dokumente 1928–1939* (Basel, 1979); *Het Nieuwe Bouwen Internationaal — International — CIAM — Volkshuisvesting Stedebouw: Housing, Town Planning,* exhibition catalogue, Rijksmuseum Kröller-Müller (Otterlo, 1983).

6. In this connection Vittorio Magnago Lampugnani speaks about a "historiography of exclusion," which supports a "manifesto-like writing of history" and assigns Sigfried Giedion a central role in constructing a unified version of the Modern Movement; see "Die Geschichte der Geschichte der 'Modernen Bewegung' in der Architektur 1925–1941" (The history of the history of the "Modern Movement" in architecture, 1925–1941), in *Moderne Architektur in Deutschland 1900 bis 1950: Expressionismus und Neue Sachlichkeit*, exhibition catalogue, Deutsches Architekturmuseum (Frankfurt am Main, 1994), 273–295.

7. The exact sequence of these discussions cannot be determined from the protocol. Owing to the resistance of the Dutch, Swiss, and German representatives, Le Corbusier's article on aesthetic principles was deleted from the final declaration. gta, CIAM-Archive.

8. Giedion therefore judged the results of the congress to be "a clear push to the left." Sigfried Giedion to Walter Gropius, 5 June 1928, gta, CIAM-Archive.

9. Hans Schmidt, "Zur frage der politischen haltung der CIAM" (On the question of the political position of the CIAM), unpublished typescript dated 17 February 1934. gta, CIAM-Archive, estate of Hans Schmidt.

10. The earliest list of likely participants, probably compiled by Gabriel Guevrékian, lists Adolf Loos and Josef Gočár as the representatives of Czechoslovakia (gta, CIAM-Archive). However, Van Eesteren had reservations regarding this selection: "Gochar Prague??? Why don't you ask Teige who should be considered. Surely, there must be some better qualified people" (Sigfried Giedion to Walter Gropius, 5 June 1928, gta, CIAM-Archive).

11. Jaromír Krejcar, Karel Teige, and Emanuela Kittrichová to Sigfried Giedion, 17 May 1947, gta, CIAM-Archive.

12. Gustav Adolf Platz, *Die Baukunst der neuesten Zeit* (Modern building art) (Berlin 1927). The first descriptive summaries from within modern architecture's own ranks were published at the same time: Adolf Behne, *Der moderne Zweckbau* (Modern functional architecture) (Munich, 1926); Walter Gropius, *Internationale Architektur* (International architecture) (Munich, 1925); Ludwig Hilberseimer, *Internationale neue Baukunst* (New international building art) (Stuttgart, 1927).

13. In his report on La Sarraz, Hugo Häring characterized the meeting in Stuttgart, during which the possibility of an international association was discussed, as "the first meeting of the architects of the new movement"; "Internationaler Ausschuss für neues Bauen" (International commission of new building), *Bauwelt* 19 (1928): 644.

14. Giedion wrote to Krejcar that he was well acquainted with his work as published in *Stavba* and pointed out that "Czechoslovakia was the first country which had noticed the importance of Le Corbusier's work." Sigfried Giedion to Jaromír Krejcar, 12 October 1927, gta, estate of Sigfried Giedion.

15. The official program shows Josef Gočár and Adolf Loos as delegates, as well as those proposed by Teige (Jaromír Krejcar and Oldřich Starý). For a certain time, Arnošt Wiesner and Bohuslav Fuchs also had been discussed as Czechoslovak delegates: see the definitive program for La Sarraz; Karel Teige to Sigfried Giedion, 25 May 1928; Arnošt Wiesner to Gabriel Guevrékian, 30 May 1928; handwritten list of delegates by Gabriel Guevrékian (all documents in gta, CIAM-Archive).

16. In one of his frequent letters to Karel Teige, Giedion later expressed his regret concerning the official absence of the Czechs in Frankfurt and wanted to know "what is the actual existing situation in Czechoslovakia." Sigfried Giedion to Karel Teige, 16 January, 1930, BHA, holdings Karel Teige.

17. Karel Teige to Sigfried Giedion, 19 October 1929, responding to Giedion's two letters of invitation, dated 22 August and 4 October 1929. In his reply Teige also excused the ailing Jaromír Krejcar, who had been certified as a Czechoslovak delegate for the meeting in La Sarraz (all documents in gta, CIAM-Archive).

18. Levá fronta was founded on 18 October 1929. During the 1930s it became, with its broad spectrum of subsections (architecture, photography, philosophy, sociology, etc.) the intellectual fulcrum of left discussion. See *Levá fronta* 1–3 (1930–1933); Jaroslav Anděl and C. Albroch, eds., *The Art of the Avant-Garde in Czechoslovakia, 1918–1938*, exhibition catalogue (Valencia, 1993), 451–452.

19. *Avantgarda známa a neznámá,* ed. Štěpán Vlašín et al. (Avant-garde known and unknown), vol. 3 (Prague, 1970); Karel Teige, *Svět stavby a básně* (The world of architecture and poetry), vol. 1 of *Výbor z díla* (Selected works) (Prague, 1966), 566–570, 610–614. The core of these discussions was occupied by the question of political engagement by leftist artists. An additional source of conflict was created by the division of opinions concerning the new leadership of the Communist Party under Klement Gottwald.

20. Karel Teige, "1929," *ReD* 3 (1929–1931): 41–42. The world economic crisis reached Czechoslovakia relatively late and had its climax in 1933; see Jörg K. Hoensch, *Geschichte der Tschechoslowakischen Republik 1918–1965* (History of the Czechoslovak Republic, 1918–1965) (Stuttgart, 1966), 60–61.

21. ASLEF was founded on 30 September 1930. An active Brno branch was formed as early as the summer of 1930, under the leadership of Jiří Kroha. See also *Český funkcionalismus 1920–1940* (Czech functionalism, 1920–1940), vol. *Architektura,* exhibition catalogue, Moravská galerie v Brně, Uměleckoprůmyslové muzeum v Praze (Prague and Brno, 1978), n.p.

22. Karel Teige to Sigfried Giedion, 17 May 1930, gta, CIAM-Archive.

23. Karel Teige, ed., *Za socialistickou architekturu* (For a socialist architecture) (Prague 1933). On the SSA, see *Český funkcionalismus 1920–1940*.

24. "By our action we are attempting . . . to lay the foundation for international cooperation with sympathetic groups abroad"; "Výzva k architektonické levici" (Appeal to the architectural left), in Teige, *Za socialistickou architekturu,* 8–10. Contacts were first established with the Polish scene around Szymon Syrkus (present in Prague during the congress), as well as with the Kollektiv für sozialistisches Bauen (Collective for Socialist Architecture) and the Arbeitsgemeinschaft sozialistischer Architekten (Working Community of Socialist Architects) in Berlin.

25. Karel Teige, "Doslov" (Epilogue), in ibid., 214–229; quotation, 225. See also Teige, "Publikace Svazu socialistických architektů" (Publications of the Association of Left Architects), *Stavitel* 14 (1933–1934): 23. Levá fronta used strategies similar to those of CIAM, relying on such methods as a questionnaire on housing, which was answered by Hannes Meyer among others; see, Meyer, *Bauen und Gesellschaft: Schriften, Briefe, Projekte* (Architecture and society: Writings, letters, projects), ed. Lena Meyer-Bergner (Dresden, 1980), 121–128.

26. Teige envisioned the possible cooperation of the SSA with only "a few left groups in the CIAM"; see Karel Teige, "Levá architektura v Československu" (The architecture of the left in Czechoslovakia), *Index* 5 (1933): 79–83. A "sanitized" version of the article, in German, was sent by the Czechoslovak group as a circular to the CIAM members; gta, CIAM-Archive.

27. See the CIAM Congress publication *Die Wohnung für das Existenzminimum* (The dwelling for the existential minimum) (Frankfurt am Main, 1930). Teige compiled a brief report on the congress proceedings: "Druhý kongres mezinárodní nové architektury" (Second International Congress for a new architecture), *ReD* 2 (1928–1929): 62. Bohuslav Fuchs and Josef Polášek, who participated in the Frankfurt Congress as gate crashers, also wrote a short report; "II. Mezinárodní kongres moderní architektury" (Second International Congress for a new architecture), *Index* 1, no. 11 (1929): 1.

28. See the proposals of the utopian socialists, or the writings of Friedrich Engels: *Die Lage der arbeitenden Klasse in England* (The condition of the working class in England) (Leipzig, 1845), and *Zur Wohnungsfrage* (On the housing question) (Leipzig, 1872).

29. Le Corbusier, *Towards a New Architecture,* trans. Frederick Etchells (1927; rpt., New York, 1986), 269. First published as *Vers une architecture* (Paris, 1922).

30. Walter Gropius, "Die soziologischen Grundlagen der Minimalwohnung für die städtische Bevölkerung" (The sociological fundamentals of the minimum dwelling for urban populations), in *Die Wohnung für das Existenzminimum,* 17–19; Victor Bourgeois, "L'organisation de l'habitation minimum" (The organization of the minimum dwelling), in ibid., 30–34. Hannes Meyer countered such positions by asserting that the broad support for the CIAM's investigations and the effort to shrink the dwelling were just as much the captive of the capitalist logic and its desire to maximize profit; see *Bauen und Gesellschaft,* 124.

31. Teige to Sigfried Giedion, 19 October 1929, gta, CIAM-Archive.

32. See Karel Teige, ed., *Mezinárodní soudobá architektura* (Contemporary international architecture), MSA 1 (Prague, 1929).

33. See above Rostislav Švácha's "Before and After the Mundaneum: Teige as Theoretician of the Architectural Avant-Garde."

34. The contribution of Walter Gropius was based in many points on Hans Schmidt's critical report on the Second Congress. However, Gropius left out those parts of the report that dealt with the social conditions needed to realize the minimum dwelling. Schmidt considered it as "illusory" that the problem could be solved exclusively by new technologies and methods, since these were dependent on profit-oriented institutions such as industrial enterprises and banks. See Steinmann, *CIAM,* 48–49.

35. Karel Teige to Sigfried Giedion, 17 May 1930, gta, CIAM-Archive. Along with Teige, the Brussels Congress was also attended by Karel Hannauer, Augusta Müllerová, and Josef Špalek; see Signatures on the Membership List of Brussels Congress, gta, CIAM-Archive. For detailed information, see Teige's congress reports: "Třetí mezinárodní kongres moderní architektury v Bruselu" (Third International Congress for a new architecture in Brussels), *Index* 3 (1931): 17–20; "3. mezinárodní kongres moderní architektury" (Third International Congress for a new architecture), *Stavba* 9 (1930–1931): 105–116.

36. The *Journées de l'habitation minimum* (Days of the minimum dwelling) took place from 22 to 25 November 1930 in Brussels; it was organized by the Belgian CIAM Group, as was the congress itself.

37. See page 2 of the circular distributed to the delegates, dated 25 August 1930; gta, CIAM-Archive.

38. *Rationelle Bebauungsweisen* (Rational building methods) (Frankfurt am Main, 1931), tabs. 40–41. In expanded version, see also *Stavitel* 11 (1930): 61–63, 85–87, as well as Josef Havlíček and Karel Honzík, *Stavby a plány* (Buildings and plans), MSA 3 (Prague, 1931), 49–62.

39. Karel Teige to Sigfried Giedion, 19 September 1930, gta, CIAM-Archive. Teige probably intended to submit as the promised third project the plans for a collective dwelling in Prague-Pankrác (also known as the "L-Project"), designed by the ASLEF members Peer Bücking, Jan Gillar, Augusta Müllerová, and Josef Špalek and submitted for a competition by the Central Social Insurance Institute during the fall of 1930; see *Stavba* 9 (1930–1931): 116–119. Later Teige described this project as "the greatest single accomplishment of Czechoslovak architecture to date" and as having the character of an "architectural manifesto"; Teige, *Nejmenší byt* (The minimum dwelling), ESMA 1 (Prague, 1932), 314.

40. See Karel Teige, "K sociologii architektury" (On the sociology of architecture), *ReD* 3 (1929–1931): 163–223 (also published separately [Prague, 1930]); "Minimální byt a kolektivní dům" (The minimum dwelling and the collective house), *Stavba* 9 (1930–1931): 28–29, 47–50, 65–68 (parts intended as contribution to the CIAM Congress in Brussels), translated above. For additional information, see E. Dluhosch, "'Nejmenší byt,' The Minimum Dwelling," *Rassegna* 15, no. 53/1 (1993): 30–37; Švácha, "Karel Teige and Czech Modern Architecture."

41. *Stavitel* 9 (1930): 32.

42. The position of ASLEF, "Zásadní stanovisko k pražské soutěži na domy s malými byty" (Fundamental position on the Prague Competition for Houses with Minimum Dwellings) was published in a number of journals. See, e.g., *ReD* 3 (1929–1931): 285–287; *Stavitel* 11 (1930): 68–73.

43. Karel Teige, "Die Wohungsfrage der Schichten des Existenz-Minimums (Zusammenfassung der Landesberichte für den Brüsseler Kongress)" (The question of housing for minimum income strata [summary of country reports of the Brussels Congress]), in *Rationelle Bebauungsweisen,* 64–70; quotation, 66. The responses to the questionnaire of the Second Congress were disappointing. It was for this reason that the delegates were asked in a circular to compile new reports on the condition of housing in their respective countries.

44. Ibid., 66, 67, 70. Teige was not alone in his views. A similar position had already been taken in the reaction of the Communist press to the Frankfurt CIAM Congress; see "Zum Wohnproblem" (On the question of the housing problem), *Mensch und Energie, Technische Beilage der Kommunistischen Tagespresse* (Man and energy, Technical supplement of the Communist Daily Press) 3, no. 19 (12 August 1929): 1.

45. Neither Karel Teige nor Josef Špalek, who was at that time second delegate, went to Berlin. Instead, the architects Bücking and Nesis were sent as substitutes. Little is known about them; they came from Germany and Lithuania, respectively. Both lived in Prague from approximately 1929 to 1931, and both were actively involved in Levá fronta. As radical Commu-

nists they were among the first Western architects to go and work in the USSR (see *Český funkcionalismus 1920–1940);* Šlapeta, "Funkcionalismus a skupina CIAM," 92 (in Czech), 62 (in German); Karel Honzík, *Ze života avantgardy* (From the life of the avant-garde) (Prague, 1963), 205–206.

46. Sigfried Giedion to Karel Teige, 8 October 1931, BHA, holdings Karel Teige.

47. See *Amtlicher Katalog und Führer zur Deutschen Bauausstellung vom 9. Mai–2. August* (Official catalogue and guide to the German Building Exhibition from 9 May to 2 August) (Berlin, 1931); *Bauwelt,* Berlin theme volume, 13 (1931): 607–648.

48. Daily Agenda of the Extraordinary Congress Meeting in Berlin 1931, gta, CIAM-Archive. Reference was also made to the simultaneously occurring Congress of the International Association of Housing and the Meeting of the Association of German Architects, as well as to the traveling exhibition *Rationelle Bebauungsweisen* (Rational Building Methods) associated with the Berlin Building Exposition, which provided an overview of the results of the Third CIAM Congress.

49. Comments on the visit of the hall *Die Wohnung unserer Zeit,* compiled by the Czechoslovak group and Dutch representatives; gta, CIAM-Archive.

50. Karel Teige, "Architektura a třídní boj" (Architecture and the class struggle), *ReD* 3 (1929–1931): 297–310.

51. Position taken by the Czechoslovak group on the concept of the Dutch group concerning the "functional city," unpublished typescript, not dated. The reservations of the Czech delegates concerning the preparations for the Fourth Congress can also be found in the Session Protocols of 4–6 June 1931 (all documents in gta, CIAM-Archive).

52. On the subject of the Kollektiv für sozialistisches Bauen, see "Arbeitsgemeinschaft proletarischer Architekten" (The working community of proletarian architects), *Bauwelt* 12 (1931): 128; Jürgen Kramer, "Die Assoziation Revolutionärer Bildender Künstler Deutschlands (ARKBD)" (The Association of Revolutionary Creative Artists of Germany [ARKBD]), in *Wem gehört die Welt? Kunst und Gesellschaft in der Weimarer Republik* (To whom belongs the world? Art and society in the Weimar Republic), exhibition catalogue, Staatliche Kunsthalle (Berlin, 1977), 174–204. It is not a coincidence that later on Karel Teige printed a contribution of the Kollektiv für sozialistisches Bauen in the publication of the Congress of Left Architects, "Základní otázky, úkoly a metody práce" (Fundamental questions, tasks, and methods of work), in *Za socialistickou architekturu,* 167–174.

53. *Proletarische Bauausstellung,* exhibition brochure (Berlin, 1931); gta, CIAM-Archive. It was Siegfried Kracauer as well who drew attention to this counterexhibition in his penetrating essays and who recommended visiting it as a supplement to the official exhibition: "And it sharpens . . . our perception for certain plans and initiatives, whose unstoppable growth can be clearly felt in some of the exhibition rooms." See Kracauer, "Bauausstellung im Osten" (Building exhibition in the East), in his *Berliner Nebeneinander: Ausgewählte Feuilletons 1930–1933* (Berlin compared: Selected feuilletons, 1930–1933) (Zurich, 1996), 122–124.

54. Protocol of the sessions of 5 and 6 June, 27–28, gta, CIAM-Archive. Such arguments are based on orthodox Marxism, which had already been used against the CIAM by the Commu-

nist dailies after the Second Congress in Frankfurt; it was also revisited somewhat later, for example, by Jiří Kroha in his sociological studies on housing.

55. For articles referring to *Výstava proletářského bydlení* (Exhibition of Proletarian Housing), see Nusim Nesis, "Co nesmí vidět veřejnost, k zákazu výstavy proletářského bydlení" (What the public is not allowed to see; on the prohibited Exhibition of Proletarian Housing), *Tvorba* 5 (1930): 374–375; Adolf Benš, G. [Jan Gillar], and N. [Nusim Nesis], "Výstava proletářského bydlení," *Stavitel* 12 (1931): 101–106; "Výstava proletářského bydlení," *Stavba* 10 (1931–1932): 49–50; *de 8 OPBOUW* 3 (1932): 116–118.

56. Teige, "Architektura a třídní boj," 307.

57. On Teige's contacts with Hannes Meyer, see Karel Storch, "Hannes Meyer," *Architektura ČSR* 29 (1970): 432–441; Klaus-Jürgen Winkler, *Der Architekt Hannes Meyer: Anschauungen und Werk* (The architect Hannes Meyer: Theory and works) ([East] Berlin, 1989), esp. 122–130. Concerning other relations between Czechoslovakia and the Bauhaus, see the articles by Vladimír Šlapeta, "Bauhaus a česká avantgarda" (Bauhaus and the Czech Avant-Garde), parts 1 and 2, *Umění a řemesla* (Arts and Crafts), no. 3 (1977): 29–35; no. 3 (1980): 54–62; "Das Bauhaus und die Avantgarde in der Tschechoslowakei um 1933" (The Bauhaus and the avant-garde in Czechoslovakia around 1933), in *Bauhaus Berlin,* ed. Peter Hahn (Berlin, 1985), 241–252.

58. Teige, *Mezinárodní soudobá architektura,* 157.

59. Records of the extensive correspondence between Hannes Meyer and Karel Teige between 1928 and 1930 contain only Meyer's letters, not Teige's replies; BHA, holdings Karel Teige. Hannes Meyer to Karel Teige, 17 October 1928, BHA, holdings Karel Teige. Meyer emphasized that "the Czech endeavors are of greatest interest here in the Bauhaus, and that for us parallel work to the Bauhaus movement in other countries is important." He visited Prague personally as early as the end of 1928 (see *ReD* 2 [1928–1929]: 171).

60. See the prospectus of Teige's visiting lecture (20–25 January 1930) by the Bauhaus directorate, BHA, holdings Karel Teige.

61. Hannes Meyer, "Bauhaus a společnost," *ReD* 3 (1929–1931): 133–136 (the entire issue, no. 5, was dedicated to the Bauhaus). During the same spring of 1930, Karel Teige also published his summary study of the Bauhaus (dated "Dessau, January 1930"), "Deset let Bauhausu" (Ten years of the Bauhaus), *Stavba* 8 (1929–1930): 146–152. For other reports by Teige on the Bauhaus, see Teige, *Svět stavby a básně,* 570–571.

62. Hannes Meyer to Karel Teige, 12 February 1930, BHA, holdings Karel Teige. According to the Bauhaus lecture program, Teige chose the title "Sociology of the City and Housing." For his presentation, see *hannes meyer 1889–1954 — architekt, urbanist, lehrer* (Hannes Meyer, 1889–1954: Architect, urbanist, teacher), exhibition catalogue, Bauhaus-Archiv, Berlin; Deutsches Architekturmuseum, Frankfurt am Main, and Museum für Gestaltung, Zurich (Berlin, 1989), 177. Existing documents do not definitely prove that Teige's visiting lecture actually took place.

63. Hannes Meyer to Karel Teige, 31 October 1929; Meyer to Teige, 31 July and 6 August 1930, BHA, holdings Karel Teige. Immediately after his dismissal was announced, Meyer wrote Teige: "I would like to tell you today in great haste that I have been 'made to go.'"

64. Teige himself took positions for Hannes Meyer in *Stavba* and *Tvorba* (see Teige, *Svět stavby a básně*, 571). For other letters of protest (from Levá fronta and various architectural professional associations), see Winkler, *Der Architekt Hannes Meyer*, 128–129; Storch, "Hannes Meyer," 439.

65. Winkler, *Der Architekt Hannes Meyer*, 130. See also Peer Bücking to Hannes Meyer, 4 September 1930, Stiftung Bauhaus Dessau, Literary Archive: "I am of the same opinion as Teige, namely that you are the only non-Russian architect who will be capable of assuming the leadership of the new movement, which will advance architecture beyond its current state and which is to be most certainly based on the widely proclaimed Marxist basis."

66. Meyer to Teige, dated 29 August 1930, BHA, holdings Karel Teige. Teige's criticism took issue with the "open letter" by Hannes Meyer, which he characterized as "insufficiently Marxist." The exact wording of Teige's accusations cannot be verified, since all that remains is Meyer's answer, in which he tried to legitimize his "half-measures and inconsistencies" by citing "tactical reasons."

67. Protocol of the Meeting of Delegates in Frankfurt am Main on 25 September 1930, 26–27, gta, CIAM-Archive. It is striking that Hugo Häring's statement that the dismissal had "relatively little in common with Hannes Meyer's political attitude" has not been disputed.

68. Gropius wrote later that Meyer had been dismissed "on my recommendation, to be replaced by Mies van der Rohe." Walter Gropius to Richard Döcker, quoted in Winkler, *Der Architekt Hannes Meyer*, 127, 638.

69. Speech by Hannes Meyer around 1929–1930; quoted in ibid., 124.

70. Karel Teige, "Dvorec sovětov v Moskvě" (The Palace of the Soviets in Moscow), *Žijeme* 2 (1932–1933): 20–22. Teige believed that the prize given to the projects of Iofan, Zholtovsky, and Hamilton should be interpreted as merely a temporary regression into academic architecture; he could not imagine that this "symbol of the government and homeland of the international proletariat could be conceived as an architectural work designed in the spirit of medieval feudalism or American imperialism."

71. Hannes Meyer to Nikolai J. Kolli, 29 July 1937, Deutsches Architekturmuseum Frankfurt am Main, remains Hannes Meyer.

72. See on this subject Otakar Máčel, "Paradise Lost: Teige and Soviet Russia," *Rassegna* 15, no. 53/1 (1993): 70–77. Máčel characterizes Teige's change of mind most aptly as a "loss of paradise."

73. Karel Teige, *Sovětská architektura* (Soviet architecture) (Prague, 1936); Teige, *Surrealismus proti proudu* (Surrealism against the current) (Prague, 1938). See also Ivan Pfaff, *Česká levice proti Moskvě, 1936–1938* (The Czech left against Moscow, 1936–1938) (Prague, 1993).

74. The German translation of Hannes Meyer's answers published in the periodical *Levá fronta* was later also published under the title "Der Architekt im Klassenkampf" (The architect in the class struggle), *Der rote Aufbau* 5 (1932): 614–619; reprinted in Meyer, *Bauen und Gesellschaft*, 121–128 (quotation, 125).

75. Circular from Walter Gropius, sent, among others, to Karel Teige on 4 April 1934, BHA, holdings Karel Teige. From the spring of 1934 on, Walter Gropius acted as deputy for Cornelius

van Eesteren, who was seriously ill for a long period. In October 1934 Gropius emigrated to England.

76. See Protocol of the Meetings of Delegates in London (20–21 May 1934), and Amsterdam (9–13 June 1935), gta, CIAM-Archive; Sigfried Giedion to Karel Teige, 17 May 1935, BHA, holdings Karel Teige.

77. At first, strategies were discussed only within the inner circle and submitted later to the general membership without warning, in condensed form. Walter Gropius to Sigfried Giedion, 19 December 1934, gta, CIAM-Archive: "it may be best to negotiate questions of personnel at first only with you, Eesteren, and myself."

78. Walter Gropius to Sigfried Giedion, 14 February 1935, gta, CIAM-Archive: "I have observed that the Communist sympathizers within the various country delegations are in silent agreement (Weissmann, Sert, Stam, Wells Coates etc.), in order to impose one day a different direction on the whole congress."

79. Protocol of the Meetings of Delegates in London (20–21 May 1934), 1, gta, CIAM-Archive.

80. Teige, "Architektura a třídní boj," 309.

81. Walter Gropius to Sigfried Giedion, 27 December 1934, gta, CIAM-Archive.

82. Even though the Zurich Secretariat continued to send memoranda and other documents to Prague, the Czechoslovak CIAM Group ceased to make any significant contributions, the only exception being the submission of tables for the Fourth Congress's "Population and Traffic Analysis of the City of Prague," gta, CIAM-Archive.

83. In this context, see Sigfried Giedion's remark to Walter Gropius (6 May 1935, gta, CIAM-Archive):

 Now again, we have made the same experience; with the Spanish, Dutch, French, English, and Polish groups contact is immediate and fruitful . . . as to the other groups, as usual, silence. I must confess to you that I might as well throw all the memos in the lake instead. . . . [I]t may eventually get to the point that groups of this or that color may eventually separate themselves; instead, we should maintain the possibility . . . to strengthen the allegiance of the other groups to our core constituency."

84. See Protocol of the Meeting of Delegates in Amsterdam (9–13 June 1935), 4, 11, gta, CIAM-Archive.

85. Ibid.

86. Mart and Lotte Stam to Teige, 22 November 1934, PNP: "We heard . . . about the conflict that took place within the 'Congress for a New Architecture.' Could you explain to us what all this is about? The general opinion is: An overly tendentious political position of the Czech Group?"

87. Stam was probably interested mainly in Kroha's *Sociologický fragment bydlení,* worked out in 1930 to 1932; for more details, see Jiří Kroha, *Sociologický fragment bydlení* (Sociological fragment on housing) (Brno 1973); Josef Císařovský, *Jiří Kroha a meziválečná avantgarda* (Jiří Kroha and the interwar avant-garde) (Prague, 1967), esp. 25–29; and *Jiří Kroha 1893–1974 — Kubist, Expressionist, Funktionalist, Realist,* exhibition catalogue, Architektur Zentrum

Wien (Vienna, 1998). Actually, Stam had already proposed Jiří Kroha as speaker for the Meeting of Delegates in Amsterdam, but his suggestion was categorically rejected by Giedion and van Eesteren. The latter considered it completely unacceptable to "allow some unknown by the name of Kroha to make such an important introductory speech"; Cornelius van Eesteren to Walter Gropius, 17 May 1935, gta, CIAM-Archive.

88. Sigfried Giedion to Walter Gropius, 22 February 1935, gta, CIAM-Archive.

89. Walter Gropius to Sigfried Giedion, 29 December 1934, gta, CIAM-Archive. In fact, Honzík spoke with Walter Gropius during his visit to London early in 1935, and they discussed the situation of the Czechoslovak group (see Gropius to Giedion, 13 March 1935, gta, CIAM-Archive; Honzík, *Ze života avantgardy,* 204).

90. František Kalivoda, Bohuslav Fuchs, and Karel Honzík to Walter Gropius, n.d., BHA, correspondence Walter Gropius. Attached to the letter was Kalivoda's extensive report on the CIAM, which was published in the December issue of *Index:* "Mezinárodní kongresy moderní architektury" (International congresses for a new architecture), *Index* 7 (1935): 97–104. However, handwritten notes by Giedion on a membership list dated April 1935 prove that Kalivoda and Fuchs had already been certified by the CIAM leaders as Teige's successors at that date; gta, CIAM-Archive.

91. Kalivoda participated in 1933 as observer at the Fourth CIAM Congress. His lively correspondence with Sigfried Giedion and his regular soujourns in Switzerland testify as well to his intense efforts to rebuild the Czechoslovak CIAM Group from the middle of 1935 on; gta, CIAM-Archive. On the activities of Kalivoda, see Šlapeta, "Funkcionalismus a skupina CIAM."

92. Karel Teige to Sigfried Giedion, 13 May 1936, gta, CIAM-Archive. Apart from Teige, other signatories included Jan Gillar, Josef Chochol, Josef Kittrich, Jaromír Krejcar, and Adolf Benš.

93. Sigfried Giedion to Karel Teige and the Prague group, dated 23 December 1936, BHA, holdings Karel Teige. The most important activity of the Brno group was the organization of the three CIAM East Congresses in Budapest (29 January to 2 February 1937), Brno and Zlín (4 April to 5 May 1937), and in the beginning of June 1938 in Micenae, which resulted in cooperation with the Hungarian group. See *Magazin AKA,* no. 1 (1937): 16; no. 2 (1938): 16; correspondence František Kalivoda–Sigfried Giedion–Molnár Farkas, gta, CIAM-Archive.

94. Jaromír Krejcar to Sigfried Giedion, 23 July 1946, gta, CIAM-Archive. This letter announced the formation of a new Czechoslovak group, chaired by Karel Teige and with Jaromír Krejcar as secretary.

95. Sigfried Giedion to Jaromír Krejcar, 14 September 1946, gta, CIAM-Archive.

96. Karel Teige to Sigfried Giedion, 18 May 1947, gta, CIAM-Archive.

97. For more details, see Karel Teige, *Osvobozování života a poezie* (The Liberation of Life and Poetry), vol. 3 of *Výbor z díla* (Selected works) (Prague, 1994), esp. 628–630.

98. A summary of works and publications can be found in the official report of the Bridgwater CIAM Congress, "Report of the Czechoslovakian Group CIAM," gta, CIAM-Archive.

99. Giedion was active during his studies in Munich in a socialist student group and wrote plays for a worker's theater. It is also known that Gropius participated in the Arbeitsrat für Kunst (Worker's Council for the Arts) and the Novembergruppe (November Group). During the

same time he also used Feininger's woodcut *The Cathedral of Socialism* to illustrate the first Bauhaus manifesto of 1919.

100. "The decision of the jury of the Palace of Soviets is a direct offence to the spirit of the Russian Revolution and to the realization of the five-year plan"; Sigfried Giedion, Cornelius van Eesteren, and Victor Bourgeois to Stalin, dated 20 April 1932, gta, CIAM-Archive.

101. Hans Schmidt to Cornelius van Eesteren, 14 August 1932, gta, CIAM-Archive. Altogether twenty-six architects, among them Hannes Meyer, Hans Schmidt, and Peer Bücking, characterized the statement as a "defiance of the Soviet public": gta, remains Hans Schmidt; *Die neue Stadt* (1932–1933), 146.

102. Jan Mukařovský, "K problému funkcí v architektuře" (On the problem of functions in architecture), *Stavba* 14 (1937–1938): 5–12; in German, "Zum Problem der Funktionen in der Architektur," in his *Kunst, Poetik, Semiotik* (Art, poetry, semiotics), ed. Květoslav Chvatík (Frankfurt am Main, 1989), 109–128.

103. Teige, *Nejmenší byt,* 29.

104. Karel Teige, "Etapy vývoje" (Stages of development), *Stavba* 8 (1929–1930): 6–16, 19–23.

105. See Günther Uhlig, *Kollektivmodell "Einküchenhaus": Wohnreform und Architekturdebatte zwischen Frauenbewegung und Funktionalismus 1900–1933* (Collective model "Single Kitchen House": Housing reform and architectural debate between feminism and functionalism, 1900–1933) (Giessen, 1981), esp. 117–119. In the chapter "Moderne am Umbruchpunkt" (Modernism at the crossroads), Uhlig discusses the relationship between politics and theory by investigating collective housing types.

106. Circular of the CIAM leadership to the country delegates (April 1934), gta, CIAM-Archive.

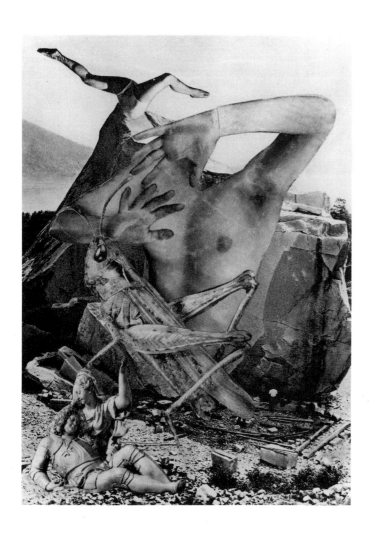

KAREL TEIGE DURING THE THIRTIES: PROJECTING DIALECTICS

Karel Srp
(Translated by Karolina Vočadlo)

THE LEFT FRONT

The early thirties saw the culmination of the widespread activities singular to Devětsil.[1] By this time it had become a highly regarded art association gathering together writers, artists, architects, actors, and musicians. Teige published extensively, backed numerous artistic and cultural-political initiatives, and also published his own magazine *ReD* (*Revue Devětsil*), which reflected his idea of an exemplary international avant-garde periodical. He even had the opportunity to lecture for a term at the Bauhaus.

Nevertheless, internal feuds began to simmer beneath the surface of a seemingly united effort. Teige, whose faith in avant-garde artistic ideas never flagged, found himself unexpectedly in serious conflict with the artist Jindřich Štyrský, who defended the right of the artist to independence of expression based on his own political orientation.[2] Teige was also criticized by the architect Vít Obrtel for the overly decorative constructivist features in many of his typographical designs of that time.[3] By the late twenties, his dream of a unified, collective avant-garde movement had dissolved without significantly affecting "official" culture, which favored so-called bourgeois art and which, for all intents and purposes, represented the First Republic to the outside world. The nominally unified avant-garde disintegrated at the worst possible time, a time when the political situation was approaching a crisis because of labor unrest, caused by the depression of the late twenties and early thirties. The translation of Lautreamont's *Les Chants de Maldoror,* illustrated by Štyrský (figure 1), actually became one of the first victims of censorship, as left-oriented publications were shut down by the authorities and even the pages of *ReD* were censored.

The artistic association Levá fronta (Left Front) was established on 18 October 1929 as a watchdog against external interference in the cultural life of the left avant-garde and with the purpose of "concentrating and mobilizing the cultural left." While the Left Front did not represent the same broad generational platform as Devětsil had done during the twenties, neither did it limit itself to acting strictly in the interest of a single generation. For example, František Xaver Šalda, an important art critic of the 1890s generation, supported the Left Front and for a short time even became its mascot, since "the aim of the Left Front is to focus on the common work and activities of all those whose art is imbued with the modern spirit."[4] It would seem that Šalda's support of the Left Front, at least during its initial stages (since it later became controlled by narrowly oriented Communist ideologues), confirmed from an unexpected quarter

the promotion of Teige's idea of "antithetical development." While certain members of the Stubborn Ones (Tvrdošíjní) did not support those members of the younger generation who had in the interim become close friends of Tomáš Garrigue Masaryk (the first Czechoslovak president), this was not true of Šalda, who remained in opposition to official cultural policy for most of his life.

The efforts of the first signatories of the Left Front, who were largely members of Devětsil, temporarily overlapped with those who joined later—for example, Vladislav Vančura, Jaroslav Seifert, Jindřich Štyrský, and Toyen—and younger artists who had joined Devětsil during the late twenties, such as the poets Vilém Závada and František Halas. They proclaimed their solidarity in declaring their opposition "against the ruling and decaying liberal culture" and against "conservatism and reaction," as well as in promoting an artistic approach that would "draw a line of demarcation between modern art and its materialistic worldview, and old, exhausted aesthetic and idealistic trends."[5]

Although Teige was not among the first signatories, he did sympathize with its program. He commented on the Left Front at length in *ReD* and eventually became its chairman. Several of the ideas defining the group's particular orientation were probably initiated by him; these include "a debating evening on housing issues, discussion eve-

1. Jindřich Štyrský, *Kresba k Maldororovy* (*A Drawing [Dedicated] to Maldoror*), cover of *ReD* 3, no. 2 (November 1929). The Mitchell Wolfson Jr. Collection, the Wolfsonian–Florida International University, Miami Beach, Florida.

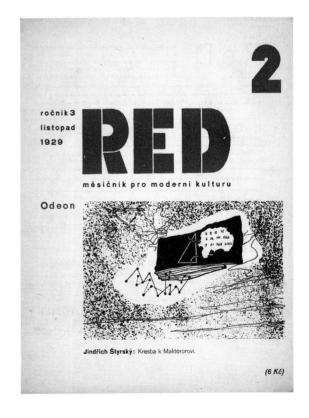

nings on architectural and social issues, freedom of artistic and scientific expression, and discussions on censorship,"[6] as well as his initiative to organize a traveling exhibition of "the minimum dwelling" that was intended to coincide with the publication of his comprehensive book on the subject.

Throughout its activities, the Left Front maintained a clear and unambiguous confrontational position directed against the ruling official ideology. Its chief role may be best characterized as that of an open platform for assorted left-oriented intellectuals. Unlike the avant-garde program of the early Devětsil, which focused its efforts on an assault on all old forms of art, the Left Front merely tried to support left-oriented cultural-political objectives without founding any particular artistic movement. The late twenties and early thirties thus represented a period of a certain artistic destabilization in the ranks of the avant-garde, whose main requirement for membership was being reduced to unquestioningly subscribing to a single worldview as artistic and intellectual guide: namely, Marxist dialectic materialism.

ARS UNA: SENSUALITY, THE SENSES, AND SURREALISM

Even though poets and artists whose work registered tragedy, pessimism, and social disillusion reacted with great concern to the fading of the optimistic and utopian ideals that Devětsil had espoused during the early twenties, Teige's primary, sensuous elementary tropes, singled out during early poetism as their chief inspirational source, remained the focus of his attention. Teige actually called for their regeneration during the late twenties: "Humanity must be taught to use their senses in the most intensive and most direct manner," even as other deep-rooted sources for their existence were discovered beyond simple susceptibility.[7]

Given the tenor of the time, the fleeting sensuous atmosphere of early and high poetism was no longer seen as a front of sensuality but was now replaced by the notion of human instinctiveness. In his article "Báseň, svět, člověk" ("Poem, World, Man"), Teige developed his complex conception of ars una, "in which the activities of all the senses, the body and the spirit, our hands and brain, come together in a higher synthesis. The creative instinct (which is complex and composed of many factors) is energy existing beyond the spiritual and physical regions." For Teige, this sensual conjunction found its expression in pure "sexual erotic energy," which motivates the whole sphere of the imagination. Continuing along this line of thinking, he suggested that "the new

society needs a sensually balanced, harmonious, total man whose biological core is the basis for the instinctive affirmation of all things." Clearly, Teige regarded the libido as the principal influence by means of which the "liquidation of art" was to reach a new stage: "Once society has eliminated the oppression of the libido, art will become superfluous as a mechanism for the sublimation of the libido[;] . . . beauty will not be the artificial product of a poem but an epiphenomenon of all living expression." Nevertheless, the creative instinct cannot be expected to move off in this direction of its own accord. In Teige's opinion, it had to be coaxed. If, during the early twenties, Teige found an enemy in formalism, as he did in all "-isms" before 1914, by 1930 Romanticism had become the new adversary, assailed for its characteristically "magical, mythological, religious, metaphysical, and idealistic thinking."[8]

While Teige's article "Poem, World, Man" preceded the publication of the Czech edition of Breton's "Second Surrealist Manifesto," Vítězslav Nezval's "Third Poetist Manifesto," intended for the third (unpublished) issue of *Zvěrokruh* (*Zodiac*), did represent a partial response to its challenge. Nezval's fundamental idea was to cause disruption: "We wish to accept lies as the consequence of an act of life with the same degree of vehemence with which we face reality." Nezval even professed to reject any form of positive human quality such as solidarity, helpfulness, or any other "benevolent gesture" and noted in this connection that certain eminent Czech artists "had rushed like a pack of rats" to join the cause of humanity's pathetic noblemindedness.[9]

Along with declaring as unacceptable the conventional lifestyle of the late twenties, the former representatives of poetism, particularly Teige, Nezval, Štyrský, and Toyen, also had to confront the issue of surrealism. Though at first condemning the movement, they were ultimately able to use it to inject a new vitality into original poetist ideas.

Toward the end of the twenties, Teige and Nezval began to promote the coexistence of dialectical materialism and psychoanalysis with greater intensity than before, now regarding them as mutually complementary and supportive theories. For a while, Freud became as important to them as Marx. They even used dialectics to criticize the surrealists. For example, we can read in Nezval's third and most radical poetist manifesto that "it is an advantage that dialectical thinking gives me license not to have to employ the term 'surrealist' — which I have yet to do — but see confronting me a pure simultaneity of reality that 'is and is not.' . . . I make my judgments dialectically; I see the

enduring and inseparable unity of these contradictions that the surrealists wish to see in conflict; they would wipe out one with the other."[10] Nezval, who recalled Heraclitus with his emphasis on the fusion and simultaneous "unity of contradictions," should have been relieved that his third manifesto on poetism was left in manuscript form, as his relationship with Breton and the Paris surrealists took a positive turn shortly after 1930. By 1938 he had come to admire them greatly.

Karel Teige's acceptance of surrealism proved to be the most complex. While surrealism penetrated the artificialism of Štyrský and Toyen from 1929 on, almost against the will of both painters, and appeared more or less spontaneously in the poems of Nezval, Teige approached surrealism more on a theoretical level. For him, as the chief initiator of poetism, rapprochement was by no means simple, since during the twenties poetism and surrealism had existed as parallel movements. In his article "Deset let surrealismu" ("Ten Years of Surrealism") Teige compared the publication dates of the manifestos of both movements and found that the two key poetist manifestos (spring 1924 and June 1928, respectively) actually preceded Breton's surrealist manifestos (October 1924 and December 1929). In addition, Teige observed that the initial distinctions existing between the movements in 1924 varied according to their source: the patron of poetism was chiefly Apollinaire, while surrealism was based on dadaist concepts. Poetism had been linked from the beginning with the idea of the communist and proletarian revolution; Paris surrealism, in contrast, had not freed itself from certain "mystical" traits, nor had it resolved the controversy between "avant-garde politics and avant-garde art." Despite the initial idealism and a rather vague adoption of dialectical materialism in poetist and surrealist works other than his own, and after the publication of the second manifesto, Teige reached the conclusion that these contemporary movements did share similar beliefs. Thus, in 1934 Teige was able to argue with a clear conscience that "at this stage in their development, the poetists have declared themselves to be surrealists."[11]

It should be noted, however, that poetism and surrealism had already shared certain traits back in the early twenties, when members of Devětsil had whiled away many hours in Prague coffeehouses, dreaming up collective games, both verbal and pictorial; discovering enigmatic figures in the patterns of marble table tops; and debating different ways to stimulate automatic writing. They did all this without translating their experiments into a specific program. In fact, poetism's existence was largely dependent on

the collective principles of Devětsil during the twenties; but as its unified front began to break up during the early thirties, Devětsil was unable to sustain its status as a broad avant-garde movement that it had enjoyed during the previous decade — a situation of which Teige was well aware.

OBJECTIVE SUPERREALITY: DIALECTICAL MATERIALISM

As already noted, Teige's name was not to be found among the first signatories of the Left Front, even though he was its chairman, nor was he among the first signatories of the Czechoslovak Surrealist Group (1934), even though he became its chief theorist almost immediately after its inauguration. Teige's absence from the opening event organized by the Czechoslovak Surrealist Group was actually the result of a long-standing rift with Jindřich Štyrský (dating back to the autumn of 1929), which Nezval finally succeeded in smoothing over in spring 1935 when Teige and Štyrský finally shook hands during that year's May Day rally.[12] But even before their formal reconciliation, Teige had already written an introduction to the catalogue that was published to coincide with the first exhibition of the Czechoslovak Surrealist Group (January–February 1935; see figures 2 and 3), in which he voiced his great appreciation of Štyrský's collages.[13]

Teige saw dialectical materialism as a possible point of contact with Breton as well as a general framework embracing all avant-garde movements of the thirties, and thus the key term for all of its activities.[14] However, he did not regard dialectical materialism merely as an abstract concept, for he succeeded in defining and rendering it operational succinctly in his own artistic endeavors. Thus, in his catalogue introduction, Teige highlighted three mutually complementary spheres of surrealist activity, namely, "the poetic, the experimental, and the critical." All three were characteristic, for example, of Štyrský's collage *Marriage,* part of a larger series titled *Traveling Cabinet* (1934; figure 4). As Teige writes,

unlike tendentious graphic art, the surrealist montages by Jindřich Štyrský are of a profoundly subversive character, since they are free of social sentiment; they are capable of achieving their effect in a purely materialist manner without having to take recourse to accounting intellectually for the here and now of human instincts. . . . Using obscene and repugnant combinations, he succeeds in ripping into shreds the fabric of the sacred sentiments of which the institutions of family and marriage are woven. . . . [They are] nothing but canonized forms of prostitution; mechanisms for the murder of revolt and love; mechanisms for the production of spiritual wretchedness.[15]

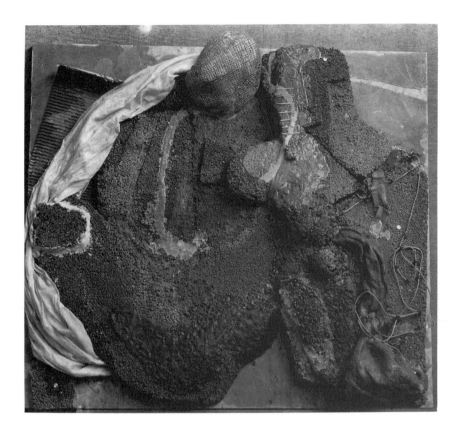

2. Vincenc Makovský, *Woman with Vase*.
Materials: Cork, wax, tar, cloth, string,
matches, 1933. National Gallery, Prague.
Photo by Josef Sudek.

3. Ladislav Zívr, *Srdce incognito* (*Incog-
nito Heart*). Materials: Wood, wire, skin,
cloth, netting, metal, 1936. National Gal-
lery, Prague. Photo by Josef Sudek.

4. Jindřich Štyrský, *Stěhovací kabinet,
Manželství* (from the cycle *Traveling Cabi-
net: Marriage*). Collage, 1934. Private Col-
lection, Paris. Photo by Josef Sudek.

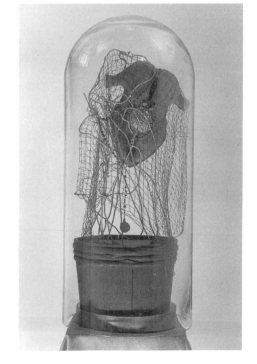

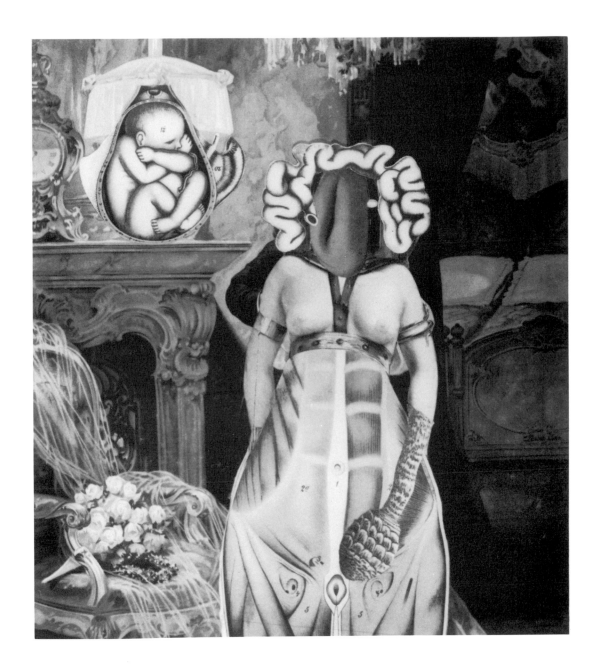

It is quite conceivable that Štyrský executed the collage *Marriage* at Teige's bidding in the same way that Jaroslav Seifert "wrote" poems very closely allied to Teige's theses of the early twenties. Accordingly, it is composed of several disparate segments, superimposed on a colored lithograph of a typical middle-class nineteenth-century interior; it thus comments on the problematic state of that century's social conditions, as outlined in Teige's book *Nejmenší byt* (*The Minimal Dwelling,* 1932). The lithograph presents a view from the living room to the bedroom with its marital beds. In *Nejmenší byt* Teige describes a similar vista: "The typical bourgeois dwelling consists in a flat containing many rooms, . . . affording a view through to all the chambers — a kind of connecting corridor ending with the bedroom and the monumental catafalque of two marital beds placed side by side."[16] As discussed in a companion contribution to this volume (see Eric Dluhosch, "Teige's Minimum Dwelling as a Critique of Modern Architecture,"), marriage in general and the marital bed in particular evoked an obsessive terror in Teige, to the extent that he seriously proposed to banish the marital bed from his version of the minimum dwelling. He considers the "marital bedroom as a den of the lowest forms of bourgeois sexual life, . . . a hatching place of lowly forms of bourgeois sexual life, the picture of shocking erotic banality and decadence."[17] Elaborating on this theme in the collage *Marriage,* Štyrský includes a half-naked female figure with a man standing behind her, unbuttoning her dress. Her body became the chief object of Štyrský's compositional scheme: there is an anatomical incision superimposed on the lower part of her body, a parasol mushroom is substituted in place of her right hand, and the head is turned into an erotic-anal object, from which sprout intestines instead of hair to provide the frame for an unidentifiable organ, resembling either a vagina or a mouth. Next to the couple, Štyrský places typical items of the bourgeois home environment — a flower bouquet and a veil are discarded on a chair; a lamp standing on the mantelpiece contains an embryo, ostensibly symbolizing the future the bourgeois family — all of which both the poetists and the surrealists abhorred and spurned. Štyrský's collage is clearly an allusion to the wedding night and its bourgeois marital hangover, already condemned not only in the utopian ideas of Charles Fourier, which Teige held in high regard, but also by the anarcho-communists, with whom many members of Devětsil were closely associated during the early twenties.

Teige and Štyrský remained single and childless all their lives. They openly professed a negative attitude toward marriage, "that canonized form of prostitution." In

Teige's view, the revolutionary character of Štyrský's collage was made apparent in its aim "to discredit the sacrament of bourgeois morality," which was achieved by "the unfettered means of the surrealist imagination."[18] The collage must have fascinated Teige immensely, since he interpreted it largely from a dialectical materialist position and characterized the manner of its conception as "materialist"; that is, by dialectically reversing the meaning of the originals used in his collage, Štyrský had managed to reveal the true nature of the "human instinct," tearing down the mask of officially recognized bourgeois values and critically pointing to the artificiality of the institutionalized bourgeois marriage and family. Thus Teige perceived Štyrský's collage as a unique synthesis of all three surrealist domains: the injection of poetics into artistic method, experimentation by means of a new technique, and a critical perspective vis-à-vis a chosen theme.

Teige followed the surrealist period of Jindřich Štyrský and Toyen with considerable interest (indeed, he studied their work all his life and on a number of occasions wrote on them). They were the only artists whose work consistently held his interest during the course of the thirties. Through it he was able to observe the enduring vitality and depth of surrealist aesthetics; in contrast, he did not analyze the poems of Vítězslav Nezval in any depth at all.

Teige's study of surrealism required him to distinguish between its "intuitive" phase and its phase of "objective superreality." In his view, the first phase should be seen essentially as a short prologue, containing principally the work of Štyrský and Toyen as shown at the first exhibition of the Czechoslovak Surrealist Group in 1935. Graphically it was best exemplified by the complementary and ambivalent 1934 paintings *Magnet Woman* by Toyen and *Man-Cuttlefish* by Štyrský (figures 5 and 6). The first depicts red-hot, oozing lava in the form of a female torso; the second work portrays an image of tendons and muscles of a lower neck and jaw. Štyrský and Toyen, who worked together from 1923 on, represented for Teige a union of kindred spirits, moving in one clearly defined artistic direction as each individual varied in approach: Toyen made use of the contrast between red-hot and cold, full volume and empty shell; Štyrský favored the collision between external physiognomy and anatomical sections, sensuality and barbarity.

After 1936, Czech surrealist expression became more focused, and even more defined by materialistic dialectics than it was during its previous intuitive phase. Štyrský's and Toyen's new phase incorporated Teige's "objective superreality" in their work. Teige

5. Toyen, *Magnetová žena* (*Magnet Woman*). Oil on canvas, 1934. Collection Bernard Galateau, Paris. Photo by Ústav dějin umění Akademie věd České republiky (ÚDU AVČR; Institute of Art History of the Academy of Sciences of the Czech Republic), Prague.

6. Jindřich Štyrský, *Člověk-sepie* (*Man-Cuttlefish*). Oil on canvas, 1934. Collection Bernard Galateau, Paris. Photo by ÚDU AVČR, Prague.

put forward Toyen's *Message of the Forest* (1936) and Štyrský's *Trauma of Birth* (1936) as examples of this conceptual shift (figures 7 and 8). Both paintings present a situation "in which the world of free imagination assumes an almost convincing matter-of-factness and a tangible consistency, not unlike the world of everyday reality. In these paintings, imagination seeks out a world and transposes it into the realm of phenomenal fact."[19] Objects appearing in the paintings of Toyen and Štyrský perform the function of virtual analogies: they assume the guise of reality in a naturalistic way. For example, in the painting *Message of the Forest,* a giant bird carries off an accurately drawn child's head as its prey; *The Trauma of Birth* contains isolated motifs placed one next to the other, graphically rendered in such a way that they look like examples drawn by a teacher on a blackboard during a lesson on the subject of the typical features of surrealist poetics.[20]

Dialectical materialism, of which — according to Teige — these paintings were meant to be an expression, thus signified the discovery of superreality in the midst of ordinary reality around us, as Štyrský suggested in comments on his own surrealist photographs.[21] In his reflections on surrealist painting, he added this self-critical note: "As long as I did not keep fast completely and consistently to the dialectical materialist line, and to the extent that I found myself at variance with it, I failed to ask myself whether that which is commonly known as semblance is definitely based on the laws of real existence." Dialectical materialism does not suppress intuition or spontaneity, but it does criticize Bergson's concept of them: "Surrealism has reawakened in painting reality and its emotionality as constituted in its psychological sense. The fact that something appears to us in one or another way has a deeper cause — unless, of course, we have chosen to conceive it as a dazzling piece of ambitious subjectivity. The cause lies in the laws of reality's true existence; namely, it is a way of looking at things not from a positivistic but a dialectical and materialistic point of view."[22]

SOCIALIST REALISM, SURREALISM, AND ROMANTICISM: MAGNITOGORSK STORM TROOPER/ASTURIAN BARRICADE FIGHTER

Teige was so taken by dialectical materialism that he used the concept to interpret André Breton's famous line from the "Second Surrealist Manifesto" about the point at which contradictions are done away with: he not only found here the "dialectical es-

7. Toyen, *Poselství lesa* (*Message of the Forest*). Oil on canvas, 1936. Collection Hans Neumann, Caracas. Photo by Josef Sudek, ÚDU AVČR, Prague.

8. Jindřich Štyrský, *Trauma zrození* (*The Trauma of Birth*). Oil on canvas, 1936. Collection Maitre Binoche, Paris. Photo by ÚDU AVČR, Prague.

sence of the surrealist view" but at the same time perceived it as a way to approach the "inseparable nature of identity and distinction and the [achievement of] the unity of opposites." He followed closely Breton's gradual transition from subjective idealism, which he regarded as a source of mysticism, metaphysics, and spiritism — traits typical of the early stages of surrealism — to dialectical idealism, which indicated Breton's eventual assimilation of Hegel's works and the dialectical materialism of Marx. Teige even claimed that in Hegel's philosophical manuscripts from the period 1817–1818, "it is possible to detect the trace of a sound interpretation of early surrealism."[23] Breton's idea that "construction and destruction are no longer in contradiction" made a strong impression on Teige's dialectical materialist view. It allowed him to reconcile conflicting approaches emerging from different directions to approach the same goal: the constructive efforts of the "Magnitogorsk storm trooper" and the destructive "Asturian barricade fighter" struggling together to change the world.

The end of leftist idealism was augured symbolically by the death of two prominent avant-garde poets, Vladimir Mayakovsky and Federico García Lorca, both united by the idea of revolution and the avant-garde. Their deaths affected Jindřich Štyrský to such an extent that he dedicated separate paintings to each one. Their presence was evoked by specific, very real objects, which were, however, placed into unreal, surrealistic contexts. Thus huge military boots are placed on the feet of a disintegrating figure in the painting *In memoriam Federico García Lorca* (1937; figure 9), where the prone figure of Lorca is furthermore rendered in an extremely ambiguous manner (which may be an allusion to a wish to end the dictatorship). The second painting, *Mayakovsky's Jacket* (1939), depicts a jacket full of bullet holes hanging from a tree, which may have been intended to evoke the image of Mayakovsky's suicide.

Štyrský's dialectical materialist orientation is most explicit in the painting *Hommage to Karl Marx* (1937; figure 10), in which he combined the bearded head of Karl Marx — transformed by the artist's dreams to resemble a man of the wild, or perhaps a member of an ancient barbarian culture — with a loosely executed classical female torso.[24] Here, two entirely different worlds come together in one painting. Teige was perhaps too facile in characterizing Štyrský's surrealist paintings: "All his paintings are . . . a tribute to Marx, whose dialectical materialism represents an unstoppable force to change the world and set the stage for the triumph over the prehistory of mankind and for the arrival of the realm of freedom."[25] Aside from their Marxist bias, Štyrský's paint-

9. Jindřich Štyrský, *In Memoriam Feder-ico García Lorca*. Oil on canvas, 1937. Re-produced from *Volné směry*. Photo by ÚDU AVČR, Prague.

10. Jindřich Štyrský, *Homage to Karl Marx*. Oil on canvas, 1937. Reproduced from Karel Teige and Vítězslav Nezval, *Štyrský a Toyen* (*Štyrský and Toyen*) (Prague, 1938). Photo by ÚDU AVČR, Prague.

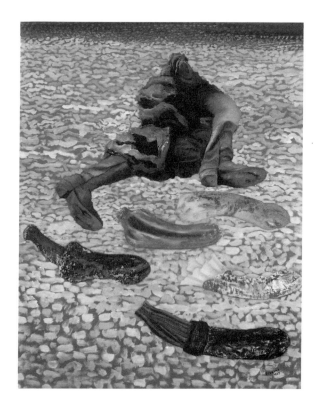

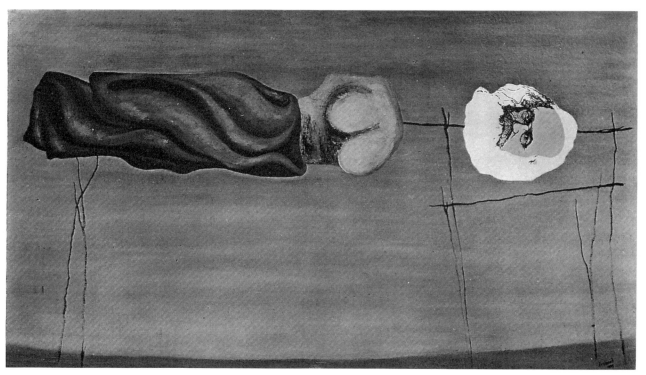

ings also clearly reveal his high-principled criticism of dictatorship, be it that of Franco's Spain or Stalin's Russia. In the end, the death of the two poets symbolized for him the futility of the early Devětsil's utopian dreams of a classless society. Stalin's assumption of dictatorial powers in the USSR had an immediate and direct effect on the political orientation of the Czechoslovak Communist Party, whose chairman happened to be one of Stalin's fellow travelers, Klement Gottwald, who subsequently became the first Communist president of Czechoslovakia (1948–1953).

The first attempt to undermine the solidarity of the avant-garde movement was launched at the Conference on Revolutionary Proletarian Literature, held in Kharkov in 1930, which dispatched an open letter from the conference's "revolutionary writers" to Stalinist sympathizers in Bohemia. The letter exhorted them to "fight against the imperialist war in defense of the USSR, against fascism and the white terror, and to combat with utmost zeal all elements of fascism."[26] It also criticized both the representatives of Devětsil and the young Slovak avant-garde movement associated with the magazine *Dav* (*Crowd*). The schism that Soviet ideology tried to create within the Czech and Slovak intellectuals of the left avant-garde through the Kharkov conference affected the Paris surrealist group as well. Two of its members who had participated in the Kharkov conference, Louis Aragon and Georges Sadoul, were unable to defend their surrealist principles against the ideological attacks of the hard-liners and were consequently expelled from the group.

The mechanical understanding of dialectical materialism, unmistakable in the dull theses on proletarian literature advanced during the Kharkov conference, became more controversial at the beginning of the thirties with the arrival of socialist realism, which after the First Federal Congress of Soviet Writers became the official cultural representative of Stalinist ideology. Thus, after the Left Front organized an evening of lectures titled "Surrealismus v diskusi" ("Surrealism in Discussion") in Prague during May 1934, an opposing evening debate on the subject of socialist realism was held in November of that same year. The commemorative volumes published subsequently contained the transcripts of these lectures and debates, as well as lengthy essays by Teige.

The first volume contained his treatise "Ten Years of Surrealism," which addressed the relationship between surrealism and poetism and which also contained a short history of the twentieth-century avant-garde on the road to dialectical materialism. The

second set of published lectures included the essay "Socialistický realismus a surreal-ismus" ("Socialist Realism and Surrealism"), one of the most penetrating comments on the subject of socialist realism versus surrealism made during the thirties. In it, Teige ex-pounded on the coexistence of two parallel approaches, both professing to be based on the precepts of dialectical materialism. But, according to Teige, socialist realism could not compete with surrealism, since the latter was supported by its long history and effective artistic results. Socialist realism, in contrast, rested on highly questionable artistic foundations (e.g., descriptive, peripheral realism in literature and neoclassicism in architecture), which the avant-garde regarded as obsolete. Instead, Teige was pro-posing a possible alternative method to artists who wanted to reflect the tenets of so-cialist realism in their work, one that — in his opinion — would be far better suited for their goals. He urged them to replace the "realistic plot" novel, which they tended to favor, with a more timely genre, to be represented by "historical-materialistic reportage and works on [Marxist] historiography" (figure 11).[27] Teige made this suggestion several years after the Kharkov conference, at a time when proposals recommending "report-age and journalistic work" to "revolutionary writers" were branded as a "left deviation"; it was also after Georg Lukács's critical essay, published in Czech in the anthology *K marxistické estetice* (*Toward Marxist Aesthetics*), had rejected the reportage-novel and, in consequence, the montage-novel as well.[28]

Although Teige recognized the more profound intellectual aspects of socialist real-ism and surrealism, and although he noted that they had common origins in "revolution-ary romanticism" and thus were open to dialectical materialist interpretation, he openly acknowledged the substantial differences that set them apart and ultimately ensured their incompatibility: the former worked by overwhelming the individual with power and monumentality, the latter by creating a synthesis of dream and reality. He was also quite aware that given the situation in the 1930s, the espousal of socialist realist ideas inevitably pointed the way toward the criticism of surrealism as being overly "formalis-tic." Moreover, he recognized that the former represented official Soviet ideology and obviously could not fail to see that socialist realism had to be accepted as the sole rep-resentative of official Soviet cultural policy and ideology after 1932.

But it is important to note further that Teige did not remain content with merely an-alyzing the effect of surrealism on poetism and socialist Realism, for the simple reason that surrealism inspired him to search for a more nuanced concept of romanticism,

11. Anonymous artist, cover for Lubomír Linhart's book *Sociální fotografie* (*Social Photography*) (Prague, 1934).

which he had previously scorned in his essay "Poem, World, Man." He now made a more subtle distinction between various kinds of romanticism—such as reactionary, liberal, and subversive, as well as the "romanticism of revolt and revolution" (the last representing an idea subsequently developed further by the surrealists)—attributing to each of these "levels" its corresponding trend in the political spectrum, whether right-wing, moderate, or left-wing.[29] Teige's more articulate concept of romanticism offered a more sophisticated reflection on his own time, which succeeded in encompassing all three spheres of its cultural influence—from avant-garde to bourgeois to socialist realist art.

SURREALISM AGAINST THE CURRENT

By virtue of the "dialectics of opposites," Teige had to confront a very common situation that dated back to the twenties but became even more controversial during the thirties; the decision of "writers of proletarian origin [to] cross over to the bourgeois camp" and, conversely, of "avant-garde artists of a modernist bent [to] move to join the proletariat, not by virtue of the process of 'proletarianization' but by reason of their own art."[30] This asymmetrical positioning puzzled Teige. How could bourgeois art, at least in part, adopt avant-garde forms and stand for proletarian art while simultaneously professing a taste for academicism and classical art forms? Clearly, actual artistic practice was more complicated than facile opposing theories might suggest. In Teige's view, such ambiguous conflicts, illustrated in numerous examples, proved that the development of art was in permanent "dialectical tension." Back in the early twenties it must also have been clear to Teige that the proletariat was hardly ready to embrace avant-garde art as its own; he thus believed that it was necessary to persuade them in the most subtle manner possible of, say, the necessity of developing a concept for the minimum flat in a collective house.

In his polemics, Teige managed to sharpen the divisions between academicism and modernism, between the bourgeoisie and the avant-garde, to such an extent that all conflicts were framed as a struggle between revolution and conservatism. By placing the avant-garde in such an exalted position, he at the same time made it much more vulnerable vis-à-vis the traditionalists. Rejected by the proletariat, condemned by proponents of socialist realism, held in contempt by academics, and mocked by the bourgeoisie, the avant-garde of the thirties not surprisingly found itself in a rather difficult position, especially when the Communist proponents of socialist realism labeled its

works as bourgeois art even as the advocates of bourgeois art considered it as an expression of ultra-left-wing radicalism.

This is set out most clearly in Teige's lengthy literary apologia *Surrealismus proti proudu* (*Surrealism against the Current*), written in the spring of 1938; Teige was both reacting directly to Vítězslav Nezval's attempt to dissolve the Czechoslovak Surrealist Group and defending avant-garde art against numerous attacks from the so-called left under the sway of the Communist Party's new cultural policy. The orientation of *Surrealism against the Current* is made quite clear on its cover. The image of a hand holding a quill pen that is cutting through a wall was borrowed from a poster pronouncing the verdict for the execution of Louis XVI in 1793. Teige here calls for the "unity of action of all artistic and scientific forces within the avant-garde,"[31] but he soon recognized that the attempt to discredit the surrealist group and the bid to topple the movement had actually been long in preparation by Soviet ideologues who sought to sow discord and create conflict in the calm democratic environment of Czechoslovakia.[32]

Even if the letter composed by the revolutionary writers at the Kharkov conference was merely some kind of unpremeditated rehearsal for some future, more serious action, the indirect and insidious leverage of Soviet agents trying to influence Czech culture during the latter half of the thirties began to look more and more ominous. It started with a visit by Soviet writers and journalists to Czechoslovakia in 1935, which was plainly intended to provoke confusion and dissension in Czech avant-garde theater and literary circles; there followed the censorship of exhibitions of Czech modern art, held in Moscow and Leningrad in 1937 (the paintings of Toyen, Štyrský, and many others were excluded);[33] and it ended with Nezval's efforts to dissolve the Czechoslovak Surrealist Group. Teige made the unpleasant discovery that "the incubation period of this rupture roughly coincided with the time when the reversal of the cultural policies of the Czechoslovak Communist Party were put into effect."[34] In fact, the crusade against surrealism waged by both the ultra-left and ultra-right press may well be compared with Goebbel's crusade against "degenerate art" (*entartete Kunst*) in Germany or Kerzhencev's drive to oust "monstrous formalism" in Russia.

BOOK COVERS

While Teige did not promote any of his own artistic methods in manifestos during the thirties as he did in the twenties for his picture poems, he had the opportunity between

1932 and 1938 to create designs for eight works by Vítězslav Nezval; these make it possible to trace the development of his typographical ideas year by year. In fact, this can be done much more positively with book covers than with other designs by Teige from the same period.[35] The first striking feature of the cover for Nezval's *Skleněný havelok* (*The Glass Havelock,* 1932) is that in addition to the abstract, functionalist diagonals Teige had been incorporating in his designs since the late twenties, he also made use of xylography. These were a direct reference to the novel-collages of Max Ernst, which earlier had also found an echo in Štyrský's montages, and which Štyrský used again for the illustrations of Nezval's *Sexuální nokturno* (*Sexual Nocturne,* 1931). One could say that by such means dialectical reflection in response to party criticism had infiltrated Teige's own creative work.

Teige liked to single out individual themes, as Štyrský had done for his cover of Brouk's *Psychoanalysa* (*Psychoanalysis,* 1931). He treated them independently, as freely arranged semantic concepts whose selection could be irrational. For example, the cover for Nezval's *Zpáteční lístek* (*Return Ticket,* 1933) depicts a locomotive engine, the planet Saturn, and a top hat positioned close to one another. In the bottom right-hand corner a swan appears, borrowed from a famous photograph by László Moholy-Nagy. By adopting another artist's work, even that of a contemporary, and without mentioning Moholy-Nagy by name, Teige revealed an important trait of his future approach, two years before he began consistently to work on collages. He was probably the first in the history of the interwar avant-garde to develop this technique, which he subsequently incorporated into his typographical designs and collages via reproductions. On occasion he would juxtapose elements unexpectedly with important artworks of the past. Placed alongside isolated objects in empty space, Teige's typography represented a return to an illusory spatial projection that, given his aesthetics of the twenties, was surprising to say the least. For example, the cover of Nezval's *Neviditelná Moskva* (*Invisible Moscow,* 1935) shows a three-dimensional object; it resembles a coffin in the shape of a multifaceted crystal, with a small female head superimposed onto one of the facets. This "coffin" is set face to face with an arch leading into a void. These themes of the covers of Nezval's *Return Ticket* and *Invisible Moscow* later also appeared in Teige's collages, the first of which were designed in 1935.[36]

Very soon, however, the relationship between self-generated and borrowed art in his work became more balanced. His designs from the period 1936–1937 show these

two domains being developed in parallel. As a result, by the late forties he was moving toward the reuse of earlier ready-made collages, completed several years earlier, for his covers.

Teige's book covers are distinctive for their striking contrasts. The artist repulses and at the same time beckons illusion. He ties together and at the same time severs continuous areas into fragments, but he rearranges all in unified space. From the thirties on, the external frame of his typographical procedure came to be determined mainly by the content of the work and by his linking the precepts of dialectical materialism with those of psychoanalysis. This process is demonstrated on the cover of Nezval's *Pantomima* (*Pantomime,* 1935). Here, the dominant theme is a dancer balancing on her toes atop a chessboard cube, with one leg thrown up into the air. Teige attached a single breast to her full skirt and replaced the upper part of her body with an upside-down hook; the whole resembled a question mark.

To see the radical change to which typography was subjected by avant-garde designs during the thirties, one need only look at the cover of the first edition of Nezval's *Pantomime* (1924), designed by Jindřich Štyrský in the form of a picture poem, Thus, while on Štyrský's cover each succeeding subject freely merges with the previous one, Teige's cover design was conceived in a truly surrealist manner: the contrast consists in the contradictions between individual themes, not their concurrence.

Teige's designs for three further works by Nezval are yet more complex. Each cover is followed by a frontispiece, a title page, and an independent illustration in the form of a free collage. Even though the poetry collections *Praha s prsty deště* (*Prague with Fingers of Rain,* 1936), *Žena v množném čísle* (*Woman in the Plural,* 1936), and *Most* (*The Bridge,* 1937) have a close thematic affinity, Teige chose not to respect this feature. Instead, he developed his designs as individual themes, each representing its own specific allusions to the content of the book and its title, drawing on a free source of imagery, no longer entirely dependent on the theme of the literary work and thus able to exist autonomously. In the illustration for *Prague with Fingers of Rain,* Teige used various references to "old Prague themes," from beveled Gothic arches to the typical signs hanging outside of houses and shops (crayfish, wheel, key), thereby both deploying and piercing the veneer of a tourist's vision of Prague. An autonomous illustration inside the book depicts a dreamlike view of the city with oblique facades; fingers of two left hands touching (the space between the thumb and forefinger re-

279

sembles a woman's vagina); a naked, somnambulant girl whose genitalia are protected by a signet ring and whose head is replaced by a single eye; and finally some keys, representing the psychoanalytic symbol of coitus. Štyrský's cover design for Brouk's *Psychoanalysis* had used as its theme elements of dream symbolism, transposed directly from Freud's texts; Teige now offered his own version, also clearly influenced by his own study of psychoanalysis.

Together with the solitary breast, which evidently made its first appearance in Teige's design on the cover of *Pantomime* and which was to become an almost omnipresent motif in his collages from 1936 onward, the image of an eye also began to acquire a dominant position in his work. Teige had earlier defined its terms of reference in his essay "Poem, World, Man":

This erogenous region, furthest removed from the sexual object[,] . . . namely the eye, is more potent in its ability to excite than all the others, precisely because of its very own qualities, precipitated by what I call the beauty of the love object. The optical impression is the medium through which libidinous excitement is most frequently awakened; it is also where the process of selection is initiated and what allows the sexual object to grow in beauty. The excitement that creates images of beauty [is] once more intensified by them, kindling delight and inviting the excitement of other organs and erogenous zones.[37]

While for Teige the breast represented the main erogenous zone of the female body, that is, its haptic region, he considered the function of the eye to be far more ambiguous. No matter how impersonal the gaze of the eye, it could never remove the traces of its original sensual role: it literally stared out from the collages, even though the artist treated it as he would have treated any neutral feature. Endowed with a potential vital erotic quality, the eye gained much greater importance than did other motifs, since it not only gave life to a "dead" body and all manner of other inanimate objects, but also sometimes in effect "anthropomorphized" them (e.g., in one collage Teige placed an eye on the surface of the water, with a second eye reflected on a canoe paddle; see *Collage no. 295,* 1944). Teige went to extraordinary lengths to accentuate the very moment at which the outer world throws back its gaze at our stare, when every object becomes a mirror that reflects not reality but its counterpart in our dreams and imagination.

From the thirties onward, Teige used xylography in the majority of his typographical designs, even more frequently than Štyrský. Later, he began to combine these with reproductions of photographs, a technique that was not commonplace in European surrealism. He applied this combination both in his early collages from the period 1935 to 1938 and in his designs for *Woman in the Plural* and *The Bridge,* perhaps hoping to show a way to exemplify the concept of the dialectical tension between past and contemporary art. In fact, in the years 1936 and 1937 Teige somewhat surprisingly decided to revisit various historical themes that he had summarily rejected during the twenties. We can assume that the typography for the collection *Prague with Fingers of Rain* was based on its content, that is, specifically, reflecting the interest of Breton and Nezval in Prague house signs; the designs of the other two collections, *Woman in the Plural* and *The Bridge,* were endowed with a more or less "nostalgic" quality, clearly evoking the atmosphere of centuries past. In a similar vein, Teige favored xylography for the title page of *Woman in the Plural,* and a baroque high portal appears on the title page of *The Bridge.* Given Teige's typographical approach developed during the late twenties and early thirties on the basis of modernist Bauhaus principles, these motifs were indeed unprecedented in his work.

Dialectical materialism introduced a certain dynamism into Teige's previously too-dogmatic avant-garde attitude. While the cover of *The Bridge* still testifies to Teige's iconoclastic early avant-garde point of view, the title page does actually manage to contain a historical theme. Thus we see that Teige was not altogether immune in his illustrations to the influences of art at large, and painting in particular. This is also evidenced by the frontispiece of *Prague with Fingers of Rain,* where a hand emerges through an open window holding a violin, referring to the work *Oedipus Rex* (1922) by Max Ernst.[38] Similarly, the frontispiece and illustrations for *The Bridge* lend themselves to a comparison with Josef Šíma's work, to which Teige, as a theorist during the thirties, did not pay any particular attention. It may be observed that the female torso, positioned on a small stone table in front of an image of a bridge, is reminiscent of Šíma's painting *Remembering an Unknown Landscape* (1936). Teige's illustration for *The Bridge,* with a staircase ending in the sea and a headless female nude, alludes to the somewhat atypical painting by Šíma titled *Flood* (1938). Here, the artist portrays a staircase in front of a window with a sitting female nude gazing out to the sea.

The covers Teige designed for Nezval began to assume more and more the character of an autonomous vision, based only loosely on the book's title or the contents of the collection. This trend culminated in the cover design for *Básně noci* (*Poems of the Night,* 2nd ed., 1938), which both was a synthesis of Teige's imagery to date — that is, the frequent combination of a female torso with architectural themes, mostly staircases — and also a presentation of a number of other specific images, such as a lone moth fluttering around a street light, which in turn is mounted onto a female torso in place of the head. The torso itself becomes part of a balustrade. The intricate complexity of the above motifs suggests the confluence of the work of two artists who had chosen to use similar themes in their work: in the first case, it recalls the well-known collage from Max Ernst's novel *La femme 100 tetes* (1929); in the second, it refers to an undated note by Štyrský that may have been a verbal intimation of a collage he wished to complete at a later date, titled *A Girl Growing out of a Balustrade.*[39]

There is no question that Teige's covers for eight works by Vítězslav Nezval occupy an important position in Czech typography of the thirties — not only for their great inherent artistic value, which went far beyond conventional Czech typographical production at that time, but also for their movement in the direction of a specific though not explicitly articulated artistic program.

COLLAGES

The principles guiding Teige's work with collage were never formulated in writing, just as he did not produce any written commentaries to accompany them. Between the year 1935 and his untimely death in 1951, he completed a total of 374 collages.

Dialectical materialism was not necessarily the only source that broadened his imagery. Beyond Hegel and Marx, he was also influenced by Jan Mukařovský — particularly by the widely discussed book *Estetická funkce, norma a hodnota jako sociální fakty* (*Aesthetic Function, Norm, and Value as Social Facts,* 1936), which introduced Teige to the theory of past historical art that had been passionately rejected by the artist during the twenties. Teige found personal companionship and theoretical inspiration in Mukařovský during the latter half of the thirties, although not entirely agreeing with all the tenets of his structuralism and semantics. Using Breton's theory of the "inner model" and Hegel's triad "thesis–antithesis–synthesis" as a base, Teige developed his own phenomenology of modern art. His belief that "a work of art does not remain un-

changed for centuries" was expressed in the section in his treatise "Sovětská kulturní tvorba a otázky kulturního dědictví" ("Soviet Culture and Questions of Cultural Heritage," 1936) titled "The Dynamism of Cultural and Artistic Values." He explained,

It does not generally change its structure or its material existence, if it is not reworked, revised, adapted, or violated to a greater or lesser degree as a result of these reconstructions; it does, however, change in the course of time as a living cultural value. If the work itself does not change, its reader does; a new poem is created from a new synthesis, a new dialectic unity, and for a new reader. Old works survive their era so long as they are able to become part of a new, forever-changing synthesis.[40]

Teige was taken not so much with Mukařovský's analysis of individual works of art as with his highly flexible interpretation of changing values within the historical process, which Teige applied to great effect in the choice of the visual material used in his collages. Thus, during the late thirties Teige did not deal with the past exclusively as a theorist, acting more as an artist choosing to adopt a purely creative attitude to it. By placing historical examples in a new, contemporary context, Teige used his own creative gestures to breathe new life into themes taken from earlier art, thereby giving certain well-known examples of world painting a new voice: Dürer's *Melancolia* (*Collage no. 70,* 1939), David's *Oath of the Horatii* (*Collage no. 189,* 1941), and Rembrandt's *Abduction of Ganymede* (*Collage no. 194,* 1941). While some of Teige's collages seem somewhat overworked, their importance lay in their own moment of playfulness, in which the action itself conjures up all kinds of themes that, in turn, develop in unexpected and interesting mutual relationships. As a rule Teige did, however, prefer contemporary inspiration to classical works. For example, he inserted avant-garde art from the twenties and thirties into his collages, frequently using famous reproductions of works by foreign artists (Man Ray, Brassaï, Moholy-Nagy, Florence Henri/Umbo) and by Czech contemporary photographers (Jaromír Funke [figure 12], Jaroslav Rössler, Miroslav Hák, Karel Ludwig, Jindřich Štyrský). In addition to photographs (for example, Moholy-Nagy's positive and negative prints from 1927 of a sailboat tugging another smaller boat appeared as a background for two of Teige's collages from 1942), he also used images of well-known avant-garde architecture for his backgrounds.[41] It should also be emphasized that these individual, highly artistic themes had little in common with photojournalism as practiced at that time.

The combinations used for the collages, sometimes quite incongruous and fla-
grant, were not chosen for any explicitly profound, iconographic, or thematic reason.
By the same token, they should not be regarded as hasty improvisations. What we find
instead is an amalgam of different reproductions, a kind of detective story for art histori-
ans, rather than "visual dialectics" based on slavish dependence on external systems
of rules and simplistic notions of discontinuity. Thus, these collages were no longer
based on Teige's previous conception of the evolution of art, that is, the substitution of
past concepts for modern ones — for example, the replacement of traditional painting
techniques by collage or picture poem. Moreover, all forms of explicit references to
avant-garde teleology disappeared from Teige's collages and typographical designs of
the thirties. For example, a baroque staircase was thrust directly in front of a classical
temple (*Collage no. 76,* 1939). Here, none of the elements are intended to be experi-
enced as part of a successive narrative any more, as they were on the cover of *Život 2*
(Prague, 1923), which featured the juxtaposition of the geometry of the Doric order and
an automobile wheel. In his collages of the thirties, Teige began to perceive visual
forms as simultaneous phenomenal complexes, torn out of their original setting, out-
side the context of time. Themes and subjects were arbitrarily fished out of the history
of art and rearranged freely to suit the artist's own intentions.

12. Jaromír Funke, Nude, 1939–1940. Pri-
vate collection, Prague.

The enduring theme in the majority of Teige's collages was the naked female body or some fragment of it (most often the breast), all subjected to assorted distortions and convulsions. Their presence was used to disrupt all temporal context: the naked body or its parts could be confronted with anything, any theme from art history, architecture, or even technology. But no matter what the combination, it was the female body, although variously dissected and deformed, that provided Teige with a fulcrum around which all the other themes were arranged (figure 13). Even though Teige was exhilarated by erotic images, it is clear from some of his collages that his attitude toward the female body may not always have been positive—as, for example, when he made a female torso serve as a pedestal for an ashtray full of cigarette butts.

Two collages repeating a single theme tell us that Teige's juxtaposition of past with contemporary works of art was not coincidental. In one (*Collage no. 205,* 1941), Teige used a picture of the elaborate and ornate tombstone of Jan Wratislav of Mitrovice by the prominent Central European baroque sculptor Ferdinand Brokoff; it depicts a Knight dressed in armor, reclining in a dying pose at the side of the allegorical figure of glory. In cutting out the heart of the composition he transformed the dead knight into a sleeping figure. The content of the knight's dreams is projected onto the background of the collage, where an arch frames the torso of a woman's body, the source of the latter

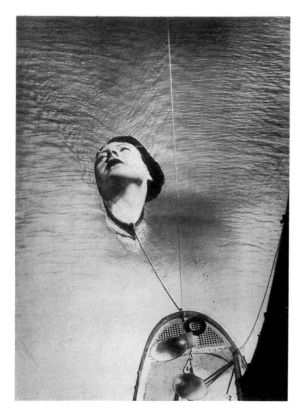

13. Karel Teige, *Collage no. 243,* 1942. PNP, Prague. Reproduced by permission of Olga Hilmerová, Prague.

14. Karel Teige, *Collage no. 239,* 1942. PNP, Prague. Reproduced by permission of Olga Hilmerová, Prague.

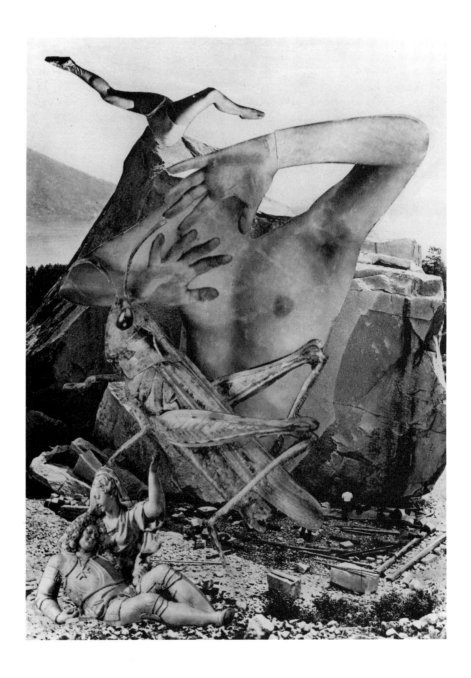

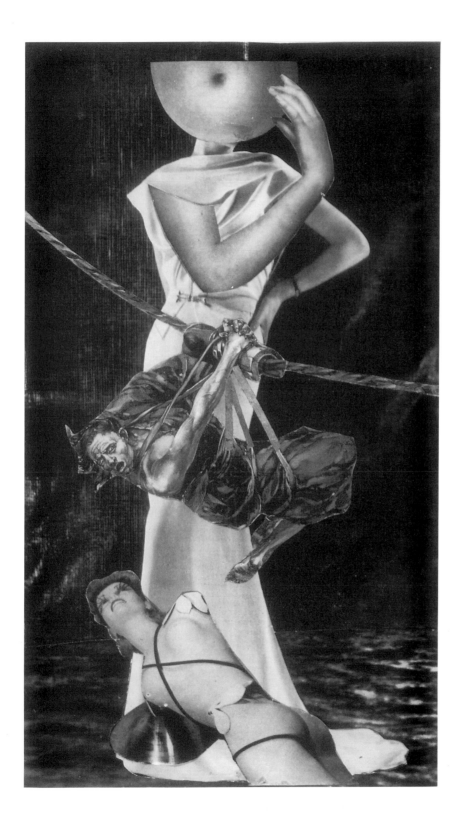

15. Karel Teige, *Collage no. 45,* 1938. PNP, Prague. Reproduced by permission of Olga Hilmerová, Prague.

image being Man Ray's photograph *La retour a la raison* (1923). And yet, according to *Collage no. 239* (1942; figure 14), the departed Wratislav of Mitrovice had evidently even more lurid dreams, this time visualized in a rocky mountain landscape. Here, a female nude, this time taken from a work by Jaromír Funke, defends herself against a grasshopper (one of the most important surrealist motifs), with her moving legs melded into the body of a rocky ridge. Both collages are based on the absurd encounter of a baroque tombstone and contemporary avant-garde photography, and both may be interpreted as an attempt to expose the surreal contrast between death and sensuality as a dialectical coupling of radical opposites (figure 15). Superimposing the images of contemporary objects of thought on the image of a baroque character also represents an exegesis on the era in which Jan Wratislav of Mitrovice lived, thus providing a balance between "memento mori" and "ecstatic sensuality."

In constructing his collages, Teige found ways of conveying his ideas by a number of different forms of expression, with varying degrees of clarity or deliberate obscurity. With the mysterious eye, so often staring at us from Teige's collages, the viewer is, paradoxically, induced to "see" contemporary art with the same eye through the "medium" of past works of art. This technique is not blatant or simplistic. Teige was careful to put up certain obstacles in the path of an overly obvious, facile reading of his dialectical thinking. He explained this circumspection by referring to a Phoenician and Greek method of reading and writing known as *boustrophèdon* (literally, "turning like oxen in plowing"),

where the even lines are read from the right to the left and the odd lines from the left to the right. . . . [T]hus, the text is written without interruption; it furrows the writing area in the same way as a ploughman furrows his field by turning his plough in the opposite direction with each turn: similarly, one should read the script of architecture and painting alike as [a continuous] graph of social development, in uninterrupted and in [perpetual] countermotion.[42]

Teige's collages in particular should be read in this way. They retain their artistic and temporal openness as they are understood, as one is able proceed from one element to the next and from one subject to the next without ever being told where to start.

Notes

1. On Teige's activities in 1930s, see the volume of his selected writings of that decade, Karel Teige, *Zápasy o smysl moderní tvorby. Studie z třicátých let* (The struggles for the sense of modern art: Studies from the thirties), vol. 2 of *Výbor z díla* (Selected works) (Prague, 1969); Teige, "Architecture and Poetry," *Rassegna* 15, no. 53/1 (1993); Karel Srp, ed., *Karel Teige 1900–1951,* exhibition catalogue, Prague Municipal Gallery (Prague, 1994); *Umění* 43 (1995): 1–181 (special issue on Teige); M. Castagnara Codeluppi, ed., *Karel Teige, Archittetura, Poesia, Praga 1900–1951* (Milan, 1996); Lenka Bydžovská and Karel Srp, eds., *Český surrealismus 1929–1953* (Czech surrealism, 1929–1953) (Prague, 1996); E. Starcky and J. Anděl, eds., *Prague, 1900–1938: Capitale secrète des avant-gardes,* exhibition catalogue (Dijon, 1997).

2. This was one of the great debates of the generation known as the "generation on two chairs"; it probably affected every representative of the interwar avant-garde. See essays in Štěpán Vlašín, ed., *Avantgarda známá a neznámá* (Avant-garde known and unknown), vol. 3 (Prague, 1970). Jindřich Štyrský, *Každý z nás stopuje vlastní ropuchu* (Each of us tracks his own toad], ed. Karel Srp (Prague, 1996).

3. V.O. [Vít Obrtel], "Obálková terminologie" (Book cover terminology), *Plán* 1 (1929–1930): 126.

4. The declaration of the Left Front and commentary by Karel Teige appear in *ReD* 3 (November 1929): 48.

5. Ibid.

6. Ibid.

7. Karel Teige, "Báseň, svět, člověk" (Poem, world, man), *Zvěrokruh* (Zodiac), no. 1 (November 1930): 9–15.

8. Ibid. Teige understood the treatise "Báseň, svět, člověk" as a continuation of his "Second Poetist Manifesto."

9. Vítězslav Nezval, "Třetí manifest poetismu" (The third manifesto of poetism), in Nezval, *Manifesty, eseje a kritické projevy z poetismu* (Manifestos, essays, and critical expression in poetism), ed. Milan Blahynka, *Dílo* 24 (Prague, 1967), 329–337; According to Blahynka, this text, dated December 1930, was to be included in the completed but unpublished third issue of *Zvěrokruh.*

10. Ibid.

11. Karel Teige, "Deset let surrealismu" (Ten years of surrealism), in *Surrealismus v diskusi* (Surrealism in discussion) (Prague, 1934), 7–56. The volume was published by the Left Front.

12. Vítězslav Nezval, *Z méhc života* (From my life) (Prague, 1967), 134.

13. Karel Teige, introduction to *Surrealismus není uměleckou školou* (Surrealism is not a school of art), exhibition catalogue, first exhibition held by the Czechoslovak Surrealist Group (Prague, 1935).

14. Teige's adoption of dialectical materialism occurred independently of Breton, from whom, critics generally agree, he took the idea of the inner model — though this too could have had different origins. Jaroslav Kubišta, who taught at Teige's secondary school in Křemencová Street, was also the first to translate Plotinus's discourse *On Beauty* (Prague, 1912), from

which the idea of the inner model is traditionally derived. I am indebted to Rostislav Švácha for information on Kubišta.

15. Teige, introduction to *Surrealismus není uměleckou školou.*

16. Karel Teige, *Nejmenší byt* (The minimum dwelling) (Prague, 1932), 151.

17. Ibid.

18. Ibid.

19. Karel Teige, "Od artificialismu k surrealismu" (From artificialism to surrealism), in Vítězslav Nezval and Teige, *Štyrský a Toyen* (Štyrský and Toyen) (Prague, 1938), 189–195.

20. For a study of Štyrský's painting *Trauma zrození,* see Karel Srp, "The Anguish of Rebirth," *Umění* 42 (1994): 74–84.

21. Jindřich Štyrský, "Surrealistická fotografie" (Surrealist photography), *České slovo* 27, no. 25 (30 January 1935): 10.

22. Jindřich Štyrský, "Surrealistické malířství" (Surrealist painting), *Doba* 1, no. 9 (1934–1935): 135–136.

23. Teige, "Deset let surrealismu."

24. See Jindřich Štyrský, "Sen o vousaté hlavě" (Dream about a bearded face, 1936), in his *Sny* (Dreams), ed. František Šmejkal (Prague, 1970), 80–81.

25. Teige, "Od artificialismu k surrealismu," 195.

26. An open letter to revolutionary writers in Czechoslovakia, *Tvorba* 5, no. 50 (24 December 1930): 794.

27. Karel Teige, "Socialistický realismus a surrealismus" (Socialist realism and surrealism), in the commemorative volume *Socialistický realismus* (Socialist realism) (Prague, 1935), 120–181. The volume was published by the Left Front.

28. In *K marxistické estetice* (Toward Marxist aesthetics), comp. Bedřich Václavek (Prague, 1934). This anthology of theorists of German left-wing literature was published by the Left Front.

29. Karel Teige, *Jarmark umění* (The bazaar of art) (Prague, 1936).

30. Karel Teige, "Intelektuálové a revoluce" (Intellectuals of the revolution), *Tvorba* 5 (1930): 794.

31. Karel Teige, *Surrealismus proti proudu* (Prague, 1938).

32. See Ivan Pfaff, *Česká levice proti Moskvě 1936–1938* (The Czech Left against Moscow, 1936–1938) (Prague, 1993).

33. Bydžovská and Srp, *Český surrealismus 1929–1953,* 90.

34. Teige, *Surrealismus proti proudu.*

35. Polana Bregantová, "Mezi tvorbou a normou 30. let" (Between art and norm of the thirties), in Srp, *Karel Teige 1900–1951,* 111–125.

36. The extent of the thematic overlap in Teige's book illustrations and his collages is remarkably narrow. Many examples may be found during the early stages (1935–1938) of his work, when he embarked on his first collages: the swan appears in *Collage no. 157* (1941), Saturn in *Collage no. 74* (1939), the train in *Collage no. 49* (1938), arches in *Collage no. 318* (1946), and a pistol aimed at its target in *Collage no. 68* (1939).

37. Teige, "Báseň, svět, člověk."

38. Karel Srp, "Max Ernst a Skupina surrealistů v ČSR" (Max Ernst and the Czechoslovak Surrealist Group), *Ateliér* 7, no. 6 (24 March 1994): 2.

39. Jindřich Štyrský, *Poezie* (Poetry) (Prague, 1946).

40. Karel Teige, "Sovětská kulturní tvorba a otázky kulturního dědictví" (Soviet culture and issues of cultural heritage), *Praha-Moskva* 1, no. 6 (1936): 186–197; 1, no. 8 (1936): 260–275.

41. Karel Srp, "Vratká stabilita" (Precarious stability), *Ateliér* 9, no. 21 (10 October 1996): 6–7.

42. Karel Teige, "Předmluva o architektuře a přírodě" (Prolegomena on architecture and nature), in *Obytná krajina* (The inhabited landscape), by Ladislav Žák (Prague, 1947), 7–21.

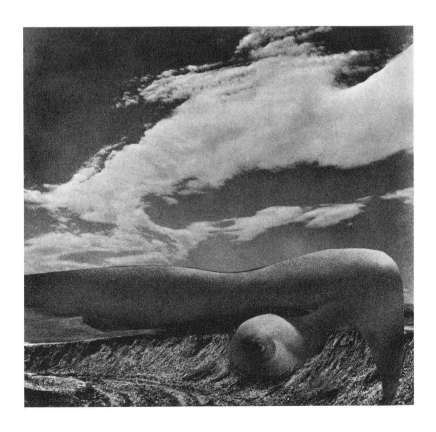

KAREL TEIGE'S COLLAGES, 1935–1951: THE EROTIC OBJECT, THE SOCIAL OBJECT, AND SURREALIST LANDSCAPE ART

/ 12

Vojtěch Lahoda
(Translated by David Chirico)

IDEOLOGY AND THE EROTIC

Karel Teige has been recognized primarily for his theoretical activities as the herald of the Czech modernist avant-garde, which have earned him his prominence, at least among European intellectuals; but he has not been sufficiently appreciated as an active creative artist. In the history books of the Czech visual arts he has secured his place not only with his cubist work from the early 1920s, of which little has been preserved, but much more because of his typographic book designs, of which a great number have survived. In contrast, the collages that he began systematically to produce after 1935 have only recently received serious attention from art historians, both in his own country and abroad.[1]

Around 1935, when he started to work with collages, Teige was speculating about 'the possible interrelationship between socialist realism and surrealism.[2] At that time he was an ardent defender of the sociological approach to avant-garde work and the notion of socialist collectivism; he linked both to the revolutionary art of Soviet Russia, which he referred to as "socialist America." After all, Soviet constructivism was, in Teige's opinion, "in its very heart . . . socialist Americanism, made complete by the spirit of Leninism."[3] It was his faith in the USSR, in the "world of the new future," that led him to edit the reviews *Země sovětů* (*Land of the Soviets,* 1931–1936) and *Praha-Moskva* (*Prague-Moscow,* 1936). A cloud appeared on the horizon of his vision of this "world of the new future" in the shape of the Moscow political trials of 1936. And so it appears that collage provided Teige with both release and relief, because its making was bound neither by party discipline nor by the imperative to be explicitly principled.

The earliest collages from Teige's remarkable pictorial diary date from 1935; the latest are dated 1951, the year of his death. Teige's collages are not simply or solely the diary of their author. They are, at the same time, the visual interpretation of his ideology, and therefore they mirror in a graphic manner some of the themes dealt with in Teige's theory. In addition, they are highly charged with a rich repertoire of erotic ideas. Furthermore, examined as a whole, they can be seen as utopian visions of landscapes and towns where peculiar objects make their appearance, often in the form of the female body or female organs, frequently transformed into designs of strange objects, placed in their surroundings as singular monuments. In some cases, these collages uncannily anticipate the "object-monuments" of Claes Oldenburg. The siting of Teige's collages in landscapes or towns, their "narrative" nature, and their denial of a planar "formalistic"

principle (recalling the collages of Picasso and Kurt Schwitters), along with the fragmentation of the female body, have in many cases an ideological origin in Teige's views on architecture, urbanism, landscape, woman, and family.[4]

COLLAGE: ART FOR ALL

Teige succeeded in being recognized as the spokesman of the left-wing Czechoslovak avant-garde in the twenties and thirties not only because of his quick intellect but also because of his prodigious industriousness and his ability to read an unbelievable amount of literature, from political and sociological books to works on art and architectural history. He was also familiar with a large number of avant-garde magazines from all over the world. Teige's literary legacy is currently stored in the Museum of Czech Literature in Prague, which also contains a series of his manuscripts, reference lists, and excerpts from his reading.

Among the latter can also be found his notes on collage. Here one can find a quotation from Louis Aragon's introduction to the catalogue of the exhibition *La Peinture au Défi* in the Goemans Gallery in Paris in March 1930: "The collage is poor. Its market value will long be denied. It can be reproduced at will. Anyone can make collages."[5] Teige's citing of Aragon seems important here. Despite apparent contradictions, Teige never broke the links with the original starting points of his thinking: he sometimes corrected them or stressed other meanings, but the basic principles endured. Such a principle was his vision, formulated in the 1920s, that everyone should be able to make art, and that art should become life. Teige's own collages from the thirties and forties may be considered to be an indirect confirmation of this viewpoint.

Teige copied out another quotation from Aragon on the collage exhibition: "Poetry should be made by everyone. The miraculous should also be made by everyone, not by one."[6] In his article "O fotomontáži" ("On Photomontage") from 1932, Teige points out one of the important features of the new medium: "Photomontage demolishes artistic professionalism. Here, just as in photography, dilettantes and autodidacts can have their say. Photomontage and photography permit even 'armless Raphaels' to create with the new materials; their techniques are so simple that they can basically be mastered by everyone."[7]

Collage is therefore a method with which everyone can make poetry, since poetry is not bound by any single discipline or by norms and codes as are art theory, ideology,

and politics. A romantic in disguise, Teige believed in the poetic power of the people. Thus, it is no coincidence that he stresses "laicization" primarily in the fields of photography, photomontage, and therefore also collage, emphasizing their relative simplicity as well as their potential for amateur creativity.[8]

COLLAGE AND PHOTOMONTAGE: THE PATH TO NARRATIVE

Teige's conception of the collage was derived from his understanding of photomontage.[9] It is clear from his fundamental study "O fotomontáži" that Teige saw photomontage to a certain extent as synonymous with collage. Photomontage, of course, works with fragments of picture reproductions or photographs, while a collage can also be made with fragments of paper and other materials (wallpaper, colored paper, tinfoil, and so on). For Teige, collage was probably too closely linked with cubism (the *papier collé*) and therefore tainted with the sin of aesthetic formalism; it no longer expressed the real revolutionary change in media, and photomontage did. Above all, *collage* (in its original French signification) did not possess the political "agitprop" connotations that Teige recognized in photomontage. For him, the essence of the collage was contained in the singular individuality of the work as a concrete and de facto nonreproducible artifact, with its origins in the cubism of Picasso and Braque. In contrast, he asserts, photomontage is "a type of mechanized graphic art[,] . . . the result of the needs of modern advertising and political propaganda."[10] In his book *Sovětská kultura* (*Soviet Culture*) Teige wrote that "photomontage is an image, constructed from diverse photographs, and its aim is to be a sort of pictorial epic and poem of modern times."[11] Its result is comparable to that of the poster. The essence of photomontage is, for Teige, its signifying activity and therefore he associates it with film: "Photomontage is always more active than a simple photograph, which only captures one moment of the action: only a combination of photographs can produce an adequate image of the dialectics and dynamics of life."[12]

Teige's interest in films and their texts suggests that he was excited by the possibilities of the medium, which decomposes a frozen moment of life into a series of sequences. He found a similar appeal in photomontage: the sequence of montages of photographs has, in photomontage, the same function as the individual frames of a film.[13] Photomontage is "not a harmony of colors and forms" (as presumably in the case of Picasso's collages), but an "exhortation," a "communication" — in other words,

296

an epic and a narrative. The difference between "today's photomontages" and "the collages (stuck-together pictures) of the dadaists has been verified by events, in that those of today are more fully worked out and more systematic in their conception." Photomontage and collage tend to more or less overlap; for example, Teige calls the work of Max Ernst "surrealist montages."[14] The collage, for Teige, is thus a kind of sub-species of the photomontage, which he takes to "refer not only to images pasted together from diverse photographs, but to all ways of using photographs in the (political, advertising, or book) text."[15]

The photomontage and the "typophoto" (and thus also the collage) are for Teige a new type of script for a new pictorial language. "We have only grasped the alphabet," he writes, but when we master this new language we will be able to "write new truths and exhortations as well as new poems."[16] The principle of the collage, the reworking of material (of cutout photographs, reproductions, etc.), in no way resembles Schwitters's *i-kunst;* for Teige it is, in conjunction with *decalque* and *frottage,* similar to the way in which "the subliminal workings of the dream revise the oneiric fabric."[17] The key to Teige's theory of photomontage is the term "montage" itself, which he explains most succinctly using the example of film. It is a "planned and deliberate association and alternation of diverse film fragments and images with the aim of reaching a desired rhythmic and visual effect."[18] Teige linked the conception of montage primarily with that of constructivism, whose basic intent was the creation of a new man, the "design of a new world."[19] One may, therefore, with a certain license understand Teige's collages as designs for a new world in the spirit of the utopian avant-garde principles of the twenties. The term "film fragments and images" may thus be legitimately replaced with "fragments of reproductions or photographs."

By the end of the 1940s, Teige no longer emphasized the "lay" character of collage, object art, and ready-mades:

Only an artistic creative spirit recognizes the fact that it is not sufficient merely to choose a certain detail of some object or image from the world surrounding us, perhaps just a nameless photograph, an astronomic or X-ray shot, or some engraving, but that what is more important is to define and delimit its most significant attributes and—most of all—detach it from its stereotypical daily context in order for the object to be presented in such a way that it can be experienced and valued by others as a work of art as well.[20]

1. Karel Teige, *Collage no. 62,* 1938.
Památník národního písemnictví (PNP;
Museum of Czech Literature), Prague. Re-
produced by permission of Olga Hilmer-
ová, Prague. Photo by František Krejčí,
Ústav dějin umění Akademie věd České
republiky (ÚDU AVČR; Institute of Art His-
tory of the Academy of Sciences of the
Czech Republic), Prague.

2. Karel Teige, *Collage no. 51,* 1938. PNP,
Prague. Reproduced by permission of
Olga Hilmerová, Prague.

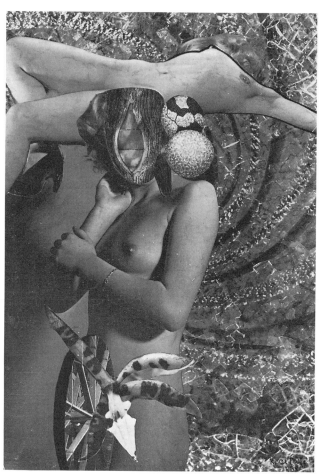

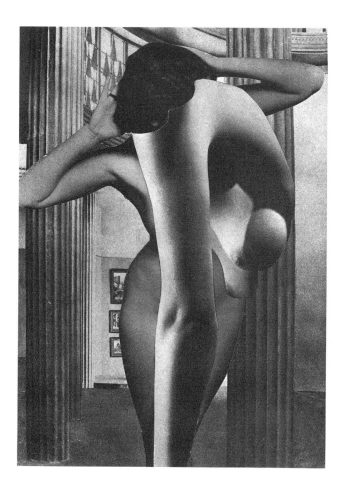

THE EROTIC OBJECT

The series of collages that may be legitimately characterized as "erotic objects" quite frequently appear in the form of strange sculptures or other constructions (figure 1), placed either indoors or outdoors. For example, *Collage no. 51* (1938; figure 2) presents the viewer with the facsimile of a group of contemporary female sculptures, with fragments of the female body placed in a modern architectural interior. *Collage no. 340* (1948) depicts a fragment of a female leg bearing a sign saying "PRAHA" ("PRAGUE"), with a road in the background. Entering Prague is thus transformed into the lure of entering an erotic object. In effect, the collage acts as an advertisement for the "erotic" town of Prague. Similarly, fragments of the female body create a kind of monument to the erotic in *Collage no. 26* (1936); in the background is a xylographic reproduction from the nineteenth century that depicts the construction of the Basilica of the Sacré Coeur in Paris. In that sense, Teige used collage as a tool for expressing his vision of an imaginary object placed in the real environment of a concrete reproduction or photograph. The essential "vocabulary" of these objects and "constructions" in miscellaneous interiors, exteriors, or landscapes is made up of the "alphabet" of the female body; the "script" of the object, variously cut and edited, formed, "delimited," and "removed from its proper context," nevertheless "invariably puts an emphasis on the erotic substance of the subject."[21]

This "alphabet" (of the female body) is certainly already present in Teige's typographical and graphic arrangement of Vítězslav Nezval's book *Abeceda* (*Alphabet*) of 1926, which combines the language of the female body, expressed by means of gymnastic dance movements, with poetry accompanying each letter of the alphabet. Teige's alphabet is also in full accord with his general interest in photographs of dance, ballet, and sports; and not surprisingly, fragments of the female body — a breast, arm, leg, torso, head, or lips — appear in almost every collage. Teige proceeded like an architect with scissors: by combining fragments of the female body, he created exotic objects that were then placed mainly in the context of "real" architecture, be it a functionalist interior, a baroque church, or a city street. It is no coincidence that Teige had procured privately various writings and marginalia on erotica and erotic art.[22]

One may say that this fusion of erotica and poetry — particularly in the 1940s — replaced Teige's earlier espousal of the polarity between constructivism and poetry.[23] The collage became the most suitable medium for Teige to express and communicate the

3. Karel Teige, *Collage no. 133,* 1940.
PNP, Prague. Reproduced by permission
of Olga Hilmerová, Prague. Photo by Fran-
tišek Krejčí, ÚDU AVČR, Prague.

4. Karel Teige, *Collage no. 127,* 1939.
PNP, Prague. Reproduced by permission
of Olga Hilmerová, Prague. Photo by Fran-
tišek Krejčí, ÚDU AVČR, Prague.

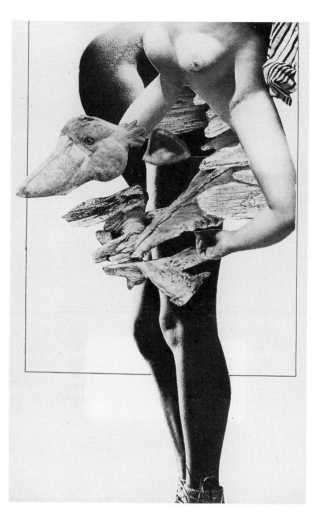

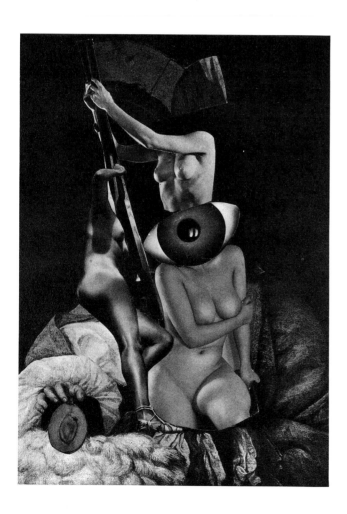

poetic values he discovered in the realm of Eros, in part because he shared Philippe Soupault's opinion that the collage "corresponds to a new form of language and image, which could greatly influence . . . and give force to poetry."[24] And it was Ernst, the father of the surrealist collage, who spoke of the medium as mutually reconciling originally foreign elements that, when combined in a new composition, will be capable of arousing "electric or erotic tension" and creating an "allusive mating" to ignite the "spark of poetry." Ernst recognized the erotic potential in the very principle of collage. Teige had similar ideas in his study "Báseň, svět, člověk" ("Poem, World, Man") of 1930, where he replaced the concept of art with poetry (i.e., "poetism") and where he tried to explain this concept by borrowing from Freud the concept of "life-giving creation" as a function of the "sexual instinct."[25]

In his erotic collages of the forties, which coincided with the installation of the Czech and Moravian Protectorate after the Allied appeasement pact of Munich in 1938 and the subsequent Nazi occupation in 1939, Teige directed his attention toward politically less provocative "signs," which were in fact very much in accord with his earlier writings on the subject of surrealist automatic texts (figure 3).[26] The fragmentary and disembodied presence in Teige's collage figures is not always aesthetically pleasing; for example, in a recurrent motif the head of a nude female body has in place of its head a rudder, a water tap, or the head of a predatory fish. The results of some of these amputations are strange creatures, such as cephalopods or quadrupeds without heads, sometimes with fingers in place of their legs, all made up from various fragments of the female body. Dismemberment and fragmentation are thus among the most important signifying elements of Teige's collages. Perhaps they were meant to communicate something about a world in which humanity and freedom are being ever more thoroughly whittled away, until only a fragment of past desire remains, and—yes—sometimes only a fragment of a fragment.

SOCIAL OBJECT

Teige's series of collages of erotic objects and those of female "monuments" has, of course, another side, characterized mainly by its powerful social and ideological aspects. These are expressed particularly well in *Collage no. 127* (1939; figure 4), where a system of fragments of female nudes is arranged in a pseudo-revolutionary composition recalling Delacroix's painting *Freedom Leads the People to the Barricades* (1830).

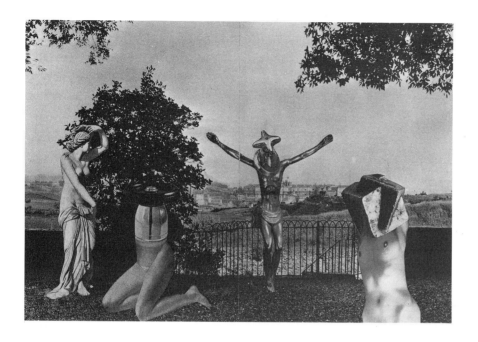

5. Karel Teige, *Collage no. 322,* 1946.
PNP, Prague. Reproduced by permission
of Olga Hilmerová, Prague. Photo by Fran-
tišek Krejčí, ÚDU AVČR, Prague.

6. Karel Teige, *Collage no. 249,* 1942.
PNP, Prague. Reproduced by permission
of Olga Hilmerová, Prague. Photo by Fran-
tišek Krejčí, ÚDU AVČR, Prague.

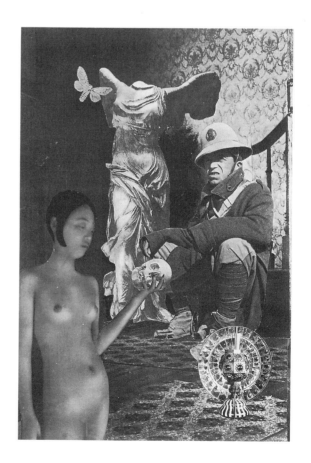

A series of other collages with more or less openly erotic themes mocks the idea of the Catholic Church in general, thus commenting unambiguously on Teige's Marxist atheist convictions. The most radical is *Collage no. 322* (1946; figure 5), which includes the sculpture of a crucifix with a water tap in place of the head. The same is true of *Collage no. 5* (1935), where a female half-nude is "crucified" on a photograph of an iron bridge seen from below.

In a social commentary, *Collage no. 32* (1937) presents the viewer with the contrast of athletic physicality, an erotic fragment, and the photograph of a poor proletarian woman breast-feeding her child in a tree-lined alley. Several collages are striking for their antiwar character. In *Collage no. 249* (1942; figure 6), a Japanese nude holds a skull in her hand; next to her in the composition Teige placed the figure of a soldier and the famous classical sculpture of the Nike of Samothrace, symbolizing beauty and art.

Teige also attempts the deliberate fusion of social and ideological themes with erotic objects by utilizing fragments from the nineteenth century, such as historical dresses, corsets, or clothes and figures from the art nouveau period. From the vantage point of Teige's theory, the emphasis on images from the nineteenth century, which he saw as the flowering of the bourgeoisie and of capitalism, is quite logical. It was precisely in that epoch, particularly after the revolutionary "tremors" of 1830 and 1848, that Teige recognized the conditions for a "fundamental regeneration of art, for a metamorphosis that changes the foundations of work and the concept of art to their deepest roots and thus shatters the historical identity of the structure of art: an upheaval just as portentous as the difference between ape-man and man." According to Teige, this "primal" regeneration would have been inconceivable without the English and French Revolutions of 1648 and 1789: "This provides the fundamental legitimacy for the sociological developmental terminology in the articulation of artistic production; this justifies a new conception of historiography that will search for the boundary lines of individual chapters of art outside art in the movement and shifts of economic and social structures."[27]

In the light of the above quote, the female figure in a "bourgeois" corset appears in *Collage no. 48* (1938) to be directly opposing the idea of constructivist architecture; a lady cut out of some nineteenth-century pictorial magazine becomes a "social" object in a landscape, with a flower placed in front of a fragment of a female arm and breast (figure 7); figures culled from photographs from the Austro-Hungarian period circle an

7. Karel Teige, *Collage no. 290,* 1943.
PNP, Prague. Reproduced by permission
of Olga Hilmerová, Prague. Photo by Fran-
tišek Krejčí, ÚDU AVČR, Prague.

8. Karel Teige, *Collage no. 306,* 1945.
PNP, Prague. Reproduced by permission
of Olga Hilmerová, Prague. Photo by Fran-
tišek Krejčí, ÚDU AVČR, Prague.

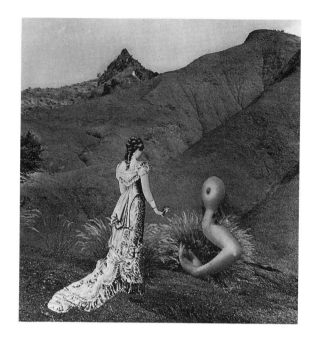

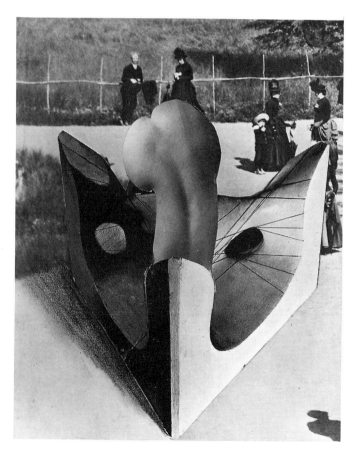

avant-garde object by Man Ray, evidently a phallic symbol represented by the forms of a female body (figure 8).[28] In *Collage no. 221* (1938), one can see a fragment of a female breast placed inside a historical theater interior, creating a striking contrast between the two. *Collage no. 55* (1938; figure 9) is a "stage set" of erotic fragments placed in the interior of nineteenth-century architecture, in this case represented by the revered National Theater in Prague. In a *Collage no. 263* (1939), a breast is a rendered as a true fetish in an open window in the walls of a half-demolished house from an old nineteenth-century xylographic illustration. Here the city is rendered as a spider, which is recalled in Teige's description of the capitalist metropolis in "Předmluva o architektuře a přírodě" ("Prolegomena on Architecture and Nature"), his introduction to Ladislav Žák's book *Obytná krajina* (*The Inhabited Landscape,* 1947). Teige also believed that it was during the nineteenth century that man lost the ground under his feet in the "capi-

9. Karel Teige, *Collage no. 55,* 1938. PNP, Prague. Reproduced by permission of Olga Hilmerová, Prague. Photo by Franti-šek Krejčí, ÚDU AVČR, Prague.

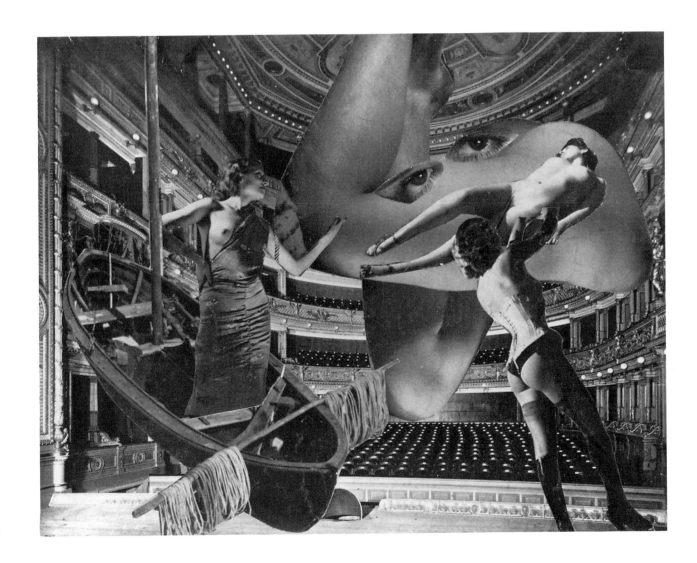

talist maze," or to use the words of Karl Marx, in the "mystical space of wheeling and dealing."[29] But Teige saw in "the breath of eroticism" — and therefore poetry — not only hope for a better future but also something precious to hold onto beyond mere materialism.

In a number of other collages the erotic object, represented again by fragments of the nude female body, is confronted by the machine. The subterranean machinism of Teige's object selection captures again not only his fascination with machines but also the mechanical nature of the modern age, a subject he repeatedly dealt with in his texts. In *Collage no. 57* (1938) he features the head of a woman, dressed in a costume of the turn of the century, with a peacock feather hat "filled" both with erotic fragments (breasts) and with a detailed panoply of various mechanical constructions. *Collage no. 49* (1938) confronts the fragment of a female body with the mechanism of a locomotive hurtling through a photograph in the background of the photomontage. In another work, a female nude with a head in the form of pelvic bones in erotic disguise is placed in a station of the Moscow metro with a sign saying "Dzerzhinskaya" (figure 10). Teige did not place this erotic object into a Soviet setting by chance: the collage was produced in 1938, when Teige was protesting the Moscow political trials in the book *Surrealismus proti proudu* (*Surrealism against the Current*). In its conclusion he also addressed those of his colleagues on the left who had criticized him for his attacks on the politics of the USSR:

Considering the tasks facing the USSR and the efforts for a united antifascist front, it is not the open criticism of Soviet cultural and artistic practice but Soviet cultural politics and practice themselves that are currently unjustifiable and highly dangerous. Obviously, our opponents would like to force us into a choice: either to be silent about the troublesome events in the cultural and political development of the USSR, in spite of the remarkable success of the five-year plans and the force of the Red Army facing the threat of fascism, or to allow ourselves to be pushed into the ranks of the enemies of socialism. However, we will not allow ourselves to be forced by such inquisitorial methods into this deceitfully contrived, monstrous choice.[30]

Given the defiant spirit of these words, it is not hard to understand why Teige chose to use "Dzerzhinskaya" in his collage with a motif from the Moscow metro. Felix Edmundovich Dzerzhinski (1877–1926) was in fact the founder and president of the

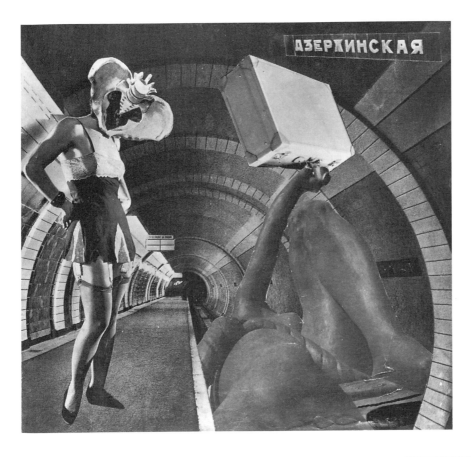

10. Karel Teige, *Collage no. 50* ("Dzherz-hinskaya"), 1938. PNP, Prague. Reproduced by permission of Olga Hilmerová, Prague. Photo by František Krejčí, ÚDU AVČR, Prague.

11. Karel Teige, *Collage,* 1941. PNP, Prague. Reproduced by permission of Olga Hilmerová, Prague. Photo by František Krejčí, ÚDU AVČR, Prague.

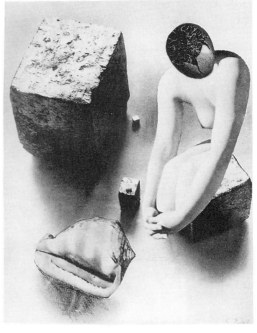

All-Russian Extraordinary Commission to Combat Counterrevolution, which became notorious under the name of the Cheka (which became the GPU, the NKVD, and finally the KGB). It and its successors all operated as the Bolsheviks' secret police. Later, Dzerzhinsky was put in charge of the Interior Ministry (until 1923); he was finally removed by Stalin from his original post in 1926. His name is associated with the liquidation of a great number of "enemies of the revolution."

The socially impregnated objects of Teige's collages underwent their own metamorphoses as well. Alongside richly structured clusters of female body fragments, one can find quite simple elementary objects and forms; for example, an unnumbered collage of 1941 uses blocks of stones or shells and, again, female body fragments (figure 11). It is in these collages that Teige created something like visionary "installations" of objects and sculptures, with an emphasis on illusion and volume—including designs for real installations and landscapes with bizarre objects, usually containing fragments of the female body. Erotic fragments even appear as if encapsulated in clusters of petrified crystals (*Collage no. 169,* 1940) or grapes (*Collage no. 271,* 1943).

This approach, regardless of the difference of the time of its making, recalls to today's viewer the method of Joseph Beuys, in particular his conception of "social sculpture" in the 1970s and 1980s. As Beuys affirms, "das erste Produkt menschlicher Kreativität ist der Gedanke. Und ich möchte ihn regelrecht objektahft den Menschen sichtbar machen in seinem Enststehungsprozess. Ich sage aus diesem Grund DENKEN IST PLASTIK." (the first product of human creativity is the idea. And I would like to render it properly objective for people to visualize in its process of conception. For this reason I say that THINKING IS PLASTIC [FORM]).[31] According to Beuys, thought can, of course, be immaterial too, whence his conception of the "social sculpture" with its pronounced political accent.[32] The items and objects in a number of Teige's collages can thus be understood in the framework of such a conception as a utopian "social sculpture" *avant la lettre.*

Moreover, a parallel can be drawn between Beuys and Teige for another reason: Teige was already, in the 1920s, trying to anticipate what Beuys managed to do systematically in the 1970s and 1980s; namely, the liquidation of "art with a capital *A,*" a notion discussed by Teige in 1925.[33] At that time, and based on the work of the Modernist Movement, he understood constructivism not as an "-ism" but as a process, a way things come into existence. This is why, according to Teige, "in constructivism you

cannot think of art," because "art" means, first and foremost, to construct. Therefore collage — or photomontage, a term that Teige thought more appropriate for his own work — which was such a "construction" of cutout reproductions, represents art in general. Collage is synonymous with both construction and art. Teige also spoke of the "twilight of artistic models," which would have certainly agreed well with Beuys's views. Of course, Teige in his study "Konstruktivismus a likvidace 'umění'" ("Constructivism and the Liquidation of 'Art'") contemplated "machine civilization" in the belief that it would replace the civilization of arts and crafts; Beuys's conceptual scheme is lodged instead in the civilization of thought and information, which relegates into the background the machine — and dependence on the machine — praised by modernism.

SURREALIST LANDSCAPE ART

It is as if Teige projected in his collages a utopian vision of towns or landscapes ruled over by monuments of eroticism (figure 12), where woman is the embodiment of erotic sensuality and palpably of poetry as well. Understood in this sense, his collages are really a "design for a new planet," a theme he had already touched on in "Konstruktivismus a likvidace 'umění.'" In these collages, he gave objects, sculptures, and the co-

12. Karel Teige, *Collage no. 336,* 1947. PNP, Prague. Reproduced by permission of Olga Hilmerová, Prague. Original photograph by František Illek and Alexander Paul photo studio. Photo by František Krejčí, ÚDU AVČR, Prague.

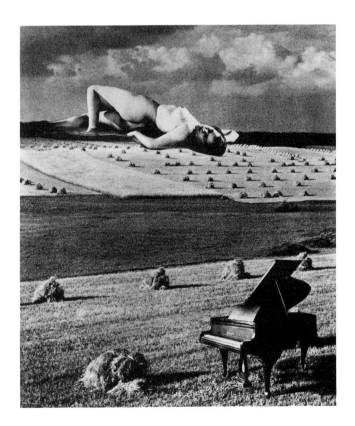

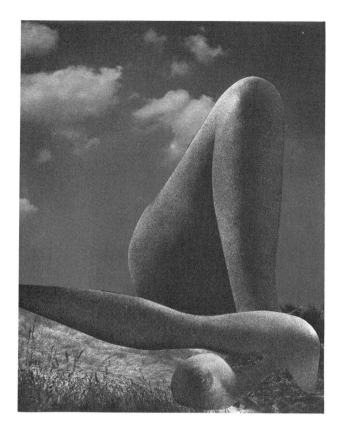

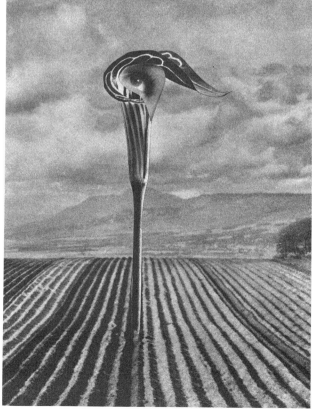

13. Karel Teige, *Collage no. 339,* 1948.
PNP, Prague. Reproduced by permission
of Olga Hilmerová, Prague. Photo by Fran-
tišek Krejčí, ÚDU AVČR, Prague.

14. Karel Teige, *Collage no. 325,* 1947.
PNP, Prague. Reproduced by permission
of Olga Hilmerová, Prague. Photo by Fran-
tišek Krejčí, ÚDU AVČR, Prague.

nundrum of eroticism and beauty (because beauty and erotica were considered as one by Teige) a chance to "speak." Collages with motifs of body fragments in a landscape (figure 13) thus became distant precursors of more or less utopian landscape projects, projects of defamiliarization or manipulation of the landscape such as those of Christo, Robert Smithson, Hans Hollein, or the Superstudio group in the 1960s and 1970s.

Teige's collages with erotic objects placed in a landscape are difficult to explain unless one knows Teige's long introduction to Ladislav Žák's *Obytná krajina.* Teige understood and agreed with Žák's theoretical and practical suggestions on how to give the contemporary landscape a human dimension. Žák had published a series of photographs of an ideal landscape reconstituted by man, along with indications of how it could be improved, thus projecting his desire of how it should look. Teige's collages are similarly a project of desire: because he strongly identifies the female element with the source of beauty and eroticism, his reworked landscape becomes a synonym for woman, beauty, and fertility (figure 14). Teige interpreted Žák's book as a "transformation of a world in which we are condemned to live into one in which we would like to live."[34] According to Teige, the will to live in such a world is the only force powerful enough to change the lived-in world of the present into a new world in which it would be possible to transform life itself into art, specifically modern art:

In modern art, in painting and in poetry, there is a powerful tendency to make ideas real in life, to materialize an illusion inspired by dream and desire in the heart of the material world. Painters, whose dreams were inspired by the love of nature and yearning for paradise, lived in the illusion they had created on canvas. Made concrete by a scientific plan, it becomes transformed into reality: the dream of paradise that created the painted landscape wants to be realized in a living landscape, wants to become incarnate by creating a liberated nature from the industrial desert.

In Teige's vision, "the resurrected, 'composed' landscape now becomes a three-dimensional work of art, the incarnation of a poetic dream, no longer to be merely captured by impressionist landscape painting, which provides only a momentary snapshot of nature. It will be a higher, man-willed nature in Hegel's sense: a humanized nature, which will be man's organ as well as the work of his soul."

Teige further asserts that such a "composed" landscape can be created by the integration of modern art with landscape design; that is, by the direct composition of a

landscape in the manner of a modern artifact. Accordingly, modern sculpture must renounce its questionable monumental, "pompous" aims. It must erect

its sculptures not only in the green of city parks, but in forest nooks as well, in the alleys and open spaces of the residential landscape, whose various sectors it will, perhaps even capriciously, sculpt as a whole and thus change into a park, into a freely conceived sculptural and fantastic collection of stones, vegetation, and water, realizing poetic space within natural space, the reintroduction of a new myth into nature.

Teige wonders why "among the stones that form the rapids of mountain streams there should not be a place for the bronze, stone, or wooden statues of Brancusi or Arp's *Concrétions humaines.*" Teige believes that modern art will be able to change a natural space into a park, that is, a "surrealist landscape." This is precisely the impulse that dominates his landscape collages, where the leading role is played by erotic and bodily objects, often conceived as artistic "monuments" in a landscape.

It was not only in his theory of the "habitable landscape" but in his collages as well (where he "sculpted" the landscape with the forms of the female body; figure 15) that Teige drew on important examples of the past.[35] He recalls them in his "Prolegomena"

15. Karel Teige, *Collage no. 346,* 1948. PNP, Prague. Reproduced by permission of Olga Hilmerová, Prague. Photo by František Krejčí, ÚDU AVČR, Prague.

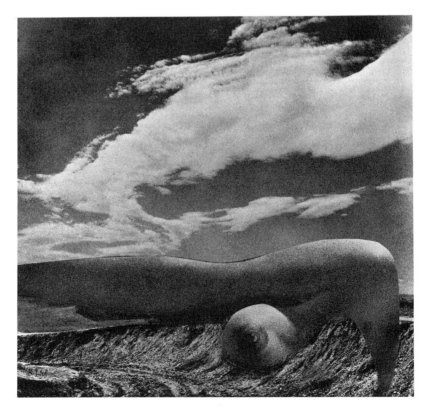

16. Václav Levý, heads carved in rocks in woods near Liběchov (1841–1842), Czech Republic. Photo by ÚDU AVČR, Prague.

17. Václav Levý, *Jan Žižka and Prokop Holý* (1845), sculpted figures in rocks in woods near Liběchov, Czech Republic. Photo by ÚDU AVČR, Prague.

18. Matyáš Bernard Braun, *Garinus in Front of the Cave* (1724–1726). Betlém in Kuks, Eastern Bohemia, Czech Republic. Photo by ÚDU AVČR, Prague.

19. Karel Teige, *Collage no. 371,* 1951. PNP, Prague. Reproduced by permission of Olga Hilmerová, Prague. Photo by František Krejčí, ÚDU AVČR, Prague.

20. Karel E. Ludwig, *Listopad* (*November*). Photograph published on cover of *Salon* 19, no. 11 (1940).

to Žák's *Obytná krajina,* where he refers to the Czech baroque sculptor Matyáš Bernard Braun, who built a quasi-sculpture park within a park in Betlém near Kuks in eastern Bohemia, where he carved colossal sculptures from rocks and boulders as well as bas-reliefs in the trunks of imposing trees, established a hermitage, and had frescos painted on a flat, rocky cliff by Petr Brandl, another baroque painter. In fact, baroque themes appear in a number of Teige's collages as the background to erotic presentations. Two examples are the interior of the Church of St. Nicholas in Prague and a group of sculptures by the baroque sculptor Ferdinand Maxmilián Brokoff.

In his "Prolegomena" Teige highlights another species of "sculpted" landscapes, this time from the middle of the nineteenth century. In the forest above the chateau of Liběchov the sculptor Václav Levý created the Klácelka cave, a set of reliefs of fantastic beings taken from Grandville's *bizarreries* together with bas-relief sculptures of the history of the Czech nation (figures 16 and 17). The art historian Václav Volavka, who characterizes Levý as the first modern Czech sculptor, describes them as "a majestic vision, created more from light, half-shadows, and shadows than from the robust shapes wrested from the rock."[36] In fact, Teige valued Grandville, along with Füssli, Blake, and Goya, as "iridescent beacons of light, illuminating the temporal world of an inner, fantastic model of painterly poetry."[37]

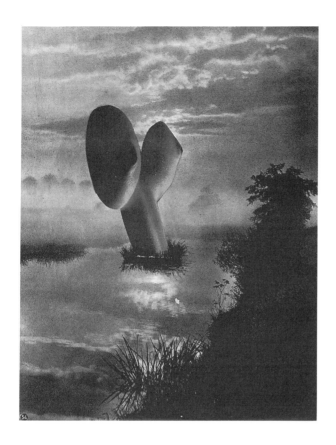

Teige's quotation of these two projects, the baroque Braun (figure 18) and of the Romantic Levý, reveals the precursors of his landscape visions and his surreal landscape art. This is fully confirmed by *Collage no. 371* (1951; figure 19), where a strikingly erotic phallic object penetrates a clump of grass in a melancholy landscape. The penetrating penis is created by the montage of a woman's breasts. Here, as in a number of other collages, Teige made use of a prominent work of photography, in this case a reproduction of Karel Ludwig's photograph *Listopad* (*November*), which was published on the cover of the magazine *Salon* in 1940 (figure 20). Again, it is as if Teige had intended to create a visionary project of a surrealist landscape, enlivened by an erotic object posing as a statue. Karel Ludwig was himself one of the most important Czech photographers from the 1940s to the 1960s, and in his article "Cesty československé fotografie" ("The Ways of Czechoslovak Photography") Teige acknowledged Ludwig's "courageous vision."[38]

THE COLLAGE AS THE TOPOS OF THE AVANT-GARDE

Another important visual element in the collages of Karel Teige is the incorporation of women's torsos or fragments of figures in avant-garde architectural surroundings, such as the designs of J. J. P. Oud or André Lurcat. However, Teige also used pictorial quotations of fragmentary motifs from the works of other avant-garde artists (figure 21), many of them constructivists such as Antoine Pevsner, Marcel Duchamp, and Man Ray. He even used reproductions of Rodchenko's avant-garde photographs.[39] These quotations and inferences are so reliably present that it is possible to define them, as far as Teige's collages are concerned, as a manifestation of the most distinct topos of the avant-garde (figure 22).

Teige situated his objects, his stories, and his visions in the conceptual space of the avant-garde. In the sphere of collage, he was also interested in the work of his avant-garde precursors; thus his notes and the collages themselves testify to his close acquaintance with Ernst's *La Femme 100 Tetes* of 1929 and with the work of John Heartfield.[40] He also followed the work of Hannah Hoch and the collages of Kurt Schwitters, who came to Prague in September 1921 with Raoul Haussmann. Many of the imaginative ideas and hallucinogenic objects in Teige's collages — particularly the surprising objects and bodies placed in a landscape or inside houses, or the windows or passageways leading into the space of a female body — are related to the surrealist

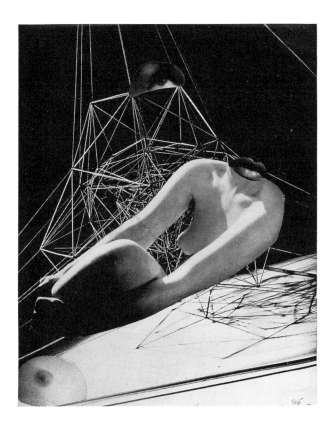

21. Karel Teige, *Collage no. 299,* 1944. PNP, Prague. Reproduced by permission of Olga Hilmerová, Prague. Photo by František Krejčí, ÚDU AVČR, Prague.

22. Karel Teige, *Collage no. 314,* 1945. PNP, Prague. Reproduced by permission of Olga Hilmerová, Prague. Photo by František Krejčí, ÚDU AVČR, Prague.

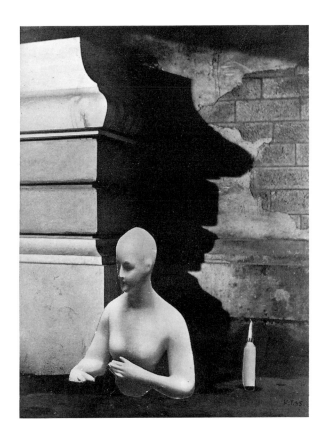

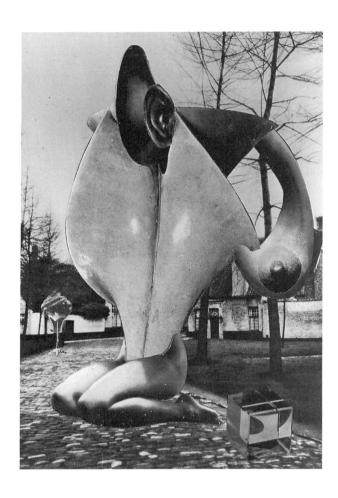

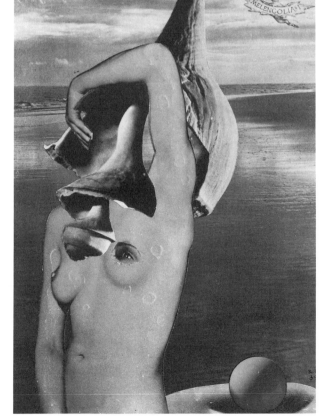

23. Karel Teige, *Collage no. 70, Melancolia*, 1939. PNP, Prague. Reproduced by permission of Olga Hilmerová, Prague. Photo by František Krejčí, ÚDU AVČR, Prague.

24. Karel Teige, *Collage no. 147*, 1940. PNP, Prague. Reproduced by permission of Olga Hilmerová, Prague. Photo by František Krejčí, ÚDU AVČR, Prague.

imagination of René Magritte, whose poetic counterpositioning of apparently unrelated objects was similar to the approach taken by Teige.[41]

The incorporating of avant-garde quotations in Teige's landscapes and collage architecture from the end of the thirties may be construed as part of a melancholy vision of the avant-garde, a swan song of the synthesis of construction and poetry, of rationality and eroticism (figure 23). It is as if in Teige's collages one can hear the reverberations of the Moscow trials and the thunder of the marching feet of the brownshirts during their book-burning frenzies in Germany. For Teige, an ardent Marxist revolutionary, the connection between the meaning of his collages and contemporary reality must have been particularly cruel, and it has sometimes been denied by his detractors. But in the end, it would be difficult if not impossible to ignore the importance of this connection for a correct understanding of his work.[42] A number of collages, including the one discussed above that includes the "Dzershinskhaya" logo, display the growth of aggressively pugnacious and deliberately discomforting elements in the construction of Teige's collages after 1938.

When he was dissolving the Czechoslovak Surrealist Group, the poet Vítězslav Nezval proclaimed that "we must even praise such acts of the Soviet regime as the death sentences of the Moscow trials";[43] Teige violently disagreed, declaring those trials to be an monstrous sham. Symptomatic of his attitude is *Collage no. 278* (1939), made up from photoreportage of a Moscow street, with a sign in Cyrillic spelling the word CINEMA, again with a fragment of a female body, perhaps of a ballerina (it is hard to imagine a more typical figure of Soviet art), and with the image of Duchamp.[44] It represents a kind of symbolic farewell to the avant-garde, evoked not only by the geometric figure of Duchamp but also by the reference to the locus of the most trenchant avant-garde experiments of the 1920s and 1930s, Moscow (apparently, Teige had at one time seriously considered emigrating to Moscow) (figure 24).

The last collage in the collection of the Památník národního písemnictví (Museum of Czech Literature) dates from 1951. In a strange landscape, a cloud-body floats across the sky, quite similar to the famous image by Man Ray (1932) in which a pair of female lips hang in the sky. The female nude as a fundamental embodiment of the cosmos echoes the strongly romantic ideal that enticed Teige to enter the realm of pictorial poems, embrace social utopias of functionalism, and advocate the minimalist notions of dwelling and that finally led him to his landscapes with ethereal visions of erotic objects.

It may be said that Teige tried to realize in his collages the utopian idea of the metamorphosis of the new man — that is, a social and ideally conceived communist transformation of such a man — going hand in hand with an erotically colored metamorphosis of landscape and architecture. In attempting this, he combined freedom of spirit with love, which he understood as an essential part of female corporeality, and he believed that he found the expression of these ideals in his "oneiric pictures": that is, in the collages of his surrealist landscape art, where nature becomes the setting for an erotic "composed" landscape, a kind of Jungian Mother Earth. For Teige, this was ultimately to be poetry as life, and life as poetry.

Notes

1. Teige's collages were first placed in the context of Czech modern art in the exhibition and catalogue *Tschechische Kunst der 20er und 30er Jahre: Avantgarde und Tradition* (Czech art of the 1920s and 1930s: Avant-garde and tradition), ed. J. Kotalík (Darmstadt, 1984), 421–422. In 1989 a large collection of Teige's collages was presented at the exhibition *Czech Modernism, 1900–1945* (Houston, 1989) and the Cooper-Hewitt Museum (New York, 1991) (see the catalogue with the same title, ed. J. Anděl [Houston, 1989]). See also Karel Teige, folder labeled "Koláž, fotomontáž" (Collage, Photomontage), manuscript notes, collection Karel Teige, Literary Archive of the Památník národního písemnictví (Museum of Czech Literature, hereafter cited as PNP), Prague, 2266–2277; F. Šmejkal, "Koláže Karla Teiga" (The collages of Karel Teige), *Výtvarná práce* 11, nos. 19–20 (1963): 6; *Teige-Collagen 1935–1951* (Teige's collages, 1935–1951), exhibition catalogue, intro. V. Effenberger (Essen, 1966); *Karel Teige. Surrealistické koláže* (Karel Teige: Surrealist collages), exhibition catalogue, intro. V. Effenberger (Prague, 1966); *Karel Teige. Od poetismu k surrealismu* (Karel Teige: From poetism to surrealism), exhibition catalogue, text V. Effenberger, Dům umění (Brno, 1967); H. Císařová, "Surrealism and Functionalism: Teige's Dual Way," *Rassegna* 15, no. 53/1 (1993): 78–88; H. Císařová, "Libido op de snijtafel. 'Liquidatie von Kunst' in de praktik van film, fotografie en fotomontage," in *Teige animator,* ed. H. Císařová, K. Sierman, and O. Máčel, exhibition catalogue, Stedelijk Museum (Amsterdam, 1994), 6, 16–23; V. Lahoda, "Utopická krajina Eróta a Poezie. Koláže Karla Teigeho 1935–1951" (The utopian landscape of eros and poetry: The collages of Karel Teige, 1935–1951), in *Karel Teige 1900–1951,* ed. K. Srp, exhibition catalogue, Prague Municipal Gallery (Prague, 1994), 135–154; Lahoda, "Teige a Magritte" (Teige and Magritte), *Umění* 43 (1995): 161–163; Lahoda, "Teige's Violation: The Collages of Karel Teige, the Visual Concepts of the Avant-garde and René Magritte," in *Karel Teige, Surrealist Collages: 1935–1951* (Prague, 1994), 7–18; Lahoda, "L'architettura del frammento erotico. I collages, 1935–1951" (The architecture of the erotic fragment: The collages, 1935–1951), in *Karel Teige, Architettura, Poesia, Praga 1900–1951,* ed. M. Castagnara Codeluppi, exhibition catalogue (Milan, 1996), 195–204; L. Bydžovská and K. Srp, "Halucinatorní, virtuální a mentální objekty. Jindřich Štyrský, Toyen, Karel Teige" (Hallucinatory, virtual,

and mental objects: Jindřich Štyrský, Toyen, Karel Teige), in *Český surrealismus 1929–1953* (Czech surrealism, 1929–1953), ed. Bydžovská and Srp (Prague, 1996), 112–169; E. Petrová, commentary on the collages of Karel Teige in *Prague, 1900–1938: Capitale secrète des avant-gardes,* ed. E. Starcky and J. Anděl, exhibition catalogue (Dijon, 1997), 272–273.

2. Karel Teige, "Socialistický realismus a surrealismus" (Socialist realism and surrealism), in *Socialistický realismus* (Socialist realism) (Prague, 1935), 120–181.

3. Karel Teige, "Výtvarná práce Sovětského Ruska" (Creative arts in the Soviet Union), in *Sovětská kultura* (Soviet culture) (Prague, 1927), 41–99.

4. The influence of Friedrich Engels on Teige's idea of the disintegration of the traditional "bourgeois" family was pointed out in connection with his book *Nejmenší byt* (The minimum dwelling) (Prague, 1932) by R. Švácha, "Karel Teige jako inspirátor moderní architektury—Karel Teige jako stavebník" (Karel Teige as the inspirer of modern architecture—Karel Teige as builder), in Srp, *Karel Teige 1900–1951,* 87. Teige quotes Marx and Engels's views on the family and on the role of women in *Nejmenší byt,* 157–158.

5. Karel Teige, folder labeled "Koláž, fotomontáž" (Collage, photomontage), manuscript notes, PNP, Collection Karel Teige, 2266–2277, p. 6a.

6. Ibid., p. 9.

7. Karel Teige, "O fotomontáži" (On photomontage), *Žijeme* 2 (1932): 107–112, 173–178.

8. See Karel Teige, "Nedělní amatéři a proletářští fotografové" (Sunday amateurs and proletarian photographers), *Svět práce* (The World of Labor) 2, no. 3 (1934): 15. Of course, Teige makes a distinction between the "Sunday amateur–ish language" of the petty bourgeoisie and the "people's art" of working-class photographers.

9. On photomontage, see esp. D. Ades, *Photomontage* (London, 1992), and C. Lodder, *Russian Constructivism* (New Haven, 1982), 182.

10. Teige, "O fotomontáži"; cf. Ades, *Photomontage.*

11. Teige, *Sovětská kultura,* 20.

12. Teige, "O fotomontáži."

13. For Teige's relationship to film, see M. Bregant, "Teigův film" (Teige's film), in Srp, *Karel Teige 1900–1951,* 63–68; V. Lahoda, "K. Teige," in *Anthologie du Cinéma Invisible,* ed. C. Janicot (Paris, 1995), 616.

14. In several collages from 1935–1936, Teige follows the example of Max Ernst in using old xylographic reproductions and illustrations from magazines from the end of the nineteenth century (e.g., *Collage no. 202*).

15. Teige, "O fotomontáži."

16. Ibid.

17. Karel Teige, *Vývojové proměny v umění* (Developmental changes in art) (Prague, 1966), 186. On the "oneiric object" in Teige's collages, see Bydžovská and Srp, "Halucinatorní, virtuální a mentální objekty," 162–165.

18. Karel Teige, "K estetice filmu" (Toward an aesthetics of film), *Studio* 1 (1929): no. 6, 166–171; no. 7, 193–197; no. 8, 231–234; no. 9, 262–266; no. 10, 289–293.

19. Karel Teige, "Konstruktivismus a likvidace 'umění'" (Constructivism and the liquidation of "Art"), *Disk,* no. 2 (spring 1925): 4–8.

20. Karel Teige, *Vývojové proměny v umění,* 186.

21. Ibid.

22. Teige's papers in the Literary Archives (PNP) contain the following important items: "Eros a estetika" (Eros and aesthetics), 1708–1720; "Erotismus" (Eroticism), 1721–1723; "Eroto-estetika" (Eroto-aesthetics), 1734–1742; "EROS," 1724–1733; "Erotické umění" (Erotic art) 1, 2, 1743–1756; and "EROS.LÁSKA" (EROS.LOVE), 1757–1758. For a more detailed discussion of the relation between erotica and collage, see Lahoda, "Utopická krajina Erota a Poezie."

23. The fundamental dichotomy between constructivism and poetry, and the resulting analogical theoretical polarities in Teige's work (such as reason—eros), is explored in Rostislav Švácha's contribution to this volume, "Before and After the Mundaneum," above.

24. See "EROS.LÁSKA," entry "Láska" (Love), crossed out.

25. Karel Teige, "Báseň, svět, člověk," *Zvěrokruh* (Zodiac), no. 1 (November 1930): 9–15. On Ernst, see Karel Teige, "Max Ernst," manuscript notes and excerpts, PNP, Literary Archives, Collection Karel Teige, 1706–1707.

26. See also Lahoda, "Utopická Krajina Erota a Poezie," 152 (a record of a dream from 1942). A more complete set of Teige's surrealist texts was published in G. Dierna, "Bloudíci láska. Automatické texty K. Teiga" (Roving love: Automatic texts of K. Teige), *Umění* 42 (1994): 85–89.

27. Karel Teige, "Fenomenologie umění" (Phenomenology of art) (unfinished), in *Osvobozování života a poezie* (The liberation of life and poetry), vol. 3 of *Výbor z díla* (Selected works) (Prague, 1994), 424–425.

28. The social perspective of a number of these collages that create through their iconography the atmosphere of the nineteenth century is in accord with Teige's conviction that the nineteenth century saw social and economic problems accumulating, as Marx and Engels described. See Teige, *Nejmenší byt,* where there are a series of references to the critical social situation of the proletariat, which reached its peak in the nineteenth century.

29. Karel Teige, "Předmluva o architektuře a přírodě," in *Obytná krajina,* by L. Žák (Prague, 1947), 7–21.

30. Karel Teige, *Surrealismus proti proudu* (Prague, 1938), 66–67.

31. J. Beuys, in *Selbstdarstellungen—Künstler über sich selbst* (Self-portraits—Artists on themselves), ed. W. Herzogenrath (Düsseldorf, 1976), 33.

32. For Beuys's conception of "social sculpture," see B. Elsen, "Studien zu den Prinzipien der Installationen von Joseph Beuys. Ein Beitrag zur Gegendstandssicherung" (Studies of the principles of the installations of Joseph Beuys: A contribution to the clarification of the subject) (Inauguraldissertation, Rheinische Friedrich-Wilhelms Universität, Bonn, 1992), 17–24.

33. Teige, "Konstruktivismus a likvidace 'umění.'"

34. Teige, "Předmluva o architektuře a přírodě"; the quotations in the following discussion are taken from this essay.

35. On the close relationship between the mannerist concept of the anthropomorphic and amorphous landscape and modern art, particularly the art of Man Ray—which was also a source

of Teige's poetics, as he used reproductions of Man Ray's photographs for his collages, including the famous *Return to Reason* from 1932 — see G. R. Hocke, *Die Welt als Labyrinth* (The world as labyrinth) (Hamburg, 1957), 157–160.

36. V. Volavka, *České sochařství v 19. století* (Czech sculpture in the nineteenth century) (Prague, n.d.), 44.

37. Karel Teige, "Fenomenologie umění (Torzo)," in *Osvobozavání života a poezie,* 485.

38. Karel Teige, "Cesty československé fotografie" (The ways of Czechoslovak photography), *Blok* 2 (1948): 77–62. Karel Ludwig had little opportunity to devote himself to photography after the Communist takeover in 1948. In 1950 he married a film director who was to become famous in the Czech 1960s "New Wave," Věra Chytilová. He died, almost forgotten, in difficult living conditions, after he had become deeply depressed and been committed to a clinic for alcoholics. He published his photographs in the magazines *Pestrý týden, Praha v týdnu, Salon, Zdroj, Kinorevue,* and *Kino.* It is possible that Teige may have used other works by Ludwig in his collages, not attributed so far. See the exhibition catalogue edited by B. Chocholová, *Karel Ludwig. Archiv 1939–1948* (Prague, 1997).

39. On the visual quotations of Teige in his collages, see A. Fárová, "Anatomie koláže (poznámka)" (The anatomy of collage: A remark), in Srp, *Karel Teige 1900–1951,* 155. Šmejkal wrote on the relationship between Teige's collages and foreign influences: "If we wanted to find something analogous to Teige's collage work in world art, we could probably only come up with Arthur Harfaux from the Le Grand Jeu group, some of whose work Teige reproduced in volume 3 of *ReD*"; F. Šmejkal, "Poznámky ke Karlu Teigemu" (Remarks on Karel Teige), *Umění* 42 (1994): 60. See also Šmejkal, "Koláže Karla Teiga," 6. In the catalogue *Karel Teige, Architettura, Poesia, Praga 1900–1951* (ed. Castagnara Codeluppi), Simone Hain explored the possibility that Teige's collage work might have been influenced by the collages of the Belgian surrealist E. L. T. Mesens ("Karel nel Paese delle Meraviglie. I conflitti teorici degli anni Trenta," 128). See also Lahoda, "Teige's Violation." Teige's collages are also close to the collages of the French poet Georges Hugnet.

40. See Teige, "Max Ernst," manuscript notes and extracts.

41. See Lahoda, "Teige a Magritte"; Lahoda, "Teige's Violation." Teige's study "Osud umělecké avantgardy v obou světových válkách" (Fate of the artistic avant-garde in two world wars) placed Magritte in the current of "inner realism"; *Kvart* 4 (1946): 375–392. *Mezinárodní surrealismus* (International Surrealism) (unnumbered) mentions Magritte, "who, making use of optical illusions, paradoxically allowed the image to oscillate on the boundary between illusion and reality."

42. For example, Cisařová, in "Surrealism and Functionalism," writes that Effenberger's 1960 classification of Teige's collages by motif was justified and natural, while "today it is no longer correct to categorize them according to their composition or a content of social criticism" (185).

43. Quoted in Teige, *Surrealismus proti proudu,* 33.

44. Discs and spirals from Duchamp's film *Anémic Cinéma* (1926).

KAREL TEIGE: ART
THEORY BETWEEN
PHENOMENOLOGY AND
STRUCTURALISM

Miroslav Petříček Jr.
(Translation by David Chirico)

SIGN AND PREFIGURATION

Teige's reflections on modern art, growing into a new conception of aesthetics, form one of the pillars of his theoretical work from its very beginnings in the 1920s, when he published his first exhibition reviews and his essay "Obrazy a předobrazy" ("Figures and Prefigurations," 1921), a wild celebration of the birth of a new reality, whose prefiguration is, in Teige's eyes, an art that ceases to be art.[1] This gravitation toward a systematic theory subsequently continued in countless articles on various but primarily modern and contemporary artistic movements, as well as in his intense interest in architecture and in his reflections on film and photography. The result is his first attempt to evaluate the fate of the avant-garde between the two world wars and, most important, his unfinished opus *Fenomenologie umění* (*Phenomenology of Art,* 1950–1951), the latter clearly intended to represent the synthesis and epitome of all his earlier theoretical thinking.[2] But not only that: it was also, in accordance with Teige's dialectical method, an open summary, a new formulation of negation and contradiction. Accordingly, this synthesis was to signal an important shift in Teige's outlook. For even though at the core of the new project one can still find ideas already articulated in *Jarmark umění* (*The Bazaar of Art,* 1936), where he insisted that "the desire to liberate poem, dream, fantasy, and love . . . must also participate in the reconstruction of history,"[3] it also represents a certain theoretical *novum*. Thus, according to Vratislav Effenberger, the transition from aesthetic theory to phenomenology constitutes the final step in Teige's thinking; the theory of art is remodeled into a theoretical construction of a broader scope, and imagination is freed from its exclusive dependence on aesthetics.[4] Seen from this point of view, Teige's "phenomenology" is in effect a culmination of his ruminations on art and presents, in its own way, a kind of surrealist "theory of theories."

That this broader foundation of Teige's phenomenology goes beyond the boundaries of "mere" aesthetics is evidenced primarily by its sociological ground plan and by its criticism of the autonomous periodization of art emanating from that ground plan, shown not to be quite accurate when subjected to "close historical analysis."[5] Only a descent to the deeper levels of historical reality will make it possible to discover the true turning points that demarcate the dynamics of social structure through all time.

No matter how brilliant his conception and how lively his vocabulary, Teige basically derives all his argument from the Marxist relation between base and superstructure; or, in his own words, "a work of art . . . does, after all, exist as a function of

something that exceeds it, and therefore not only functions on the artistic plane—that is, on the plane of artistic creation and aesthetic contemplation—but radiates far beyond its frontier."[6] This is a paradigm that Teige attempts to retain even when he returns to the problem of periodization and when he provides his own overview of the development of modern art. In his view, the most important milestone in the history of art is the transition from impressionism to postimpressionism to those movements that ventured beyond the naturalistic tendencies of impressionism. This revolution was later to culminate in cubism and surrealism.

This rupture in the history of art represents not only an echo of a course of events that were already inexorably in motion (namely, the establishment of liberty by the French Revolution) but also a prophecy (of the Russian Revolution) and thus a *manifest sign* of an immanent transformation of both the social and the economic systems. The transition from impressionist to postimpressionist tendencies, which created the rupture, initiates a "fundamental regeneration of art" so radical that it disrupts art's very historical identity and structure.[7] In some instances, Teige adds to the core of his terminology on the development of modern art more precise designations that he subsequently develops further.

The origin or presage of this break is also linked to the deepening rift between modernity and academicism (the source of the modern conception of realism), a theme that he develops in greater detail both in his "Pokus o názvoslovnou a pojmoslovnou revisi" ("An Attempt to Revise the Terminology of Designation and Conception"), and in the text titled "Realismus a irealismus kubistické tvorby" ("Realism and Irrealism in Cubist Work").[8] Teige places particular emphasis on the conflict between contemporary "prophetic" work and its interpretation by critics who rely on outdated normative criteria, a conflict that on closer inspection would have to encompass all kinds of other normative statements on aesthetics as well, including Teige's own "speculative" aesthetics. It becomes evident that the thrust of Teige's phenomenology exceeds the bounds of a narrowly or autonomously limited field of aesthetics, for

As long as a speculative aesthetics announced in its codices the universal laws of ideal beauty and the various norms, then criticism, imposing its prescriptions and rules on artists according to this dogma, could produce no more than a series of blunders and misunderstandings. The history of criticism may thus be considered as nothing but a history of attributions of blame; however,

nothing new was gained by this. . . . Modern aesthetics . . . transposes the question of the basis and function of art from the metaphysical sphere to the historical ground.[9]

The above is intended to clarify the central point of reference in Teige's "phenomenology." Given this broader context, one has to concede to him the right to pursue what is actually the *disruption of the historical identity of art.* This discontinuity may be located in modern art having separated itself from a certain mode of aesthetic thinking and — at the same time — having subverted a certain aesthetic whose distinguishing mark is the *referee* or the *judge* and whose location is the *salon,* administered by such a referee or judge and organized, in principle, mimetically: any work exhibited here must pay homage to certain changeless norms, mirror them, and be either their realization or their fulfillment. This also means that the historical identity of "art" is ruptured precisely at the point when the salon is replaced by the *fairground* and the *bazaar,* which, somewhat paradoxically but necessarily — unlike the salon — are not subject to the dictates of the market. In using this vocabulary, Teige draws primarily on ideas expressed as early as the mid-1930s in his book *The Bazaar of Art,* which sums up the program of Devětsil, the program of a poetically open world, in which beauty is no longer limited to the sphere of art and which requires as its precondition a search for a new wholeness. This program, according to Květoslav Chvatík, implies an attempt to produce a new cultural anthropology.[10] Clearly, words like "fairground" or "bazaar" hint at this in a very subtle way, since the transition from an aesthetics to a phenomenology of modern art is a transition not only to a new, broader theory of art but also, above all, to a new semiology.

A work of art, exhibited in salons and judged according to classical or academically grounded aesthetics, is a *sign* with a certain type of exchange value. Thus, on the one hand, it is a work that is produced as a commodity, according to demand; on the other hand, it is a work that is a "substitution" for certain criteria or norms, defined and produced within the determinate confines of a certain aesthetic. The semiology of the salon is characterized primarily by the fact that the work-sign communicates (transmits and spreads and in this sense in-forms) a certain aesthetic norm, which is its own signifier. Hence, the basis of such a communication is the norm, and therefore what is transmitted in this way precedes all signs, whatever their character. In the theoretical language that Teige used all his life, it can also be said that classical aesthetics (the aes-

thetics of the salon and of its referees) is a *repression of the figure* (of the signifier), be-cause by emphasizing this version of the exchange value of the figure-sign, it relies on the "metaphysical" presumption of a categorically "ultimate" ground as a precondition for the possibility (and at the same time as an instance of control) of communication (it is unimportant in this context whether this ultimate ground is presented as an ideal set of norms, as a transcendental subjectivity, or in any other way). The salon is noth-ing but an exchange market, because its conception of the exhibited "sign" relies on the premise of universal equivalence: the signifiers of all signs all have their roots in a common ground that has the features of a metaphysical ultimate or final ground: they are all convertible, and in this regard all art objects in a salon are the same, because — in the end — they are really not art objects but money. The work of the artist is hidden within the suppressed designator. Another unavoidable implication of this line of think-ing is that the salon is also a museum, because the precedence of the base always im-plies the "pastness" of the norm. In other words, the norm is what has already been verified: "As a proud representation of power and government, as a luxurious demon-stration of class and caste, the museum is a monument: a warehouse stockpiling the artistic heritage of the past, a mausoleum, where famous values are mummified."[11]

On the other side of this rupture, which demarcates the discontinuity in the histori-cal identity of art, we find, therefore, not the aesthetics of salon signs but a *phenome-nology* — together with a different semiology, the *semiology of prophetic signs*. At the same time, phenomenology seeks to encounter the work as a sign (Teige was very well acquainted with the theoretical work of the Prague Structuralists, a subject to which we will return), but a sign of a quite different type: one that has the character of a sig-nal, one whose location is not the salon but the fairground.

Teige's own vocabulary is quite clear in this regard, and a quick glance through some of his expressions will suffice: "first mission and early prophecy"; "the confusing sense and extent of these signals"; "a signal before dawn"; "fiery signals"; "rare and fan-tasmatic signals";[12] "signals of a rift"; "the clear blazing light of freedom";[13] "the break of a new day"; and even a "magic aura."[14] And, of course, such a sign may also become a "scandal." This vocabulary has its deep roots in Teige's early texts and in the meta-phors contained in his essay "Figures and Prefigurations," where he argues that new art truly "creates the prefiguration of a new life. . . . [T]his prefiguration is a condensa-tion, a generalization and simplification of the complicated, a thing or a person existing

in fiction and dream. In this way the aim of all mental creation is to prefigure the new world."[15] It is on this very basis that Teige's semiology has to be accepted as a possible working proposition.

"Prefiguration" is a polyvalent term; it points to what does not yet exist (going beyond the "past" grounding of the salon sign and thus becoming a "prophetic" sign). At the same time, it is the initiation of a process of creating what may not yet exist but is already arriving in the form of its "prefiguration" (i.e., the prefiguration ceases to be a sign in the traditional sense of the word and becomes sign–figure–new reality itself).

This concept is anchored in Teige's general concept of semiology, and above all in his outline for a new theory of the development of art: he follows the genesis of prophetic signs in such a way that the field of his investigation becomes the figure itself — that is, the figure as "designator" or the figure-sign, which moves beyond the definitional bounds of the flat painted figure (of traditional salon exchange value) and thus opens a new space of cognition. It is in this conceptual turn that Teige finds the key significance of the postimpressionist phase of modern art and of its culmination in analytic and synthetic cubism.

In a kind of shortcut, Teige analyzes this metamorphosis of salon signs into prophetic signs by using the example of contemporary Czech art, in particular that of Bohumil Kubišta. The first "tidings" (both "message" and prior signal of what does not yet exist — in-formation from the future) of this revolution were the exhibitions of the Osma (Eight) group from the first decade of this century, especially Kubišta's *Kuřák* (*The Smoker*), which is one of the earliest documents of the first stage of cubism. For Teige, the exhibitions of Osma were "Moments of prefigurations and prophecies, the dawning of a new day, stages of protomorphosis and preparation, sparks of initiative, the opening manifestos of the avant-garde, the early heroic years of new movements."[16]

The step by which the figure-sign abandons the definitional space of the flat painted figure (and its "mimeticism," in the sense that it represents certified norms) is, from the point of view of communication, the step with which it encounters the extreme constraints and the categorical limitations of the communal salon; and it is for this very reason that the figure-sign must establish its own authentic autonomy, for "only now is it a self-sufficient *poièsis.*" It is from this boundary that it already can glimpse the new definitional space of art, an "art, moved out to the furthest boundary of social action, endowed with the power of anticipation; its revolutions precede the shifts in social structures and announce forms of life not yet incarnate."[17]

According to Teige, the true autonomy of art will be established only when the emphasis is placed upon the "designator" as the carrier of what is communicated by prophetic signs. In this way, art abandons the salon (as the place of a semiology anchored in the "past") and enters the bazaar or fairground. That too is, in its own way, a "market," but the kind of market whose dominant principle is not exchange and exchange value, but rather "demonstration" (a semiology turned toward the future). It is a market as space of exhibition. And in this way, too, the appropriate discipline of art theory becomes *phenomenology.*

THE INNER MODEL

If we read Teige's phenomenology as suggested above — in the context of semiotics as the domain of the "prophetic" signal, within which the "prospective" direction of the sign and the signifying process becomes recognized — a variety of inspirational stimuli can be identified in its orbit. In the first place there is, of course, the energizing stimulus of interwar avant-garde art itself. In his theoretical interpretation of this art, Teige owes much to contemporary structuralism, particularly that of Jan Mukařovský (i.e., the conception of the sign and the differentiation between the value of the sign and its reference; the conception of "aesthetic function, norm, and value as social facts"; the link between art and communication; and so on), and there are some indications that his work also contains (perhaps indirect) echoes of the philosophical phenomenology of Edmund Husserl, which — to a certain extent — is an implicit part of the theory of the Prague Structuralists of that time as well.[18]

From formalist "defamiliarization" to the exegesis of poetic function as an emphasis on artistic approach, by turning its attention to the very construction of the artistic sign structuralism constantly expresses a tendency both to "destabilize" horizons of expectation and to emphasize the creative process (language is not an *ergon* but an *energeia*). In that sense, too, structuralism is, according to Shklovsky, a strong criticism of a semiotics oriented toward the past: "The aim of art is to give the feeling of things as facts of vision, not as facts of cognition; the method of art is the method of defamiliarization of things and the method of desimplification of forms, increasing the difficulty and length of perception, because the process of perception is in itself the aim of art, and thus must be prolonged."[19] Because the aesthetic sign does not permit recognition, it therefore must be interpreted not instrumentally as re-presentation but as

presentation. At the same time, such a semiology reveals that the basis of communication is "creation" and "production"; there are no ready-made contents whose only function is to be shared on the basis of predetermined (historical) norms.

In this regard it is also possible to follow up on the links between structuralism and phenomenology, which as a philosophical conception of man emphasizes the (partially) unconscious *creativity* of the subject and the *freedom* connected with it — a freedom to step back from the world, a freedom that opens up the possibility of new dimensions. Concerning the experience of avant-garde art, we could then say that the meaning of the sign is to make possible the re-cognition of a reality signified in a certain way, but prophetic signs enable the re-cognition of what does not yet exist. In other words, they only signify insofar as they cause *radical shifts in the structure of signification itself.* Re-cognition, in which the thing is shown in and as itself, subsequently shows the thing in a way in which it has never been seen before.

Teige's thinking marks a significant shift away from classical phenomenology. While Husserl's analyses of temporality take "retention" as their exemplum, Teige sets out from nothing more but the "potential" moment: the sign is a "reflector of desire" — it re-cognizes the future, it presents the future. This shift is important, because an emphasis on retentiveness implies amnesia in two senses: both as forgetting the discrepancy between signification and the horizon of expectation and as forgetting "creativity" (the horizon of expectation appears as an impersonal given). An accent on potentiality, in contrast, incorporates into the process of understanding as identification a moment of unrecognizability) — what Adorno terms in his essay on surrealism "the radiance of the unidentifiable."[20]

Etymologically, but also in its very essence, phenomenology teaches about what manifests itself, and how. Teige's reflections permit us to distinguish between the several elucidations of this manifestation that are singled out. First is the light of the salon or the light of the norm: here, only what is already set or given can become manifest. Second is the light of the bazaar, or the "alienating" light: it tears things out of context, returns them to life, surprises by illuminating unexpected connections, brings stationary time into motion. In order, however, to become truly prophetic, it must metamorphose into a miraculous or *surreal* light, the light of André Breton's *inner model.* Teige explains:

332

The object chosen by desire reveals itself in a light that we have never glimpsed, in a glance that we have never noticed before. It disconnects itself from its real connections and fantasy creates around it another reality that it has awakened inside the inner being, but that scarcely reveals the outward stimulus that elicited it. The superreal appearance of things contained in their real nature is what is imprinted into reality at the moment when, in the spark of conflict between the thing and the subject, the imprint of poetry loses its everyday appearance.[21]

Such an image-sign, which is the materialization of an inner model, is already turned toward the future and illuminates contemporary reality with the future by allowing reality, transformed by art, to be penetrated by something of repressed desire, of the pleasure principle.

Teige's phenomenology, judging by surviving fragments, was to have two complementary levels: it investigates the (manifest) process of the liberation of the signifier and, simultaneously, interprets this process from the perspective of the prophetic sign. This means that along with examining the liberation of the signifier, it studies the (latent) process in which phenomenology takes the place of aesthetics as the theoretical field freeing the imagination from the bounds of a metaphysically founded theory of art. It follows that in such a scheme the real theme of phenomenology is not art itself but the disruption of the historical identity of art, which occurs whenever the stage of reality begins to be illuminated by that third, magic, and radiant light of the "ineffable" as it points to a deeper freedom. The field of salon aesthetics is too narrow to reveal this historical shift of emphasis:

In the revolutions through which modern science has passed and is passing, and in the metamorphosis which modern art has experienced and is experiencing, we note an equivalent epistemological position, the same radically critical revision of previous conceptions and the brave advance of the same inventiveness that has renounced all the petrified systems, dogmas, and authorities of the past and that penetrates to ever deeper levels of reality and possibility, until [it reaches] a point when the possible will coincide with the real.[22]

The liberation of the "figurativeness" of the figure (the signifier) is effected by (the painter's) creativeness itself. Inasmuch as the salon figure-sign embodies value as a product and at the same time is denied the capacity of "production" (because it is un-

derstood as the re-production of a norm rather than its own image), the figure-sign conceals the fact that meaning is not given but is created by the effect of its figure-forms. Thus, while the sign-figure is a fetish, the *sign-prophecy* is first and foremost the sign of liberated production, of creativity, of an opened world. For this reason, it is a "confounding" sign, because it does not rest on any other foundation but the (painterly) work itself. Hence it does not point to the given but to the nongiven; it is nothing but radical potential. It would therefore not be correct in this context to understand Breton's inner model as something that precedes the work — its temporality is evidently other, not least because of its contrast with the past, retention-oriented direction of salon aesthetics.

Starting in the 1940s, Teige linked his semiology of the prophetic sign with surrealism, with the difference that in the surrealist process the emphasis on the potential sign is not only brought into sharper focus but also made more precise and interpreted anew. This shift is confirmed by his vocabulary. For example, in an article about Jan Zrzavý (who is now revealed as a key precursor), "early pre-diction" becomes a "phantasmagoric signal" and is no longer limited within the restricted purview of the avant-garde; now it applies quite generally and is, also quite generally, "of the future": "Neither in the present nor in the past is fantastic art a precisely delimitable sphere; it is not a genre in itself, a curiosity, vegetating to one side, outside central currents and major styles. We meet with it during [all] revolutionary times of historical trauma; it directly precedes these shocks to the social organism and the intellectual world, or it grows out of them."[23]

Breton's inner model is, for Teige (indubitably under the influence of a structuralist vocabulary), an "inner subject" — or (in Breton's terms) a source from which the "magic diktat" emanates. This is so not only because in its miraculous light (provided that the artist succeeds in changing it into form) reality is awakened and becomes the symbol of an unconscious drama, but also and primarily because this light reveals in the real the possible: in this light, the difference "that divides phantasm from reality" is broken, and dream materializes.[24]

The inner model from which Teige draws his definition of the prophetic sign is nothing preprepared: it stands for possibility as desire and desire as possible reality, and therefore it is something in the nature of pure *dunamis*. It is "labor becoming a work"; more precisely still, it is what has presence only in (artistic) labor, which becomes an

act in an experiment breaking through the bounds of the "reality principle" (i.e., the dimensions of the salon horizons of expectation). The work that emerges at the other end of this rupture in the historical identity of art thus does not look for its model in past canon but looks always ahead, at a prospect of infinite possibilities and free choice. It is, in fact, in the most powerful sense of the word that the "model" is present uniquely in the process itself; that is, in the labor of both the disruption and the construction of its signifiers. Thus, in the language of the philosophy of the second half of this century, the inner model may be described as something like a lightning bolt illuminating a possible future, a future that can become real only if it is able to prove its capacity to organize the present in such a way as to open it to that future.

Teige's move toward accepting the concept of the inner model opens a new space of cognition, a kind of cognition that is not able to legitimate itself with respect to some preceding given identity, for no ultimate grounding can be taken for granted: it knows its final *Grundslosigkeit* — and, as a result, also its radical responsibility. If we understand Teige's "phenomenology" in this way, we can say that in many respects, and sometimes remarkably closely, it agrees with Castoriadis's theory of the imaginary as the "ungrounded ground" of institutionalization: "The imaginary of which I speak is not some figure of something. It is an uninterrupted and (sociohistorically and psychically) undetermined creation of appearances/forms/figures, which is the basis for the fact that we are able to speak about something at all. We may thank only these appearances, forms, and figures for what we call reality and rationality."[25]

Notes

The word *obraz,* which is here translated systematically as "figure," is also used in Czech to mean "picture/painting" and "image," and both Teige and Petříček play on these multiple significations. I choose "figure" in this particular context, as it best allows the expression of derivations of the word *figure,* such as *prefiguration, figurative,* and so forth. *Trans.*

1. The relationship between Teige's thinking and phenomenology and structuralism has so far not been the subject of any special study, but it is referred to in the following essays: Vratislav Effenberger, "Charakteristika názorového systému Karla Teigeho" (The characteristics of Karel Teige's idea system), in *Vývojové proměny v umění* (Developmental changes in art), by Karel Teige (Prague, 1966), 339–397; Effenberger, *Realita a poesie* (Reality and poetry) (Prague, 1969); Květoslav Chvatík, *Strukturalismus a avantgarda* (Structuralism and the avant-garde) (Prague, 1970); Effenberger, "Vývojová cesta" (Paths of development), in *Osvobozování života a poezie: Studie ze čtyřicátých let* (The liberation of Life and Poetry: Studies from the 1940s), by Karel Teige, vol. 3 of *Výbor z díla* (Selected works) (Prague, 1994),

600–664; Chvatík, "Karel Teige a pražský surrealismus" (Karel Teige and Prague surrealism), *Umění* 43 (1995): 116–118; Miroslav Petříček, "Setkání surrealismu s fenomenologií v magické Praze" (The meeting of surrealism and phenomenology in magic Prague), in *Český surrealismus 1929–1953* (Czech surrealism, 1929–1953), ed. Lenka Bydžovská and Karel Srp (Prague, 1996), 106–111; Rostislav Švácha, "La théorie du fonctionalisme tchéque," in *Prague, 1900–1938: Capitale secrète des avant-gardes,* ed. E. Starcky and J. Anděl, exhibition catalogue (Dijon, 1997), 209–214.

2. Karel Teige, "Osud umělecké avantgardy v obou světových válkách" (Fate of the artistic avant-garde in two world wars), *Kvart* 4 (1946): 375–392. For his unfinished work, see "Fenomenologie umění," in *Osvobozování života a poezie.*

3. Karel Teige, *Jarmark umění* (The bazaar of art) (Prague, 1936).

4. Effenberger, "Charakteristika názorového systému Karla Teigeho," 361–362.

5. Cf. Teige's essay "Sociologický půdorys" (Sociological ground plan), from the 1950–1951 "Fenomenologie umění," first published in Teige, *Osvobozování života a poezie,* 417–425.

6. Quoted from Teige's "Fenomenologie umění," chapter titled "Bastila akademismu" (The Bastille of academism), in Teige, *Osvobozování života a poezie,* 426–461; quotation, 443.

7. See Teige, "Sociologický půdorys."

8. Both texts appeared in 1966 in Karel Teige, *Vývojové proměny v umění.*

9. Teige, "Bastila akademismu," 442.

10. Chvatík, *Strukturalismus a avantgarda.*

11. Teige, "Bastila akademismu," 460.

12. All quotes are from Karel Teige, "Jan Zrzavý—předchůdce" (Jan Zrzavý—Precursor), in *Dílo Jana Zrzavého 1906–1940* (The works of Jan Zrzavý, 1906–1940) (Prague, 1941), 49–66.

13. Teige, "Bastila akademismu."

14. Teige, "Fenomenologie umění," essay titled "Periodizace moderního umění" (The periodization of modern art), in Teige, *Osvobozování života a poezie,* 462–471.

15. Karel Teige, "Obrazy a předobrazy" (Figures and prefigurations), *Musaion* 2 (1921): 52–58.

16. Karel Teige, "Bohumil Kubišta," *Kvart* 6 (1949): 350–378, reprinted in *Osvobozování života a poezie;* quotation, 347.

17. Ibid., 351.

18. See Elmar Hollenstein, *Linguistik, Semiotik, Hermeneutik. Pläydoyers für eine strukturale Phänomenologie* (Frankfurt am Main, 1976).

19. Viktor Šklovskij (Shklovsky), *Teorie prózy,* trans. Boh. Mathesius (Theory of prose), (Prague, 1948), 15.

20. T. Adorno, in *Noten zur Literatur* (Frankfurt am Main, 1991), 105.

21. Teige, "Jan Zrzavý—předchůdce."

22. Teige, "Bohumil Kubišta," 367.

23. Teige, "Jan Zrzavý—předchůdce."

24. Ibid.

25. Cornelius Castoriadis, *Gesellschaft als imaginäre Institution* (Society as an imaginary institution), trans. Horst Brühmann (Frankfurt am Main, 1984), 12.

THE INNER MODEL

/ 14

Karel Teige
(Translated by Alexandra Büchler)

Originally published as "Vnitřní model" in *Kvart* 5 (1945): 149–154.

The question of form is posed differently in the cases of naturalist, formalist, and imaginative painting.[1] At one end of the spectrum, the *naturalist* has no aesthetic (artistic, painterly) form; what he has is an *external model,* whose objective shapes he transfers onto the canvas by the technical means of his craft. Technique is in this instance employed to imitate the external model in a situation of primacy, or rather supremacy of the imitation principle over the aesthetic principle, which is eliminated as much as possible. The transfer of the external model's objective shapes onto the canvas is done by means of technical craftsmanship. The importance of such a painting is proportionate in the first instance to the importance of its external model, and only secondarily to the quality of its craftsmanship.

From the mid–nineteenth century on, most functions of naturalist painting were taken over and performed more successfully by photography. Photography (considered only in its primary, documentary function) has no inherent aesthetic form; it has an external model and records its objective shapes on a light-sensitive surface by the technical, optical, and chemical means of its paraphernalia. Technology is in this case subjected to the aim of imitating the external model in a situation where the imitation principle rules supreme, while the aesthetic principle is absent from the beginning. The transfer of the external model's objective forms onto the photographic plate or paper happens by means of a technical, photochemical process that is essentially automatic. The importance of the photograph is in the first instance proportionate to the importance of the external model and only secondarily to the quality of photochemical craftsmanship. The picture emerges in two stages: by means of exposure when it is captured — which is essentially an automatic process — and by the negative/positive darkroom process, where the aesthetic principle becomes gradually invoked as a secondary consideration.

By virtue of its very nature, photography was able to take the place of naturalistic painting. Under pressure from evolving photography and owing to its own developmental necessities, painting began to seek an aesthetic form, weakening the position of the external model in the process by developing and refining its own technical and artisanal means. Technique ceased to serve the external model exclusively and began to serve aesthetic form as well. The supremacy of the imitation principle over the aesthetic principle gradually weakened, and the aesthetic principle was recognized as more or less equal to the imitation principle. The importance of the picture came to

340

depend as much on the importance of the model as it did on the quality of technical craftsmanship and artistic treatment. For, as long as the supremacy of the imitation principle persisted, it was compensated by the fact that the faithful image of the model, as seen by the painter's eye, was subsequently augmented, corrected, and stylized by artistic form, resulting in a process of secondary, aesthetic treatment.

This state of precarious balance between imitation and aesthetics as well as between photography and painting was disturbed the moment emphasis shifted toward form itself. *Formalist painting* either has no external model or retains only its remnants; it does have aesthetic form, and its technique is subservient to aesthetic form in a situation of primacy or rather supremacy of the aesthetic principle over the imitation principle, which is being gradually eliminated. The formal aspects of a picture are achieved by means of aesthetic elaboration. Its importance is proportionate, above all, to the purity of form, in a lesser degree to the quality of craftsmanship, and in the last place to the importance of the external model, insofar as it has not been entirely eliminated. Aesthetic treatment is primary. There is no secondary treatment. Here, painting shares neither its interests nor its functions with photography.

As soon as the aesthetic principle became paramount in formalist painting and the external model was eliminated (abstraction, objectless art), the way was open for a gradual shift or a sudden reversion back to naturalist painting with an external model, or to photography, or eventually to imaginative painting.

Imaginative painting has an inner model, and thus transfers onto the canvas its spiritual form by means of technical craft. Technique is here put in the service of rendering the inner model in a situation of primacy, or, in some extreme cases, supremacy of the imitation principle over the aesthetic principle, which is all but eliminated or rather absent from the beginning, or at least relegated to the background. The transposition of the mentally induced forms of the inner model onto the canvas can be accomplished by means of several technical processes. The inner model itself is formed by the process of psychic automatism. The importance of the picture is proportionate in the first instance to the significance of the inner model and only to a lesser degree to the quality of its technical treatment. The picture emerges in two stages: the first is characterized by inspiration — that is, by the mental formation of the inner model — and it is at this moment that the image residing in the mind emerges as essentially complete; the second is the process of fixing the mental image onto the canvas, during

which sometimes a secondary, aesthetic treatment may be invoked, which may, after all, affect to a considerable degree the process of mental formation of the inner model already during its formative phase.

Here, we find ourselves at the opposite pole of the above-mentioned process: it is imaginative painting with an inner model. External perception is replaced by an inner image, by a kind of snapshot of the world of imagination. Seen this way, painting that refers to an inner model — that is, to mental visualization as an irrational product of the imagination, both lyrical and poetic — also has no painterly aesthetic form but a spiritual one, namely the form of its spiritual model. The inner model is formed by those forces of the psychic apparatus that act on it before it becomes what it is, before it finds its psychic form seen by the painter in his mind's eye and recorded by means of his technical craft onto the canvas with requisite precision. At the extreme limit of this program of action, the aim is to fix with utmost accuracy a faithful picture of the inner model onto the canvas: the craftsman paints the vision of the poet's mind. It takes the camera a fraction of a second to create a documentary photograph of the external model. All that is subsequently needed is to develop and print it.

For painting to capture the spiritual form of the inner model with the same hallucinatory precision with which the naturalist (having been overtaken by the photographer) depicts the objective forms of the external model, it would have to become, as Salvador Dalí has written, "a handmade color snapshot of concrete irrationality and of the whole world of imagination." To achieve that, the painter would need to have at his disposal a highly photosensitive plate, for his inner model emerges from the darkness of the unconscious, and an instant shutter, as the inner model is considerably changeable and mobile, as well as an automatic release button, since we are dealing here with a self-portrait of the psyche. The process of printing by means of which a definitive picture is obtained is a secondary factor. That would require the feasibility of taking photographs of the inner world. In such a case it would be necessary to substitute photomechanical automatism by psychic automatism. The first was discovered by modern optics; the search for the latter may be accomplished with the assistance of modern psychology.

We become a photosensitive plate capable of capturing images by submerging ourselves into a state of passivity, similar with respect to the distribution of psychic energy and transient attention to the state of falling asleep or being under hypnosis in

which we watch our inner images, a state which allows the emergence of involuntary ideas and one in which volition and the critical faculties are weakened. This is the state of introspection: it differs from rational thinking as it classifies and takes a critical view of one's own thoughts, rejects or cuts off one's own ideas, which means that it does not follow the paths such ideas may have opened up, while at the same time remaining completely unaware of other ideas and, in fact, suppressing them at their very conception even before they become conscious.

Conversely, in a state of introspection, in order to become a photosensitive plate of a psychograph, we suppress the light of critical reason to the extent to which it might disturb the free flow of our thoughts and images that are intimately linked up with their associations; we remain completely indifferent to the direction our thoughts may take, letting ourselves be carried with the flow, unconcerned with the potential outcome of the process and, in short, with everything that is not part of the passive life of the psyche. It is precisely the poet, the introvert given to reveries, who is ideally suited to transforming himself into a photosensitive plate, a sounding board or a hypersensitive film of inner activity. It is he who fulfills the condition of poetic creation described by Friedrich Schiller in a letter to Körner as "calling off the guards from the gates of reason."[2] When the powerful cluster of associations, brought about by a permanent waking activity of the unconscious (which is different from dream activity), creates in one's mind an image that enchants us and imposes itself upon us as the inner model, it causes a psychic shock, which comes very close to a state of ecstasy and illumination: the blinding flash of inspiration is the moment of exposure. It is this flash of instant exposure that gives birth to the image on the sensitive plate of our mind and completes it at the same time. As for automatic shutter release action, this can be achieved by various methods that help increase the frequency with which subconscious ideas enter our consciousness, thus forcing inspiration to act as frequently as possible.

The sum total of these processes including sensitization, exposure, and fixation is called *psychic automatism.*

In contrast to a verbal and written record by means of a poetic text, which develops in time, such as when writing is synchronized with thinking and when something like a film of a dynamic series of imaginative ideas unfolds, painting and sculpture as record have their own complex peculiarities. Such a record is not a continuous film showing a flow of unconscious inner ideas; rather, it is a static record of certain outstanding

moments that impose themselves by virtue of their emotive power as the equivalent of the inner model. The formation of an imaginative idea, of an inner model in one's head and its fixation by means of a painting or a sculpture, is not synchronous. In this sense, a painting can never become an absolute psychogram. Instead, it has the power to achieve a greater sharpness of vision.

Considering that a painter's work arises in two stages (inspiration and materialization, exposure and copying or fixing), which are connected by imaginative memory, it is necessary to "call off the guards from the gates of reason" twice, if the process of automatism is not to be interrupted. The first time is at the moment of inspiration, when the model is being formed and as it appears in the mind, and when a contingent and simultaneous graphic sketch may not only act as a support for memory but also to some extent become a catalyst in the process of the crystallization of the inner model (as one of the processes that stimulate inspiration). The second time is when the mental image becomes stabilized and the inner model is copied by means of painting, at which time the very process of the painter's work, carried out with memory animating the inner image, has the capacity to influence the work's completion as well as its secondary treatment in the mind, similarly to the way some negative and positive photographic processes greatly influence the final appearance of a photograph. Yet in both cases the image is essentially complete at the moment of exposure, that is, at the moment of inspiration.

During these more or less ecstatic moments of inspiration it may be possible to draw a sketch, but only in exceptional cases would the artist be able to produce a complete painting, although some methods are known that would make this feasible (states of trance, etc.). Inspiration is entirely beyond the reach of the will. However, the execution of a painting cannot be entirely involuntary and requires (even without calling into question the matter of spontaneity) a certain concentration. As long as will and concentration are focused on perfectly reproducing, fixing, and copying the inner model that, precisely because of its attentive confrontation with the evolving painting, may well undergo certain changes, the process of psycho-automatic birth of the painting is not disrupted and the painter's hand obeys the dictates of the thought's vision — that is, the dictate of desire. However, should attention seek its aims elsewhere — outside the inner model and outside the effort to create its faithful copy on canvas — or if it were to pursue its own aesthetic interests and criticize and correct the

evolving painting from an aesthetic position, thereby changing its original subject consciously and intentionally while paying attention to those mental instances that have nothing to do with inspiration other than interfering with it, the painting would cease to be altogether a product of that magical compulsion. It would instead become a work inspired by the subconscious and constructed consciously with the help of the intellect or, expressed differently, reconstructed, because as such it would be subjected to change in the process of aesthetization and rationalization of the initial idea.

In the first case, when a painting is a faithful copy of the inner model as if it were emerging complete from the fixative bath, we are looking at a secondary psychological elaboration, induced by the materialization of the idea by means of the painting process. In the second case, when the inner idea goes through the process of aesthetic distillation, transfiguration, stylization, and composition as it is being recorded on the canvas, the image on the canvas becomes a more or less remote variant, an echo of the original inner image; that is, when the image is being transformed rather than completed by the process of painting, it ceases to represent the imprint of the inner face and becomes instead a stylized mask, thereby arresting the process of psychic automatism, at which point we cannot speak anymore about a kind of handmade color photograph. By means of such secondary aesthetic elaboration the image is removed even further from its inner model (just as it was removed from the external model at the opposite end of the scheme) and moves toward the sphere of formalist painting, with its supremacy of the aesthetic form over the model and, in this case, over the inner model. Here painterly composition and form may still resonate with a more or less remote echo of the original inspiration and the voice of the inner model, which is similar to the opposite case where optical perception and external model are nothing but a silent accompaniment to the play of colors and shapes.

When aesthetic and intellectual intentions are invoked to a more considerable degree during the translation of an ideated fantasy into the medium of painting, the fantasy becomes transmuted. If the vitality of such a fantasy is more assertive than the power of the aesthetic principle controlling the painterly elaboration, it will be able to find the means by which to operate even with aesthetically distilled shapes and through them. The psychic forces that formed the inner model and were transformed by it in turn now try to take hold of the shapes constructed in the image by the power of intellectual compositional discipline. They become the hidden undercurrent of such

work. Here we are touching on the mystery of the effect that artworks have on us: even where the aesthetic moment appears to be dominant, the hidden impact of the psychic forces that are the source of lyrical imagination is disproportionately more powerful.

All living works of art have found their inspiration in such sources and only a small number of them are the strict result of psychic automatism. The operative mechanism of aesthetic contemplation and pleasure is what Fechner called the "principle of aesthetic succor or intensification," that is, the increased aesthetic pleasure we experience when watching artworks that have emerged from the depth of powerful psychic potencies. Contemplation that evokes aesthetic pleasure, driven in the same way as the primordial and eternally infantile desires springing from unconscious depths, causes a more powerful emotion than one that could be stirred in us merely by the aesthetic coefficient of a work of art. In its passive, receptive, and yet focused state of mind, aesthetic contemplation resembles to some extent introspection, as it stirs the tide of unconscious ideas and desires. The pleasure caused by formal composition, which is the true mark of aesthetic pleasure, makes possible the quenching of the living thirst for lyricism that pulsates inside of us from sources that otherwise remain hidden.

The true joy given to us by a work of art is the result of the gratification of our desires from deeper sources, as they are made accessible and become stirred up by the sensation of aesthetic pleasure. To see the role of the aesthetic coefficient as the exclusive source of pleasurable emotions stirred in us by a certain poem, painting, or piece of music would be to misunderstand it and to overestimate it. The real roots of such pleasure remain largely outside the consciousness of the viewer and the author, and the delight derived from these subterranean regions is usually attributed to the aesthetic component, that is, to the factor that consciously aims to give pleasure. And yet, what has always deeply moved us in any artwork has been its latent poetry.

Notes
1. By "formalist" painting we understand, above all, the postimpressionist period of development up until abstraction. By "imaginative" or "poetic" painting we understand mainly surrealism. The term "formalist" has no pejorative meaning here.
2. See Sigmund Freud, *General Introduction to Psychoanalysis* [1916] and *The Interpretation of Dreams* [1900]. On psychic automatism, see André Breton's first "Manifesto of Surrealism" [1924].

Note: The original Czech version of Dačeva's chronology was published in *Karel Teige,* exhibition catalogue, Galerie hlavního města Prahy, Památník národního písemnictví, Ústav dějin umění Akademie věd České republiky, Uměleckoprůmyslové muzeum v Praze (Prague, 1994); it is reprinted here with the permission of the ÚDU AVČR, PNP.

APPENDIX

CHRONOLOGICAL OVERVIEW: DATES, EVENTS, PUBLICATIONS, MANIFESTOS, AND BOOKS

Rumjana Dačeva
(Translated by Eric Dluhosch)

1900 Karel Teige was born on 13 December 1900 in Prague, 12a Černá Street (14 Černá Street today). Teige's father, Josef Teige (1862–1921) JUDr. [J. D.] and Ph.D., was a historian and archivist of the Prague Municipality. His mother, Johanna Teigová, was born Fousková (1877–1931).

1911 Teige enters *reálné gymnasium* (equivalent of U.S. junior college) on Křemencova Street in Prague. His professors include Jan Zeman, Štěpán Jež, Otto Plachta, and Ladislav Šíma. Among his classmates were A. Hoffmeister, A. Wachsman, and V. Vančura, all future members of the Devětsil group.

1912 He begins writing his diary, which he keeps up until 1920.

1915 First attempts at painting and writing. He decides to become an artist-painter.

1916 Together with his classmates, Teige founds the journal *Knihy všeho* (Books about Everything). He uses the pseudonym Karel Vlk [in Czech, *vlk* means "wolf"] for his poems, stories, and translations.
May: On 4 May, he arranges his first exhibition in Pankrác (a district in Prague) with a lecture on the subject "Tváří v tvář novému umění" (Face to face with the new art).
June: On 26 June, he participates, together with painters J. Zavadil, A. Wachsman, and K. Vaněk, in the exhibition *Červená krychle* (The Red Cube) in the house U Domanských on Myslíkova Street, Prague.
Fall: Teige writes the first version of "Nová doba ve výtvarném umění" (New times in the creative arts), published in the journal *Ruch* (Hurly-Burly) 2, no. 2 (13 October 1919): 33–34.

December: Teige develops the verbal exercise "O novém umění" (On the new art). He writes studies about the painters A. Slavíček, P. Cézanne, and E. Munch.

1917 **May:** 17 May, exhibition in the house U Polikliniky on Myslíkova Street in Prague. He exhibits together with the painters K. Vaněk, A. Wachsman, Šatra, Rumčák, J. Slavíček, V. Hofman, R. Stockar, and V. Špála.
Teige's graphic works are published for the first time in the German expressionist journal *Die Aktion* (Action), edited by W. Pfemfert.

1918 **Fall:** Teige meets Emmy Häuslerová, the future wife of the Devětsil member architect Evžen Linhart, at the occasion of a concert celebrating the liberation of Czechoslovakia. Emmy later introduces Teige to one of her classmates, Josefina (Jožka) Nevařilová, who was to become his lifelong companion.
Teige is appointed art editor of the journal *Ruch*.

1919 **June:** Teige graduates from the gymnasium on 17 June and applies to be admitted to the Faculty of the History of Art at Charles University in Prague. He attends lectures by Professors K. Chytil, F. Drtina, F. X. Šalda, H. Vysoký, and V. Birnbaum.
He writes articles for the journals and newspapers *Čas* (Time) (1919–1921); *Právo lidu* (People's Rights) (1919–1922); *Kmen* (the word translates both as "Trunk" and "Tribe") (1919); *Lidové noviny* (People's News) (1919); and *Revoluce* (Revolution) (1919). *Revoluce,* edited by B. M. Klika, becomes the first art review representing the young generation of Czechoslovak artists. Articles by Teige and poetry and prose pieces by J. Seifert, the brothers Vaněk, Lev Blatný, J. Frič, V. Mixa, J. Haussmann, and V. Vančura are included, as well as reproductions of works by the graphic artists V. Sedláček, J. Rambousek, V. Rada, A. Wachsman, A. Moravec, and J. Trampota.

Teige translates articles by A. Mercereau, G. Apollinaire, J. Romains, F. Werfel, and others. He publishes an essay on Guillaume Apollinaire with illustrations by Josef Čapek in *Kmen* 3, no. 7 (19 June 1919): 51–53; no. 8, (26 June 1919): 61–62.

1920 K. Teige, K. Vaněk, and L. Süss become members of the Arts Club of the musician V. V. Šak, the nucleus of the future Art Association of Devětsil.

February: A lecture by E. Kleiner, "O moderním výraze výtvarném" (On modern expression in art), is arranged in the Arts Club on 12 February at the initiative of Teige and Vaněk.

On 18 February, the Literary Branch of the Arts Club organizes in the Sládkova síň (Sládek Hall) of the Obecní dům (Municipal House) an evening for the young. In the course of this evening the art monthly *Orfeus* is founded as a platform for the views of the young generation, with L. Vladyka and K. Teige as editors. Only three volumes are published, the last in April 1921. The first volume includes examples of Teige's creative work.

May: Teige produces three linocuts for the book by the poet Ivan Suk, *Lesy a ulice* (Forests and streets).

September: Teige writes the programmatic essay "Obrazy a předobrazy" (Images and preimages, or Figures and prefigurations), published in the second number of the anthology *Musaion* (1921): 52–58.

October: Devětsil is founded on 5 October in the Café Union in Prague (figure 1). It becomes the focal point for intellectual, literary, artistic, theater, and architectural activities of the young left avant-garde in Czechoslovakia between the years 1920 and 1931. The name *Devětsil* is derived from the stubborn country plant *Petasites vulgaris*. It is assumed that the painter Josef Čapek of the older cubist generation was its inventor. The writer V. Vančura is elected as first president, Teige represents theory, and the painter and writer Adolf Hoffmeister is appointed secretary.

December: The newspaper *Pražské pondělí* (Prague Monday) prints the manifesto of Devětsil on 6 December. On 15 December, Teige cancels the first protest evening of Devětsil, because—as remembered by Adolf Hoffmeister—he felt that "it is inadmissible to recite poetry at a time when the police are shooting workers in the streets of Prague."

1921 **January:** Teige and his followers resign from Devětsil for a few days as a result of internal disputes. The poet M. Jirko is entrusted with taking over editorial duties of the journal *Orfeus* from Teige.

A small exhibition of Devětsil is held in the bookstore U zlatého klasu in Spálená Street with Teige's participation. Teige publishes the first programmatic manifesto of the new Czech avant-garde in essays titled "Novým směrem" (In a new direction) in *Kmen* 4, no. 48 (24 February 1921): 569–571, and "Nová výtvarná generace" (The new creative generation), in the newspaper *Čas,* 4 January 1921, 4, 13, and 13 January 1921, 4–5. These essays provoke the subsequent "quarrel of the generations."

February: Matinée of Devětsil in the theater Revoluční scéna (Revolutionary Stage), with Teige's introductory remarks.

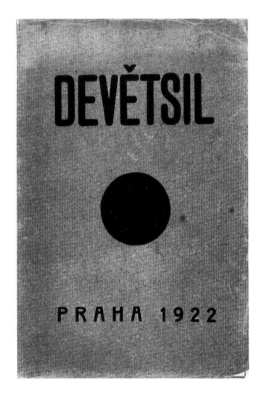

1. Karel Teige, cover of the anthology *Devětsil* (Prague, 1922). The Mitchell Wolfson Jr. Collection, the Wolfsonian–Florida International University, Miami Beach, Florida.

April: On 1 April, Teige is exempted from compulsory military service by the draft board.

From 19 April to 10 May, Teige participates in a Devětsil lecture series with speeches on Devětsil's new theory of art. Lectures take place at the "Umělecká beseda" art club, led by painters Josef Čapek and Jan Zrzavý. Teige speaks on the subject "Výtvarná krize dneška" (The creative crisis of today).

Teige assumes the post of art editor of the leftist-anarchist journal *Červen* (June), edited by the poet S. K. Neumann.

He makes contact with C. Vildrac and J. Duhamel during their visit to Prague. With their help, he begins cooperation with the French papers *L'Humanité* and *L'amour de l'art*.

May: Teige begins publication of his polemic "S novou generací" (With the new generation) in *Červen* 4, no. 7 (20 May 1921): 106–108; no. 8 (6 May 1921): 124–126; no. 9 (2 June 1921): 139–141. It is a reaction to the article "Umělecký defétismus" (Artistic defeatism) by the cubist theorist V. Nebeský, published in the paper *Tribuna,* 27 March 1921.

15–31 May: Exhibition of the Association of Students of Architecture in Jeruzalémská Street in Prague, with entries by future members of Devětsil J. Havlíček, A. Wachsman, J. Fragner, E. Linhart, K. Honzík, and V. Obrtel.

26 May marks the date of the first fundamental quarrel in Devětsil between the apolitical concept of K. Vaněk and the communist program of K. Teige.

Vaněk leaves Devětsil and founds the *Nová skupina* (New Group, or New Faction).

August: 14 August marks the founding of the cultural organization Proletkult and a journal of the same name, with poet S. K. Neumann as editor and K. Teige as member.

December: Futuristic syntheses in the Švandovo divadlo (Theater Švanda) with the participation of F. T. Marinetti, who made contact with Devětsil.

Teige writes his first summary article on futurism, "F. T. Marinetti a futurismus" (F. T. Marinetti and futurism), published in *Aktuality a kuriozity* (Actualities and Curiosities) 1, nos. 8–10 (15 January 1922): 77–79. This essay becomes the basis for his subsequent study "Futurismus a italská moderna" (Futurism and Italian modernism, 1925). Teige designs the cover and illustrations for J. Seifert's book of poetry *Město v slzách* (City in tears), edited by the Communist publisher R. Rejman.

1922 **January:** K. Teige and J. Seifert are expelled from Proletkult, allegedly for making contributions to a centrist daily.

February: On 26 February, Teige delivers a lecture in Brno, in which he makes an assessment of prewar art, especially expressionism, later published as "Čtení o německém expresionismu" (Readings on German expressionism) in the Brno art review *Host* (Guest) 1, nos. 7–8 (1922): 157–161.

March: On 13 March, the poet Jiří Wolker delivers the collective manifesto of Devětsil before the group Var (Boiling Point), bearing the title "Proletářské umění" (Proletarian art), with Teige as coauthor. It is published under Wolker's name in *Var* 1, no. 9 (1 March 1922): 271–275.

April: The opening of the *Jarní výstava Devětsilu* (Spring Exhibition of Devětsil) is held on 29 April in the Dům umělců (House of Artists) in Prague. Participants are B. Feuerstein, J. Havlíček, A. Hoffmeister, J. Jiříkovský, F. Muzika, B. Piskač, L. Süss, J. Šíma, K. Teige, K. Vaněk, and A. Wachsman.

Spring: Teige writes the articles "Nové umění proletářské" (New proletarian art) and "Umění přítomnosti" (Contemporary art) for a proposed second lecture series of Devětsil, scheduled in May in the Studentský dům (House of Students) on Albertov Street in Prague. The first lecture is subsequently published as an introduction to the anticipated *Revoluční sborník Devětsil* (Revolutionary anthology Devětsil) (December 1922).

May: A special edition of *Proletkult* 1, nos. 7–8 (1922), dedicated to Devětsil, is published on 3 May, in which J. Wolker and critic A. M. Píša announce their joining of the movement. In the same issue Teige pub-

lishes his article "Obrazy ze života" (Pictures from life) with the subtitle "Úryvek z přednášky o proletářském umění" (Fragment of a lecture on proletarian art).

On 12 May, Teige presents his second lecture titled "Umění přítomnosti," published in *Život* (Life) 2 (Prague, 1922–1923), 119–142.

June: 18 June to 12 July, Teige visits Paris for the first time. He meets Ivan Goll, Larionov, Reverdy, Gleizes, P. A. Birot, Ozenfant, and Le Corbusier.

During his Paris stay, Teige writes the article "Kubismus, orfismus, purismus a neokubismus v dnešní Paříži" (Cubism, orphism, purism, and neoCubism in today's Paris), published in *Veraikon* 8, nos. 9–12 (October–December 1922): 98–112.

Fall: Teige writes the article "Umění dnes a zítra" (Art today and tomorrow). Together with the architect Jaromír Krejcar, he prepares the publication of the anthology *Život* 2, published during the spring of 1923.

December: Publication of *Revoluční sborník Devětsil,* edited by Teige and Seifert.

At year's end a discussion about Devětsil develops between art critics F. Peroutka and F. X. Šalda, published in the daily *Tribuna;* they are later joined by the critic J. Kodíček. Their attacks are aimed primarily at Wolker and Teige. The latter responds to these attacks in an article titled "Věc Tvrdošíjných" (The case of the Stubborn Ones) in the newspaper *Československé noviny* (Czechoslovak News) 2, no. 1 (3 January 1923): 4–6. The Tvrdošíjní (the Stubborn Ones) was an Cubist art group, headed by the painter Josef Čapek, among others.

Teige is appointed art critic of *Československé noviny.*

1923 **January:** The poet Wolker leaves Devětsil. Teige writes Wolker, noting their differences, while at the same time offering Wolker his cooperation in the planned publication of a new Devětsil review, named *Disk*.

February: Teige becomes a member of the editorial staff of the monthly publication of the Club of Architects, *Stavba* (Building). After the departure of its chief editor, J. R. Marek, Teige assumes his position.

Under Teige's leadership the journal becomes a single-minded proponent of modern architecture and propagator of international purism and constructivism.

April: Devětsil mounts an exhibition of the sculptures and paintings of Alexandre Archipenko during February and March in the Dům umělců in Prague. Archipenko visits Prague during that time. On the occasion of the exhibition, Teige publishes his first book, *Archipenko.*

June: Teige concludes his studies of art history at the Faculty of Philosophy at Charles University.

July: At the request of painter J. Zrzavý and the recommendation of art critic F. X. Šalda, Teige writes the article "Jan Zrzavý," published in *Musaion* 4 (1923), published by Aventinum.

August: The following Czech architects from the Devětsil group participate in the *Bauhaus Exhibition on International Architecture* (15–30 August): J. Chochol, J. Fragner, K. Honzík, J. Krejcar, E. Linhart, V. Obrtel, B. Feuerstein, and J. E. Koula.

Teige makes personal contact with Walter Gropius and subsequently keeps in constant touch with the Bauhaus. In studies and articles Teige acquaints the Czech public with Bauhaus philosophy and its creative tendencies.

November: Publication of the first issue of the international review *Disk,* with Teige responsible for its typographical design. Editors are J. Krejcar, J. Seifert, and K. Teige. Teige publishes his article "Malířství a poezie" (Painting and poetry) in *Disk,* no. 1 (November 1923): 19–20.

Teige creates the pictorial poems *Pozdrav z cesty* (Greetings from the journey) and *Odjezd na Cytheru* (Departure for Kythera).

Teige produces the design of the cover as well as the typographical format for the second edition of J. Seifert's *Město v slzách* (City in tears), published by V. Vortel (Prague, 1923).

Together with J. Krejcar, Teige designs the cover and typography of K. Schulz's book *Sever, Jih, Západ, Východ* (North, south, west, east), published by Vortel and Rejman (Prague, 1923).

The Devětsil exhibition *Bazar moderního umění* (Bazaar of Modern Art) opens on 14 November in the Dům umělců in Prague. Participants are J. Šíma, J. Štyrský, Toyen, O. Mrkvička, K. Teige, J. Jelínek, and V. Voskovec (painters); B. Feuerstein, J. Fragner, K. Honzík, J. Chochol, J. Krejcar, E. Linhart, and V. Obrtel (architects); and, as a guest, Man Ray.

December: On 15 December, Brněnský Devětsil (Brno Devětsil) is founded as an "Association for the Propagation of Modern Active Culture." Teige follows its activities closely and gets actively involved by publishing in its house publication, *Pásmo* (literally, "The Zone," but more likely signifying a broadcast waveband).

1924 **January:** A repeat show of the exhibition *Bazaar of Modern Art,* with a changed title, *Výstava nového umění* (Exhibition of New Art), is inaugurated in the Barvičův salon in Brno in January 1924, with Ilya Ehrenburg's wife, painter L. Kozintzowa, as a guest. During its inaugural, Teige presents a lecture titled "Naše základna a naše cesta" (Our base and our path), subsequently published in *Pásmo* 1, no. 3 (September 1924): 1–2.

For the fall lecture series of the Brno Devětsil, Teige delivers a lecture on 28 January on the subject "Panorama poválečného umění" (Panorama of postwar art).

Spring: Teïge publishes a number of articles dedicated to the subject of film as art, e.g., "Filmové grotesky" (Film grotesques) and "Chaplin," in the daily *Národní osvobození* (National Liberation) 6 February, 8 March, as well as his lecture "Estetika filmu a kinematografie" (Aesthetics of film and cinematography) in *Host* 3, nos. 6–7 (April 1924): 143–152.

March: First issue of *Pásmo* (which existed from 1924 to 1926) published by the Brno Devětsil. In it, Teige publishes his sociological study "Moderní umění a společnost" (Modern art and society).

On 16 March, Teige delivers a lecture in the cinema Bio Universum in Brno on the subject "Americké veselohry" (American comedies).

Teige becomes intimately involved with Josefina Nevařilová, introduced to him by Emmy Häuslerová (see fall 1918).

April: Lecture by Teige in Brno Devětsil on cubism.

May: Teige writes the study "Poetismus" (Poetism), published in *Host* 3, nos. 9–10 (July 1924): 197–204.

July: Teige publishes "O humoru, clownech a dadaistech" (On humor, clowns, and dadaists), in the journal *Sršatec* 4, no. 38 (31 July 1924): 3–4; no. 39 (7 August 1924): 2–3; no. 40 (14 August 1924): 2–4. This article forms the basis of his later book *Svět, který se směje* (A world of laughter, 1928).

Teige finishes his two-hundred-page manuscript *Všecky krásy světa* (All the beauties of the world) for the publisher V. Petr in Prague. The book does not get published.

August: Together with J. Seifert, Teige travels to Vienna, Milan, Nice, Marseilles, Lyon, Paris, Strasbourg, and Stuttgart. In Vienna, he probably meets with stage designer and architect Frederick Kiesler.

September: Teige provides the typographical format for Nezval's book *Pantomima* (Pantomime), published by Ústřední studentské knihkupectví (Central Student Bookstore) in Prague (figure 2). Cover and illustrations by J. Štyrský.

October: On 21 October, Teige, together with T. van Doesburg, issues a proclamation published in *Pásmo* 1, nos. 7–8 (1925), urging the boycott of the spring 1925 *Exhibition of Decorative Arts* in Paris. In its place, they propose the organization of an opposing exhibit, a Congress of the Constructivist Movement, as well as international publications on modern art and architecture and performances of modern theater and film.

November: Teige and Seifert publish a joint film scenario with the title "Pan Orfeus a různé zprávy" (Mr. Orpheus and other news) with the subtitle "A Film Poem," in *Pásmo* 1, nos. 5–6 (1925): 7–8.

From 11 November until the end of the year the Klub architektů (Club of Architects) in Prague and Brno organizes a series of lectures on modern architecture, delivered by noted European architects such as J. J. P. Oud, Walter Gropius, Le Corbusier, and Adolf Loos.

December: Teige publishes a programmatic summary of new Czech architecture, "Moderní česká architektura" (Modern Czech architecture),

in the art review *Veraikon* 10, nos. 11–12 (1925): 113–133. This study becomes the basis for his later book *Moderní architektura v Československu* (Modern architecture in Czechoslovakia, 1930).

Teige publishes "Umění soudobého Ruska" (The Art of Contemporary Russia) in the December issue of *Host* 4, no. 2 (1925): 34–46.

Before Christmas, Teige delivers a lecture on the subject of Russian constructivism in Brno.

Teige and O. Mrkvička propose the typographical format for the first ten volumes of the Lidová knihovna nakladatelství Aventinum (Popular Series of the publishing house Aventinum) with uniformly conceived covers, distinguished individually by different colors and letter types.

1925 **January:** On 20 January, Le Corbusier and A. Ozenfant lecture in the Klub architektů in Prague. Le Corbusier meets members of Devětsil.

Teige translates part of Ozenfant's lecture on the subject of "O umění a strojové společnosti" (On art and machine society), published in *Stavba* 3, no. 12 (1925): 219, and reprints two of the artist's drawings in the form of tables.

2. Vítězslav Nezval (*left*) and Karel Teige (*right*), ca. 1924. Památník národního písemnictví (PNP; Museum of Czech Literature), Prague. Reproduced by permission of Olga Hilmerová, Prague.

358

Teige proposes the cover and typographical montage of J. Seifert's *Na vlnách TSF* (On the waves of the telegraph), published in the spring by V. Petr in Prague.

February: Teige publicizes his reaction to the harsh intervention of the Türingen government in Bauhaus affairs in "Osud výmarského Bauhausu" (The fate of the Weimar Bauhaus) and "Ještě případ výmarského Bauhausu" (More about the case of the Weimar Bauhaus), *Stavba* 3, no. 7 (February 1925): 130–132.

Teige publishes "Pozor na malbu" (Pay attention to painting) in *Pásmo* 1, no. 9 (February 1925): 2–3, in which he discusses the question of new pictorial structures in Šíma's abstract paintings.

March: Teige publishes "Futurismus a italská moderna" (Futurism and Italian Modernism), in *Pásmo* 1, no. 10 (March 1925): 4–6.

4 March marks the opening of an exhibition of Šíma's paintings and drawings in the gallery Topičův salon in Prague and, later, from 1 April in Barvičův salon in Brno as the second exhibition of the Brno Devětsil. Teige reports on the exhibitions in *Stavba* 3, no. 9 (March 1925): 167–168, touching on the notion of mechanical images. On 13 March, the play *Pojištění proti sebevraždě* (Insurance against suicide) by Ivan Goll opens in the hall Na Slovanech in Prague. Costumes are designed by Teige and Mrkvička, scenery by A. Heythum.

From 20 March to 1 April, Devětsil arranges a lecture series in the Akademický dům (House of the Academy, or University Hall) in Prague on the subject of film. Participants are K. Teige, J. Krejcar, J. Honzl, V. Nezval, and H. Richter. Teige's essays on film (*Film*) appear as a book from the publisher V. Petr in Prague, with Teige providing the typographical format as well.

Spring: The second number of the journal *Disk* is published, with Teige providing the typographical format. In the same issue, Teige also publishes his important article "Konstruktivismus a likvidace 'umění'" (Constructivism and the liquidation of "Art") and, together with J. Seifert, the film script "Přístav" (Harbor) with the subtitle "Partitura lyrického filmu" (A score for a lyrical film).

Teige publishes "Film I, Optický film" (Film I, optical film), dedicated to film art, in *Pásmo* 1, nos. 5–6: 10–11; "Film II," 1, nos. 7–8: 11; and "K estetice filmu" (On the aesthetics of film), 1, nos. 7–8: 2–3.

September: Jan Fromek founds the publishing house Odeon, which for the next six years becomes the publication forum of Devětsil. Teige edits a significant number of books for Odeon.

October: From 15 October to 13 November, Teige visits Russia as member of a delegation of Czech intellectuals belonging to the Společnost pro hospodářské a kulturní sblížení s novým Ruskem (Society of economic and cultural friendship with the new Russia). He visits Moscow (figure 3) and Leningrad (now St. Petersburg). Members of the delegation include T. Bartošek, G. Hart, stage director J. Honzl, poets J. Hora and J. Seifert, and historian of literature and poet B. Mathesius, as well as V. Procházka, J. Stolz, and K. Teige.

November: Teige publishes the article "Poesie pro pět smyslů" (Poetry for the five senses) in *Pásmo* 2, no. 2 (November 1925): 23–24.

Teige and Mrkvička cooperate on typographical designs and photomontages for book covers of the series Lidové romány (Popular Novels), published by the Komunistické nakladatelství (Communist publishing house) in Prague.

3. Karel Teige (with raised hand), visiting an art exhibition in Moscow, 1925. PNP, Prague. Reproduced by permission of Olga Hilmerová, Prague.

4. Cover of *ReD* 1, no. 7 (April 1928), "Osvobozené divadlo" (The Liberated Theater). The Mitchell Wolfson Jr. Collection, the Wolfsonian–FIU, Miami Beach.

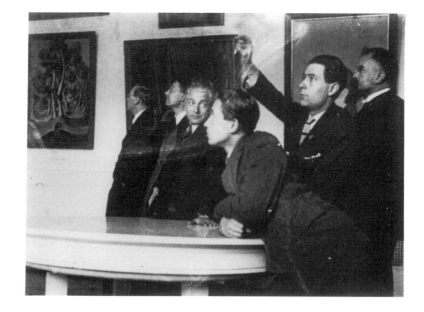

1926 **January:** Founding of the Osvobozené divadlo (The Liberated Theater) as a theater branch of Devětsil, with J. Frejka and J. Honzl as artistic directors (figure 4).

Teige and Mrkvička create a photomontage for the Osvobozené divadlo.

Teige and Nezval participate as actors in the plays *Ženy o Thesmoforiích* (The women at Thesmophoria) and *Když ženy něco slaví* (When women celebrate).

Teige leaves the editorial staff of *Pásmo*.

Teige publishes an account of his experiences during his travels to Moscow and Leningrad (in October and November 1925), "Z SSSR" (From the USSR), in *Tvorba* 1, no. 5 (1 January 1926): 85–88.

February: Teige lectures in Brno on the subject "Život a kultura v SSSR" (Life and culture in the USSR).

April: Nezval's play *Depeše na kolečkách—Vězeň Madrigal* (A telegram on wheels—The prisoner madrigal) premieres in the theater Na Slupi in Prague. The scenography is by Heythum, costumes by Šíma and Teige.

May: Exhibition of the Svaz moderní kultury Devětsil, (Association of Modern Culture of Devětsil), abbreviated as S.M.K., in the Dům umělců in Prague. Participants: J. Chochol, F. M. Černý, J. Fragner,

J. Havlíček, A. Heythum, K. Honzík, J. E. Koula, J. Krejcar, E. Linhart, V. Obrtel, J. Rosůlek, K. Stráník, J. Špalek, and P. Smetana (architects); O. Mrkvička, J. Šíma, F. Matoušek, J. Voskovec, J. Jelínek, J. Štyrský, K. Teige, and Toyen (painters); J. Rössler (photographer); M. Ponc (musician); and J. Frejka and J. Honzl (stage directors).

Spring: Teige writes the study "Slova, slova, slova" (Words, words, words), published in 1927 in the Brno review *Horizont* 1, no. 1 (January 1926): 1–3; no. 2 (February 1926): 29–32; no. 3 (March 1926): 44–47; no. 4 (April 1926): 70–73, edited by architect J. Kroha (figure 5).

October: Teige publishes "Konstruktivismus a nová architektura v SSSR" (Constructivism and the new architecture in USSR) in *Stavba* 5, no. 2 (October 1926): 19–32, no. 3 (October 1926): 35–39. He also publishes the article "Osvobozené divadlo" in the newspaper *Prager Presse* (German daily: *Prague Press*), in which he expounds his conception of the modern theater.

Apollinaire's play *Prsy Tiresiovy* (The breasts of Tiresias) premieres on 23 October in the Osvobozené divadlo in Prague. The scenography is by Teige, Mrkvička, and Zelenka, costumes designed by Teige and Mrkvička.

5. Cover of *Horizont,* nos. 29–30 (1931): issue dedicated to the Slovak architect Klement Šilinger. The Mitchell Wolfson Jr. Collection, Wolfsonian-FIU, Miami Beach.

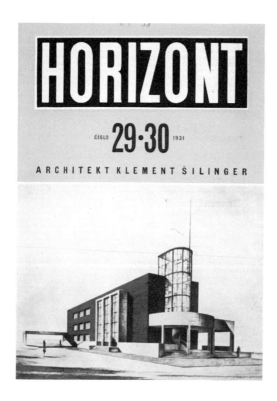

December: Publication of Nezval's book *Abeceda* (Alphabet), by
J. Otto; typographical design by Teige.

1927 **January:** Teige comments on the polemics between architects
K. Honzík and V. Ježek in the article "Podstata konstruktivismu" (The
essence of constructivism) in *Stavba* 5, no. 7 (January 1927): 111–113;
no. 8 (February 1927): 124–127.
February: Ilya Ehrenburg appears in Osvobozené divadlo on 14
February.
March: Teige defends constructivism in an article "Přednáška Ilji Eh-
renburga, čili konstruktivismus a romantismus" (A lecture by Ilya Ehren-
burg, or constructivism and romanticism), in *Stavba* 5, no. 9 (March
1927): 145–146.
Stavba a báseň (Building and poem) appears, a selection of essays from
the years 1919 to 1926 in his own typographical arrangement. It is pub-
lished by Vaněk and Votava.
June: Reconstruction of Teige's own apartment on 14 Černá Street, ac-
cording to the plans of Jaromír Krejcar, approved by the city of Prague.
Teige lived on the fifth floor, sharing it with Josefina Nevařilová.
July: Teige clarifies the nature of his cooperation with the poet
J. Wolker in an article called "Manifest Jiřího Wolkra o proletářském
umění" (The manifesto of Jiří Wolker on proletarian art); Wolker's "Pro-
letářské umění" appeared in *Var* 1 (1922): 271–275. Teige's article is pub-
lished in *Host* 6, nos. 9–10 (1927): 265–266.
August: On the sixtieth anniversary of Baudelaire's death, Odeon pub-
lishes the translation of his *Fanfarlo* (by Jožka Nevařilová) with a post-
script by Teige, who also designs the cover and the typographical
arrangement of the book.
October: On 1 October, the journal *ReD* (*Revue Devětsil*) commences
publication. Edited by Teige, it acts as the official organ of Devětsil.
The first issue of *ReD* contains Teige's article "Marcel Proust," in which
Teige compares André Gide with Marcel Proust (*ReD* 1, no. 1 [1927];
33–35, as well as the article "Hyperdada" (35–38).

363

6. Cover of *ReD* 1, no. 2 (November 1927), "Sovětská kulturní práce 1917–1927" ["Soviet Cultural Work, 1917–1927"]. The Mitchell Wolfson Jr. Collection, Wolfsonian–FIU, Miami Beach.

7. Cover of *ReD* 1, no. 8 (May 1928), "1. MÁJ V MOSKVĚ" ("First of May in Moscow"). The Mitchell Wolfson Jr. Collection, Wolfsonian–FIU, Miami Beach. Caption in top right corner reads: "Revised edition after confiscation" (by censors).

8. Cover of *ReD* 1, no. 9 (June 1928), Karel Teige and Vítězslav Nezval, "Manifesty poetismu" ("Manifestos of Poetism"). The Mitchell Wolfson Jr. Collection, Wolfsonian–FIU, Miami Beach.

November: Teige publishes "Sovětský konstruktivismus" (Soviet constructivism), outlining the emergence of constructivism in Soviet architecture, in *ReD* 1, no. 2 (1927): 54–55 (figure 6).

December: Teige publishes two articles on the sixtieth birthday of the art critic F. X. Šalda: "Básník bojů o zítřek" (The poet of the battles for tomorrow), *ReD* 1, no. 3 (1927): 89–90, and "Vůdce české moderny" (Leader of the Czech modern), *Kmen* 1, no. 12 (December 1927): 288–291.

His article "Moderní typo" (Modern typography) appears in *Typografia* 34, nos. 7–9 (1927): 189–198 (figure 7).

Teige completes the manuscript *Moderní architektura v Československu* (Modern architecture in Czechoslovakia); it is revised and enlarged during the spring of 1928, and again in 1930.

New production of the play *Pojištění proti sebevraždě* by Ivan Goll in the theater Umělecká beseda, with design input by Teige and Mrkvička.

1928 **February:** Special issue of *ReD,* dedicated entirely to architecture and containing articles by L. Hilberseimer, V. Obrtel, W. Gropius, P. Jeanneret, and others. Teige adds his own articles, "Soudobá mezinár-

odní architektura" (Contemporary international architecture) and "Le Corbusier a Ženeva" (Le Corbusier and Geneva), *ReD* 1, no. 5 (1928): 93–198.

March: Exhibition of paintings by J. Šíma, introduced by Teige in the gallery Aventinum in Prague. In his introduction in the catalogue, Teige situates Šíma's work at the intersection of poetism and surrealism. Abbreviated versions of the text appear in *Rozpravy Aventina* 1, no. 15 (29 March 1928): 179–180, and *ReD* 1, no. 8 (May 1928): 274–276.

Spring: Publication of Biebl's poetry, *S lodí, jež dováží čaj a kávu* (With a ship importing tea and coffee).

The typography and illustrations are by Teige, published by Odeon.

June: On 1 June, opening of an exhibition of new paintings by Štyrský and Toyen in the Aventinum. The introduction in the catalogue is by Teige; he discusses the common roots of artificialism and poetism. "Manifesty poetismu" (Manifestos of poetism) is published in a special issue of *ReD* 1, no. 9 (June 1928), (figure 8) which also contains Nezval's "Kapka inkoustu" (A drop of ink; 307–314), as well as Teige's articles "Ultrafialové obrazy čili artificialismus" (Ultraviolet images or artifi-

cialism; 315–316), and his "Manifest poetismu" (Manifesto of poetism; 317–336).

July: Teige publishes his seminal essay on constructivism, "K teorii konstruktivismu" (On the theory of constructivism), in *Stavba* 7, no. 1 (July 1928): 7–12; no. 2 (September 1928): 21–24.

September: Teige defines the terms of surrealist problematics in his review of A. Breton's book *Le Surréalisme et la Peinture* in "Surrealistické malířství" (Surrealist painting), *ReD* 2, no. 1 (September 1928): 1.

October: On 5 October, Le Corbusier lectures in Osvobozené divadlo on the subject of "Technika jako základ lyrismu" (Technology as the foundation of lyricism). Karel Teige acts as Le Corbusier's and Hélene de Mandrot's guide in Prague. Teige publishes "Le Corbusier v Praze" (Le Corbusier in Prague) in *Rozpravy Aventina* 4, no. 4 (October 1928): 31–32.

November: On the anniversary of Apollinaire's death, Teige publishes "Guillaume Apollinaire a jeho doba" (Guillaume Apollinaire and his time), in *ReD* 2, no. 3 (1928): 78–79.

Hannes Meyer and M. Seuphor initiate contacts with Devětsil during their visit to Prague.

Odeon publishes Teige's *Svět, který se směje* (A world of laughter) and *Sovětská kultura* (Soviet culture).

Teige cooperates with J. Krejcar and M. Lorenc on the proposal and design for a new arrangement of the theater hall in the hotel Adria on Wenceslaus Square in Prague.

1929 **January:** Teige publishes "Orfismus" (Orphism) in *ReD* 2, no. 5 (1929): 159–164, in which he discusses the paintings of František Kupka.

He initiates a polemic with Le Corbusier in his article "Polemické výklady" (Polemical comments) in *Stavba* 7, no. 7 (1929): 105–112. Teige writes a study of the work of le comte de Lautréamont, which he appends to a selection from *The Song of Maldorodor*. Together with the poet Hořejší, Teige cooperates with Philippe Soupault on the translation and the preparations for a bibliographical edition of the latter's work.

Teige also designs the cover, the typographical arrangement, and the plates for the book. Illustrations are produced by Štyrský. Part of this study also appears in "Píseň o Maldororovi," *ReD* 2, no. 7 (1929): 229–234. In July, the book is confiscated by the censors.

February: Teige publishes "F. T. Marinetti + italská moderna + světový futurismus" (F. T. Marinetti + Italian modernism + world futurism), in *ReD* 2, no. 6 (1929): 185–204.

March: Together with the Communist politician and theater critic Julius Fučík, Teige contributes to a declaration of young artists and critics directed against seven writers who issued a pamphlet opposing the new leadership of the Communist Party. It is reprinted in *Tvorba* 4, no. 12 (March 1929): 117.

April: Exhibition of drawings by Adolf Hoffmeister opens on 6 April. Teige writes the introduction to the catalogue. He continues his polemic with Le Corbusier in his article "Mundaneum" in *Stavba* 7, no. 10 (1929): 145–155, in which he severely criticizes the monumental features of Le Corbusier's design. At the same time, Teige starts a dispute on the subject of the conception of avant-garde architecture with the architect and poet Vít Obrtel.

Teige founds, edits, and publishes the first volume of a new series Mezinárodní soudobá architektura (Contemporary International Architecture), launched by the publishing house Odeon. In the concluding chapter, Teige presents a historical overview of the evolution of modern architectural thinking.

Teige's proposal for the reform of Herbert Bayer's typographical letters is published in *ReD* 2, no. 8 (1929).

May: From 16–31 May, the Klub Architektů (Club of Architects) mounts the exhibition *Mezinárodní moderní architektura* (International Modern Architecture) in the exhibition hall of the Prague Municipal Library. Teige provides the linotype design for the poster.

Spring: Teige takes part in the international exhibition *The New Typography* in the Staatliche Kunstbibliothek in Berlin, with a display of a collection of his typographical work.

Teige participates in an *Exhibition of International Books* in Dessau, which displays K. Biebl's *S lodí, která dováží čaj a kávu,* as well as the journals *ReD, Stavba,* and *Pásmo.*

Teige becomes member of the Ring Neuer Werk Gestalter (Circle of New Creative Designers).

June: While traveling on the express train to Moscow, on 8 June, Le Corbusier writes "In Defense of Architecture" as an answer to Teige's criticism of his Mundaneum design.

Karel Teige visits Paris.

Teige exhibits his work in the important show *Film und Foto* at the International Exhibition of the Deutsche Werkbund in the UfA-Palast in Berlin.

In an article "Koutek generace" (A generational nook), published in *Literární kurýr Odeonu* (Literary Courier of Odeon), Štyrský initiates the so-called generational dispute while at the same time signaling his parting of ways with Teige, by accusing him of putting politics before poetry. On his part, Teige sees the problem more as a crisis of criteria than politics.

October: The Levá fronta kulturních pracovníků a intelektuálů (Left Front of Cultural Workers and Intellectuals) is founded in Prague, with Teige as its principal organizer. He is also the author of its programmatic manifesto, published in *ReD* 2, no. 2 (November 1929): 40; he also acts as first chairman of Levá fronta during the years 1929–1930. The constituent assembly of Levá fronta publishes its own programmatic manifesto in *ReD* 3, no. 2 (November 1929): 48, signed by F. X. Šalda, J. Chochol, V. Vančura, V. Nezval, F. Halas, V. Závada, K. Teige, J. Štyrský, and Toyen, among others. Teige is appointed visiting senior lecturer at the Bauhaus in Dessau as a result of an invitation by his friend Hannes Meyer.

1930 **January:** In an article "Bouře na levé frontě" (A storm on the Left Front), published in the Brno leftist review *Index* 2, no. 1 (22 January 1930): 2–4, Teige resumes the generational dispute, in the course of

which he had been attacked as a politicizing critic and a rigid Marxist. Teige participates in the Munich exhibition *The Avant-Garde Poster.*

March: Teige lectures on typography, advertising graphics, aesthetics, and the sociology of architecture at the Bauhaus in Dessau during the 1929–1930 semester (figure 9). The lecture series on the sociology of architecture is printed in *ReD* 2, nos. 6–7 (March–April 1930): 161–223. Teige takes part in the exhibition *Neue Werbergraphik* (New Advertising Graphics) in Brussels.

Teige and the Czech photographers L. E. Berka, A. Hackenschmied, and J. Sudek take part in the exhibition *Das Lichtbild* (The Moving Picture) in Munich.

April: Teige publishes "Deset let Bauhausu" (Ten years of the Bauhaus) in *Stavba* 8, no. 10 (1930): 146–152.

Spring: Odeon publishes *Moderní architektura v Československu* and *Svět, který voní* (A fragrant world).

June: Teige publishes "Nadrealismus" (Superrealism) and "Vysoká hra" (High-stakes game) in a special edition of *ReD* (3, no. 8 [1930]: 249–255) dedicated to the Paris group Le Grand Jeu. He reacts to A. Breton's second manifesto and reevaluates his negative attitude vis-à-vis surrealism.

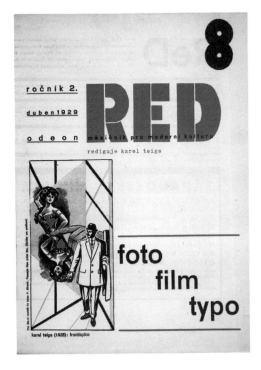

9. Cover of *ReD* 2, no. 8 (April 1929), "Foto—film—typo." The Mitchell Wolfson Jr. Collection, Wolfsonian–FIU, Miami Beach.

July: Teige publishes "Minimální byt a kolektivní dům" (The minimum dwelling and the collective house) in *Stavba* 9 (1930–1931): 28–29, 47–50, 65–68.

August: Teige stops all further cooperation with the Bauhaus and starts to publish a number of protest articles against its closing by the Nazis: "Bauhaus a otravné plyny reakce" (The Bauhaus and the poisonous odors of the reaction), *Tvorba* 5, no. 33 (21 August 1930): 521–522; no. 34 (28 August 1930): 542–543; no. 35 (4 September 1930): 559–560; "Hannes Meyer donucen k odchodu z Bauhausu" (Hannes Meyer forced to resign as director of the Bauhaus), *Stavba* 9, no. 1 (September 1930): 14; and "Doslov k Bauhausu" (An epilogue for the Bauhaus), *Tvorba* 5, no. 38 (25 September 1930): 604–606.

November: First issue of the journal *Zvěrokruh* (Zodiac), in which Teige publishes "Surrealistická revoluce" (The surrealist revolution), 47–48; "Surrealistické malířství" (Surrealist painting): 48; and "Báseň, svět, člověk" (Poem, world, man), 9–15.

Teige participates in the Third CIAM Congress in Brussels, 22–26 November, and delivers the lecture "Die Wohnungsfrage der Schichten des Existenzminimums" (The question of housing concerning the strata of an existential minimum).

1931 **February:** Exhibition of paintings by F. Muzika of the years 1930–1931 in the gallery Aventinská mansarda in Prague. The introduction to the catalogue is by Karel Teige.

July: Publication of last issue of *ReD* (3, no. 10), coinciding with the end of the collective activities of Devětsil. It includes Teige's "Architektura a třídní boj" (Architecture and the class struggle): 297–310.

Teige begins his editorial function with the new journal *Země* (Earth) and devotes his energies primarily to the subject of the sociology of architecture.

Teige participates in the exhibition *Internationale Ausstellung der Kunst der Werbung* (International Exhibition of Advertising Art) in Essen, Germany.

October: Teige writes *Nejmenší byt* (The minimum dwelling), for which he also provides the typographical design. The book is published by V. Petr (Prague, 1932).

1932 **March:** Teige publishes "Konstruktivistická typografie na cestě k nové formě knihy" (Constructivist typography on the way to new book design), in *Typografia* 39, no. 3 (1932): 41–44; no. 4 (1932): 57–61. Teige publishes "O fotomontáži" (On photomontage) in *Žijeme* 2, nos. 3–4 (1932): 107–112; no. 6 (1932): 173–178.
August: In Křtiny near Brno, Teige writes *Práce Jaromíra Krejcara* (The work of Jaromír Krejcar), published by V. Petr (Prague, 1933). Teige also designs its cover.
October: Teige participates as a member of the executive committee during the annual convention of Levá fronta, which takes place from 29 October to 1 November in Prague.

1933 **February:** The Svaz socialistických architektů (Association of Socialist Architects) is founded on 10 February in Prague, with Teige as one of its cofounders.
Teige publishes "Fototypografie. Užití fotografie v moderní typografii" (Phototypography: The use of the photograph in modern typography), in *Typografia* 40, no. 8 (1933): 176–184.
Spring: Teige publishes *Zahradní města nezaměstnaných* (Garden cities of the unemployed), published by M. Pavlová (Prague, 1933).
Teige, Nezval, and Hoffmeister engage in a polemic on the subject of Ilya Ehrenburg's pamphlet against surrealism; it appears in the review *Volné směry* 30, no. 6 (1933–1934): 139–150.
November: On 30 November, Teige speaks on the occasion of a memorial for Adolf Loos in the Prague Municipal Library.

1934 **February:** Teige edits the new journal *Doba* (Age), which appears with the subtitle *Časopis pro kulturní, sociální a politický život* (Journal of Cultural, Social, and Political Life). It appears for the last time November 1935, and it acts as the mouthpiece of the surrealists.

March: The Skupina surrealistů v ČSR (Group of Surrealists in Czecho-slovakia) is founded on 21 March in Prague, publishing the manifesto *Surrealism in Czechoslovakia.* The manifesto is conceived by the poet V. Nezval and signed by the poet K. Biebl, psychoanalyst B. Brouk, stage director J. Honzl, musician J. Ježek, sculptor V. Makovský, and painters J. Štyrský and Toyen, as well as by Teige. However, Teige did not participate in the founding of the group, because of a personal clash with Štyrský.

April: In *Doba,* no. 6 (12 April 1934), Teige welcomes the establish-ment of the new group of surrealists. A few months later, he becomes a member and its programmatic spokesman.

May: The first lecture evening of the Skupina surrealisů takes place on 11 May, in the gallery of the Mánes Union of Artists (abbreviated as "S.V.U. Mánes"), with K. Teige, V. Nezval, J. Honzl, J. Štyrský, B. Brouk, and K. Biebl as participants. S.V.U. Mánes acted as the center of the "Czech Moderne" from the end of nineteenth century on. Its publication *Volné směry* (Free directions) first appeared in 1897.

A discussion evening takes place on 18 May at Charles University on the subject "Nastolení a pád surrealismu v ČSR" (The rise and fall of surreal-ism in Czechoslovakia). Teige and Nezval participate.

On 28 May, the Association of Listeners at the Faculty of Philosophy and members of Levá fronta hold a discussion evening in the Prague Mu-nicipal Library on the subject of surrealism. The proceedings are later published in *Levá fronta* 8 (1934) as "Surrealismus v diskusi" (Surrealism in discussion), edited by Teige and Ladislav Štoll.

Teige publishes *Architektura pravá i levá* (Architecture on the right and on the left), published by M. Pavlová (Prague, 1934).

November: Another discussion evening is held on 14 November, dedi-cated to the relationship between socialist realism and surrealism. Teige presents the lecture "Socialistický realismus a surrealismus" (Socialist re-alism and surrealism). All lectures are published in the collection *Socialis-tický realismus* (Socialist realism) by Levá fronta (Prague, 1935).

1935 **January:** The first exhibition *Surrealismus v ČSR* (Surrealism in Czechoslovakia) is inaugurated on 15 January in the gallery Mánes in Prague. The introduction and catalogue are by Teige and Nezval. Teige's contribution carries the title "Surrealismus není uměleckou školou" (Surrealism is not a school of art).

March: Paul Eluard and André Breton and his wife visit Prague between 27 March and 10 April. Breton lectures on the surrealist movement in the gallery Mánes.

Czech surrealists accompany A. Breton to Karlovy Vary and Mariánské Lázně (world-famous spas also known by their German names Karlsbad and Marienbad) on 31 March (see figure 10).

April: Teige publishes an extensive review of Breton's lecture "Surrealism and Poetry in Painting" in *Volné směry* 31 (1934–1935): 179–185.

May: Publication of the *1. mezinárodní bulletin surrealismu* (First international bulletin of surrealism), containing Czech and French texts of a joint proclamation and excerpts from lectures by A. Breton and V. Nezval, as well as a reprint of Teige's interview with A. Breton and P. Eluard, originally published in the Communist newspaper *Haló noviny* (Hello News).

10. André Breton (*left*) and Karel Teige (*right*) in Karlovy Vary (Karlsbad), 1935. PNP, Prague. Reproduced by permission of Olga Hilmerová, Prague.

September: Teige influences the decision of the members of the Skupina surrealistů not to sign Breton's text "Z doby, kdy surrealisté měli pravdu" (From a time when the surrealists held the truth). Teige later explains his position in *Surrealismus proti proudu* (Surrealism against the current) (Prague, 1938).

Teige creates his first collages, and continues in this effort until his death.

1936 **January:** During one of the soirées of Levá fronta, Teige reads his text "Čin Romaina Rolanda" (The deed of Romain Roland), also published in *Tvorba* 11, no. 6 (7 January 1936): 88–90; no. 7 (14 February 1936): 107–110; no. 8 (21 February 1936): 123–125.

February: The first and only issue of the review *Surrealismus,* edited by Nezval and Teige, is published. Teige contributes the article "Poezie a revoluce" (Poetry and revolution), 43–48.

April: Teige designs the cover and typographical arrangement for the collection of poetry by V. Nezval, *Žena v množném čísle* (Woman in the plural), published by F. Borový.

June: Teige contributes the article "Revoluční romantik K. H. Mácha" (The revolutionary romantic K. H. Mácha) to the memorial volume *Ani labut' ani lůna* (Neither a swan nor a bosom, 10–28), published by the surrealist group on the anniversary of the death of Czech poet K. H. Mácha (1810–1836).

A soirée of the surrealist group dedicated to K. H. Mácha takes place on 22 June in the E. F. Burian's avant-garde theater D 36, with the title *Ani labut' ani lůna.*

December: Teige designs the cover, frontispiece, and typographical arrangement of Nezval's collection of poems *Praha s prsty deště* (Prague with fingers of rain), published by F. Borový.

Teige publishes *Jarmark umění* (Bazaar of art), published by F. H. Müller (Prague, 1936).

1937 **January:** Teige takes part in a discussion, arranged by the discussion club Přítomnost (The Present), dedicated to the critique of André Gide's book *Návrat ze Sovětského svazu* (Return from the Soviet Union).

March: Teige and stage director E. F. Burian inaugurate an exhibition of the new generation of surrealists F. Gross, B. Lacina, L. Zívr, M. Hák, and V. Zykmund in the theater D 37.

Teige takes part in lectures presented in the theater at the occasion of the exhibition.

The second edition of Nezval's book *Most* (The bridge) is published with Teige's typographical design by the publishing house F. Borový.

April: In a memorial collection, titled *10 let Osvobozeného divadla* (Ten years of the liberated theater), published by F. Borový, Teige contributes the article "Poezie na divadle. Několik poznámek k tvorbě režiséra Jindřicha Honzla" (Poetry in the theater: Some remarks on the work of the stage director Jindřich Honzl; 55–72).

November: The Prague City Council approves the plans of architect Jan Gillar for the construction of a rental house for Karel Teige and his sister Jana Teigová on the street U Šalamounky, no. 2369/5 (figure 11). Teige is still living with Jožka Nevařilová.

11. Karel Teige and Jožka Nevařilová on the balcony of Teige's house on U Šalamounky Street in Prague. Photo by Olga Hilmerová, ca. 1940s.

1938 **January:** Second exhibition of the Skupina surrealistů v ČSR (Group of Surrealists in Czechoslovakia), showing works by J. Štyrský and Toyen in the Topičův salon in Prague (the exhibition travels to Bratislava in March, and to Brno in April). Teige prepares the catalogue, which in its introduction equates Nazism with Stalinism. Nezval's monograph *Štyrský a Toyen* is published by F. Borový with a postscript by Teige.

March: A conflict between the poet V. Nezval and the surrealist group erupts on 7 March in the wine bar U Locha (Today Viola) in Prague. The reason for the altercation are differing opinions on Stalinism.

On 11 March, V. Nezval, holding a Stalinist position, announces the dissolution of the surrealist group in the newspaper *Haló noviny.*

On 13 March, the surrealist group rejects Nezval's attempt at its liquidation by an announcement in the daily press, and confirms its continuing existence during a meeting held on 14 March.

On 17 March, Teige publishes the article "K případu V. Nezvala a surrealistické většiny" (On the affair of V. Nezval and the surrealist majority) in the newspaper *Ranní noviny* (Morning News), 4.

The re-formed group consists of K. Biebl, B. Brouk, J. Heisler, J. Honzl, J. Ježek, J. Štyrský, K. Teige, and Toyen.

May: Teige writes the polemical brochure *Surrealismus proti proudu* (Surrealism against the current), published by the surrealist group in Komise české knihy (Czech Book Commission) (Prague, 1938).

Teige writes a manifesto, explaining the surrealist position of the year 1938 (not published). The proposed review *Lykantrop* also fails to get published.

1939 From the beginning of the Second World War until his death, Teige works on his book *Fenomenologie moderního umění* (Phenomenology of modern art), which he originally planned to be published in ten volumes; each volume was to be dedicated to a particular developmental cycle, dating from the French Revolution up to the present.

Jan Gillar draws plans for a summer cottage for Karel Teige, Jana Teigová, and Jožka Nevařilová to be built in Nový Vestec, near Prague.

1940 Teige writes the extensive study "Jan Zrzavý—předchůdce," which precedes the memorial volume *Dílo Jana Zrzavého, 1906–1940* (The work of Jan Zrzavý, 1906–1940), published by Umělecká Beseda and Družstevní práce (Prague, 1941), 49–66.

1941 Teige meets Eva Ebertová (1915–1951), the illegitimate child of the poet J. S. Machar (figure 12). He continues living with two women, Jožka and Eva, until his death in 1951.

1942 Teige signs contract for the publication of the book *Fantastické umění* (Fantastic art) with the publishing house Družstevní práce.

1945 Teige occupies himself mainly with publicity and graphic work and the installation of general, non-art-related exhibitions.
Teige makes preparations for the publication of the book *Guillaume Apollinaire* with the publisher V. Schmidt; *Moderní malířství* (Modern paint-

12. Eva Ebertová, ca. 1945. Reproduced by permission of Olga Hilmerová, Prague.

ing) with the publishing house Čin; and *Jarmark umění,* to be published
in a new edition by Družstvo Máje (the Cooperative Association May).
None of these books were published at that time.

May: Right after the May uprising against the German occupation,
Teige dispatches a written self-critique to the Central Agitprop of the
Communist Party of Czechoslovakia, as requested by its general secre-
tary, the poet L. Čivrný. In January 1946, Hoffmeister asks Teige for a
copy of this document, which he intends to show to the Communist
minister of culture and information, Václav Kopecký.

Teige publishes "Entartete Kunst" (Decadent art), in *Kvart* 4, no. 1
(1945): 42–59.

In the article "Osud umělecké avantgardy v obou světových válkách"
(Fate of the artistic avant-garde in two world wars), published in
Obrtel's review *Kvart* 4, no. 6 (1945): 375–392, Teige returns to the sub-
ject of the Czech cubist painter Bohumil Kubišta, this time from a surre-
alist position and from the point of view of art-historical considerations.

There is an exhibition of the surrealist paintings of Václav Tikal from the
years 1941 to 1945 in the administration building of the Fantovy závody
(Fanta Works). Teige writes the introduction in the exhibition brochure.

November: An exhibition of Toyen's paintings and drawings of the
years 1939 to 1945 is inaugurated on 27 November in the Topičův salon
in Prague. Teige provides the text for the catalogue.

Teige submits his "Jarmark umění, studie k sociologii moderního
umění" (A study of the sociology of modern art) and "Jan Zrzavý—
předchůdce" (Jan Zrzavý—Precursor) as his doctoral dissertation to the
Faculty of Philosophy at Charles University. Critical comments are pro-
vided by the structuralist J. Mukařovský, J. Král, and K. Krejčí.

1946 F. Borový publishes a collection of twelve drawings by Toyen from the
years 1939–1940, titled *Střelnice* (The shooting gallery), with an introduc-
tion by Teige.

Teige maintains friendly relations with a group of young surrealists, who
develop their work independently from the French center in Paris,

called Spořilovská skupina (the Prague-Spořilov Group) and Skupina Ra (the Group of Ra). Teige participates in the restoration of activities of the Czechoslovak CIAM Group, interrupted by the Second World War. He writes "Estetické úvahy Bohumila Kubišty" (The aesthetic reflections of Bohumil Kubišta), the postscript for a book of essays by the cubist painter B. Kubišta titled *Předpoklady slohu* (The prerequisites for style), published in cooperation with František Kubišta by O. Girgal (Prague, 1947).

June: On 18–19 June, Teige participates in the Congress of Czech Writers and contributes to the discussion with the theme "K aktuálním otázkám kulturního života" (Concerning actual questions of cultural life) and "Poslání kritiky" (The task [or mission] of criticism), also published in *Kvart* 5, no. 1 (1946): 14.

On 18 June he is called to defend his dissertation on aesthetics and the history of art at the Faculty of Philosophy at Charles University. However, he is not granted the title of doctor of philosophy, as he fails to appear for the minor examination.

December: Exhibition of the works of Josef Istler of 1941 to 1946 in the gallery Topičův Salon. Teige writes the text for the catalogue.

On 18 December, Teige makes a radio broadcast of his lecture, dedicated to the founder of the Czech modern architecture, Jan Kotěra.

1947 **January:** On 10 January, Teige concludes a contract with the publisher O. Girgal for the launching of the Orloj (Horology) edition, with himself as chief editor. Among other works, he prepares the translation of Maurice Nadeau's *History of Surrealism*. In 1948 the plates for this book are melted down.

March: At the request of S. Giedion, dated 10 November 1946, Teige writes an essay dealing with the mutual relationship between painting, sculpture, and architecture, intended as a contribution to the CIAM Congress to be held in May.

April: As part of a lecture series dedicated to the work of F. X. Šalda and organized by the Společnost F. X. Šaldy (F. X. Šalda Society),

Teige delivers on 16 April the lecture "F. X. Šalda a léta devadesátá" (F. X. Šalda and the 1890s) in the Municipal Library of Prague. The lecture is published in *F. X. Šalda, 1867–1937–1967* (Prague, 1968), 165–189.

Teige makes preparations for the books *Moderní architektura v ČSR* (Modern architecture in Czechoslovakia) and *Moderní fotografie* (Modern photography), both commissioned by the Czechoslovak Ministry of Information and Education (to be published in 1947).

Teige writes a collection of essays *Umění přítomnosti* (The art of the present) for the Ars series of the publishing house Orbis.

November: The exhibition *International Surrealism,* 14 November to 3 December, takes place in Topičův salon, curated by Jindřich Heisler and Teige. The text of the catalogue is by Breton and Teige; the opening speech is by Teige.

December: Discussion on the subject of surrealist ideology on 2 December as part of the exhibition International Surrealism. Teige delivers the opening speech.

1948 **January:** Art historian Jan Krofta informs Teige in a letter that his proposed manuscript of a monograph on Jindřich Štyrský has been rejected by the presidium of the Mánes Union of Artists.

A new group of surrealists begins to form around the person of Teige, representing the young generation of artists, such as poet and art historian V. Effenberger, poet K. Hynek, painters V. Tikal, J. Istler, and M. Medek, and photographer E. Medková.

April: During the Sjezd národní kultury (Congress of National Culture), the minister V. Kopecký mentions a planned encyclopedia on the creative arts, prepared in outline by Teige.

July: Teige begins to write an introduction for a catalogue of a comprehensive exhibition *Bohumil Kubišta,* to be inaugurated in January 1949 in the gallery Mánes. The exhibition is later canceled. Teige publishes the text of his study "Bohumil Kubišta" in *Kvart* 5, no. 6 (June 1949): 350–378 (his last published work before his death in 1951).

Teige prepares the volume *Nové obzory: abstraktivismus, surrealismus a novorealismus* (New horizons: Abstractism, surrealism, and neorealism) for a five-volume edition of the proposed encyclopedia of Czech modern art, as well as contributing to the third part of the series his essay "Sto let československého umění: Malířství, sochařství a architektura" (A Hundred years of Czechoslovak art: Painting, sculpture, and architecture). The encyclopedia was not published.

During the late summer, J. Mukařovský, on his own initiative and supported by the political leadership, proposes Karel Teige for a professorship at Charles University.

On 13 September, the art historian and collector of Picasso and Braque paintings Vincenc Kramář sends Teige a letter expressing his reaction to the latter's essay "Bohumil Kubišta," published in *Kvart*. This provides the incentive for Teige to write a more extensive but unfinished manuscript with the broad title *Vývojové proměny v umění* (Developmental changes in art), only published seventeen years later (Prague, 1966). One part, dedicated to lexicographical and conceptual revisions and finished in March 1950, takes issue with Kramář's letter.

1950 **January:** A press campaign instigated by the ruling Communist Party containing a series of violent denunciations of Teige, Devětsil, and the surrealist group reaches its crescendo. Nezval contributes to the mounting tensions surrounding Teige by his critique of Teige's activities during the 22 January meeting in Prague of the Svaz českých spisovatelů (Federation of Czech Writers, at that time the "official" association representing all literary "workers" in the Czechoslovak Socialist Republic, approved by the Communist Party).

April: In a letter to the Communist politician and art critic L. Štoll, Teige reacts against the latter's criticism of Devětsil and himself in the article "Od proletářské poesie k poetismu" (From proletarian poetry to poetism), published in *Tvorba* 19, no. 14 (1950): 318–319.

1951 **January:** The group of surrealists around Teige begins the publication of ten unedited memorial volumes under the title *Znamení zvěrokruhu* (The signs of the zodiac), to which Teige contributes (commencing with the month of February) the chapter "Realismus a irealismus kubistické tvorby" (Realism and irrealism in cubist work).

October: On 1 October, Teige dies of heart attack, followed by the suicides of Josefina Nevařilová (2 October), and Eva Ebertová (12 October[?]).

Officials of the Communist State Security confiscate all of Teige's manuscripts and writings in the apartment of Teige and Eva Ebertová.

The group of surrealists publishes its tenth memorial volume of the *Znamení zvěrokruhu,* which also contains an unfinished chapter of Teige's study on cubism, intended for the October volume.

Mojmír Grygar, a Communist theoretician of literature, publishes the article "Teigovština-trockistická agentura v naší kultuře" (The Teigeist-Trotskyist agency in our culture), published in *Tvorba* 20, no. 42 (18 October 1951); no. 43 (25 October 1951); and no. 44 (1 November 1951) (figure 13).

13. Karel Teige. Photo by Olga Hilmerová, ca. 1948.

As I am trying to refresh my memory after four decades about events that happened half a century ago with respect to a past situation that was not only full of tensions, but also quite opaque, I discover many gaps and errors in recent literary biographies about my uncle, Karel Teige. I will try to be concise in writing about his complex relationships and bonds.

From 1937 to 1938, as a student of the *realné gymnasium* (the equivalent of a U.S. junior college) in Prague, I kept in regular contact with K.T. usually during weekends; later, I saw him quite often after my graduation in 1942, when his friend the architect Fragner gave me my first job. A year later I was commandeered into forced labor in Germany and thus was able to see my uncle only occasionally during holiday furlough visits to my aunt. After the war, we frequently met on Saturdays until his death in 1951.

My aunt, Jožka (Josefina) Nevařilová, became very close to Teige in 1924. After the architect Krejcar completed the reconstruction of the exterior of Teige's house on Černá Street (in Prague), adding two small dwelling units with a common small kitchen and a balcony on its flat roof, my aunt moved there. A proposed marriage did not happen, because my aunt had won a competition sponsored by the Ministry of Social Welfare for a position as social secretary, which was open only for single women. K.T. did not have a steady income at that time, and besides, he used all his extra money to buy foreign books, which occasionally left him penniless. He was able to get access to our own literature with the help of his father, who, as archivist of the Prague libraries, provided open access for his son to all public libraries and the state archives in the city, a privilege that Teige used abundantly. I should mention that K.T. had a phenomenal memory with which he dazzled his friends: in discussions he often cited from memory dozens of sources, together with all evidentiary data.

In 1936 Teige's kin sold the family home and commissioned the architect Gillar to build an ultramodern apartment house with four comfortably equipped mini-flats and a small flat for the concierge on the sunny side of the Smíchov Hill (in Prague). All three moved there, and Karel lived there with Jožka until their tragic deaths in 1951. K.T. made the acquaintance of Eva Ebertová (the illegitimate child of the Czech poet J. S. Machar) in 1941. Occasionally, he did his writing in her apartment, usually at times when my aunt was working in the ministry.

She knew about the relationship, and remained his steady companion; she also took care of their common household. K.T. expressed his relationship with my aunt in a letter (21 June 1948) to her coworker Mary in which he writes: "Occasionally one finds rare, real people in the person of a genuine sterling human being, you and Jožka."

A watershed in K.T.'s life occurred in 1936, when he made a public statement condemning Stalin's Moscow trials as a counterfeit comedy. His friends, who agreed with him, were summarily expelled from the Czechoslovak Communist Party (note that K.T. himself was never a card-carrying member of any political party), and all were denounced as counterrevolutionary Trotskyites.

Curiously, during the Second World War his denunciation of Stalin's Moscow trials saved K.T. from the concentration camp, but at the same time it brought him to the attention of the Gestapo as an expert on Marxism, capable of denouncing the Party's top leadership and thus potentially useful for their anti-Soviet propaganda efforts of that time. Fortunately, my aunt had a school friend who had married a Prague German and who was employed as a clerk by the Gestapo during the war. She learned from her that the Gestapo was intending to call on Teige to use him in their propaganda campaign. Thus warned, he managed to disappear from Prague for a few days until given the signal that it was safe to return.

His situation became worse after the war. In order to be allowed to work even for minor publishing houses, he was obliged to apologize (for his ideological deviation) and had to issue a public statement of self-criticism. This enabled him to earn a modest living until 1948. After the communist takeover (actually a putsch) of Czechoslovakia on 4 February 1948, however, not a single publisher could afford to employ a "Trotskyite counterrevolutionary," and Teige was effectively left without an official source of income. My aunt was thrown out of the ministry, but she was lucky to find employment in the House of Youth, where one of her old friends offered her protection.

This was not the end of Teige's difficulties. Some of his former friends with connections to the Central Committee of the Czechoslovak Communist Party (ÚV KSČ) found out that a trial against important opposition intellectuals was being prepared. K.T. assumed that its model would surely be the Moscow trials of

1936 and that the accused had to expect to be tortured, with the verdict either the gallows or lifelong imprisonment. He immediately hid all his "Trotskyite" books and papers in an old, unused underground war shelter and burned all his international correspondence. In December 1950 he composed his last will, deeding all his movable possessions to my aunt.

Emigration was out of the question, as he was being constantly watched by the secret police, whose agents he could often identify from behind the curtains of his window. K.T. also knew that the principal initiator of his persecution was his former opponent, the art photographer L. Kopřiva, who had become the boss of all the secret security organs of the Prague region. K.T. tried to extricate himself from this hopeless situation by concentrating on his work on the development of modern art. He did his writing in Eva's apartment, where he felt safer, since it had two separate exits. It was also there where he suffered his heart attack on 1 October 1951.

My aunt learned about this immediately, and while shattered by the news, she managed to go home and compose a last will in the full possession of her rational faculties, with the intent to secure all movable property in order that it would not be pilfered or fall into the wrong hands. She handed over this document to her cousin, a notary by profession; after taking care of all this, she lay down in her small kitchen and opened the gas. The next morning she was found there, dead. [Editor's note: Eva Ebertová committed suicide in a similar manner, ten days later. Jaroslav Seifert, in his book *Všecky krásy světa* (*All the Beauties of the World*) (Prague, 1993), describes this tragedy in a chapter titled "Smíchovský danse macabre" ("Dance Macabre in Smíchov," 504–511).]

State security organizations immediately sealed both apartments, and their personnel lounged about for two weeks under the pretense of compiling an inventory of K.T.'s papers and the contents of his library. They removed eight linear meters of books in four languages on Marxism and also stole from my aunt's library a large collection of detective novels, of which she was a passionate reader. After fourteen days they gave us back the keys along with an order to vacate the apartment within a month. It was subsequently assigned to a notable party functionary.

MILOŠ AULICKÝ, 26 November 1998 (Translated by Eric Dluhosch)

SELECTED BIBLIOGRAPHY

Note: Only English titles are shown. Foreign language references are included in the endnotes of the individual chapters.

Anděl, Jaroslav. "The 1920's: The Improbable Wedding of Constructivism and Poetism." In *The Art of the Avant-Garde in Czechoslovakia, 1918–1938,* edited by Anděl and C. Alborch: 21–60. Valencia, 1993.

Anděl, Jaroslav, et al. *Czech Modernism 1900–1940.* Exhibition catalogue. Boston, 1989.

Bydžovská, Lenka, and Karel Srp. "On the Iconography of the Chessboard in Devětsil." *Umění* 41 (1993): 39–46.

Císařová, Hana. "Surrealism and Functionalism: Karel Teige's Dual Way." *Rassegna* 15, no. 53/1 (1993): 78–88.

Czech Functionalism. Introductory essay by Vladimír Šlapeta, foreword by Gustav Peichl. London, 1987.

Dluhosch, Eric. "'Nejmenší byt,' The Minimum Dwelling." *Rassegna* 15, no. 53/1 (1993): 30–37.

Frampton, Kenneth. *Modern Architecture: A Critical History.* London, 1985.

Hain, Simone. "Karel in Wonderland: The Theoretical Conflicts of the Thirties." In *Karel Teige, Architettura, Poesia, Praga 1900–1951,* edited by Manuela Castagnara Codeluppi. Exhibition catalogue. Milan, 1996.

"Karel Teige's 'Mundaneum' (1929) and Le Corbusier's "In Defense of Architecture" (1931), introduction by George Baird, in *Oppositions,* no. 4 (October 1974): 79–108.

Lahoda, Vojtěch. "Teige's Violation: The Collages of Karel Teige, the Visual Concepts of the Avant-garde, and René Magritte." In *Karel Teige: Surrealist Collages, 1935–1951,* 7–18. Prague, 1994.

Máčel, Otakar. "Paradise Lost: Karel Teige and Soviet Russia." *Rassegna* 15, no. 53/1 (1993): 70–77.

Masák, Miroslav, Rostislav Švácha, and Jindřich Vybíral. *The Trade Fair Palace in Prague.* Prague, 1995.

Masaryk, T. G. *Masaryk on Marx.* Translated and edited by Erazim V. Kohák. Lewisburg, Pa., 1972.

Mukařovský, Jan. *Aesthetic Function, Norm, and Value of Social Facts.* Translated and edited by Mark E. Suino. Ann Arbor, 1979.

Mukařovský, Jan. *Structure, Sign, and Function: Selected Essays.* Translated and edited by John Burbank and Peter Steiner. New Haven, 1978.

Rassegna 15, no. 53/1 (March 1993): "Karel Teige, Architecture and Poetry." Whole issue dedicated to Karel Teige.

Sayer, Derek. *The Coasts of Bohemia: A Czech History.* Princeton, N.J., 1998.

Skilling, H. Gordon. *T. G. Masaryk: Against the Current, 1882–1914.* New York, 1994.

Šlapeta, Vladimír. "Czech Organic." *Architectural Review,* July 1988,q 73–78.

Šmejkal, František, and Rostislav Švácha, eds. *Devětsil: Czech Avant-Garde Art, Architecture, and Design of the 1920s and 1930s.* Exhibition catalogue. Oxford and London, 1990.

Srp, Karel, ed. *Karel Teige 1900–1951.* Exhibition catalogue, Prague City Gallery. Prague, 1994.

Švácha, Rostislav. "Karel Teige and the Devětsil Architects." *Rassegna* 15, no. 53/1 (1993): 7–21.

Švácha, Rostislav, A. Tenzer, and Klaus Spechtenhauser. *Jaromír Krejcar 1895–1949.* Exhibition catalogue in Czech and English. Prague, 1995.

Szporluk, Roman. *The Political Thought of Thomas G. Masaryk.* Boulder, Colo., 1981.

Umění 43 (1995), special issue on Teige.

SOURCES

Olga Hilmerová, representing the heirs to Karel Teige's estate, Zbyňek Aulický and Miloš Aulický, has granted exclusive rights to The MIT Press to publish the English translations of the following original essays authored by Karel Teige: "Poetismus" (Poetism), *Host* (1924); "Minimální byt a kolektivní dům" (The minimum dwelling and the collective house), *Stavba* (1930); "Moderní typo" (Modern typography), *Typografia* (1927); and "Vnitřní model" (The inner model), *Kvart* (1946); in the book titled: *Karel Teige (1900–1951): L'Enfant Terrible of the Czech Modernist Avant-Garde,* edited by Eric Dluhosch and Rostislav Švácha.

Olga Hilmerová and Teige's heirs have also granted The MIT Press permission to publish the following reproductions of Teige's original collages and related illustrations in the above-named book: collages nos. 45, 50, 51, 55, 62, 70, 127, 133, 147, 205, 239, 243, 249, 290, 299, 306, 314, 322, 325, 336, 339, 346, 371, and an unnumbered collage dated 1941. Other illustrations: photograph of Karel Teige and André Breton in Karlsbad; Karel Teige in Moscow, 1925; Karel Teige, photo by Olga Hilmerová, ca. 1948; Eva Ebertová, ca. 1945; Karel Teige and Jožka Nevařilová on the balcony of Teige's house in U Šalamounky Street in Prague; Karel Teige's apartment in his own house on U Šalamounky Street, 1951.

The Památník národního písemnictví (PNP; Museum of Czech Literature) in Prague, owner of the above-listed collages, has granted The MIT Press exclusive permission to publish these as well as to reproduce other pictorial matter, as noted in the captions accompanying each illustration.

The ÚDU AVČR (Ústav dějin umění Akademie věd České republiky; the Institute of Art History of the Academy of Sciences of the Czech Republic) has loaned The MIT Press twenty-three illustrations for exclusive publication in this volume. These illustrations are identified as such in the list of illustrations as well as in the captions.

The photographers Miloslava Čeňková, František Illek, Jiří Hampl, František Krejčí, Jan Malý, Zdeněk Matyásko, Pavel Štecha, and Josef Sudek claim copyrights for illustrations published in this book, identified as theirs in the captions.

418

This book contains many expressions, titles, names, and words rendered in their original Czech spelling, including diacritical marks and accents peculiar to that language. The pronunciation of these marks falls into two basic categories.

The first *lengthens* the vowels, hence:
- **a** = somewhere between **a** as in cat and **u** as in hut
- **á** = like **ah,** as in bar or far
- **e** = like hen or end
- **é** = like **ae** in pear or swear
- **ě** = like ye in yellow or yen
- **i** = like **i** in hit or bit
- **í** = like **ee** in sweet or heat
- **u** = like **oo** in foot or loot
- **ú** = like **oo** (long) in coon or shoot
- **ů** = same as **ú**
- **y** = same as **i**
- **ý** = same as **í**
- **ou** = phonetically separate, like in **go-u**nder

The second modifies the sound, hence:
- **č** = like **ch** in China (or **cz** in Czech). Hence **Č**apek is not *K*apek but *Ch*apek.
- **ř** = difficult! like **rzh** in Dvořak (Dor-zhak). Only natives can pronounce it!
- **š** = like **sh** in shovel or shim
- **ž** = like **zh** in Zhivago or seizure
- **ň** = like **ni** in bunion (but softer), or the Spanish **ñ** in El Niño
- **t** = soft, like tune or tulip (but more like tiulip)
- **d** = soft, like dune or duke

Some consonants are pronounced differently than in English.
- **c** = like **ts** in tsar or cats
- **j** has a sound similar to **y** as in yet or yellow (*not* like the English jet).
- **v** and **w** are pronounced the same, like **v** in viper
- **q** sounds like **kv** in quart, but with a **v** before the **a** (example: k'vart)
- **c** and **k** together are not just like **k** in English, but **c** (ts) - **k** (kh) are sounded separately, as in Palacký = *Pa*-lats-kee, not Pa-l*a*-key.

All letters are pronounced phonetically and consistently the same. The stress is generally on the first syllable, not on the second, as in English.

DATE DUE

GAYLORD PRINTED IN U.S.A.